# THE AGE OF THE
# IMPRESSIONISTS

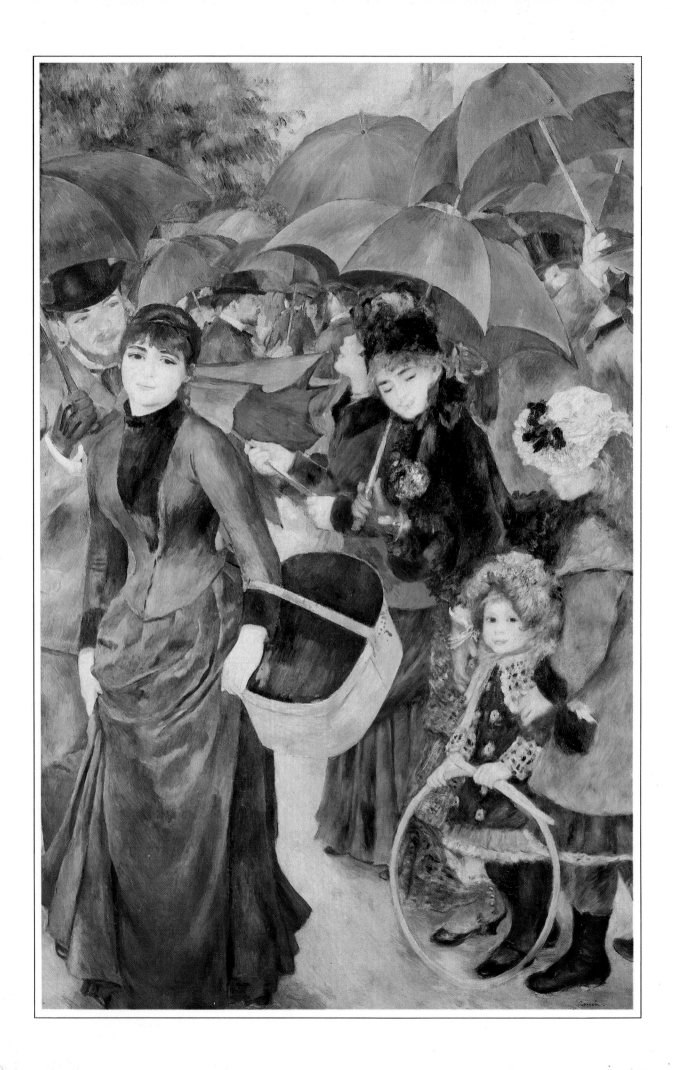

# THE AGE OF THE
# IMPRESSIONISTS

## DENIS THOMAS

HAMLYN

Acknowledgments

The illustrations on the following pages are reproduced by courtesy of the Trustees, The National Gallery, London 27, 45 left, 51 bottom, 59, 66, 67, 72, 74 bottom, 77, 78, 79, 83, 120, 124, 129, 133 right, 142 bottom, 158, 160, 190, 193, 194, 212, 233, 239.

Photographs

Ashmolean Museum, Oxford 106; Bayerische Staatsgemälde-sammlungen, Munich 69, 123 top; Bridgeman Art Library, London 14, 22–23, 32 bottom, 34, 56, 65, 70, 92, 95, 98 top, 109, 110, 128, 136 top, 125, 135 top, 137, 141 top, 146, 175, 201; Bulloz, Paris 12, 22, 119; Sterling and Francine Clark Art Institute, Williamstown, Massachusetts 103; Columbus Museum of Fine Art, Ohio 230; Courtauld Institute Galleries, London 45 right, 97, 107, 123 bottom, 143 bottom, 159, 161, 179, 189, 192, 214; Fogg Art Museum, Cambridge, Massachusetts 118; Photographie Giraudon, Paris 6, 16, 17, 18, 41 top, 41 bottom, 42, 46, 48 bottom, 51 top, 61, 73 top, 74 top, 80 top, 80 bottom, 81, 84, 85, 87 top, 87 bottom, 88, 89, 91, 96, 99, 100, 101, 102, 105, 116, 127, 142 top, 143 top, 148 left, 155, 157, 176, 185, 200, 202 bottom, 222, 228, 235, 242 top, 249; Glasgow Art Gallery and Museum 224; Richard Green, London 47 bottom, 82, 86; Fundação Calouste Gulbenkian, Lisbon 68; Hamburger Kunsthalle 140–141; Hamlyn Group Picture Library 20, 21, 24 top, 25, 26, 28, 30, 31, 32 top, 35, 36, 37, 39, 40, 43, 50 top, 50 bottom, 51 bottom, 52, 53, 55 top, 55 bottom, 58 top, 58 bottom, 60, 63 left, 63 right, 66, 75, 77, 98 bottom, 108, 111, 112, 124, 126 top, 132 left, 132 right, 133 top, 133 bottom, 142 bottom, 144, 145, 147, 148 right, 158, 160, 162, 164 top, 164 bottom, 171 top, 173 top, 173 bottom, 174, 188, 190, 195, 196 left, 196 right, 197, 198 left, 198 right, 199 top, 199 centre, 202 top, 203 left, 203 right, 207 top right, 207 bottom, 209, 212, 215 top, 218, 219, 220, 227, 229, 231, 232–233, 234, 237, 241 top, 241, bottom, 243, 246, 247, 248; Hamlyn Group – Fine Art Photography 210; Hermitage Museum, Leningrad 172; Hans Hinz, Allschwil 76, 165, 177, 238; M. Holford, Loughton 64; Kröller Müller Stichting, Otterlo 181, 183, 187; Marlborough Fine Art (London) Ltd 216, 217, 223; Metropolitan Museum of Art, New York 15, 24 bottom; Musées Nationaux, Paris 9, 13, 19, 33, 38, 44, 48 top, 49, 57, 62, 71, 113, 114, 115, 117, 126 bottom, 130, 131, 135 bottom, 136 bottom, 141 bottom, 152, 156, 166, 178, 180, 184, 215 bottom, 240, 242 bottom; Museu de Arte, São Paulo 90; National Gallery, London 27, 45 left, 59, 67, 72, 74 bottom, 78, 79, 83, 121, 129, 193, 194, 233, 239; National Gallery, Prague 163, 171 bottom, 199 bottom; National Gallery of Art, Washington D.C. 47 top, 149, 151 left, 151 right; National Museum of Wales, Cardiff 154; National Museum of Western Art, Tokyo 93; Ny Carlsberg Glyptotek, Copenhagen 10, 168, 170; Phaidon Press, Oxford 186; Oskar Reinhart 'Am Römer-holz', Winterhur 191; Scala, Antella 221; Norton Simon Foundation, Los Angeles 6–7; Southampton Art Gallery 134; Städtische Kunsthalle Mannheim 120; Szépművészeti Muzeum, Budapest 11; Tate Gallery, London 204, 205, 206, 207 top left, 208, 211 top, 211 bottom; Wadsworth Atheneum, Hartford, Connecticut 73 bottom; Wallraf-Richartz Museum, Cologne 138; J. Ziolo Paris 153, 250.

The photograph on page 150 © 1987 The Art Institute of Chicago. All rights reserved.
© ADAGP 1987 Mary Cassatt
© ADAGP/DACS 1987 Pierre Bonnard, Armand Guillaumin
© DACS 1987 Émile Bernard, Maurice Denis, Claude Monet, Paul Signac, Édouard Vuillard

Frontispiece: *Renoir*. The Umbrellas, *c. 1880–83. National Gallery, London.*

This edition first published 1990 by
The Hamlyn Publishing Group Limited
Michelin House, 81 Fulham Road,
London SW3 6RB.
Copyright © The Hamlyn Publishing Group Limited 1987
Third Impression 1990
ISBN 0 600 56956 X

Produced by Mandarin Offset
Printed and bound in Hong Kong

# Contents

# 1 Shock of the New

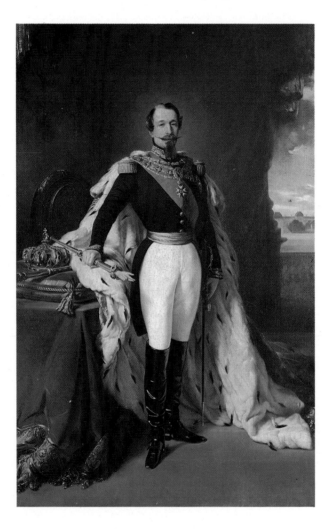

Portrait of Napoleon III. *Chateau de Versailles.*

Impressionism, to many of its admirers, still represents what is popularly regarded as modern art. It marks a cultural watershed which, to this day, affects the way we look at paintings and, by extension, at the domestic world about us. By asserting the primacy of the eye, and hence of colour, it also made way for the revelations of Abstraction, which remains a force even in an increasingly pragmatic society.

For the original Impressionists no such prospect was in view. They thought of themselves primarily as realists, and sought no other justification. But to think of them as a band of persecuted non-conformists

*Renoir.* Le Pont des Arts, *1868.
Norton Simon Foundation, Los
Angeles. Following the coup which
ushered in the Second Empire, Paris
was transformed into a capital
befitting its new imperial pretensions
under Napoleon III. This view in*

*Baron Haussmann's refurbished city
centre, painted by the youthful
Renoir in 1867, was bought by Paul
Durand-Ruel, the Impressionists'
dealer and champion. He was
later obliged to sell the painting
at a loss.*

is only part of the picture. The reasons why they were so bitterly
obstructed are inseparable from the social and cultural climate of the times
they lived in – times in which liberal idealism was out of fashion. In the
Revolution of 1789, aristocratic heads had rolled. But by 1848 the republic
was an autocracy again. The noble republican slogan, 'Liberty, Fraternity,
Equality', was scrubbed off the walls by order of a new sovereign and with
the full approval of an urban middle class enriched by the burgeoning
industrial revolution. The trappings of statehood were hastily commis-
sioned to support the pretensions of an up-jumped regime. In the Second
Empire, artists, craftsmen, decorators, architects, were given the job of

creating a showiness to rival that of the Napoleonic era.

But there were benefits as well as frivolous excesses. Napoleon III's architect, Baron Haussmann, was given the task of modernizing the capital. Narrow, insanitary lanes were swept away and broad boulevards driven through in their place. The new streets and avenues, wide enough to enable a carriage-and-four to turn, attracted pedestrians and sightseers, for whom shops, cafés and meeting places sprang up, enlivening the scene. Further out of the city, but now accessible, were sophisticated amusements of all kinds, from casinos to race-tracks, parks to bathing-places. The culture of the capital was one of urbanity, style, cutting a dash. With the slums demolished or carefully hidden, Paris became an agreeable place for a new, dandified class of men-about-town to make their mark in society. The entertainments industry flourished. Young women were released from domesticity in their family hovels to find work in the shopping centres, laundries and sweat-shops, or as waitresses, paid only in tips, in the bars and brasseries where, if they were willing, there was ready money to be earned after hours. The opera, ballet, theatre, music-hall, circuses, night clubs were there to be enjoyed by those who could afford them, and lived off by many who could not.

Paris was now a modern city, where people began to lead more open lives and became socially active. This too was the age of the minor celebrity and the gossip. A new reality took over; and for artists and writers born into this milieu the word 'realism' took on a wider significance. It became a philosophical concept of the kind embraced, in their different degrees, by Millet, the painter who identified completely with the peasant, and Courbet, who elevated realism into a socialist creed. When he was asked to put some angels into a painting for a church, he replied: 'I have never seen angels. Show me one and I will paint it.' Both kinds of realism had their adherents; but to an urban intelligentsia there was more substance in Courbet's rugged disbelief than in Millet's 'cry of the earth', his evocation of 'a stony place, a man hacking away whose grunts have been heard all day long and who straightens up for a moment to catch his breath.' To young painters looking for a theme, toiling slaves of Mother Earth were less immediate than the vivid street-life of the city and the pleasures of visiting friends and bars, going boating, looking for girls.

Meanwhile, with a monarch who had appointed himself the dictator of public morals, and a President of the École des Beaux-Arts, the much-revered Jean-Auguste Dominique Ingres, as dictator of taste in art, the aspiring realists were obliged to make their own way. To Ingres, himself a flawless artist, the roots of art lay in the classical past and were inviolable. The only criterion was classical art, because – in the academic view – it came closest to the beauties of nature itself. Accordingly, artists were expected to copy from the antique with scrupulous care. Any more earthy elements must be eradicated. 'Ugliness,' Ingres decreed, 'is an accident. It is not a feature of nature.'

Copying nature included the unclothed female form, in the guise of nymphs, goddesses or women immortalized in classical legend. This genre reached a peak of sanitized eroticism in Thomas Couture's *The Romans of the Decadence*, which hangs in Paris's recently converted railway station, the Musée d'Orsay. It was a tremendous success, with its tableau showing naked petting and two fully-robed philosophers, with disapproving expressions, looking on. 'At last France has its Veronese!' cried one critic.

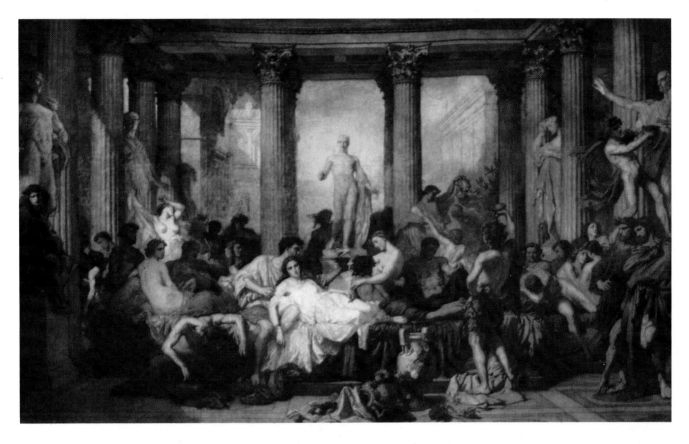

The publicity went to Couture's head; he declared himself 'the only true serious artist of our epoch'.

Couture became a fashionable teacher, and – fatefully perhaps – took in the young Edouard Manet, who was to spend six years with him. Their relationship ended abruptly when Manet showed him *The Absinthe Drinker*, his first entry for the Salon (it did not get in) in 1859. Couture, studying the squiffy figure of a local rag-picker whom the artist had posed as his model, jeered: 'The only drunkard here is you!' The incident illustrates the divide between the accepted ethos of the pre-Impressionist age and a new, daring preference for realism in the arts, based on ordinary people engaged in ordinary pursuits. This shift from the often vapid values of the Salon, encouraged by the Barbizon painters, notably Millet, and by the example of Courbet and Corot, coincided with the emergence of the hugely-gifted generation of painters who were to be headed by the figure of Manet.

When Louis Napoleon seized power in 1851 Pissarro was 21, Degas 17, Cézanne and Sisley were both 12, Monet was 11; Renoir, Berthe Morisot, Guillaumin and Bazille were only 10. The pretentious Second Empire was to collapse in 1871, following the humiliation of the Franco–Prussian war and the Commune that ushered in the rigidly bourgeois Third Republic. Those two decades were the ones in which the Impressionists-to-be found their vocation.

To a modern eye, their paintings are among the most instantly pleasurable of all works of art. The Impressionists are, without question, the most popular painters who have ever lived. There is no mystery as to why this should be so, and why their works continue to change hands at prices which now threaten to demean them as art by heaping them with

*Couture. The Romans of the Decadence, 1847. Musée d'Orsay, Paris. This work by the monarch's choice as Court Painter illustrates the ambiguous attitude to realism at the outset of the Impressionist epoch. The suggestive subject of this very large picture, set at a safe distance in time and place, is given a veneer of rectitude by a group of spectators who are shown registering disapproval. The painting now occupies a prominent position in the new Musée d'Orsay, the former Paris railway station which has been converted into a spacious national gallery.*

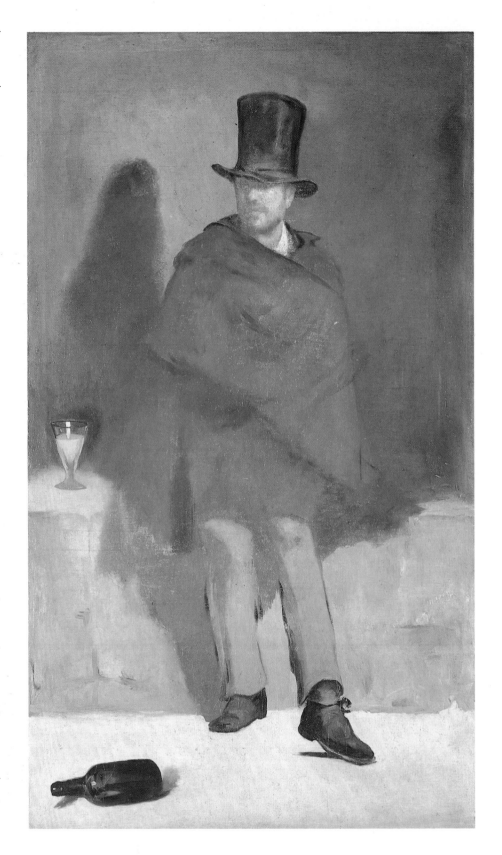

**Right**: *Manet*. The Absinthe Drinker, *1859. Ny Carlsberg Glyptotek, Copenhagen. This is the painting with which Manet abruptly disengaged from his teacher, Couture, after seven years. The sitter was a ragman who hung around the Louvre. Manet saw in him a subject for his recently-acquired Velasquez manner, which did not, however, prevent its being rejected at the Salon.*

**Opposite**: *Manet*. The Barricade, *1871. Szépmüvészeti Múzeum, Budapest. The siege of Paris by the Prussian army was followed in 1871 by civil insurrection against the doomed Versailles government, whose troops rounded up and shot thousands of suspected Communards on the streets of Paris in a single week of terror. Whether Manet was an eye-witness or reconstructed the scene from other sources is open to question; but his revulsion is evident from this watercolour sketch, painted on the back of a study for the* Execution of Maximilian *(illustrated on page 35), another political atrocity that had shocked him two years earlier, and on which he based his composition for* The Barricade.

money. They represent familiar human pleasures: family life, outings, friendships, walks in the country, river trips, a drink at a bar. The Impressionist manner seems so natural, so 'truthful', that it is hard to think of it as revolutionary, much less as an attitude reaching back to the Renaissance – the idea that painting is, above all else, a matter of seeing. This simple proposition may seem unchallengeable, but the majority of the painters whom we think of as old masters went beyond it, enlarging our understanding of the natural world by introducing the dimension of insight.

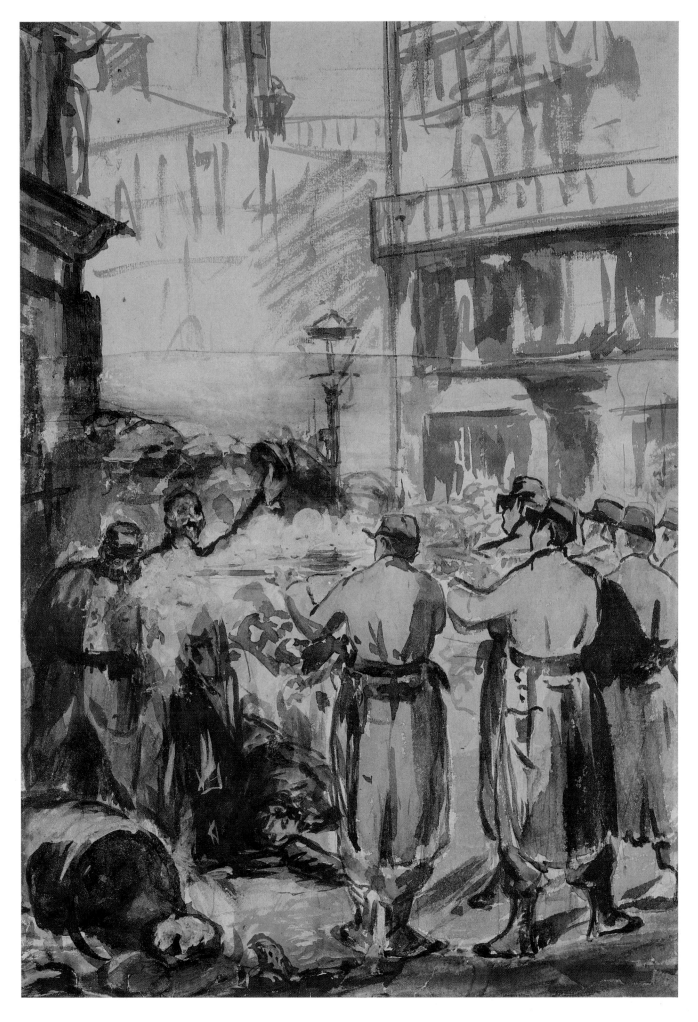

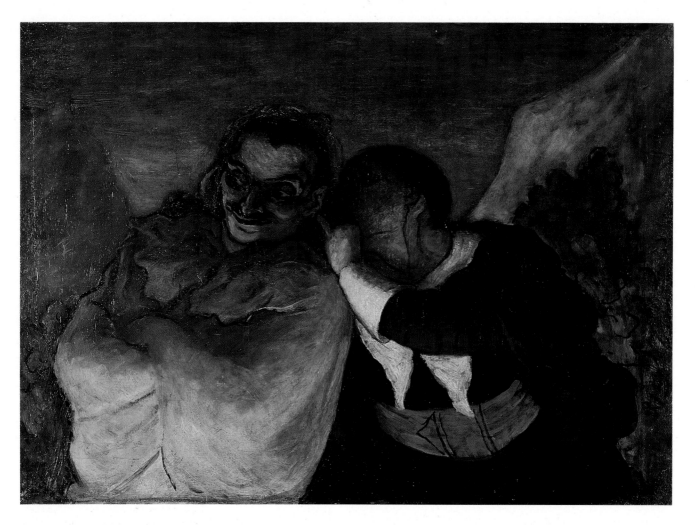

*Daumier*. Crispin and Scapin, *c.1864. Musée d'Orsay, Paris. Honoré Daumier ranks with Courbet as the most politically committed French artist of his time. His mocking cartoons for* Charivari *and his paintings on social themes won him the admiration of Delacroix, Baudelaire, Balzac and Corot. His oils mostly date from the 1860s, the interval between the Barbizon painters and the onset of Impressionism. His treatment of theatrical subjects such as this one anticipates that of Manet, Degas and Toulouse-Lautrec.*

The attraction of Impressionism and its limitations are one and the same. It is a view of the world as what we see, not what we think or feel; a surface view, immediate and beguiling, in which solid shapes dissolve and re-form in a shower of colours. Monet, its greatest practitioner, sought to paint what he imagined a blind person might see on suddenly regaining his sight. Pissarro urged young painters not to define too closely the outlines of things, since precise drawing 'destroys all sensations'. He added: 'Don't proceed according to rules and principles, but paint what you observe . . . Paint generously and unhesitatingly, for it is best not to lose the first impression.'

That use of the word 'impression' typifies the manner adopted by Monet, the young Renoir, Sisley and Pissarro. It was not as yet a familiar term, and tended to have different shades of meaning for different people. At the opposite extreme from Pissarro's use of the word, for example, stands Turner, whose late works have been called proto-impressionist, 30 years ahead of his time. Turner would have made no sense of such a claim. To him, an impression was what is left in the mind after leaving the scene, a powerful recollection rather than a quick, receptive glance.

The word was not new when the critic of *Le Charvari*, Louis Leroy, threw it in the Impressionists' faces. Corot frequently used it to describe his own purposes in landscape. It occurs in Constable's writings; and Monet's friend Jongkind said that, with him, 'everything lies in the impression', using the term as an unaware forerunner of Monet. Its usefulness grew as the cultural ripples from the artistic avant-garde of the 1870s spread into other fields. Mallarmé came to be known as the Impressionist poet, and Debussy as an Impressionist composer, though neither in literature nor in music can such a term be truly valid. To the painters, it was a convenient substitute for abstruse explanations for what

was essentially a simple belief in their response to things seen, in which the painting itself, the impression, was what mattered, not the subject. Hard outlines, precise detail, high finish were all to be avoided as having no place in an image so fleetingly perceived yet so realistically seen. The Impressionist eye was both descriptive and non-literal, a conjunction which confused the spectator and irritated the critic. There were no rules to be offered as substitutes for conventional practices. Every painter had a right to make up his own rules, if he needed any. The paint itself, the whole apparatus of making a picture, played a dominant part. The trick was to give the game away.

How it was done is epitomized, in Monet especially, by an extraordinary care for tone and colour. Light is everywhere, even in the shadows; the Impressionist idea of shadow is simply a complementary tone which includes the surrounding primary colours. Much use is made of the white surface of the canvas, rather as in a watercolour, to achieve an all-pervading sense of light. The brushwork tends to consist of small dabs of colour, which work with one another to suggest form.

Monet, certainly, was a painter of pleasures. But there is more to his work than an apparently uncritical response to the diversions of life or the undemanding charm of a friendly landscape. Émile Zola wrote of him, in 1868, that he had 'sucked the milk of our age', that he had grown, and would continue to grow, in his admiration of everything around him – the rooftops of cities, busy streets, women with their umbrellas, gloves, ribbons, wigs, face-powder – 'everything that makes them daughters of our civilisation.' In the fields, he went on, Monet preferred an English-style park to a corner of a forest, was pleased to detect man's presence everywhere, a true Parisian who liked to bring Paris to the country – an artist who could hardly paint a landscape without putting well-dressed men and women in it. 'Nature seems to lose its interest for him as soon as it fails to bear the stamp of our way of life: he particularly loves nature that makes man modern.'

*Guillaumin.* The Bridge at Charenton, *1878. Musée d'Orsay, Paris. Armand Guillaumin scraped a living on night-work so as to be able to paint. Pissarro said of him: 'Painting in the day-time and ditch-digging in the evening – what courage!'*

# SHOCK OF THE NEW

Modernity, indeed, was the characteristic that set Impressionism apart. A critic writing of the third Impressionist exhibition made a similar point, drawing attention to the Impressionists' liking for down-to-earth subjects, the appearance of spontaneity, deliberate incoherence, bold colours, a contempt for form, a naivete in mixing clours; all of which, he added, was analogous to the 'chaos of contradictory forces that trouble our era.'

These may not have been the Impressionists' own feelings about their work. Renoir, for one, never relinquished his respect for academic standards, however close his style might have come to Monet's in his early days. The two of them painted together in the summer of 1869, at a time when Renoir could barely afford paints and canvas. He joined Monet that August at *La Grenouillère*, or The Frogpool, a popular boating and bathing place, with a restaurant, on the Seine just outside Paris. Though there is little enough to choose between them in subject matter – both painted from the same viewpoint – it is possible to discern, in Renoir's version, a less ruthless elimination of conventional prettiness. His touch is more tender, his treatment of the figures less cursory, than Monet's. The result is an altogether more lyrical painting, by a young artist who would never eliminate from his work the caressing brushstroke, the smiling touch of pigment, that set him apart, even when, as here, he has obviously made a deliberate effort to emulate his friend's way of seeing. They could have been looking over one another's shoulders; yet each has defined the subject facing him in his own Impressionist terms.

That the Impressionist method involved an element of hard work is hinted at in one of Monet's letters, written to his friend Bazille from Honfleur in 1864. The weather is so beautiful, he tells Bazille, that he is 'going mad', his head spinning because he wants to do everything. He goes

*Renoir*. La Grenouillère, *1869.*
*Oskar Reinhardt collection 'Am Römerholz', Winterthur.*

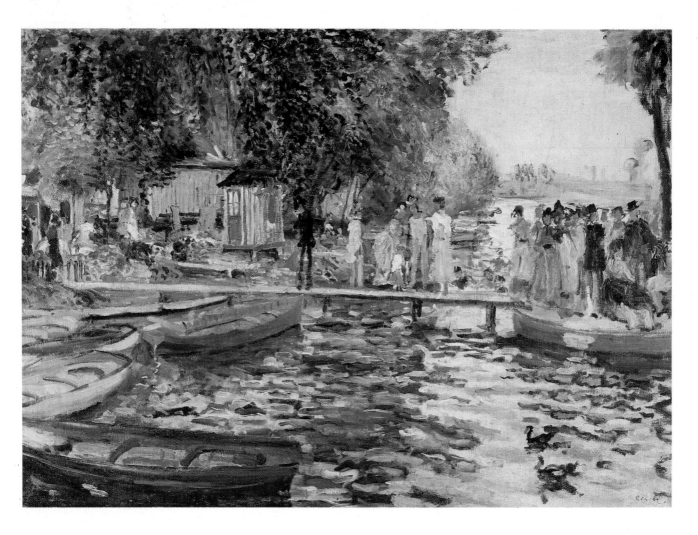

on: 'I want to struggle, destroy and begin again, because one can do what one wants and understands – I see it all done, completely written down, when I look at nature. When it comes to getting it down yourself and you are actually working on it – that's when the going gets rough!'

It helps, when looking at Impressionist pictures, to keep in mind the acknowledged limitations of the method, while enjoying to the utmost the subtleties and beauty. Before the 19th century was over, the Impressionist concept was proving inadequate for painters of the quality of Renoir, Cézanne, Gauguin and Van Gogh. In a manuscript written while he was in Tahiti, Gauguin put his finger on what he saw as its essence. 'The Impressionists,' he said, 'study colour exclusively for decorative effect, but without freedom, retaining the shackles of verisimilitude . . . They heed only the eye, and neglect the mysterious centres of thought.'

Nevertheless, the movement that was to follow owed much to the Impressionists. They cleared the path for artists who wanted to go their own way, rather than work within the conventions of polite, Salon-dominated taste. Gauguin was speaking for a whole generation when he asserted that 'the painter is not the slave either of the past or the present, either of nature or his neighbour: he is always himself.' That could not have been said 30 years earlier, when the Impressionist revolution began.

Some revolutions are both necessary and inevitable and the Impressionist revolution was no exception. It was necessary if painting in Europe was to break away from the postures of institutional Classical and Romantic art; and it was inevitable because, midway through the 19th century, the men and the motivation were at hand. Like other activists

*Monet.* La Grenouillère, *1869. Metropolitan Museum of Art, New York. Bequest of Mrs H. O. Havermeyer, 1929. The H. O. Havermeyer Collection. La Grenouillère, or Frogpool, was a popular riverside rendezvous just outside Paris and a typical location for the young Renoir and Monet. In 1869, the date of these two versions, there was little to separate their styles. Both painters were already excluding black from shadows in favour of tones of the prevailing colours, which helps to unite their compositions in a common mood seized on the instant – not a closely-observed record of time and place, but an impression.*

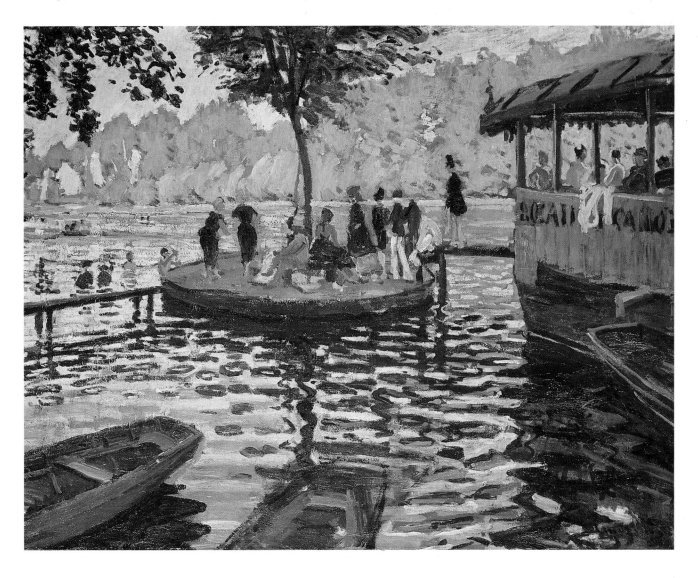

# SHOCK OF THE NEW

before them, they were a band of individuals, widely different in character and background, neither of one class nor of one mind. None of them relished a life of poverty and ridicule. A few were protected against starvation by family resources. Others knew hunger, borrowed from friends to keep going, or scratched a living on the edge of the commercial world. Between them they produced work which, in the space of 20 years, helped to change not only the course of Western painting but also the nature of the artist's relationship to his subject, his materials and himself.

The 19th-century view was practical, solid and complacent, and artists were expected to conform to these characteristics in their work. Their job was seen primarily as recorders who might also be allowed, within narrow limits, to take on the additional role of commentator or moralist. Painters were not expected to agitate, or to challenge the collective view of social and political reality. The Impressionist manner – sketchy, indistinct, apparently undisciplined – was an affront to these values; and when, from time to time, a classical theme made an appearance in an Impressionist work, it seemed provocatively ill-painted, even impertinent. A public accustomed to the graceful academism of Claude or Poussin would find nothing to please them in an Impressionist landscape. Few French gallery-goers would have known of John Constable, even if they felt at home with their own Barbizon painters, who inherited the English master's concept of the 'natural painter'.

The year 1874 stands as the opening of the great Impressionist epoch. In April of that year a group of young artists who shared, in varying degrees, a feeling of rejection by the art Establishment of the day, held a group exhibition in Paris. Among them were Claude Monet, Auguste Renoir, Camille Pissarro, Paul Cézanne, Edgar Degas and Alfred Sisley. An older painter, Eugène Boudin, joined them out of comradeship. The only woman in the group, Berthe Morisot, braved the risk of antagonizing the Salon, where her work was readily accepted, to exhibit with her friends. With another of their circle, Armand Guillaumin, they numbered eight out of a total of 30 exhibitors, most of whose names are now forgotten. The exhibition was held in a borrowed photographer's studio on the corner of the Boulevard des Capucines. Among the paintings on view was one which

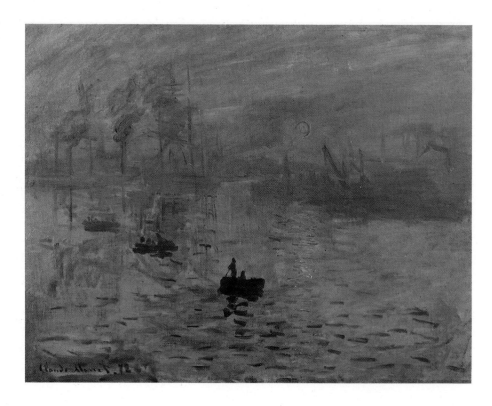

*Monet.* Impression: Sunrise, *1874. Formerly in the Musée Marmatton, Paris. This is the work that gave the Impressionists their name: a view of the harbour at Le Havre, seen through sea-mist, where Monet was living in 1872. On its appearance in the first group exhibition in 1874 it was singled out by a newspaper critic, who flung the word 'Impressionist' in the exhibitors' faces. Though hardly typical of the man who was to emerge as an unquestioned master, it is nevertheless an epoch-making work of art. With other important works by Monet, it was stolen from the Musée Marmattton in 1985.*

16

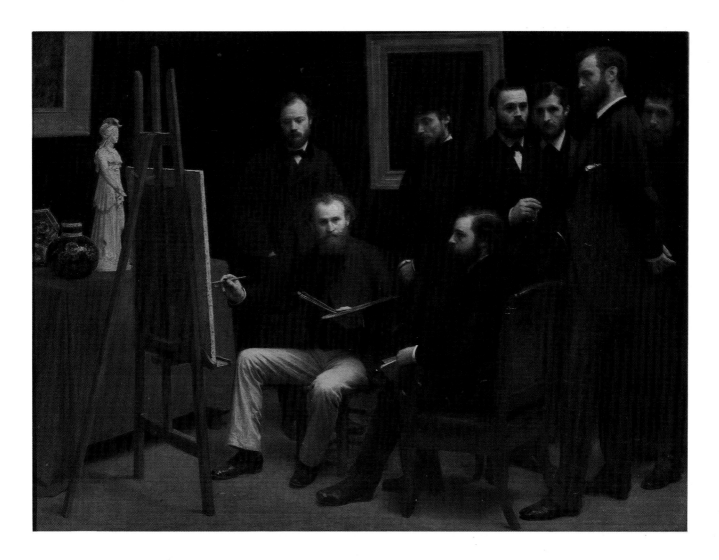

was destined to give the exhibition a name that would stick. It was by Claude Monet, and it was called *Impression: Sunrise*.

The reception the exhibition was given seems, in retrospect, hysterical. The gibes of the critics and cartoonists (one of them showed a policeman preventing a pregnant woman from entering the exhibition for fear of injury to her unborn child) fell indiscriminately on the band of painters now dubbed, scoffingly, 'Impressionists'. Amid the uproar, they recognized in that name the description they had been looking for: until then they had regarded themselves primarily as 'realists', taking as their subject matter the everyday life around them and depicting it on the spot, in deliberately unacademic terms which caught the pace and style of the streets and cafés and the suburban pleasure-grounds where they felt at home. Renoir, for one, seized on the new name. He thought it would tell the public exactly what the new painters were up to: 'Here is the kind of painting you won't like. If you come in, so much the worse for you – you won't get your money back!'

In the ensuing 100 years the impact of Impressionism on the mind, and on the mind's eye, was to transform our way of looking at art, and even of looking at nature. In that sudden brilliance, much of the painting that preceded it seems shadowy and dim. But the Impressionists themselves were by no means dismissive of their forbears: they honoured them, including the ones beloved of Ingres, as their letters and conversations reveal, and never departed from painterly values. But there is no doubt that the kind of paintings exhibited each year at the Paris Salon, and against which the Impressionists rebelled, were of an almost unrelieved mediocrity. The Salon was both the arbiter and the image of public taste in

*Henri Fantin-Latour. A Studio in the Batignolles, 1870. Musée d'Orsay, Paris. The Batignolles Quarter, near Montmartre, was frequented by the group of painters known as* la bande à Manet. *This group painting, exhibited at the Salon of 1870, shows Manet, brush in hand, painting the writer Zacharie Astruc. Others present include Renoir, Zola, Bazille and Monet.*

# SHOCK OF THE NEW

art, the only means by which an aspiring painter could find patrons and win recognition.

Since the middle of the 17th century the Salon had enjoyed a prestige unrivalled in Europe. Starting life as an exhibition reserved exclusively for members of the French Academy, the pet of French royalty and the aristocracy, it had burgeoned into a supposedly democratic institution to which any painter might submit his work. His chance of being accepted depended on the propriety of his subject-matter and the orthodoxy of his technique. He would be judged by a jury dominated by functionaries and bureaucrats and presided over by an Academician. Gallery after gallery was hung, two or three lines deep, with works chosen for their unlikeliness to startle or offend. Crowds came to stroll and gossip and compare prices. Ingres himself called it 'a bazaar in which the tremendous number of objects is overwhelming, and where business rules instead of art.' Charles Baudelaire, a regular reviewer of the Salon between 1845 and 1862, castigated a run-of-the-mill landscape painter, Constant Troyon, as typifying the 'second-class talents' who were achieving popular success with a minimum of imagination, 'skill without soul'.

The exhibitors who commanded the biggest crowds, and prices, in the Impressionists' lifetime were painters such as Ernest Meissonier, who specialized in genre and battle scenes executed in finicky detail; Jean Leon Gérôme, a sugary neo-classicist; and Alexander Cabanel, showered with honours in his lifetime and virtually forgotten ever since, except perhaps as the painter of a voluptuous *Birth of Venus*. Napoleon III bought Cabanel's *Venus* from the Salon in 1863, the year of the seminal event in the development of modern art, the Salon des Refusés. That spring, the Salon jury rejected over 3,000 of the 5,000 paintings submitted. No doubt a majority of these were feeble or incompetent by any standard, but the sweeping dismissal of so many artists' works caused an outcry. There was, in effect, nowhere else for an ambitious artist to exhibit. Painters who held one-man shows at dealers' galleries were suspect. Manet had just taken the risk of showing a group of his paintings with a dealer called Martinet,

*Cabanel.* The Birth of Venus, *1863. Musée d'Orsay, Paris. This work by a recognized Salon painter, exhibited in 1863, caught the eye of the Emperor, who promptly bought it and awarded Cabanel a promotion in the Legion of Honour. Nearby, in the Salon des Refusés, hung Manet's* Le Déjeuner sur l'Herbe *(illustrated on page 24), which the monarch declared 'immodest' and is said to have struck at with his cane.*

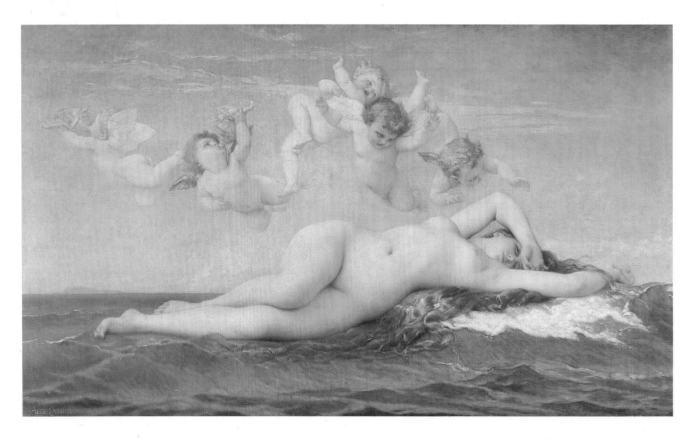

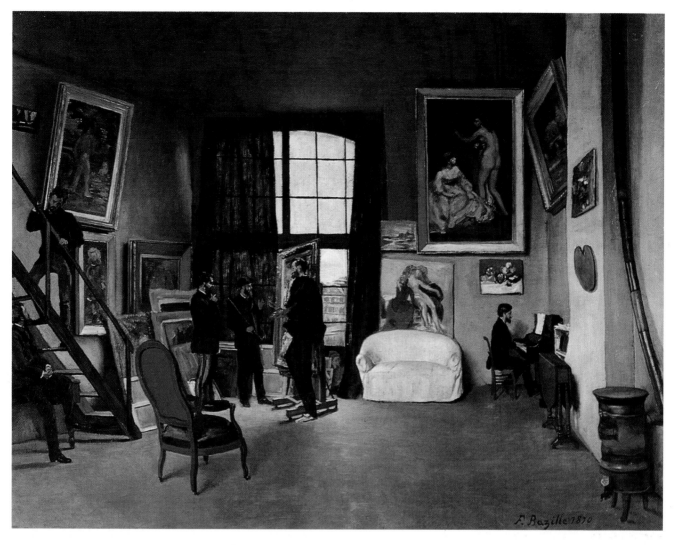

which could have prejudiced his chances with the gentlemen of the Salon.

For less daring spirits the Salon was all; rejection amounted to public censure from which there was no redress. The affronted *refusés* sent up a howl of complaint, with the press in support. The hubbub reached the ears of Louis Napoleon, who liked an excuse to simulate a liberality not evident in his political actions. He made an unannounced visit to the Salon and declared that most of the rejected paintings might be hung after all, if only so that the public could make up their own minds. He ordered that any of the rejected artists who chose to do so could have their work hung, separately from the Salon, in the adjoining Palais de l'Industrie.

Manet, with three paintings, was among those who took up the challenge. So were Pissarro, also with three paintings, Whistler and Cézanne with one each. Two of Manet's canvases were exercises in his neo-Velasquez manner. The other was a painting destined to immortalize the Salon des Refusés, as this part of the exhibition was promptly called, and to make Manet's name notorious. The crowds who flocked to see what the fuss was about found themselves confronted by a painting of two young men picnicking in a wooded glade with a pair of female companions, one of whom, stark naked, gazed out of the canvas with an air of mild curiosity.

The artist called it *Le Bain*, later to be changed to *Le Déjeuener sur l'Herbe*. Soon, however, it was being called other names: 'A practical joke, a shameless sore', protested one critic; 'An absurd composition', said another. An English art pundit, P. G. Hamerton, complained that 'some wretched Frenchman' had brutalized a classic theme, adding that 'the nude, when painted by vulgar men, is inevitably indecent.' The Emperor himself agreed, and reportedly struck at Manet's painting with his cane.

# SHOCK OF THE NEW

That gesture seems to bring to a climax the mounting hostility to the new mode. It contains all the attitudes which the young French painters recognized as standing between them and the public: self-righteousness, conservatism, and a feeling of being threatened by the forces of cultural reaction.

Not all the art world was hostile to the newcomers. One dealer, Arsène Houssaye, wrote that Monet and Renoir were the 'two masters' of the school. Instead of art for art's sake, they talked about nature for nature's sake. He commented on the 'brutal frankness of their brush' and promised that a Renoir *Bather* and Monet's *Woman in a Green Dress*, both in his gallery, would one day hang in the Musée du Luxembourg, when that institution opened its door to the new painters. He was not far wrong. But the reconciliation between the Impressionists and the Establishment was still 20 years away.

The essence of 'pure' Impessionism is that it depends on natural light: painting direct from nature, in the open air, and ideally finished on the spot. The English watercolour painters had paved the way, followed by John Constable and, through him, the members of the Barbizon School. Corot was the first French *plein air* ('open air') painter of note, though it is doubtful if many of his oils were in fact completed in the open: the studio was, and remains, the serious artist's workplace. But at last the means to paint in the open air were becoming available, thanks to portable, ready-mixed paints. Academic strictures could be modified in the cause of speed, immediacy, response to a subject on the wing, a fleeting image seen through half-closed eyes. Instead of building up from a dark ground, with blacks as shadows and brighter colours modified to respectable 'old master' tones, painters felt more free to lay clean, clear colours on to a white surface and to use variants of those colours for the necessary shadow, applied in small, deliberate dabs.

Photography played a part in changing people's perception of composition: a scene confined to a viewfinder could not help but be selective, applying a new discipline in composition, prompting the eye to select from the wider options available. Photography also had adverse effects. For some, the contrast between what the lens recorded and what the artist's eye perceived was so far apart as to make them strive for verisimilitude rather than make their own way to a personal, artistic truth.

*Corot.* The Bridge at Narni, *1826–27. Musée du Louvre, Paris. The simplicity and obvious sincerity of Corot's landscape manner were greatly respected by the younger generation. His habit of painting in the open air, and his shedding of academic pretensions, separated him from most other prominent French painters of his time. His dictum, 'Don't imitate, don't follow, or you'll be left behind', has applied to all artists since his day.*

For portrait artists, it seemed at first that photography would put them out of business – until the realization that there is in portraiture such a thing as mutually acceptable truth, which satisfies both painter and sitter; whereas in photography – assuming no trickery in the darkroom – there is no such thing. The inability of early photographic chemicals to define tones with any degree of subtlety, exaggerating darks and lights, worked to the Impressionists' advantage, opening up starker, simpler ways of describing similar subjects in paint, as in Manet's *Olympia*. That work, obviously, is not a *plein air* painting – quite the opposite. But its execution has a modernity that seems impossible without the prompting of another, unrelated medium.

Well before the turn of the century, Impressionism was being given attention in the London art journals, not all of it hostile. The first review, of Durand-Ruel's modern French artists in April 1873 – a year before the historic first Impressionist show in Paris – appeared in *The Times*. The anonymous critic lumped the contributors together as followers of Corot, recognizing in them a new school, worth studying for the tendencies it revealed of its 'most defiant and uncompromising masters and pupils'. In a later review *The Times* suggested that Courbet, rather than Corot, was the progenitor of the new school, in which the writer detected a harshness in the tints, a crudeness of local colouring and a heavy-handedness not to be found in Corot.

The word 'cynicism' appears in many of these early reviews, as if the Impressionists were curling their lip at the disconcerted public. Manet, one reviewer said, could 'out-Courbet Courbet' in this direction. 'Revolutionary' was used as a term of abuse, and 'Impressionism' as an excuse to make jokes at the artists' expense. Henry James, writing from London for the *New York Tribune* in May 1876, found it 'incompatible with the existence of first-rate talent'. A notice in the *Standard* in July 1882, reviewing an exhibition organized by Durand-Ruel in King Street, acknowledged that the Impressionists were, even then, little known in

*Rousseau. The Plain of Montmartre, c.1835. Musée du Louvre, Paris. The Barbizon painters, of whom Théodore Rousseau was among the most prominent, shared a common devotion to nature and a preference for 'realistic' landscape. With Corot and Daubigny they moved away from the conventionally sublime or picturesque, in the wake of the English master, John Constable.*

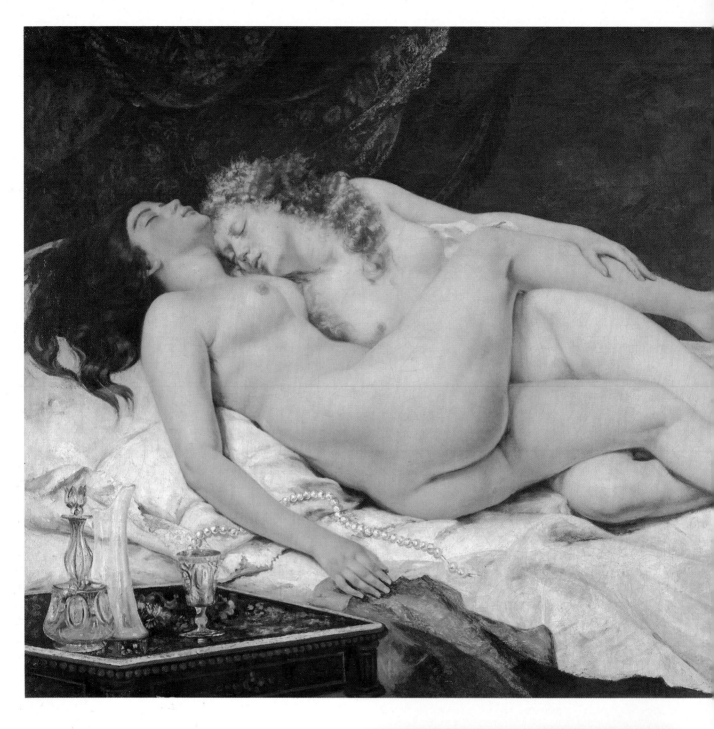

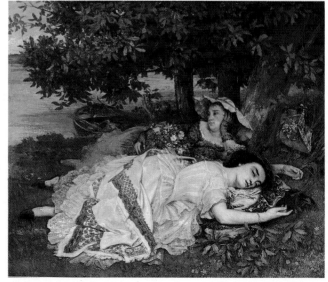

*Courbet*. Les Demoiselles au bord
de la Seine, *1857. Musée du Petit
Palais, Paris. This, to modern eyes,
unexceptional work aroused fierce
hostility at the time, partly because
the two young women were clearly
not of the right class to be gracing
such a setting. Salon exhibitors were
warned against 'abandoning the high
and pure regions of the beautiful and
the traditional paths of the great
masters' for 'the caprices of the day'.*

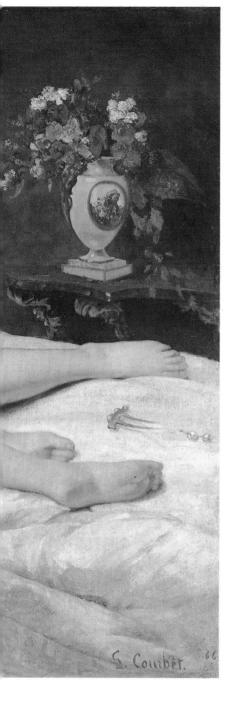

*Courbet.* Sleep, *1866. Musée du Petit Palais, Paris. The example of Courbet, with his unflinching populist notions, was in sharp contrast to the view that realism was another name for ugliness, and not to be encouraged. In 1855 he chose to exhibit in his own 'Pavilion of Realism'. In 1863 one of his works, rejected by the Salon, was considered 'too immoral' even to be shown in the Salon des Refusés.*

England, but was full of praise for Degas ('a skilled draughtsman, a brilliant and dextrous colourist'), especially for his racecourse subjects, and for Mary Cassatt, 'a highly accomplished pupil' of Degas, 'with a grace and refinement which her master is not particularly anxious about'. Renoir, Sisley and, especially, Monet are commended, Monet for his 'glowing colour and liquid light'.

By January 1883 it was possible for a long, considered account of the Impressionists to be published in the *Fortnightly Review*, written by Frederick Wedmore, invoking Turner and David Cox as forerunners, and behind them Velasquez and Frans Hals. In an article that looked keenly at Degas, Renoir ('his interest lies in the life of the body, and in its energy of expression'), Monet ('an exquisite talent'), Sisley ('happy and delightful now and then'), Morisot and Cassatt ('both adroit and refined'), he recognized in Monet, in particular, a painter 'whose vision of the world is his own', and in the group as a whole 'a new and quickened observation of the worlds they care about, and a freedom that is not only revolt'.

For all their struggles and discouragements, the Impressionists succeeded in bringing about a fundamental change in the way painters approached their work. Their vivid use of colour could not be ignored. It influenced other, more conventionally-minded painters, to the point where Emile Zola, their staunchest friend among the writers and critics of the age, thought they had gone too far: 'Was it for this that I fought – these patches of colour, these reflections, this decomposition of light? Was I mad?'

On a deeper level, the demonstration that an artist could set off in a direction of his own choosing was more important still. The liberation of light was one thing; the liberation of the painter's process was another. The whole function of painting had been challenged, and new answers suggested to old problems. The idea of 'finish' as essential to a work of art had been contradicted. The sketch was elevated to a position never known before, an object fit for exhibition in its own right, not simply for private satisfaction or as a study for a worked-up painting. This represented a change in aesthetic values which has lasted into the modern age. It helps to explain the enthusiasm with which, in England, John Constable's oil sketches – preliminary exercises for his great Dedham paintings – were newly discovered; and it contributed to the international reassessment of Turner.

As a movement (if it ever amounted to that) Impressionism lasted some 20 years. Monet, summing up his own contribution late in life, declared that he had always had a horror of theories. He claimed only the merit of having painted direct from nature, trying to convey impressions in the presence of the most fugitive effects, adding: 'I am distressed at having been the cause of the name given to a group of which the majority was not impressionist at all.' Did he mean that only he, and perhaps Pissarro, deserved the Impressionist accolade? Those two, with Sisley, were the loyalists. But the group as a whole made it possible for a later generation – Gauguin, Van Gogh, Seurat among them – to carry the concept forward, though in different terms, into an age where people's perception of what art stands for, and the means by which it works, were to be of a wholly different order. The day the Emperor of France raised his cane against Manet's most famous painting was only the beginning.

# 2 Manet

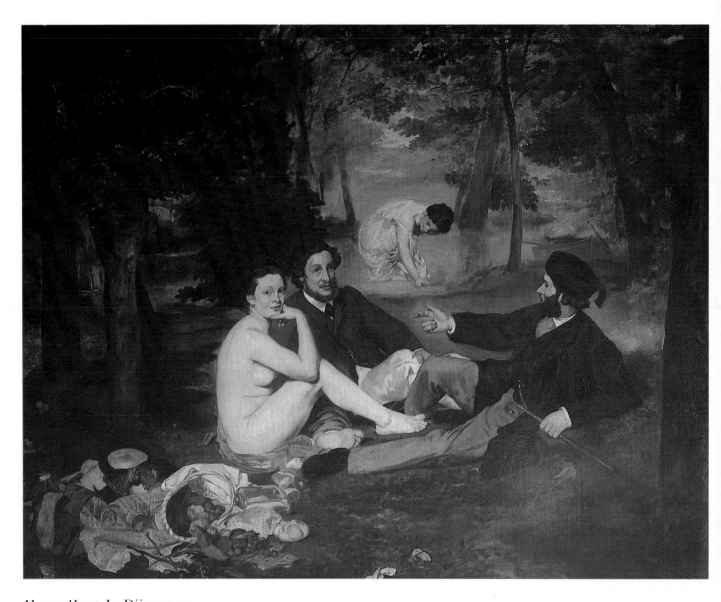

**Above:** *Manet*. Le Déjeuner sur l'Herbe, *1863. Musée d'Orsay, Paris. In 1863 the jury of the Paris Salon rejected some 3,000 of the 5,000 works offered for exhibition – an unprecedented number. The consequent outcry obliged the Emperor, Napoleon III, to order the jury to reconsider the rejected works and arrange an alternate exhibition of them as an adjunct to the official Salon, in adjoining premises. Le Déjeuner sur l'Herbe was one of three works by Manet which were allowed to be shown in what became known as the Salon des Refusés. It had respectable precedents: the* Concert Champètre *by Titian and the much-admired engraving by Marcantonio after Raphael's* Judgement of Paris *(**Right**), Metropolitan Museum of Art, New York. Rogers Fund, 1919.*

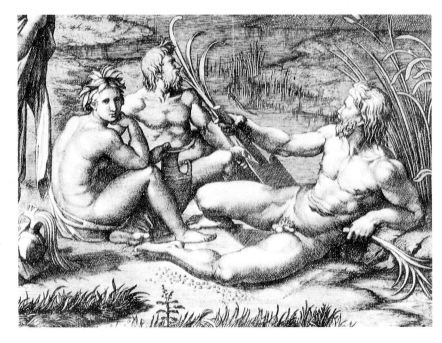

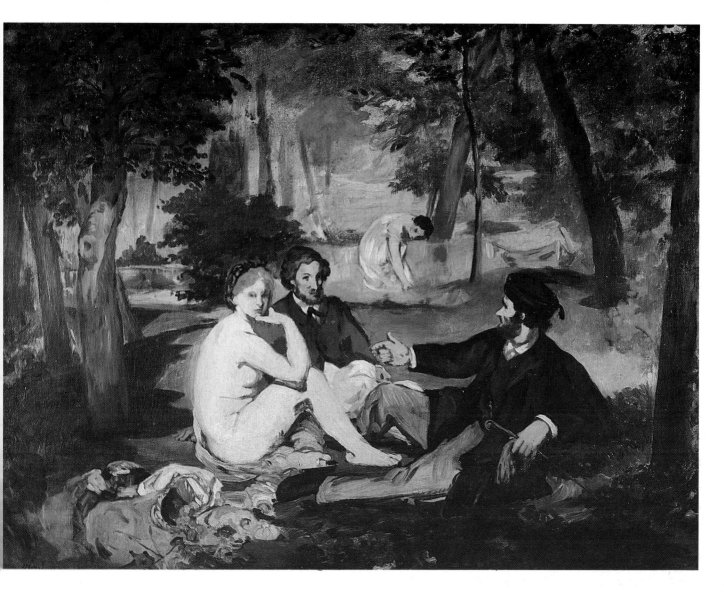

ictures shown at the Paris Salon were expected to edify the public, not upset them. Manet's *Le Déjeuner sur l'Herbe* made no such concessions to cultural values. Even its quasi-classical origins, evoking both Raphael and Giorgione, were regarded as insulting to the old masters. There were exceptions among the critics, most notably the loyal Emile Zola, who called the painting Manet's greatest picture and made fun of the general public's reaction. The naked woman, he wrote, was all they had eyes for. 'Good heavens, it's indecent! A woman without a stitch of clothing with two fully-dressed men – such a thing has never been seen!' Today, it is a reminder of the division between the obligations of a painter in Manet's time and what was acceptable as realism. The true function of the artist, as laid down by Ingres – to emulate the beauties of nature – had nothing to do with such a provocation as Manet's 'insolent daub', as one critic called it.

Manet was genuinely taken aback by the reaction. He had spent a long time on the painting, beginning with studies for the landscape background in the neighbourhood of Gennevilliers, on the Seine outside Paris, working out the composition from its borrowed source and recruiting the models, who included his brother Eugène as the male figure sitting beside the unclothed model, Victorine Meurend. He had submitted it to the Salon

*Manet.* Le Déjeuner sur l'Herbe, *c.1863. Courtauld Institute Galleries, London. Courtauld Collection. Two smaller versions of the famous* Déjeuner *exist: an unfinished watercolour (Ashmolean Museum, Oxford) and this oil in the Courtauld collection. Opinions differ over whether these are artists studies for the great work, or copies.*

*Manet. The Artist's Parents, 1860. Musée d'Orsay, Paris. At the time of this double portrait, Auguste Manet, the painter's father, a senior official in the Ministry of Justice, was 63 (he died two years later), and his mother, Eugénie Desirée, just turned 50. Manet painted them in their apartment at 69 rue de Clichy.*

with two other paintings, neither so obviously contentious, of figures in Spanish costume. They too were rejected. Manet must have been disappointed: his *Spanish Guitarist*, accepted in 1861, had won him an honourable mention. But he persevered with the Salon, submitting for the next year's exhibition his first work on a religious theme, a *Dead Christ with Angels* and *The Bullfight*. The jury accepted them both, though the *Christ* came under attack for departing radically from traditional iconography and for the unethereal appearance of the angels, who looked more, as one review put it, like Parisian *midinettes* ('working girls'). The painting's chances with the public were not helped by Manet's wilfully, or just

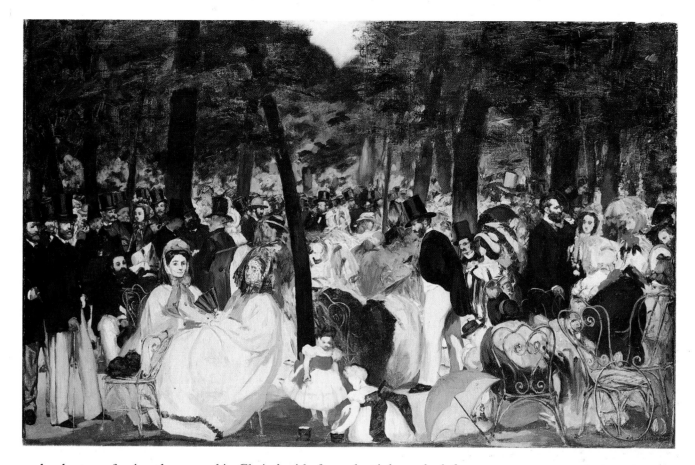

carelessly, transferring the wound in Christ's side from the right to the left.

Manet continued to insist that the place to fight the art establishment was in the Salon, not in 'fringe' exhibitions. In the Salon, he pointed out, his worst enemies were forced to look at his work. As a serious painter, basing his technique on studies of the old masters, he stood aside from his young admirers' insistence on the new realism, in which traditional values took second place to immediacy and impact. He was not cut out to be a bohemian. By birth, and by temperament, he belonged to the *haute bourgeoisie* and it would not have occurred to him to behave otherwise, either in society or as a painter. He was known for his manners and gentlemanly turn-out, and for his air of ironic detachment from the chatter around the café tables of the Batignolles. This was understood by his 'gang', *la bande*, whose ambitions were much the same as his – to secure recognition for a new movement in painting. Manet evidently thought it would be helpful if he put himself forward as a candidate for membership of the Salon jury, taking advantage of a more democratic procedure introduced in 1869. He did not receive the necessary votes, and never tried again; but it was certainly not conceit that led him to make the effort.

If he was daunted by the manhandling of the *Déjeuner sur l'Herbe*, Manet did not admit it. Already on his easel was a painting that he had withheld from the Salon jury the following year, for tactical reasons. It showed a young woman reclining on a bed, naked except for a bracelet, earrings, neck-band and slipper, her left hand lying over the mons veneris in an attitude borrowed from Poussin's *Triumph of Flora*, in the Louvre. A negress bearing a bouquet in a paper wrapping had just entered by the bedroom drapes, and on the end of the bed a small black cat arched its back, tail raised as if in an exclamation mark. Manet called the piece *Olympia*, a label with classical overtones in vague acknowledgement of its pedigree,

*Manet.* Music at the Tuilleries Gardens, *1862. National Gallery, London. The gardens were a popular meeting place for fashionable Parisians at the height of the Second Empire: the Emperor held court in the palace nearby, and well-dressed crowds liked to gather under the trees, while the band played on. Several of Manet's friends have been identified in this composition. He himself is the figure on the extreme left.*

27

# MANET

which also included Titian and Goya. The model was the same young woman who stares so unconcernedly out of the *Déjeuner sur l'Herbe*, Victorine Meurend; but this time it was her nakedness, rather than the presence of clothed men, that generated the shock.

Accepted by the Salon – a compliment, one might suppose, to Manet's status there – it was the sensation of the exhibition. The epithets thrown at *Olympia*, and at Manet's other painting that year, *Ecce Homo*, reached extraordinary heights of virulence. 'Two dreadful fakes tossed to the crowd, jokes or parodies', protested one critic. 'And what is this odalisque with a yellow belly, some degraded model picked up heaven knows where?' Théophile Gautier, a respected literary figure who in his youth had been a painter himself, thought *Olympia* was no joke: Manet had admirers, he warned, a school, even enthusiasts for his kind of art. But that 'danger', as he called it, was now over – there was nothing in *Olympia* but the desire to attract attention at any price. Emile Zola took the trouble to look at Manet's method. 'At first sight we can only distinguish two tones, two violent tones, each contrasting with the other; otherwise details are indistinguishable. Look at the girl's head: the lips are two thin lines of pink, the eyes reduced to a few black marks. Now look at the bunch of flowers – look closely, please – patches of pink, patches of blue, patches of green. Everything is simplified. If you want to reconstruct the reality you will have to step back several paces. Then everything falls into its right place. The head of Olympia stands out against the background in strong relief, the bunch of flowers becomes a marvel of brilliance and freshness.' One day, he predicted, Manet would hang in the Louvre.

*Manet.* Olympia, *1865. Musée d'Orsay, Paris. The Salon jury of 1865 accepted this painting, perhaps sharing, in part, Manet's own judgement that it was his finest work: he eventually valued it in his inventory at 20,000 francs. In 1889, Monet organized a private subscription to secure it for the nation.* Olympia, *painted a year after the* Déjeuner sur l'Herbe, *was held back from the Salon of 1864 for fear that the controversy over the* Déjeuner *would damage its chances of acceptance.*

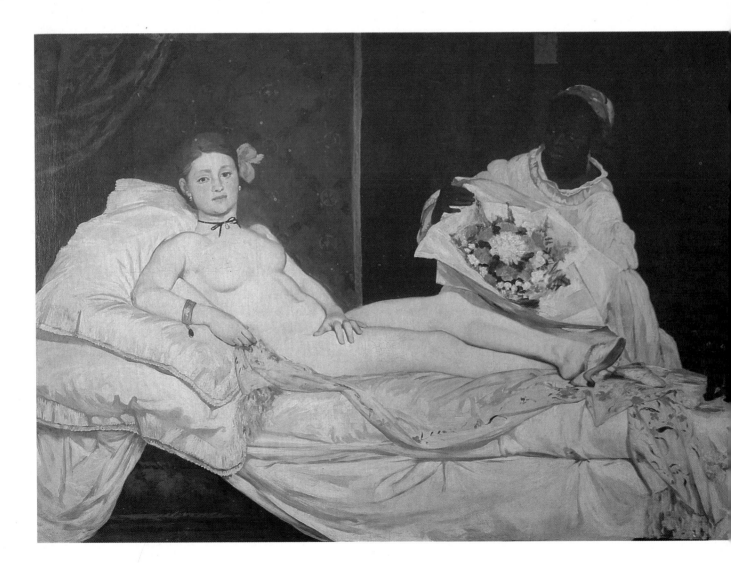

These colours remarked on by Zola are of great delicacy, brought up brutally against blacks or near-blacks, the tones colliding against each other with no gradations, the shadows forced back by the light falling on the bed. But there is no denying the presence of the naked girl, with her pert rather than voluptuous sexuality and her ordinary face, flesh, limbs. As chance would have it, the same Salon included a portrait by Courbet of his friend Proudhon, the fiery revolutionist, author and pamphleteer, who had lately died, and whom Courbet had painted in so individual a fashion that the anti-Manet chorus was joined by those who would consign all Realism to the rubbish bin.

Manet, wearying of the uproar, went to Spain to feast his eyes on Velasquez, the painter above all others whom he most admired. Once he had seen Spanish art in its historical context and setting, he never dressed up a model in Spanish costume again. *Olympia* embarked on a career of its own. So many people crowded into the Salon to see it that it was moved to a high, less conspicuous position, to put the crowds off. Degas told Manet that he had become as famous as Garibaldi, the Italian revolutionary and folk hero, who had lately been given a tumultuous reception on a visit to England. Seven years after Manet's death a subscription was raised to acquire *Olympia* for the State, but only in 1907 did it reach the Louvre, by order of the Prime Minister, Georges Clemenceau, himself; and Zola's prophesy had come to pass.

With *Le Déjeuner sur l'Herbe* and *Olympia*, painted within the space of two years, Manet announced the arrival of modern art. It was not merely the subject-matter that set them apart – each was a conventional subject in pictorial terms – but also the daring originality of the painter's method. Instead of disguising his arts, as had been the convention for centuries, Manet blatantly emphasized them. In a painting by him, the spectator was drawn into the very actions by which paint made its way from palette to canvas. The surfaces were not simulations of earth, sea, sky or human skin: they were areas of material bearing thick, organic deposits of paint, pushed around at the artist's will, the brush marks as obvious as fingerprints. A modern work of art would be an art laid bare. The means was to be part of the message. Painting as make-believe, self-censoring, prettifying, was consigned to decorators and commercial artists.

Modernity also implied a change in the artist's perception of current affairs. Given the chance, should not a painter seize on passing events, if they moved or excited him, with the eagerness of a journalist? So when, during the American Civil War, the Union corvette *Kearsarge* engaged the Confederate gunboat *Alabama* off Cherbourg on June 19th, 1864, Manet was quick to record the event. His vivid reconstruction gives the scene the immediacy of a press photograph taken practically at sea level, the sea cramming the subject into the upper third of the canvas. A less immedaite event, but one that moved Manet to a cold rage, was the execution in Mexico in June 1867 of the Archduke Maximilian, who after seizing power there on behalf of the Emperor, Napoleon III, was left to his fate when the United States protested and French troops were withdrawn. To show his disgust at this betrayal – shared by most of France – Manet dressed the firing squad in French uniforms. The painting is strikingly reminiscent of Goya's masterpiece of 'protest' art, *The Third of May*; one touch of his own is the attitude of the soldier who, on the edge of the fusillade, cocks his rifle with professional calm. Manet submitted the painting to the Salon, but it was barred from public exhibition on political grounds.

His borrowings from earlier painters laid him open to charges of plagiarism. Degas said that Manet 'could never do anything but imitate', which was blatantly untrue. By quoting from familiar painters of the past he was declaring his allegiance to the European tradition in art, conscious

# MANET

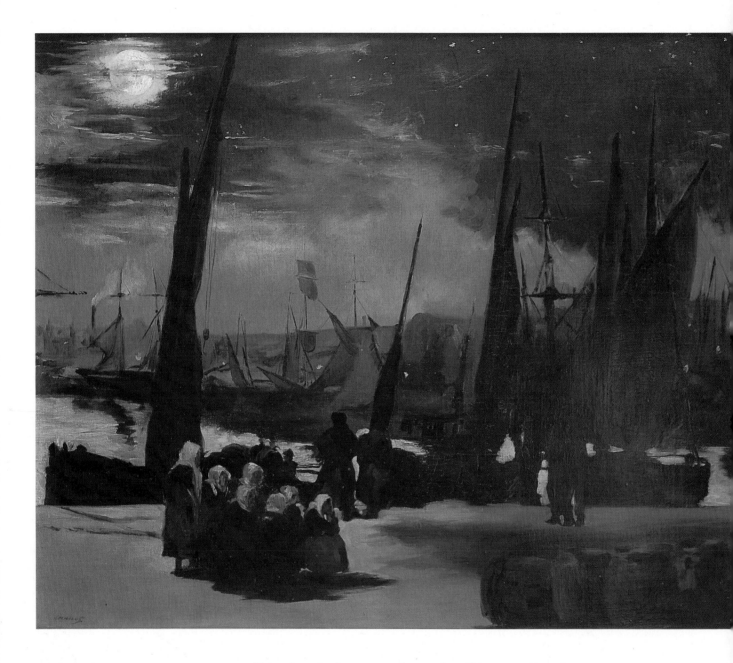

*Manet.* Clair de Lune au Port de Boulogne, *1869. Musée d'Orsay, Paris. A night scene with fishermen returned with their catch, and harking back to the Netherlands school of marine painting, this is one of a group of dockside paintings from a summer holiday with his family, apparently painted from his hotel window.*

of his place in it even as he set it off in new directions.

Despite all that has been written about him, Manet remains a contradictory character. The definitive exhibition of his work at the Grand Palais, Paris, in 1983, the centenary of his death, revealed more of his complicated genius than any biography. It was as if the man, had, all this time, obscured the painter: a sophisticated townee, never seen without hat and gloves, well-tied cravat, silver-topped cane. He had a hearty dislike for the country: Paris was where he belonged, in gentlemanly company, consorting with his peers, from Baudelaire and Mallarmé to well-connected friends in the Establishment.

While pondering his way towards a bloodless revolution in French art, he copied paintings by Fra Angelico and Boucher, Rembrandt and Titian. Once he called on Delacroix, a giant among French Romantics, for permission to copy a work of his. Delacroix, meaning well, recommended him to copy Rubens in the Louvre while he was about it. Instead, Manet

discovered Velasquez there, in whose works he saw a ready-made means of progressing his own art. The stark, black, unequivocal paintings that he began showing in the 1860s, when Monet and Renoir were outdoors charming the sunlight, had the desired effect. Delacroix, who had tried to be helpful, wrote (anonymously) that Manet's colour penetrated the eye like a steel saw, adding, 'He has the tartness of green fruit that is fated never to ripen.'

There were secrets in Manet's life which those who knew him kept to themselves. The woman he married in October 1863 – he had brought her over from Holland – had been his unsuspected mistress for over 11 years, since she was admitted into the family as a music teacher to Edouard and his brother. With typical punctilio, Manet set up the young woman, Suzanne Leenhoff, and her mother, in a furnished apartment. Manet's mother knew of the situation, but his father, a stickler for upper-middle-class morality, never learned of it. Only when his father died did Edouard regularize the liaison by marrying Suzanne. There remains the puzzle of a young lad in his life, Léon-Edouard Koella, supposedly a son of Manet's wife's mother. He makes appearances in several paintings, of which *Le Déjeuner a l'Atelier*, now in Munich, is an interesting example. Léon, then about sixteen years old, leans against the dining-table with the uncertain nonchalance of the adolescent, his blunt, boyish features just emerging into manhood. A woman in the background, and a bearded man in a hat smoking at the table, complete the trio.

The woman, wrongly identified over the years as Suzanne Leenhoff, is in fact a servant; the man is a former art-school friend of Manet's, Rousselin by name. But the subject of the painting is Léon, decked in what looks like a new set of clothes, even a new straw hat, on the brink of stepping out to face the world. Manet has gazed at the youth with undeniably parental curiosity. Other elements in the work seem deliberately analogous, pointing to symbolic clues carefully – even academically – observed. It remains one of Manet's most inscrutable

*Manet.* Copy after Titian's 'Venus of Urbino', *c.1856. Private Collection, Paris. This study, dating from Manet's second visit to Italy in 1856, on which he made several copies of old masters, anticipates the* Olympia *eight years later, in which many details – bracelet, servant, background drapes – as well as the pose, recur.*

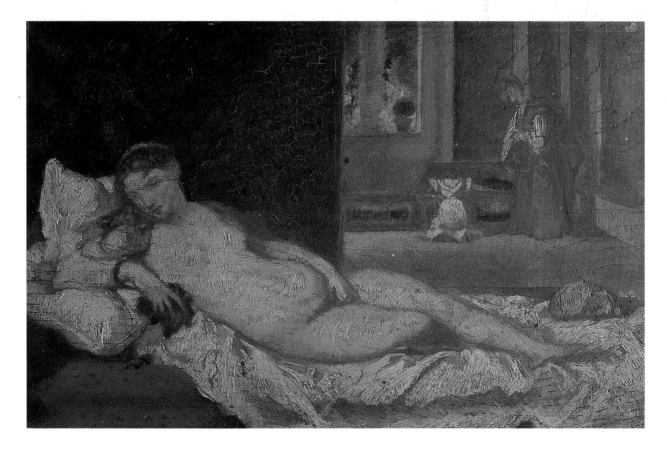

# MANET

**Right:** *Manet.* Portrait of Zacharie Astruc, *1866. Kunsthalle, Bremen. In this study of one of his closest friends and admirers, Manet separates the classical pose from the background by constructing the painting in two separate planes of light.*

**Below:** *Manet.* Le Déjeuner à l'Atelier, *1868. Neue Pinakotchek, Munich. The figure that gives this work its arresting presence, the adolescent boy, is Manet's natural son, Léon Leenhoff. Manet has painted him, with intense observation, on the brink of manhood, dressed in what looks like a set of new clothes. The woman present is not his mother, Suzanne Manet, but a servant. The seated figure is the painter Auguste Rousselin. The painting was shown at the Salon of 1868.*

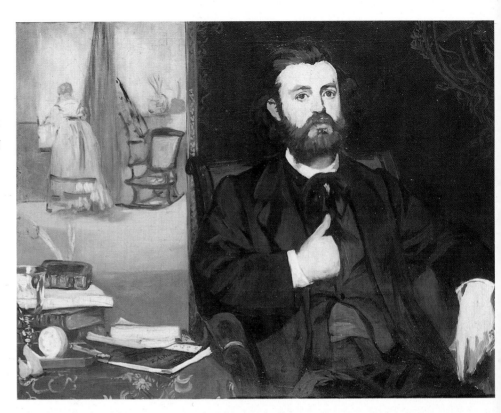

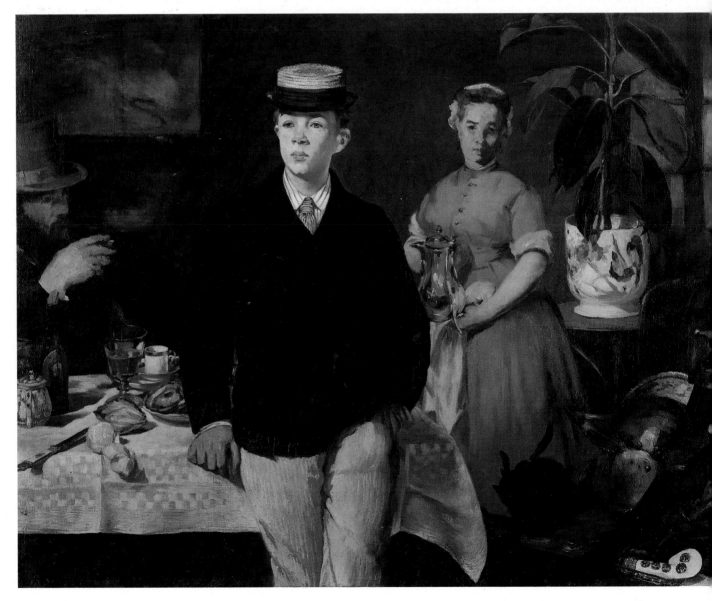

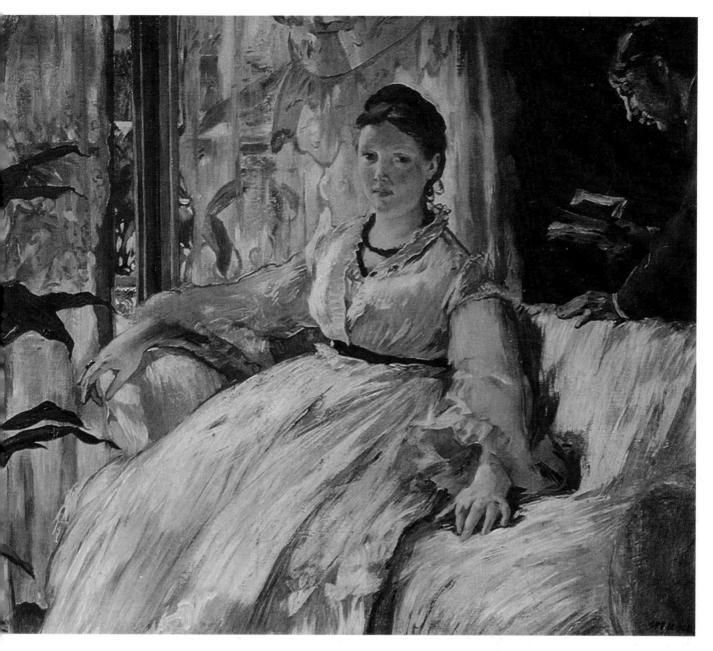

works, not least for what radiography reveals of the original setting – a painter's studio.

Suzanne, though she seems not to have played much of a role in Manet's social life, makes an attractive model for a painting dated five years later, in 1868, with the title *Reading*. She is looking obligingly out at us, her arms spread on a comfortable divan. The reader is a young man peering round the shadowy upper right-hand corner of the canvas, an open book in his hand: once again, Léon is in the picture.

Suzanne makes other appearances, as a model in her own right. *Mme Manet on a Blue Couch*, painted in 1874 is one of Manet's occasional pastels, a medium brought to its greatest heights in 18th century France, and with the notable exception of Degas, not much utilized since. Suzanne is stretched from left to right, her feet emerging from the folds of her wide skirt, one hand in her lap, the other supporting her right shoulder. She is, of course, fully clothed, even to a prim little bonnet. But the pose Manet has chosen for her, we cannot help noting, is exactly the one he made notorious with the nude Olympia.

*Manet.* Reading, *1868. Musée d'Orsay, Paris. The title draws attention to Léon, seen behind his mother, Suzanne (née Leenhoff), whom Manet had married in 1863.*

# MANET

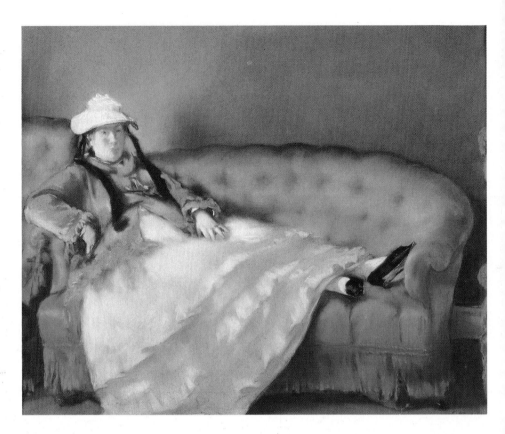

*Manet*. Mme. Manet on a Blue Couch, *1874. Musée du Louvre, Paris. For this lively study of his wife Manet has used pastel, a technique brought to its highest pitch of skill and sensitivity in France in the 18th century, and used in Manet's time by such artists as Boudin, Delacroix, Millet and – pre-eminently – Degas.*

One sometimes feels with Manet that he is simply joining in with his Impressionist friends for the fun of it, showing that anything they can do he can do, if not better then at least as well. His painting in 1878 of *Roadmenders in the Rue de Berne* is so far from the familiar studio light by which he usually worked that it looks at first sight like the work of Renoir or Monet. Pale opaque blues and seemingly transparent whites envelop the subject in pastel hues; the figures and horses are described in flashing strokes as if in motion.

A few years earlier, in the summer of 1874, when Manet was paying a visit to his family at Gennevilliers, on the other side of the Seine to where Monet was living at Argenteuil, he called on Monet and made a painting of him, Camille and little John in their garden. Manet makes the garden into a sunlit grove, in which, as if to add to authentic rusticity, his friend and host is feeding some chickens. Renoir, apparently, turned up while Manet was painting the scene, and asked Monet to lend him some paints and brushes. He then produced his own version of the scene, sitting at Manet's side. Manet, according to Monet's account later, watched Renoir out of the corner of his eye, and eventually whispered in Monet's ear: 'He has no talent, this chap . . . You're his friend – tell him to give up painting.' Monet was amused, and surely Manet was only joking. Renoir's delightful little sketch is now in the National Gallery of Art, Washington; Manet's version is in the Metropolitan Museum of Art, New York.

The last of Manet's undoubted masterpieces, the *Bar at the Folies-Bergère*, which took him the best part of two years to complete, brings together all that he had learned from the Impressionists of how colours can be made to dissolve in the very act of setting them down, and, from his own experience, how to heighten emotion by organizational means. It was Manet's entry for the Salon of 1882, his last year as an exhibitor; and it may be seen as his summing-up of the vagaries of mood and place which are the painter's main concerns in his search for truth.

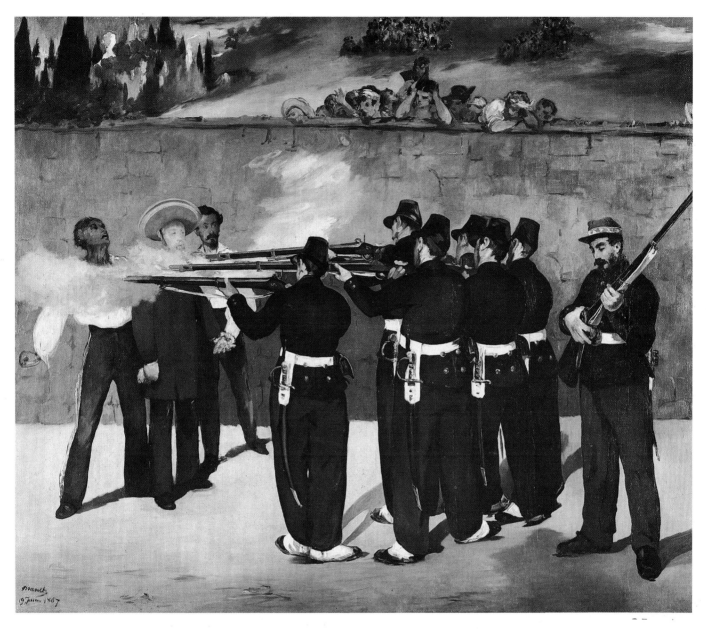

The mood of the work is melancholic, expressed in the only face, among a chattering crowd, that Manet wants us to make contact with, the face of the girl behind the bar. In the midst of the hubbub reflected in the mirror behind her, she is alone with a thought that lies too deep for us to guess at. She is not really with us, or with the place she inhabits. Nor does she see the top-hatted customer whose reflection looms in the mirror, his eyes on her, vaguely menacing, a gentlemanly predator in a place where young women like the barmaid are assumed to be available. The dainties of debauchery are all on view: beer, champagne, wine, spirits and tangerines in their shining skins to tempt the palate. We, spectators of the scene, so vividly imagine ourselves present that we too ought to be reflected in that mysterious world behind her back.

As the image of Impressionism has spread, Manet's place in its achievements has been questioned. His work figured prominently in the exhibition organized by the Louvre and the Metropolitan Museum of Art to open the 100th anniversary of the first Impressionist exhibition in 1874. But it remains a fact that Manet refused to take part in the group's shows under that name, which was coined by the critic Louis Leroy in his review

*Manet.* The Execution of Maximilian, *c.1868. Städtische Kunsthalle Mannheim. By leaving his liberal-minded envoy to his fate at the hands of the republican faction in Mexico, the Emperor of France turned him into a tragic hero. Manet, in his reconstruction of the event, dressed the firing squad in French uniforms. None of his versions was allowed to be shown publicly in France, on political grounds. The fragments of a much-damaged version once owned by Degas are now in the National Gallery, London. Manet's treatment owes an obvious debt to Goya's famous 'protest' painting,* The Third of May, *painted in 1808.*

of the 1874 exhibition. The works Leroy was referring to were the free, fresh, open-air landscape paintings of Monet, Renoir, Pissarro and Sisley. Though certain pictures of Manet's bear an obvious kinship with theirs, his work is very much his own, and in technical terms can be a contradiction of what Impressionism is assumed to be about.

Manet was essentially a figure painter, fascinated by themes of contemporary urban life, and with a psychological insight which he shared with only one of the Impressionist circle, Degas. Degas attributed Manet's refusal to consort with the other 'realists' to sheer vanity: 'Manet was more vain,' he added unkindly, 'than intelligent.' Probably only Degas, noted for his irascible turn of phrase, would have put it so. But it is not hard to sympathize with a rising star among French painters who looked askance at the company he might be keeping if he threw in his lot with a handful of young nobodies. Some of them would not be nobodies for long. But who, today, has heard of the other exhibitors who shared Nadar's gallery walls with them: Attendu, Béliard, Brandon, Bureau, Colin, Debras, Latouche, Meyer, Mulot-Durivage, Léopold Robert?

Understandably, the group could not think of a name for themselves. The outcome was the kind of bland, long-winded title that can only come out of a committee: *Société anonyme des artistes peintres, sculpteurs, graveurs, etc*. Degas was keen to persuade a couple of respectable French painters to join in, and thought of Legros and Tissot, both of whom were by then in London. He wrote to Tissot: 'Manet seems to be obstinate in his decision to stay out. He may very well regret it.'

It is doubtful if Manet had any such regrets. But he did what he could to secure a favourable press for the raggle-taggle band. In the spring of 1877 he wrote to Albert Wolff, an art critic, commending to him the works of

*Manet*. The Seine at Argenteuil, *1874. Private Collection. The influence of Monet, with whom Manet stayed at Argenteuil in the summer of 1874, is apparent in the sunny palette of the subjects which he painted at the time.*

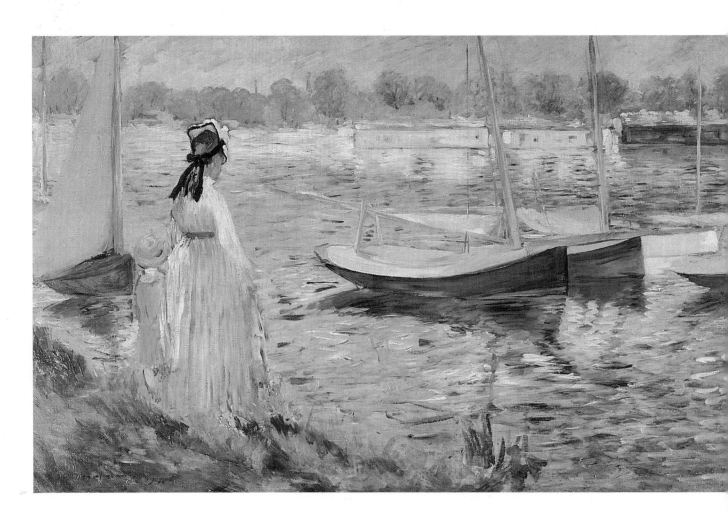

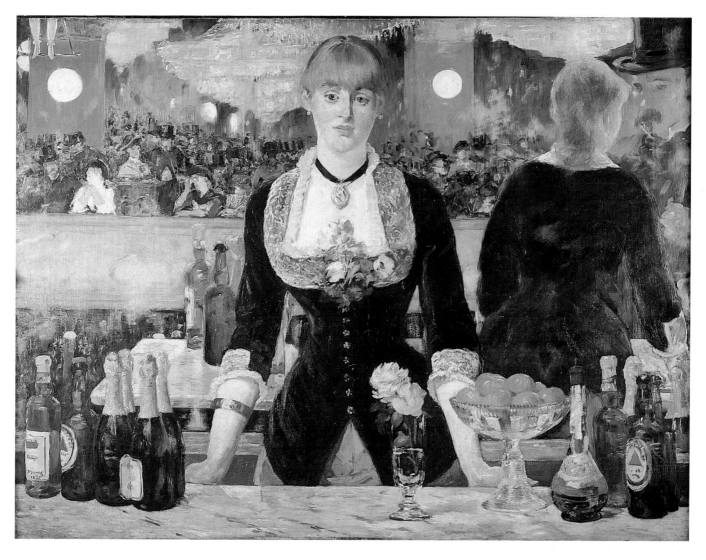

*Manet.* The Bar at the Folies Bergère, *1881–82. Courtauld Institute Galleries, London. Courtauld Collection. For this, his last masterpiece, painted when he was too weak to stand without a stick, Manet brought into his studio the very girl who worked behind the bar at the Folies Bergère. We know her name: Suzon. The looming form of the top-hatted man seems to exist only as a reflection. We know who he was, too: a painter, Gaston Latouche. Between the two figures there is a vacant space, which the spectator can fill with thoughts of his own.*

'my friends Monet, Sisley, Renoir and Berthe Morisot,' adding: 'Perhaps you do not yet like this kind of painting; but you will. It would be kind of you to say a little about them in *Le Figaro.*'

Wolff's review, when it appeared, was not exactly helpful. 'The impression that the Impressionists achieve,' he wrote, 'is of a cat walking on the keyboard of a piano, or of a monkey who seems to have got hold of a box of paints.' Manet would have been hurt; but not so badly as if he had had any pictures there. As it is, several of his paintings from the first flush of the Impressionist era reveal a kinship with the younger men that must have given them heart, apparent in a sunnier palette, stippled brushwork and the distinctive airiness. His response to Venice, late in 1874, was markedly Impressionistic; and in *Chez le Père Lathuile,* dated 1879, he achieved a fusion of his lifelong attitude to portraiture and the quick, glancing technique of Impressionism as exemplified in similar subjects by Renoir and Monet. By then he had only four years left, in which he moved back to his own personal style in the masterly series of paintings of the Parisian demi-world of bars, circuses, courtesans, and night clubs. In 1883, after an operation to amputate a gangrenous leg, in agony and delirium, he died. He was 52.

It was not long before Manet's true worth as an artist became a matter of public interest. When a quantity of his works came up for auction in Paris in February 1884, the *Figaro* speculated; 'Are the Americans going to turn

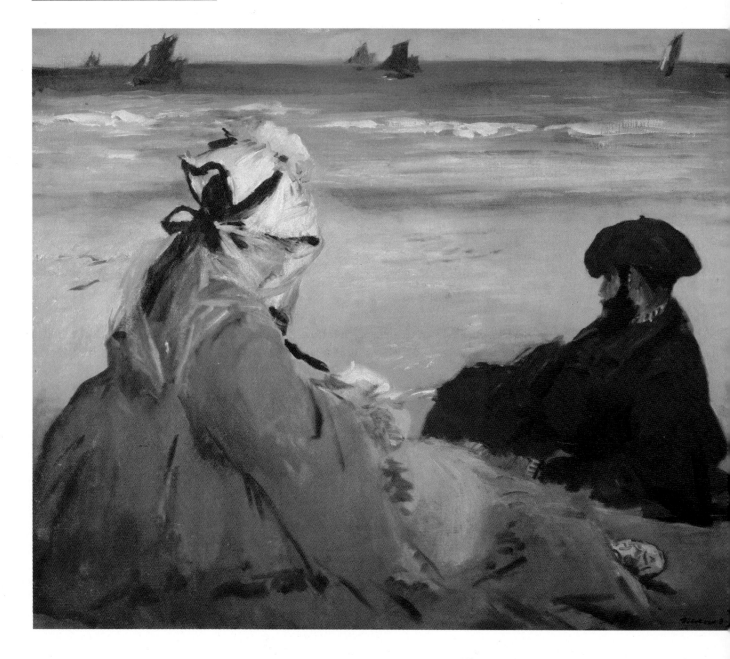

*Manet.* On the Beach, *1873. Musée d'Orsay, Paris. The two figures in this impromptu sketch – there are grains of sand in the pigment – are Suzanne Manet and Manet's brother Eugène, who within 12 months was to marry Berthe Morisot. He leans in the same attitude as Manet had posed him for the* Déjeuner sur l'Herbe.

up? Have collectors been waiting to feel the public pulse before risking their money?' A couple of days later, Albert Wolff, in the same journal, wrote of the sale: 'I was there for a whole hour and watched with considerable uneasiness this horde of friends, enthusiasts and gamblers, keenly bidding against each other, not only for works in which Manet's gifts were triumphantly apparent but also for things completely lacking in interest, either from a speculative or an artistic point of view.' The secret of these high prices, he suggested, was that by now there was a whole class of small collectors, who were banking on the same rise in Manet's prices as had been seen in those of Millet, which had appreciated a hundredfold since he died. Just over a hundred years later, on 1 December 1986, a single work by Manet, of the rue Mosnier with road-workers, came up for sale at Christie's, London. Its first owner, who bought it from the artist in 1879, the year after it was painted, paid 1,000 francs for it. At Christie's it fetched a world record price of £7,700,000. Albert Wolff's closing words in his review of 1884 are worth reviving. 'To one who has watched, as I have, his early struggles, and has stood up for him through thick and thin, any idea of belittling Manet is unthinkable. But good Lord! don't let us lose our heads.'

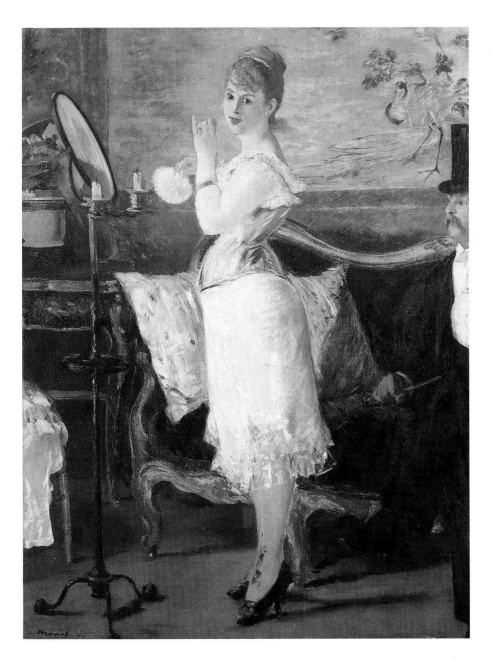

*Manet. Nana, 1877. Kunsthalle, Hamburg. The half-undressed model for this painting was a young actress, the mistress of a foreign nobleman, which may be why it was not accepted for the Salon in 1877. Manet might have had an inkling of his friend Zola's next novel, Nana, which was published in 1879, two years later.*

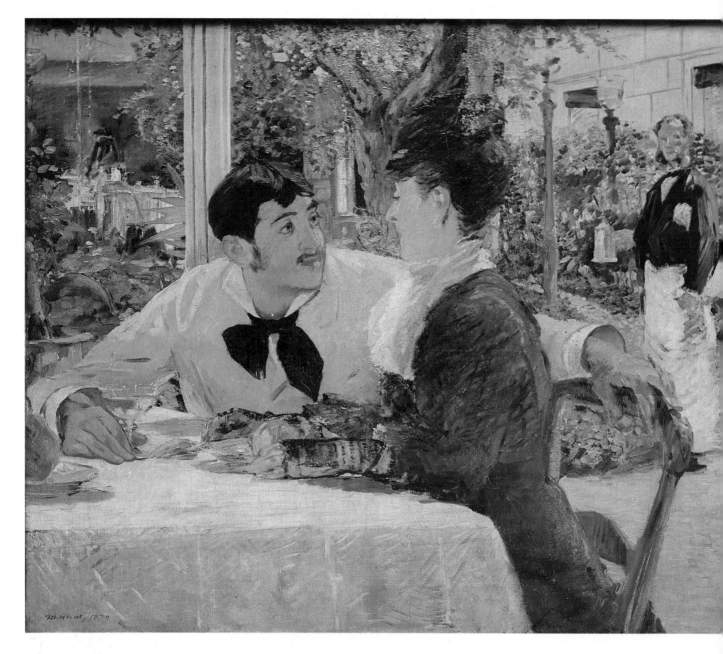

*Manet*. Chez le Père Lathuile,
*1879. Musée des Beaux-Arts,
Tournai. A mastery of figures in the
open air distinguishes this faintly
mischievous subject, an assignation at
its most interesting stage, observed by
a lurking waiter.*

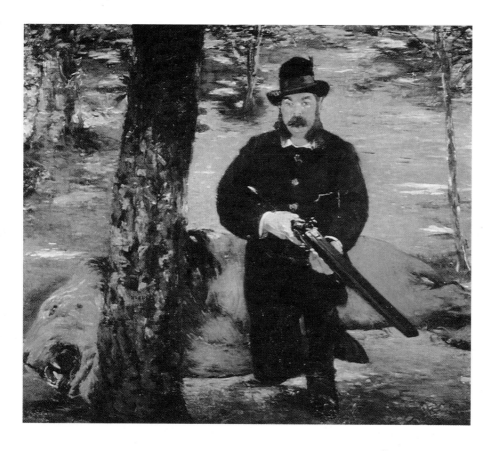

*Manet.* Portrait of M. Pertuiset, the Lion-hunter, *1881. Museu de Arte, São Paulo. Pertuiset, an adventurer, big-game hunter and sometime painter, submitted to Manet's whimsical idea of posing him more as a weekend sportsman out to bag a boar than as the slayer of the unconvincing King of Beasts by which he is kneeling. If Manet was joking, it was a joke on a grand scale: this was the biggest canvas he had tackled since* The Execution of Maximilian *in 1868.*

*Manet.* Singer in a Café-Concert, *1879. Private Collection, Paris.*

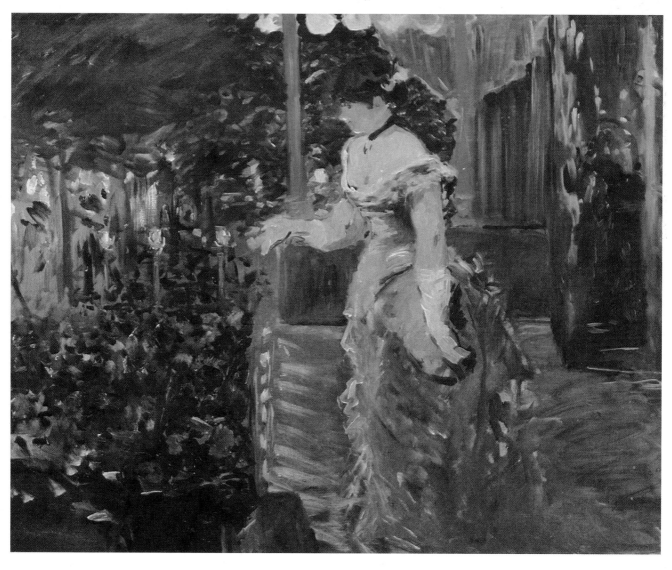

# 3 Morisot

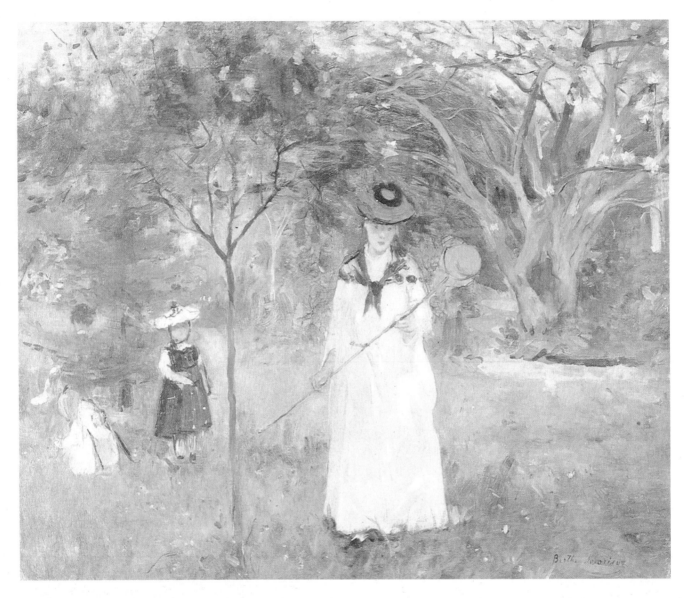

**Above:** *Morisot.* Chasing Butterflies, *1873. Musée d'Orsay, Paris.*

**Opposite:** *Manet.* The Balcony, *1868–69. Musée d'Orsay, Paris. In this group, Berthe Morisot is the young woman with a fan and a pet dog at her feet. The other woman is Fanny Claus, a concert violinist who often joined Manet's wife-to-be, Suzanne, in making music. The young man standing is Antoine Guillemet, a fellow painter who was to become an exhibitor at the group's early exhibitions. The shadowy form of a lad carrying a vessel on a plate is Manet's son, Léon. Manet made his sitters suffer: they had to hold their poses through a dozen sessions, as their expressions seem to show.*

erthe Morisot, on her first meeting with Manet in May 1868, when she was 28, wrote to one of her sisters that she had never seen so expressive a face. 'I find him quite a charming man, very much to my liking. His paintings produce the impression of a wild or even slightly unripe fruit.' This comment by a woman of Manet's own social class – she was a daughter of a former Prefect and bank official, himself an amateur artist in his youth – is typical of the cool, feminine intelligence that made her such a favourite among the Impressionist group, both as a highly accomplished artist and as a comrade-in-arms. Manet, for his part, evidently took a liking to Berthe and her sisters. He told his friend Fantin-Latour that he found them 'quite charming', adding ambiguously that it was a pity they were not men. He was to make several portraits of her, delighting in her lively features and large, green-grey eyes, which he always painted black.

In her teens Berthe had conscientiously copied old and modern masters in the Louvre, made the acquaintance of prominent artists, and begun to paint out of doors. A former pupil of Ingres, Joseph Guichard, took over from the Morisot girls' pedestrian drawing master, and under his guidance Berthe began to paint landscapes. He then introduced the sisters to Corot,

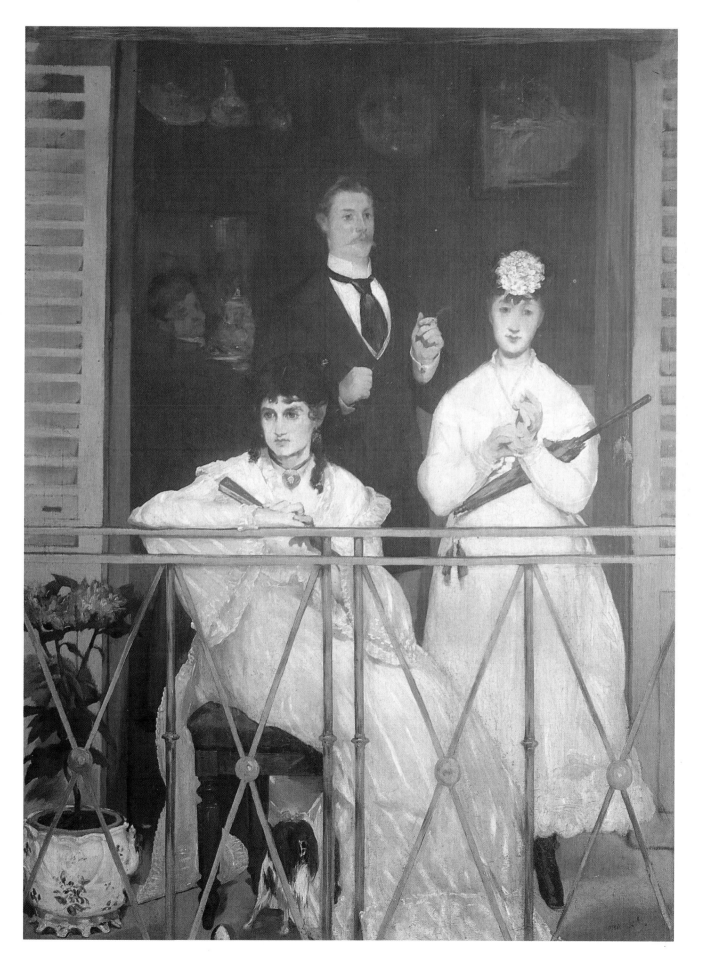

who allowed them to watch him paint at Ville d'Avray, lent them pictures of his to copy, and gave Berthe lessons. Through Corot they came to know Daubigny, a pillar of the Salon with an advanced view of landscape painting, and to Daumier, an artist as radical, in his way, as his fellow-realist, Courbet. With Corot's encouragement Berthe progressed to the Salon: two landscapes in 1864, followed by regular appearances up to 1869. In 1867 she spent the summer in Pont-Aven, in Brittany – more than 20 years before Gauguin – and when Manet entered her life a year later she was already an accepted painter in her own right. She posed for him that autumn for *The Balcony*, which was shown in the Salon the following year. Two other friends of Manet's appear in the group: the violinist Fanny Claus and the painter Antonin Guillemet, who also had a picture, *Village on the Banks of the Seine*, in the Salon that year. The figures in Manet's study are stilted and unsmiling. Guillemet complained at being made to pose fifteen times. At least Berthe was sitting down.

There is no doubting her attachment to Manet, despite his attentions in turn to a glamorous, dark-haired pupil, Eva Gonzalès, which were not popular with Berthe. 'She poses for him every day, and every evening he takes her face out and rubs it down with soap!' she wrote to her sister. At the 1870 Salon she exhibited one of her most ambitious works, *The Harbour at Lorient*, painted in the previous year, showing a young woman with a parasol sitting on the harbour wall against a background of sea, ships

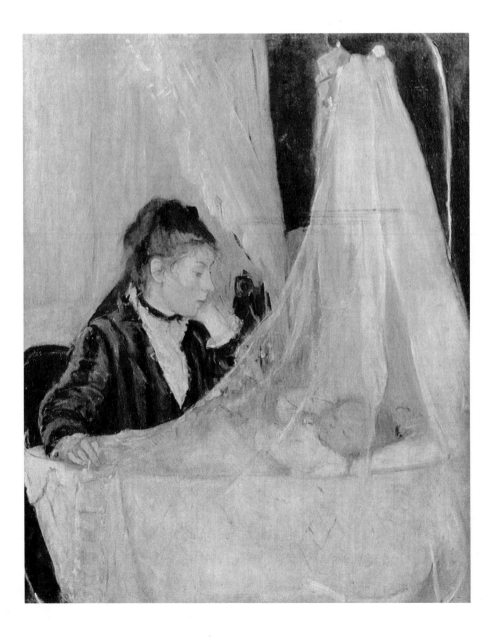

*Morisot.* The Cradle, *1874. Musée d'Orsay, Paris. Edma watches her sleeping baby: an unrepresentative subject for a 'revolutionary' art exhibition – the first Impressionist group show in 1874 – but one that united Berthe Morisot, the only woman in the group, with the men.*

and sky. This is Berthe's sister Edma, and the painting marks her marriage a year earlier to a naval officer who was stationed at Lorient at that time. Manet liked the picture so much he insisted on having it. The same Salon also included a double portrait of her mother and Edma, which Manet had insisted on retouching when she offered it to him for advice. Berthe did not like the result, but hated to hurt his feelings by saying so, or by withdrawing the painting. To her relief, nobody seemed to take any notice of it, so that her reputation suffered no harm.

She and her family stayed in Paris during the siege in 1870, sharing the sufferings of the populace. Manet told his wife, whom he had sent south for safety, that people were eating dogs, cats and rats. Berthe remembered, mischievously, that he seemed to spend his time changing uniforms. Afterwards, when the Impressionists regrouped following the self-exile of Monet and Pissarro, she joined them in their plans for an exhibition together, and subscribed to the charter for a scheme, drawn up by Pissarro, designed to prevent quarrels over the outcome of what would be their first appearance as a group. Her painting, *The Cradle*, now in the Musée d'Orsay, came in for the same treatment as the rest of the Impressionists' début. It is a typical Morisot subject, a mother gazing at her new baby through the hanging lace curtains of a cot. The critic Louis Leroy, in his mocking review in the *Charivari*, wrote: 'That young lady is not interested in reproducing trifling details. When she has a hand to paint, she makes exactly as many brushstrokes lengthwise as there are fingers, and the business is done. Stupid people who are finicky about the drawing of a hand don't understand a thing about Impressionism, and the great Manet would chase them out of his republic.'

Manet, in fact, was not there. He had refrained from committing himself to a show in which, his friends apart, he feared he would be in dubious company. The loyal Berthe took her medicine with the others, and continued to exhibit with them to the end of her life. She gave up sending to the Salon after 1870, despite Manet's protestations, and was never seen there again.

The year 1874 was not only the beginning of her public career as an Impressionist, it was also the year of her marriage to Eugène, Manet's younger brother. She was 33, independent as ever in spirit, and – following her father's recent death – wealthy in her own right. She and Eugène paid a visit to England, where she painted on the Isle of Wight and along the channel coast, subjects which were among her exhibits at the Impressionist

*Morisot.* The Artist's Sister. *Courtauld Institute Galleries, London. Prince's Gate Collection.*

*Morisot.* A Summer's Day, *1879. National Gallery, London.*

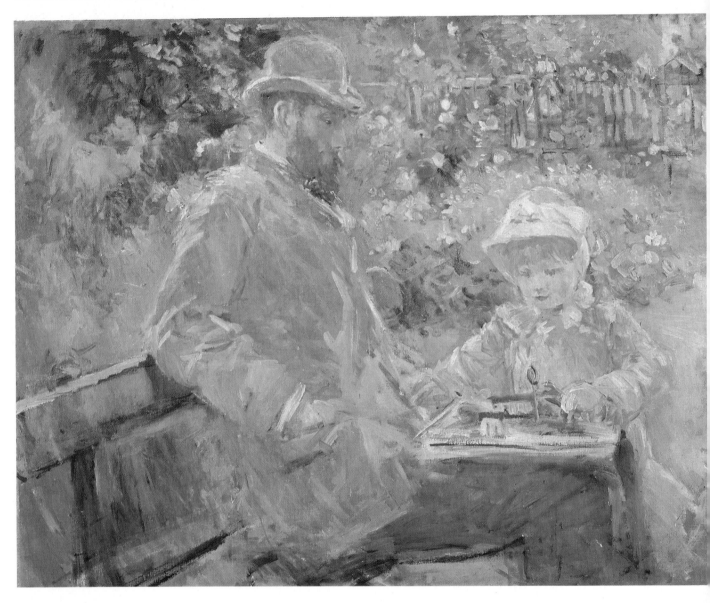

*Morisot.* Eugène Manet and his Daughter at Bougival, *1881. Private Collection. Morisot excelled at affectionate domestic scenes in which light, touch and atmosphere achieve the Impressionist aim of uniting all elements in a glance.*

exhibition of 1877. Her work at this time caught the eye of the art critic of *Le Temps*, who remarked on her freshness, improvisation, and 'sincere eye'. As she approached 40, her daughter Julie was born, which meant she did not contribute to the fourth Impressionist exhibition that year. She was by then spending the summers at Bougival, where Eugène had rented a house with a superb garden, which she delighted to paint. She and Julie were joined by Berthe's niece, Nini; the two little girls appear in several paintings, drawings and etchings of those sunny years, picking cherries, pinning flowers in their hats, scampering among the blossom-laden trees.

At their Paris home in the rue de Villejuste the Manets kept open house for their painter friends, including Degas, Renoir, Monet and Whistler, and such literary visitors as Paul Valéry and Stephane Mallarmé (dubbed by Victor Hugo 'our impressionist poet'). Berthe Morisot, presiding over these enjoyable proceedings, must have felt a long way from the hurly-burly of art feuds and tart-tongued critics. In her last years – she died after an attack of influenza in march 1885 – she was active in trying to keep her old friends from breaking up, as a new generation of painters began to shift Impressionism in other directions. Pissarro referred to her in a letter to his son Lucien as 'this distinguished woman, who had such a splendid feminine talent, and who brought honour to our Impressionist group.'

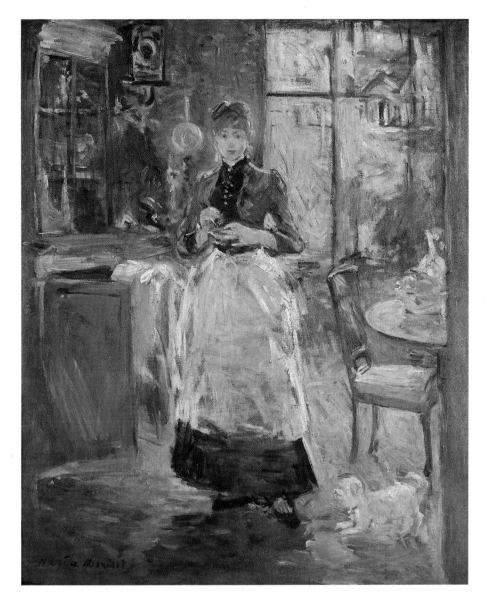

*Morisot*. In the Dining-Room,
*1886. National Gallery of Art,
Washington DC, Chester Dale
Collection. The girl is the family's
maid, painted in the house in the rue
de Villejuste, Paris, where Berthe
lived with her husband, Eugène
Manet, whom she had married ten
years earlier, and their daughter,
Julie.*

*Morisot.* Portrait of a Young Girl
(La Petite Marcelle), *c.1894.
Richard Green Gallery, London.
The critics were never so severe with
Berthe Morisot as with her male
comrades-in-arms. Twenty years
before this study was painted, the
critic Georges Rivière had written
admiringly of her 'light
unpretentious style'. She had an eye,
he added, 'of extraordinary
sensibility, and a skill and technique
which place her in the forefront of
the Impressionist group.'*

To her admirers she stands apart for the character, recognized by
Pissarro, of her bright, free touch, which comes at times closer to that of
watercolours than of oils. Her treatment of sunlit gardens, in which women
and children go about their family pleasures, are among the most directly-
realised of all Impressionist works. Her palette and delicacy are in harmony
with the scenes of unruffled domesticity all around her. She has a way of
painting faces in which the features seem to be absorbed in light, as
tenderly as if the pigment were an element itself. Likenesses are suggested
by attitude or gesture rather than by portraiture alone. These achieve
luminous results, especially in her treatment of children. None of the
Impressionists comes so touchingly close to the half-formed features of a
girl on the verge of womanhood, or the unwitting prettiness of a well-loved
child.

A scribbled entry in a notebook, shortly before she died at the age of only
54, sums up her only ambition as an artist. 'Desire for glorification after
death,' she wrote, 'seems to me an excessive ambition. Mine would be just
to capture something of the passing moment – oh, only something, the least
little thing! And yet even that ambition is excessive.'

# 4 Degas

Edgar Degas, the closest of the Impressionists to Manet in age and outlook, regarded him as an equal. He had a life-long regard for Manet, whom he confessed he admired and envied for his self-assurance, his unfailing eye and hand, and – according to the poet Paul Valéry, who knew him in his old age – for arriving, in his best works, at poetry, 'the highest point of art'.

He and Manet shared similar social backgrounds. Degas' grandfather had founded a bank, and there was money in the family. He was born in 1834, one of a family of five, to the Creole wife of De Gas père: Edgar subsequently spelled his name in the less pretentious form, Degas. His family wanted him to become a lawyer (so had Manet's, offering him the French Navy as second-best) but he seems to have had little difficulty in getting himself enrolled at the École des Beaux-Arts to study under a former pupil of Ingres, Louis Lamothe. He soon became bored with classwork and repetitive copying at the Louvre, and at the age of 22 took himself off to Italy to study the masters.

On his return to Paris he rented a studio on the Left Bank and began painting historical subjects. Then came his meeting with Manet. Their tastes and talents were similar, each aiming at directness and simplicity at the expense of finish and detail – the opposite of what was expected of professional painters. Degas shared Manet's impatience with all that was

*Above: Degas.* Portrait of René De Gas, *1857. Musée d'Orsay, Paris. As the son and grandson of bankers, Degas was born into a well-to-do family. He was 23 when he painted this portrait of his grandfather.*

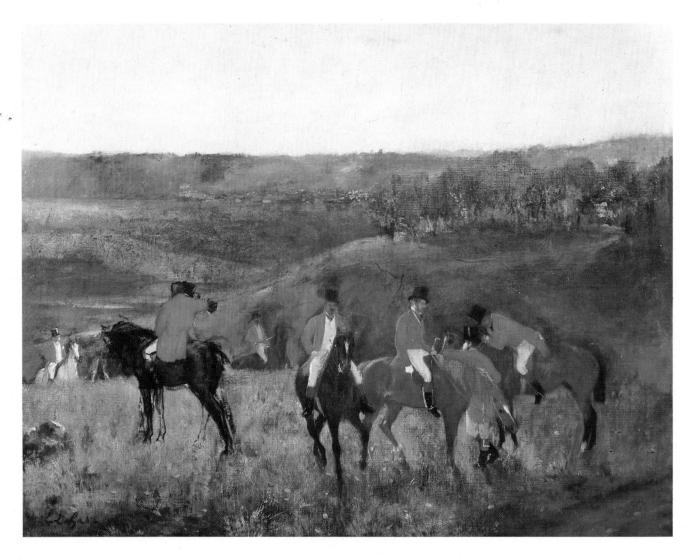

*Degas.* Portrait of a Young Woman, *1867. Musée d'Orsay, Paris. The name of the sitter is lost, but she exerts a presence that owes as much to classical European antecedents in art as to the vogue for realism.*

superfluous in painting. Verbose painters, they both agreed, were bores. Degas found Manet's artistic detachment much to his taste, and adopted the same stance in his own work.

Again, like Manet, he was more at home in the city streets and salons than in the country fields where the Barbizon painters and their heirs found both inspiration and style; and he had an instinctive distaste for the extrovert gestures of Courbet and the Romantic-Realist school which briefly flourished in the glare of his celebrity. He was quite shocked at Manet's respect for official honours. When Manet once recommended him to accept an award, he rounded on him with: 'This isn't the first time I've realized what a bourgeois you are, Manet!'

The ambivalent nature of their relationship might also have something to do with their conflicting political attitudes. Manet, despite his respect for the apparatus of social power, was a convinced republican. Degas was unashamedly a snob. Again, though they shared so much that was important to them as painters, their methods of work were different. Manet believed in putting down what he saw first time. 'If you've got it, that's it.' Degas, on the other hand, said: 'There's nothing less spontaneous than my art.' The brilliant naturalism which he seemed to achieve so easily was the result of deliberation and hard work.

In great artists, human qualtities have a way of enlarging themselves

**Opposite bottom:** *Degas.* The Meet, *1864–68. Private Collection. Degas came closer than any of his contemporaries to catching the motions of horses on the brink of action. The sense of impending movement is as strong in this sketch of huntsmen arriving for the chase as in his groups of racehorses waiting for the 'off'.*

# DEGAS

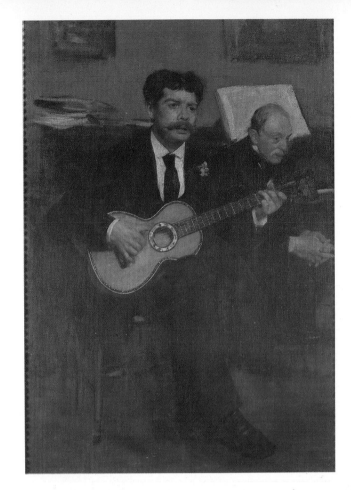

*Degas.* The Artist's Father Listening to Pagans, *c.1869. Musée d'Orsay, Paris. Degas' father liked to arrange music recitals at the family's Paris home on Monday evenings. Here, Degas catches his father's wrapt expression while listening to a well-known singer and guitarist of the day, Lorenzo Pagans.*

*Degas.* Portrait of Mlle. Marie Dihau, *1869–72. Musée d'Orsay, Paris. The snapshot nature of the pose is typical of Degas' flair for immediacy in portraiture – a gesture or turn of the head caught on the instant. Marie Dihau was the sister of Desiré Dihau, the bassoon player and friend of Degas, who is included in* Musicians in the Orchestra, *painted shortly before this study of Marie.*

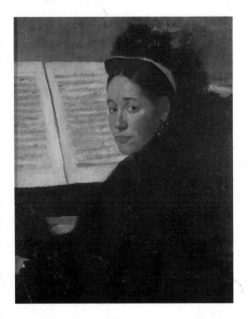

through their work, and so it is with Degas. Whatever his public self might have seemed, his private self, the artist, was capable of dignity and compassion surpassing that of moralizing painters such as Millet. In a Degas study of a shop-girl or laundress or a singer in a cafe, there is an unsentimental tenderness. Like Manet, he did not paint types, he painted real people. In his own life he did not make room for affection, or even close friendship, explaining: 'There is love and there is work, and we have only one heart.'

His work did not unduly antagonize the jury at the Salon, where he exhibited regularly after 1865. In 1870 came the war with Prussia, scattering the Impressionist band. Degas sailed to the United States, an experience which excited him (he wrote home about it like any tourist) and which produced at least one portrait, of Estelle, the blind wife of his brother René, which ranks among his masterpieces. She sits with her arms folded protectively across her pregnant body, looking into an endless distance.

Another work from this period, *The Cotton Exchange, New Orleans*, is like a press photograph and with just that kind of immediacy. It shows his uncle's office in New Orleans, and the figures are portraits of the family and staff. Degas seemed to revel in the new possibilities opened up by photography, and delighted in painting from unconventional angles, as if perched on a chair. Ironically, in view of his obvious attraction to photographic techniques, he was suffering from an eye ailment which partially obscured his vision. One thinks of him squinting through an imaginary viewfinder, allowing the composition to assume its involuntary form. He even bought a camera, and used it for organizing his pictures.

Back in Paris things had changed. The Opera had been burned down, depriving Degas of one of his major pleasures and sources of ideas. But most of the young painters he admired were still there, thinking about holding a group exhibition. Degas joined them. It was as if, after his absence, his mind was clear about what he should do next. By joining the insurgents he was turning his back on a career within the established

professional structure. He ran the same risks as they did of ridicule and rejection; and he was not, like most of them, hardened in the fire. But he gave them his support, and under their influence his own work became perceptibly higher-keyed, with the bright colours and lightness of touch which distinguish Impressionist painting at this, its historical high-water mark.

His part in holding together the disparate group around Manet was important but not disinterested. He was well aware of the need for an artist to try to influence events, to look after his own career, and to make his presence felt in the cafe-table councils where Parisians enjoyed talking and

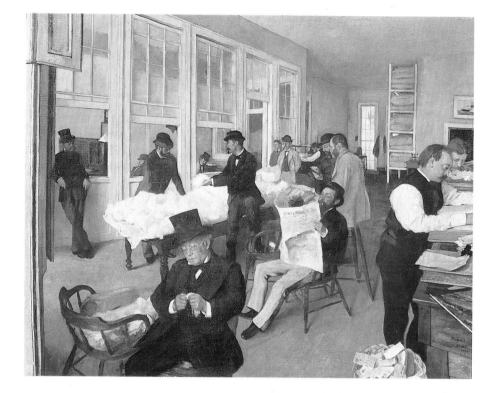

*Degas.* The Cotton Exchange, New Orleans, *1873. Musée des Beaux-Arts, Pau. Degas had two brothers who were in business as cotton merchants in New Orleans. His instinct for informal composition, akin to a cropped photograph, is apparent in his handling of this subject.*

*Degas.* Beach Scene, *c.1876. National Gallery, London. This sophisticated work, which Degas exhibited at the third Impressionist exhibition under the title 'Sea Bathing: Young Girl Being Combed by her Maid', is on three pieces of paper mounted on canvas. Despite its convincingly* plein-air *appearance, it was painted in the studio.*

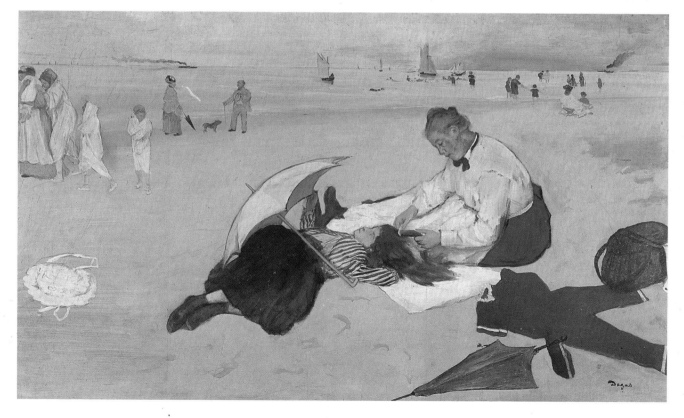

arguing, laying impossible plots, making and breaking each other's reputations, talking shop. In the 1860s the artistic coteries began to move from the Left Bank to the Right, finding there a quiet quarter with just the right atmosphere, up the hill from the rue Saint-Lazare towards Place Pigalle, bordering on Montmartre, at that time a village, and the Batignolles.

The district helped to unite a community of artistic young men in a loose camaraderie. Fantin-Latour, an early friend of Degas, included a handful of them in a painting of his studio in the Batignolles: Renoir, Zola, Bazille and Monet among them. Bazille, in his turn, painted several of his friends in *The Artist's Studio* in 1868 in what is now the rue de la Condamine. The growing circle, Degas among them, took to meeting at the Café Guerbois, near the Place de Clichy. As well as Degas, Renoir, Monet and company, its habitués included Félix Nadar, the photographer, whose studio was to house the first Impressionist exhibition in 1874, and a potentially useful handful of critics, one of whom, Armand Silvestre, has left a glimpse of the scene. 'In the gaslight and noise of the billiard table I would mention the painter Degas, his very original, very Parisian face, and his humorous, bantering expression . . . The young school owes a lot to him, and the old school admires, though with rather ill-humour, the quality of his drawing and his artistic nature. He has the privilege of being challenged by nobody, not even the fervent partisans of the School of Rome . . . This Degas has his nose in the air, the nose of a searcher. One day his works, which are too rare, will be furiously fought over by collectors.'

The reference to Degas with his nose in the air confirms other pen-pictures of his characteristic stance, head held high in a self-confident, even jaunty way, rather than in unfriendliness or pride. He was noted for sustaining a complicated argument, and kept notebooks in which he wrote down good advice for his own benefit: 'Work a great deal on night effect – lamps, candles and so on. The provocative thing is not always to show the source of the light but rather its effect . . . Do portraits of people in typical attitudes. Above all, give their faces and bodies the same expression.'

In an early work, which he called *Interior* (others knew it as *The Quarrel* or even *The Rape*), Degas put these precepts into effect. The painting, sombrely dramatic, could be taken as an illustration of a bedroom scene in a novel, and various candidates have been suggested. The source has lately

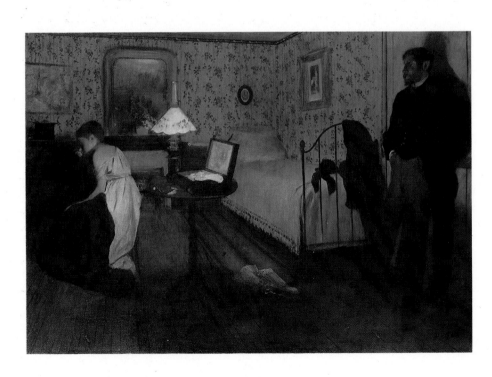

*Degas.* Interior, *1868–69. Philadelphia Museum of Art, Pennsylvania: The Henry P. McIlhenny Collection. In memory of Frances P. McIlhenny. Otherwise known as* The Quarrel *or* The Rape, *this is a scene from a little-known story by Émile Zola, a close member of the Impressionists' circle in their early days. Degas seems to have been reluctant to identify the source, preferring to let the public make up their own scenarios.*

been identified as an episode in an early work by the painter's friend Zola, *Thérèse Raquin* – a detail that Degas concealed from everybody, and which came to light only in 1972.

Though he was temperamentally a 'modern', Degas retained a deep respect for those painters of the past whose work appealed to him, whether classic or romantic. He had a particular feeling for both Ingres, the inveterate traditionalist, and Delacroix, the supreme colourist. His own collection included a sketch for Ingres' famous *Odalisque*, which he enjoyed showing to knowledgeable visitors, and nearly two hundred pencil drawings by Delacroix, in addition to several of his oils. Of his immediate predecessors he owned works by Millet and by Corot; and he also liked to have about him paintings by his friends in the Impressionist circle, notably Pissarro, Sisley, Berthe Morisot and Mary Cassatt. One omission from this company is Monet, whose work, the quintessence of Impressionist naturalism, Degas professed not to care for. According to Vollard, he found Monet's pictures either 'too draughty', making him want to turn his coat collar up, or too dazzling. 'Let me get out of here,' he said once, meeting Monet at one of his exhibitions, 'these reflections in the water hurt my eyes.'

He joined the Impressionists in all but one of their exhibitions. But, like them, he had to endure economic misfortune in the 1870s. The family's finances were found to be in such a tangle after the death of his father that

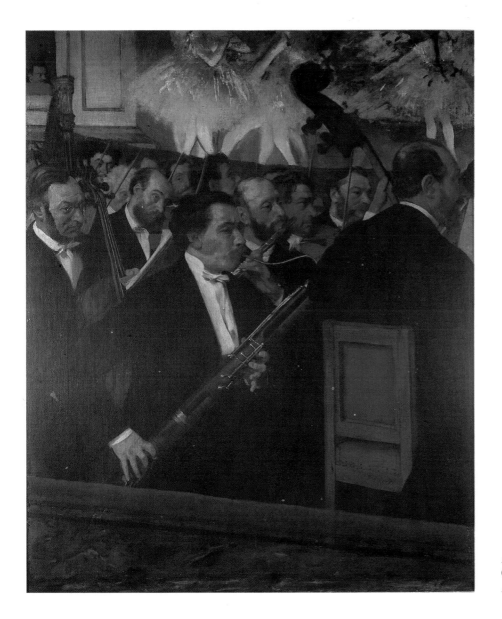

*Degas.* The Orchestra of the Paris Opéra, *1868–69. Musée d'Orsay, Paris.*

Degas, to save the family from bankruptcy, sold his collection of pictures, only to find that his brother René, husband of Estelle (whom he afterwards abandoned), was likewise in dire straits following some unlucky speculations on the stock market. Degas and a brother-in-law each paid half of what was owing, which effectively reduced Degas to a financial state not much different from that of his younger friends. Now dependent on selling his paintings for a living, he began to produce work which, while uncompromisingly his own, compelled the public to enjoy it. His technique was ideally suited to the garish, gas-lit music-hall and theatre. He became a familiar habitué of these places, one of the top-hatted elders whose presence lurks in so many of his ballet subjects.

In Degas' day, almost any man of any degree of sophistication and urbanity could secure a pass, or *abonnement*, to one of the thrice-weekly performances at the Opéra, which entitled the holder to a free run of the theatre, including the wings and the dancers' dressing rooms. The dancers, working-class girls on miserable wages, took it for granted that the gentlemanly fans' interest was not primarily artistic. Degas himself, fastidious to a degree, had another purpose in watching the dancers hour after hour, sketching them off-stage as well as in performance, stretching, scratching or yawning with the touching gaucherie of children. One of his cronies said of him that he treated the girls as if they were his own, excused their misbehaviour and laughed at everything they said. 'The *petits rats* were ready to do anything to please him.'

Degas saw his first operas and ballets in the Salle de la rue Le Peletier, before artistic standards had degenerated into the coarse, less disciplined world of popular show business. Fond of music, and well grounded in the language of the dance, he observed with an educated as well as an artistic eye, separating the flashy turns from the genuine article, sometimes as a member of the audience, at other times from a vantage point just off-stage, often taking in the orchestra pit, the bulky forms of the musicians, and the looming masculine silhouette of a bass fiddle, contrasting with the diaphanous shapes of the front-lit dancers. Often, a glimpse of a top-hatted profile introduces a non-theatrical element, subtly shifting the picture into another dimension.

Behind the scenes, Degas watches as dancers are laced into their costumes, sometimes with the help of the perennial stage mother. If we look with prurient curiosity we are likely to be disappointed. That Degas was fascinated by the entire ballet circus is undeniable; that he attended as an onlooker rather than as an artist is disproved by one masterly painting or pastel after another. Irony, wit, affectionate ribaldry are all there; but the artist's eye is true.

As he grew steadily more successful and respected, so he withdrew from the world. His sight continued to trouble him, and when he found he could no longer manage oils to his satisfaction he turned to a new medium, pastel. Somehow, thanks to a special fixative known only to himself, he transformed pastel into a medium hardly less subtle than watercolour. Instead of his colours turning each other muddy as one was laid over another, he was able to achieve miracles of lightness and delicacy which have never been equalled in the medium. Degas had always been a skilled draughtsman; now, with a crayon in his hand, he became a master. The pleasure these drawings gave, and give still, establishes him among the greatest draughtsmen of modern times. In them he passes beyond the fixed image of the photograph to suggest the next movement, and the one after that, in a single stroke. The dancer's body becomes an instrument, which in her active moments she checks and tunes like a violinist.

At the races, Degas was also in his element. There, as on the stage, was graceful movement, vivid colour, tension, physical grace, the flickering of

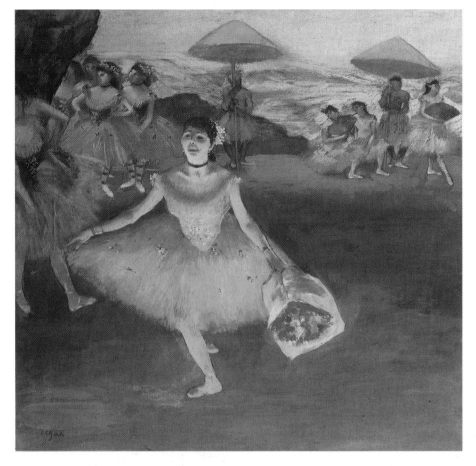

*Degas.* Dancer taking a Bow, with Bouquet, *1877. Musée d'Orsay, Paris. The harsh frontal lighting and garish colours of the musical theatre fascinated Degas. He liked to be either in the front row – among the orchestra, if possible – or to watch from the wings.*

*Degas.* Bed-time, *1883. Tate Gallery, London.*

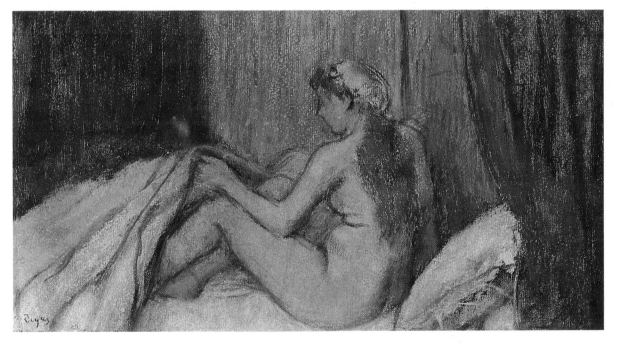

highly trained bodies, mounting tension in the minutes before the 'off'. Degas' treatment of the animals has nothing to do with conventional horse-painting, with its formal sidewise-on viewpoint, breeding in repose. His horses are charged with an electric nervousness, their bodies damp with sweat, nostrils straining, heads tossing against the reins, feet dancing in restless anxiety to plunge into the race. Since horses are difficult to draw at full speed, Degas had to rely on his remarkable visual memory to catch the movement of the legs. He was helped by the publication in 1879 of the results of Eadweard Muybridge's experimental photographs of horses in motion, including a sequence of photographs. These showed conclusively

that the 'rocking horse' action – forelegs stretched to the front, rear legs to the back – was nowhere near the truth. Degas himself had used it, following tradition, in at least one painting – in the background of *Carriage at the Races*, 1871, now in Boston.

Unlike some artists, who at first disbelieved the evidence of Muybridge's camera, Degas at once took it up. His horse sculptures and later racecourse studies show the animals moving as naturally as the camera, and subsequently the cine-camera, revealed. He also enjoyed cropping his pictures – or more accurately, his viewpoint – to give them the spontaneous impact of photo-journalism. His contemporary, Rodin, a sculptor of genius, realised that if, as he said, the artist succeeds in producing the impression of movement which takes several moments to accomplish, 'his work is certainly much less conventional than the scientific image, where time is abruptly suspended.' The artist, in fact, had the edge over the photographer; thanks to Muybridge, he knew what movement was coming next.

No one has captured the private moments of a woman, unobserved in some female ritual, with such piercing curiosity. Other artists, treating such subjects, might become voyeurs, but Degas does not react sensually to what he sees and draws. On the contrary, he seems disinterested in the conventional attitudes of coquetry and desire. This gives his figures of women infinitely more interest and sometimes, perhaps contrary to his own intentions, an unexpected pathos. It is typical of Degas that he could produce works which give such pleasure without in any way ingratiating himself with the spectator. 'Drawing,' he said, 'is not what one sees but what others have to be made to see.' This is in accord with his belief that art

*Degas.* Racehorses and Jockeys in front of the Stands, *1869–72. Musée d'Orsay, Paris.*

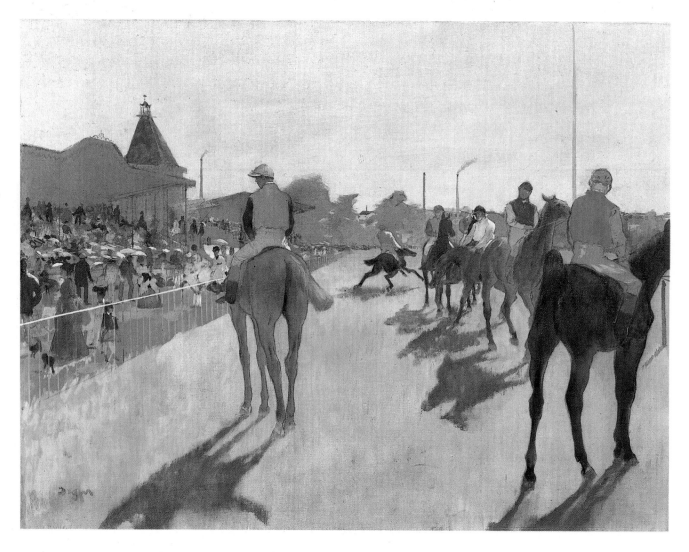

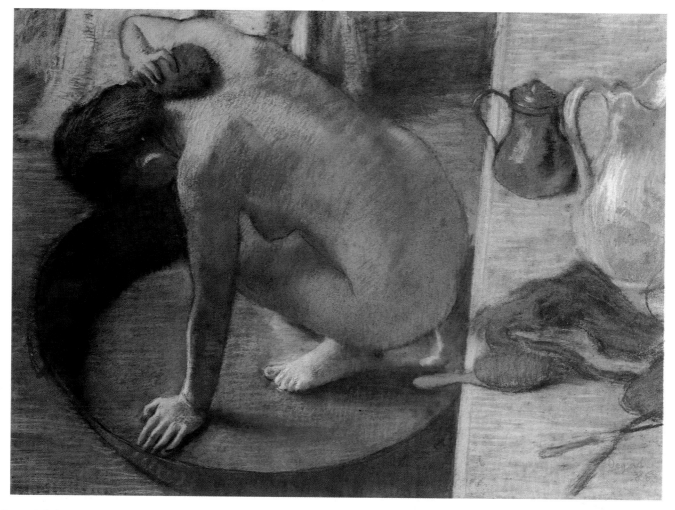

is a sleight of hand by means of which a painter can deceive the spectator into accepting the device as the reality. It brings him nearer to pre-Impressionist attitudes to art than he would perhaps have cared to admit, and certainly it seems a contradiction of Manet's dictum that painting should always look like painting, whatever subject the artist sets himself. But there are many contradictions in Degas, both in his work and in his opinions. For instance, he acknowledged the part that a painter's unconscious self plays in helping him create works of art. Only when the artist no longer knows what he is doing, Degas said, does he do good things.

Many of his later works are of this kind; the marvellously gifted practitioner, working at the same familiar subjects over and over again until they become second nature, can every so often let his unconscious, poetic self come through. Such moments brought him close to abstract painting, when as an old man, his sight – like Monet's – grown weak and unreliable, he painted less what he saw than what he felt to be true.

In 1878 he began modelling a figure of a ballet student at the Opera, Marie van Goethem, based on drawings he had made of her, unclothed, from the back, front and side, legs apart, hands behind her back, the fingers linked palm upwards. Starting with a small wax figure, he moved on to a finished version, which he announced for the fifth Impressionist exhibition in 1881. Word had spread that Degas was up to something, and the opening was anticipated with more than usual interest. When the two-thirds-lifesize *Little Dancer of Fourteen* made her bow, there was a stunned silence, followed by a stormy reaction. Typically, Degas had made a disconcertingly honest replica of little Marie, from her adolescent body to

*Degas. The Tub, 1886. Musée d'Orsay, Paris. By shifting his viewpoint, posing the model in a compact space, and introducing an original still-life, Degas creates a masterly variation on a theme which he has already made his own.*

57

# DEGAS

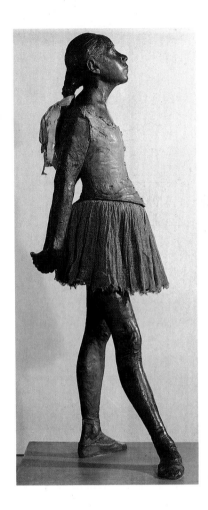

*Degas.* The Little Dancer of Fourteen, *1880–81. Tate Gallery, London. This was the only sculpture by Degas to be exhibited in his lifetime. After his death in 1917 numerous others were cast from models found in his studio.*

**Right:** *Degas.* Miss La-La at the Cirque Fernando, *1879. Tate Gallery, London. A study in pastel of La-La's spectacular act.*

**Opposite:** *Degas.* Miss La-La at the Cirque Fernando, Paris, *1879. National Gallery, London. The performer was a negress or perhaps mulatto, and Degas seems to have found in her act a subject that combines technical skill with a figure as solid as his bath-tub nudes. La-La is suspended in an auditorium that evokes the Baroque grandeur of a church interior.*

her blunt street-girl's face. Then he had dressed her in a linen bodice, a tutu of gauze and satin ballet shoes, given her a pigtail of real hair and tied it with a silk ribbon. Her pert presence dominated the show.

One critic complained that Degas had given her the skinniness and wrinkles of an old woman, not of a child. Another recoiled from the 'terrible reality', while remarking that Degas had overturned all the traditions of sculpture. Yet another declared that he had found a place for himself in the history of the 'the cruel arts'. Degas was not dismayed: on balance, the critics were on his side. He had made his point by shocking people into over-reacting to a work which had respectable historic precedents in classical Greece. It unsettled the public mainly because the real clothing suggested that there was equally real flesh underneath, not wax – the flesh of a pubescent girl, moreover, with all that that implied of sexual taboos. No doubt the original figure, in wax, suggested living flesh more effectively than do the bronze casts that have since been made from it and shown around the world. Satisfied, Degas moved on to other things.

*The Little Dancer*, his first sculpture, was the only one exhibited by Degas in his lifetime. After his death, numerous models in wax, never taken beyond the first stage, were discovered in his studio. Bronze casts made from these have established him as a master of the sculptural 'sketch',

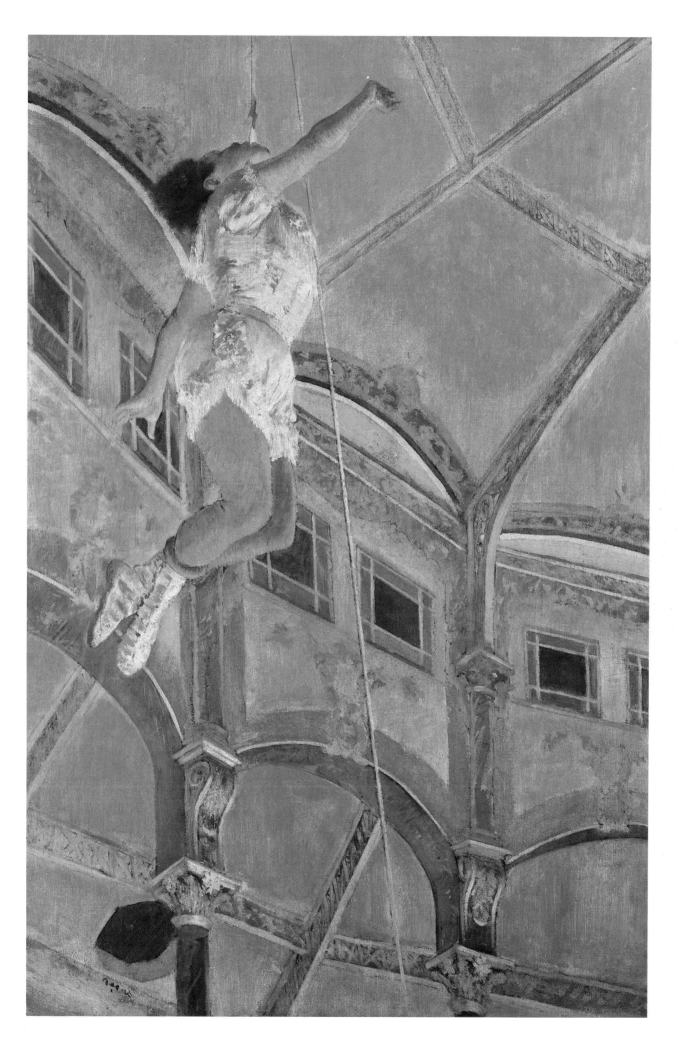

comparable with the free, loose studies for work in his more familiar media. Of the surviving pieces, 74 are of dancers, while 15 are of racehorses and bathroom scenes, which suggests that he had been venturing into sculpture some years before exhibiting *The Little Dancer*. He might even have started a sudden craze for sculpture among his Impressionist friends. Renoir began modelling in 1878, Pissarro and Gauguin followed a couple of years later.

His interest in urban subjects, shared by all the Impressionists, had already led him to realistic studies of actresses, laundresses, café tarts. In such studies, Degas, himself an intensely private man, observed the private moments of workaday women with a kind of passionate candour. He later began to see them in terms of mass and texture rather than of line and colour; and for this, print-making was the ideal medium. Well grounded, as he was, in the classic techniques, he was forever experimenting with new ones, often of his own invention. By taking proof after proof from a plate that he was never finished with – changing, deleting, going back, then re-working the plate for the umpteenth time – he produced whole series of variations on a single subject: a 'figuring out' process impossible in a painting, where there is only one result.

Perhaps his most notable advances were in monotypes, in which Degas devised a means of creating fluid movement by drawing on an etching plate in an oil-based ink, taking an impression on paper, then smudging the freshly printed image with his fingers, scratching lines with the end of his brush, smearing or dabbing with a piece of rag. As an alternative, he would cover the surface of a plate with ink, then make an image on it with a tool or a finger before taking an impression. Only four prints by Degas – he called them *essais* – were published in his lifetime. However, 400 proofs eventually came to light in his studio. Most of them have found their way into major collections around the world, to add yet another

*Degas.* Women in a Cafe at Night, *1877. Musée du Louvre, Paris.*

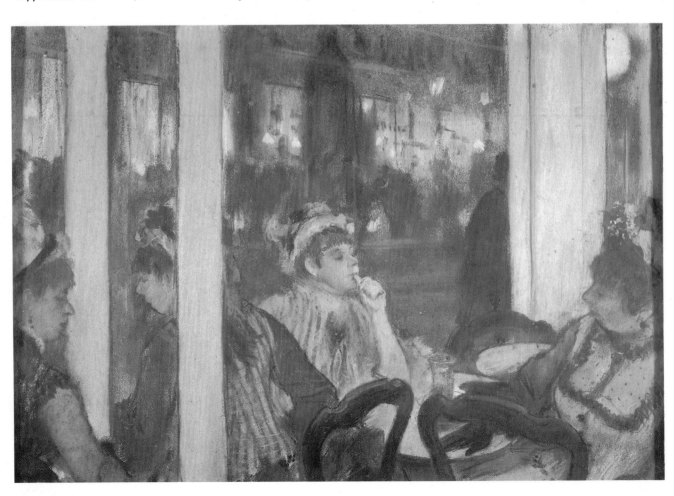

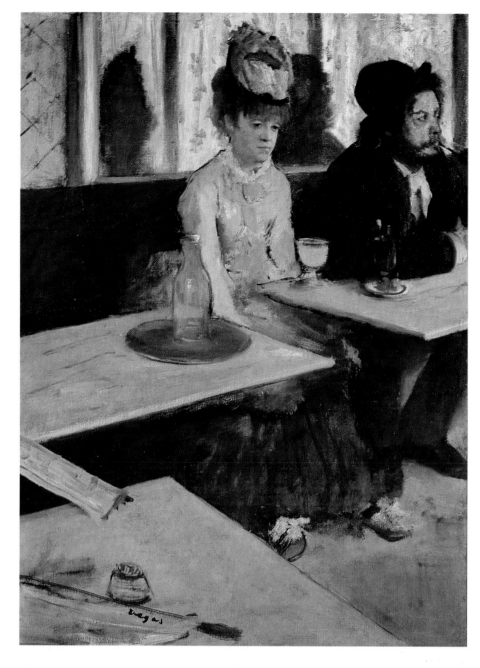

*Degas.* The Absinthe Drinkers, *1876. Musée d'Orsay, Paris. The models in this group have been identified as an actress, Ellen Andrée, and a bohemian painter, engraver and popular companion, Marcellin Desboutin.*

dimension to his seemingly endless creativity and power.

Degas occupies his own place in the history of European painting, regardless of his association with the men who called themselves Impressionists. He refused to be lumped together with them even in the years when he was closest to them, helping to organize their exhibiitons and showing his own work alongside theirs. He was essentially a non-joiner, and nearly everything that is known about his private relationships suggests that he was a difficult and sometimes cruel friend. But his artistic kinship with the Impressionists is real enough. Like them, he took his subjects from the streets and bars and entertainments of Paris, without sharing their delight in parks and riverside greenery, farmland and village landscapes. Like Manet, and like Renoir, he made the human figure the centre of much of his work and marked his human subjects with his own signature. He shared with the others an informality of pose and subject which makes his work easy to receive and enjoy.

While Manet could say, and demonstrate, that a painter's job was to put down immediately what he saw, Degas insisted that there was nothing natural about painting. It required, he said, 'as much cunning, as much malice and as much vice as committing a crime. He was nevertheless an

# DEGAS

Impressionist in a technical sense, an artist no less interested in the light in which subjects and movements exist than in the substance. His fascination with light can be seen in the way he used it to dissolve outlines – as of dancers' dresses – and the distinction he made between natural brightness and the glare of artificial light. Though he never painted from nature – his open-air subjects were worked up from sketches – there is no hint of studio stuffiness in anything he did.

*Degas.* Portraits at the Bourse c.1878. Musée d'Orsay, Paris.

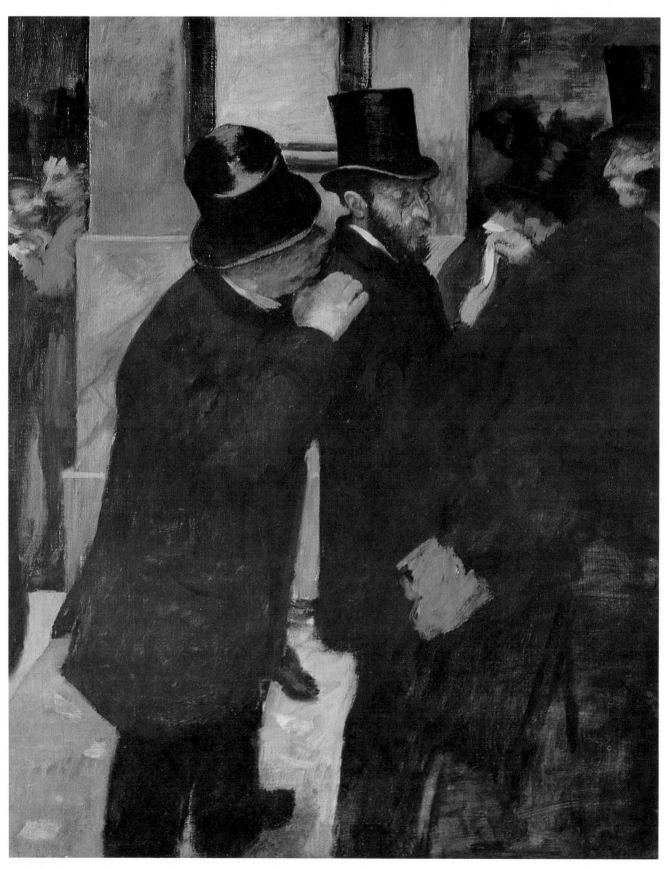

*Degas.* Before the Performance, *c.1897. National Gallery of Scotland, Edinburgh. Degas spent as much time behind the scenes as in his favourite front seat. In the disciplined gestures of the dancers he found, he said, 'all that is left to us of the harmonious movement of the Greeks'.*

In the end, secure in his fame, but less so in his grasp of what was going on around him, he had the satisfaction of attending sales at which his paintings fetched handsome prices. One of these, *Dancers Practising at the Bar*, was bought by Mrs Lousine Havemeyer, a faithful client, for the record sum of 478,000 francs. Asked how he felt about it, he said, with characteristic irony, 'Like a horse that wins the Grand Prix. I'm content with my bag of oats.'

Even in his less-than-lovable old age he seems to have had a genial way with his models. One of these, called Pauline, recalled an occasion when she was hired to pose for a sculpture. Suddenly, while humming the minuet from Mozart's *Don Giovanni*, Degas invited her down from the table to join him in an improvised dance, he in his sculptor's smock, she, naked, laughing and bobbing in his arms around the studio floor.

*Degas.* Laundresses, *c.1884. Musée d'Orsay, Paris.*

His last years were pitiable. In 1908 his sight failed and he was forced to give up work altogether. He had never made close friends, nor had he ever married. Old, nearly blind, rich, revered and alone, he lived on in Paris, shuffling about the streets with no one to visit and nowhere to go. At last, on 27 September 1917, he died. The first American troops were just landing in France. Among the congregation at a funeral service in Montmartre, attended by a hundred people, were Georges Durand-Ruel, son of the faithful Paul, Louis Forain, Ambroise Vollard, Claude Monet and Mary Cassatt, who told a friend, 'All was quiet and peaceful in the midst of this dreadful upheaval of which he was barely conscious.'

He left two million francs and a collection of other men's paintings. In his studio his brother René, heir to the fortune, came across several portfolios of brothel scenes, most of which he destroyed. Vollard was upset. Those little masterpieces, as he called them, would have been proof of how much Toulouse-Lautrec owed to the old master. Renoir also regretted the loss of so many of his old friend's late works. It was in them, he said, rather than in the ones he had done before he was fifty, that 'Degas really becomes Degas'. Also in his studio were some 150 small wax models, half of them in ruinous condition. The rest were passed to a professional iron founder, Adrien Hébrard, who made bronze casts from them while preserving the originals. Degas' ouevre, therefore, has been still further enriched by a vivacious company of dancers, jockeys and bathers, saved from oblivion for the rest of us to enjoy.

# 5 Monet

*Monet.* Gare St. Lazare, *1877. Musée d'Orsay, Paris. The huge railway station of St. Lazare appealed strongly to Monet, who saw it as a veritable universe charged with activity and atmosphere, both human and mechanical – the same qualities as prompted Émile Zola to devote a novel to railways and railwaymen,* La Bête Humaine, *three years later. Monet is said to have asked the station-master for more steam, which he readily agreed to. He makes it a separate element, infusing the scene with drama.*

Claude Monet, whose genius nourished Impressionism for more than half a century, admitted in his old age that he was undisciplined from birth – 'they could never make me bend to a rule.' He seems to have hated his schooldays, brief though they were, and to have preferred making caricatures of his teachers in his exercise books. He spent his boyhood in Le Havre, where his father was a grocer and ship's chandler, and in his teens began to leave drawings of local scenes with the neighbouring stationer and picture-framer (Normandy was already a popular place with painters), to pin up in the shop. It was there that Eugène Boudin, who himself found ample subject-matter along the quays and beaches of his native Normandy, noticed Monet's work. That contact, as Monet himself acknowledged, was a revelation to a reluctant schoolboy whose only interest was art. Boudin's example, his work, and his independent way of life, set Monet on the road to becoming a painter.

Boudin, however, as a local artist, was not the Monet family's idea of a suitable master for their precocious son. They sent him to Paris to study under the fashionable Salon painter, Thomas Couture. Unlike Manet, who had served a long stint with Couture, Monet stayed hardly any time at all. He enrolled at the Académie Suisse, a less rigorous institution on the Quai des Orfèvres, where another new acquaintance awaited him: Camille Pissarro. Through Pissarro he was drawn into the Café des Martyres set that circled around the powerful figure of Gustave Courbet, the apostle of Realism. But before he could make much progress he was called up for military service and shipped off to North Africa.

The experience did him no harm; on the contrary, he declared himself delighted with the light and colour of Algeria. After two years he succumbed to the climate and was sent home, where Boudin, who continued to take an interest in him, introduced him to the young Dutch painter, Jongkind, with whom he found aims and ideas in common.

Already Monet was committed to landscape painting. Returning to Paris in 1862 he soon made friends with Renoir, Sisley and Bazille, and the

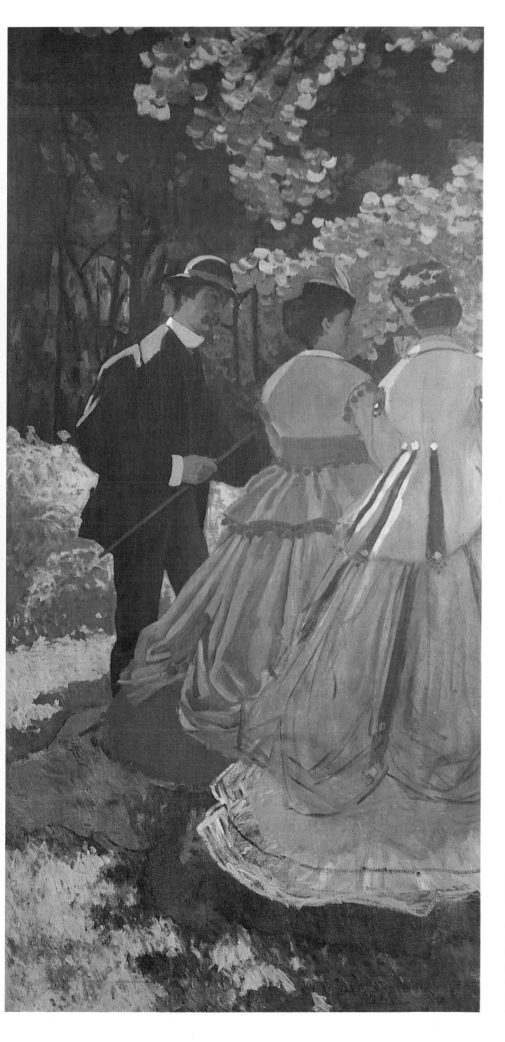

*Monet*. Le Déjeuner sur l'Herbe, *1865–66. Musée d'Orsay, Paris. This is a fragment, discovered in the 1950s, of the left-hand side of Monet's early painting, for which he borrowed Manet's celebrated title. It shows Bazille escorting two ladies, one of whom, in the vivid red underskirt, is Monet's wife-to-be, Camille Doncieux.*

# MONET

four of them practised their shared interest in the out-of-doors by painting the forest of Fontainebleau. Monet did not please his parents by associating with these nobodies, and when he refused to enter the prestigious École des Beaux – Arts, as they wished, they cut his allowance. In the 1865 Salon, the year of Manet's *Olympia*, Monet (their names were confused then, as they sometimes are today) showed two seapieces which one critic declared were the best marine paintings in the exhibition. In that year, too, he met a young girl, Camille Doncieux, who became his model and his mistress. In a mounting chaos of poverty and debt, and with Camille pregnant, he burned 200 of his paintings rather than have them seized by creditors. Then, leaving Camille in Paris, he took refuge with an aunt near Le Havre. From there he bombarded his friends with requests for money, and they responded as best they could.

In April 1869 Boudin visited him and reported to a friend that Monet was 'completely starved, his wings clipped'. The two paintings he had submitted to the Salon had been refused, but he was taking his revenge, Boudin said, by exhibiting at a Paris paint merchants, Letouche, a study of the beach at Sainte-Adresse which had 'horrified' his fellow artists. Boudin added: 'There is a crowd outside the window all the time, and from the young people this picture has produced fanatical responses.' Meanwhile Camille had had her baby, Frédéric Bazille standing as godfather. In June 1870 Monet married her and took her to Trouville, where he painted a carefree beach scene. That same summer the war with Prussia started, and Monet fled to England to avoid military service.

He was away for only a year, but his stay in London proved to be one of the formative experiences in his career. The mists and subtle hues of a northerly landscape, he found, were no less suited to Impressionism than the clear, ringing colours of the south. His views of London scenes rank among his most sensitive and successful works – an achievement he shares with Pissarro, who had also fled to London to escape the invasion.

Pissarro joined him in celebrating release from tensions at home, not only by painting but also seeking out the works of such English masters as Turner and Constable. Pissarro was to recall their enthusiasm for London

*Monet.* The Beach at Trouville, *1870. National Gallery, London. In the summer of 1870 Monet, newly married to Camille, spent a few weeks sketching at the seaside resort of Trouville, just as war was breaking out between France and Prussia. Monet then crossed the Channel to England, leaving Camille and the baby behind. Here, holding a small canvas on his knee, he achieves a snapshot-like sketch of Camille and a companion who could be either her sister or Mme. Boudin.*

as a painter's subject: 'Monet worked in the parks, while I, living in Lower Norwood, studied the effect of fog, snow and springtime . . . We also visited the museums. The watercolours and paintings of Constable and Turner and Old Crome certainly had an influence on us. We admired Gainsborough, Lawrence, Reynolds, etc, but we were struck chiefly by the landscape painters who shared more our aim with regard to open-air, light and fugitive effects.' Interesting though these observations are, Monet and Pissarro are unlikely to have seen the late Turner watercolours, and certainly not the Constable oil sketches which most powerfully evoke the Impressionist idea to our modern eyes: they were nowhere to be seen in public galleries at that time. It is, however, apparent that these great English painters encouraged them in their exile and reinforced their convictions.

Another unexpected benefit from Monet's spell in London was an introduction, through the French painter Daubigny, to the Paris dealer, Paul Durand-Ruel, who had a London gallery. He bought pictures from both Monet and Pissarro, paying two or three hundred francs each for them, five or six times as much as they were used to getting in Paris, and then rarely enough. This is how Monet's friend Armand Silvestre described works like these in 1873, in a note written for the dealer Durand-Ruel: 'Monet loves to juxtapose on the lightly ruffled surface of the water the multi-coloured reflections of the setting sun, of brightly-coloured boats and changing clouds. Metallic tones emitted by the smoothness of the waves, splashing over small uneven surfaces, are recorded in his work. The image of the shore is vague, the houses broken down as if in a children's game in which objects are assembled from pieces . . . The pictures are painted in a tonal range, extraordinarily bright. They are pervaded by a blond light – everything is gaiety, clarity, spring festivals and golden evenings . . . windows on the joyous countryside, on to rivers crowded with

*Monet.* The Thames below Westminster, *1871. National Gallery, London. In London, Monet soon found subjects that excited him. The mists and haziness of the townscape, and the moody motion of the Thames, appealed to him hardly less than the familiar painting-grounds of home.*

*Monet.* Breaking up of Ice on the Seine near Vertheuil, *1880. Fundacâo Cabuste Gulbenkian, Lisbon. This is one of a series of 18 such subjects by Monet following the greatest freeze-up of the decade. Sky and water become one element in a severe, pre-Impressionist composition.*

pleasure boats, on to a sky that shines with light mists, the life of the outdoors, panoramic and charming.' British reactions were less encouraging. Neither artist's work was accepted by the Royal Academy during their London stay.

When it was safe to return to Paris, Monet and his friends found life more difficult than ever. Monet decided to move out of the city, and settled for the suburban township of Argenteuil, down the Seine from Saint-Denis, within 20 miles of the capital by river-boat but only 20 minutes by train. Manet had recommended the place to him: his family had lived for many years just across the river.

Argenteuil had a pleasant air about it, the right mixture, it seemed, of pleasing architecture, greenery and activity, with a fine view from the bridge. There were vineyards nearby, orchards and gardens, the ruins of an old abbey, and fertile fields providing a livelihood for a multitude of market gardeners. There were also visible signs of the industrialized outskirts, with gypsum mines, distilleries, an ironworks and a chemical factory. Monet was undismayed by these encroachments: smoking chimneys a safeway off were as appropriate to his chosen landscape as, in our own day, high-rise apartment blocks or television aerials. He took pleasure in including them in his paintings: a train clattering over an iron bridge, or men unloading coal from barges, were to him everyday parts of the scene. They were also, for a professed realist, essential elements in his painter's philosophy, absorbed into an aesthetic whole.

As time passed, the balance between rural peace and industrial advance

began to tip the wrong way. In what was probably his last painting at Argenteuil, showing the river bank in flower, Monet appears to erect a barricade of blossoms against the chimneys and the murk beyond. Before long, too, his pleasure in the recreational aspect of living on the Seine, the boating and regattas, began to pall as more and more Parisians took day trips from the city, skylarking in crowded boats hired by the hour. Monet, who had painted some delightful scenes from his floating studio – an idea borrowed from Manet – gradually withdrew from the river to a small world of his own, one in which he could make overtures to nature in privacy and quiet: his garden. It became increasingly dear to him, both as a refuge and as a miniature environment, luxuriant and green, where he could realise some of his desires as a painter of nature.

The garden subjects he painted at Argenteuil in the 1870s show lilac trees, rose bushes, dahlias, often with a young woman in summery skirts – his wife, Camille, enjoying the flickering shade on a tidy lawn. In some, the garden seems to encompass a generous slice of natural countryside, bursting beyond the limits of Monet's fences. These are enjoyable pictures, celebrations of a quiet life, making no other point than that blessings can be near at hand, shared with a pretty woman. There is no pretence of true rusticity: this is suburbia rather than some pseudo-classical Illyria. On the other hand the formality of Monet's figures, the absence of anything in particular going on, might be interpreted rather differently, as an expression of polite middle-class *ennui*.

In one of his paintings of the house and garden in 1873, his little boy,

*Manet.* Monet in his Studio Boat, *1874. Neue Pinakothek, Munich. After the débacle of the first Impressionist exhibition at Nadar's gallery, Monet and Camille rented a house with a small garden at Argenteuil, on the Seine outside Paris, recommended to him by Manet, whose family had a place on the opposite side of the river. Manet's sketch shows his friend afloat, with the ever-present Camille.*

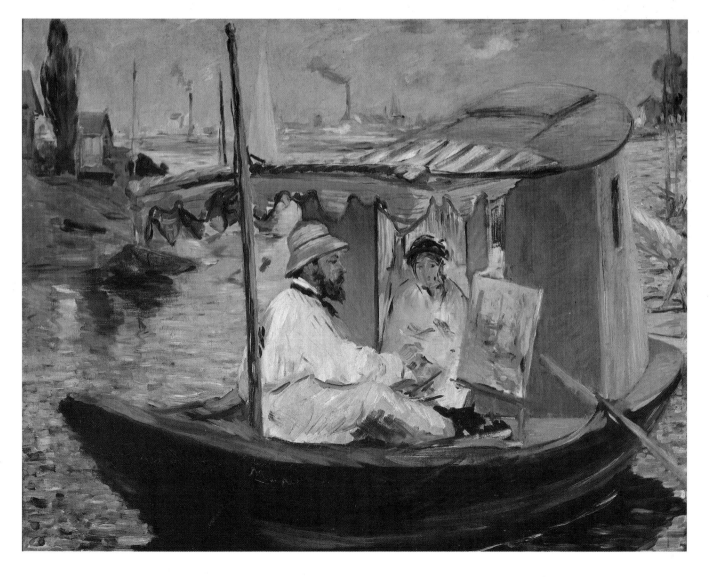

# MONET

Jean, stands with his back to us, beside a rank of large flower pots. He is holding a hoop, but rigidly, as if he had been ordered by some adult to keep still for a snapshot. The absence of action is almost stultifying; the only objects that could conceivably be on the move are a couple of fluffy clouds in an untroubled sky. There is similar immobility in a study of his family in the garden, painted in the same year. This time the figures – Camille to the fore, the boy Jean with his hoop farther back, with a standing woman in a full skirt – confront us face to face, though with no animation or curiosity. The picture is as frozen as a still-life.

In another work painted in the same year, a table in the garden is strewn with the remains of luncheon. There is a white tablecloth with a pink rose lying on it, a silver pot, and a sunshade lying on a slatted bench. Little John crouches in the shade, playing with toy bricks. The women stand in the background, dressed to the nines. Everyone is in place, but strangely disconnected. We are among polite townees with nothing to say to each other, bearing their constraints as stiffly as if they were back in Paris in an overstuffed apartment, dutifully minding their manners. The remnants of the meal suggest that some people who were here a little while ago have gone. Table talk and the clinking of cups, cutlery and glasses, leave no echo. But whose is that bonnet hanging in a tree?

Interestingly, a painting in that same year, 1873, by his friend Renoir, of Monet painting in his garden at Argenteuil, conjures up a less genteel environment than the one Monet himself would have us believe in. He is shown standing at his easel near a stretch of open fencing of the kind

*Monet.* Wild Poppies, *1873. Musée d'Orsay, Paris. A brilliant variation on a favourite Impressionists theme, figures in a landscape, in which all the elements play an equal part. It is tempting to identify the foreground figures as Camille and the infant Jean.*

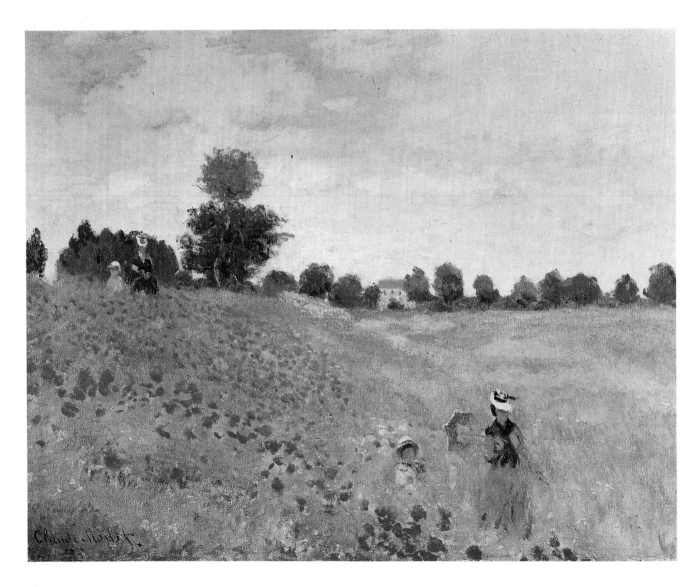

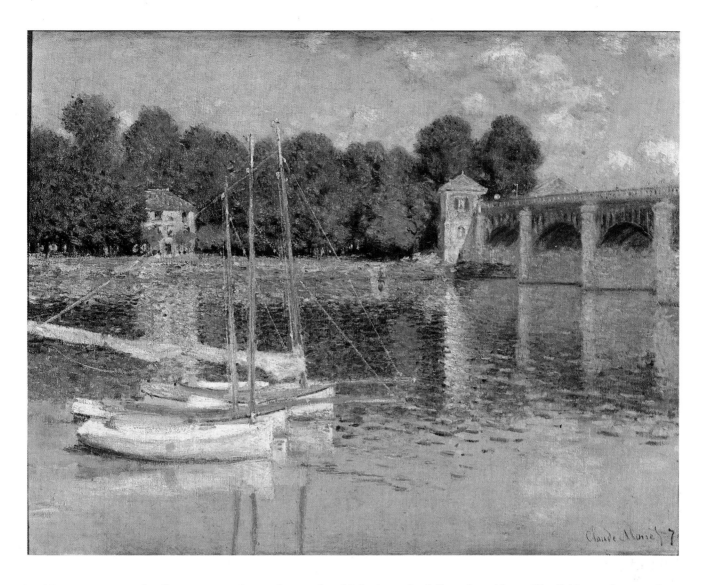

familiar to estate dwellers everywhere, beyond which is a huddle of neighbouring houses – absent from Monet's own paintings of his comfortable patch – with box-like outbuildings which we may suppose to be latrines. Renoir's candid version comes as something of a shock after the deliberate contrivances of Monet. But the difference in points of view is no reflection on Monet's artistic aims. To make a haven of one's own back garden is not dishonest; it is a natural expression of a householder's compulsion to make something out of nothing, or very little, as a creative achievement in its own right.

What Monet painted in his garden was his extension of it in terms of the social order. All of us, looking for a spot to take a picture in the garden, choose a location that leaves out the untidy corner where we have bonfires, or the view of the neighbour's garage, or the glimpse of traffic passing on the road outside. Monet knew, as the rest of us know, that a garden is a substitute for the wider natural world, where uncontrollable things can happen to break the spell that binds us to our private muses. In Monet's paintings of his garden at Argenteuil he is leading our thoughts to where we, too, would like to be, where life matches up to art.

Monet's move to the village of Giverny in 1883 proved to be the most fruitful of his long career. Halfway between Paris and Rouen, on a quiet stretch of the Seine, he found an unspoilt environment that yielded subjects of easeful grandeur, colour in abundance, and a sense of community. Barely a month after moving there he was telling people he was in raptures over it: 'Giverny is a glorious place for me.' He had discovered it while living in a rented property at Vertheuil, not far away,

where his wife, Camille, had died after the birth of their second son. Alice Hoschedé, who had been a close friend of Camille, and had offered to bring up the two infants with her own, moved in with Monet in April. The house, called *Le Pressoir* (the Wine Press), stood in a hectare of land, which Monet resolved to turn into the garden of his dreams. By that time the Impressionists were seeing less and less of one another, since most of them had moved out of Paris. Sisley was on the far side of the city, at Saint-Mammès; Pissarro was living in Eragny, further out still; Cézanne was spending most of his time in Aix-en-Provence. Renoir seemed to be perpetually travelling, though he did spend the summer of 1885 with Monet at his new home, where Cézanne briefly joined them.

It was at Giverny that Monet embarked on the ambitious series that were to become his most celebrated work: the 25 *Haystacks* between 1888 and 1891, followed by the 24 *Poplars*, the great *Rouen Cathedral* series, the *Japanese Bridge* sequence and the triumphantly beautiful *Water-lilies*. His series of 20 paintings of Rouen Cathedral, in all lights and times of the day, is among the most ambitious tasks he ever attempted. He set himself the challenge of making an objective record of fleeting light and atmosphere, as if to prove that there is no contradiction between perceived form and a pre-conceived manner of seeing. Most of his life he had favoured the use of paints that were low in oil content, and laid over indications of composition outlined in pale blue pigment, which disappeared as he worked. These preliminaries over, he would continue with flowing brushstrokes that enabled him to set the tonality without delay, adjusting the quality of his paint to the texture of whatever he was seeking to represent. For smooth water this meant a rich brushful, blended smoothly while still wet by means of parallel strokes; for rough water, small, heavier touches that left a scumbled surface.

At Giverny he addressed himself to the most difficult task of all: catching a specific moment of light and atmosphere on the instant, and repeating the process, in front of the same subject, in subtly different conditions in another light. Who was to say when a work of such a transcendental kind was finished? Monet's view was that the painter who says he has finished a canvas is 'arrogant indeed'. For him, 'finished' meant complete, perfect. 'I work on, without advancing, seeking and groping for my way, without achieving much, except tiring myself out.'

Working and groping may seem to be antithetical to Impressionism, but Monet in his later years did not spare himself in this search for material means for capturing evanescent effects. Confronted for the first time in his life by the marvels of Venice, he confessed himself 'saddened' by the unique light of the place. 'It is so beautiful! But I must make the best of it. What a pity I did not come here when I was young and bold and would stop at nothing!' he wrote to a friend, the critic Gustave Geoffroy, at the end of

*Monet*. Lavacourt, Winter, *1881. National Gallery, London.*

*Monet*. La Rue Saint-Denis, fête du 30 juin, *1878. Musée des Beaux-Arts, Rouen. The 30th June, and the city is* en fête *for the national holiday. The red of the tricolour seems to set the street ablaze.*

*Renoir*. Monet Painting in his Garden at Argenteuil, *1873. Wadsworth Atheneum, Hartford, Connecticut. Bequest of Anne Parrish Titzell. Renoir, visiting Monet and catching him at work, reveals a rather different environment from the one Monet himself liked to paint within a few paces of his back door. The neighbouring houses and the garden fence suggest a habitat more humdrum than the one he reveals in* Le Déjeuner.

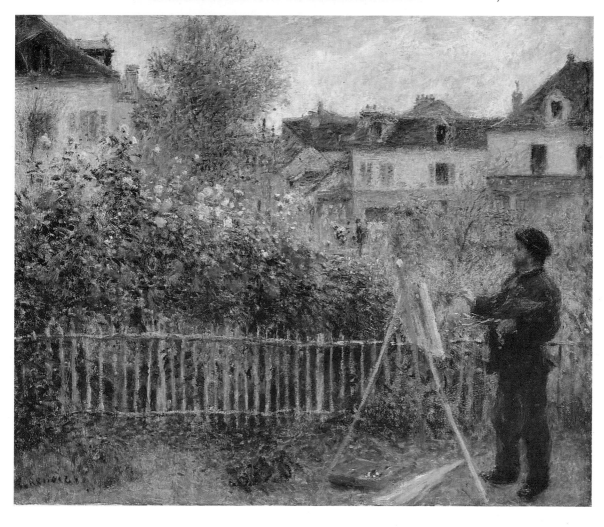

1908. 'Never mind – I am enjoying delicious moments here, almost forgetting I am an old man.'

In Venice, in the Rouen Cathedral series and in the Water-lilies, he added to his technique a device that revealed the painter's hand instead of disguising it: stabbing strokes of a stiff brush, held almost at right angles to the canvas. The Giverny paintings, based on sketches done at the pool's edge, with failing sight, are a combination of outdoor studies and studio work. The outdoor impression was carried indoors, back to the easel. There, he hoped, the perception of light and transience might somehow be given the permanence of paint. 'I have taken up some things that are impossible to do,' he told Geoffroy, 'like water with grass waving on the bottom. It is a beautiful sight to see, but trying to paint it is enough to drive one crazy. Yet I keep on tackling such things!'

**Left**. *Monet*. Rouen Cathedral in Bright Sunshine, *1894. Musée d'Orsay, Paris. One of his great series of variations on a single theme.*

*Monet*. The Water-Lily Pond, *1899. National Gallery, London. The Japanese bridge at Giverny figures in numerous studies.*

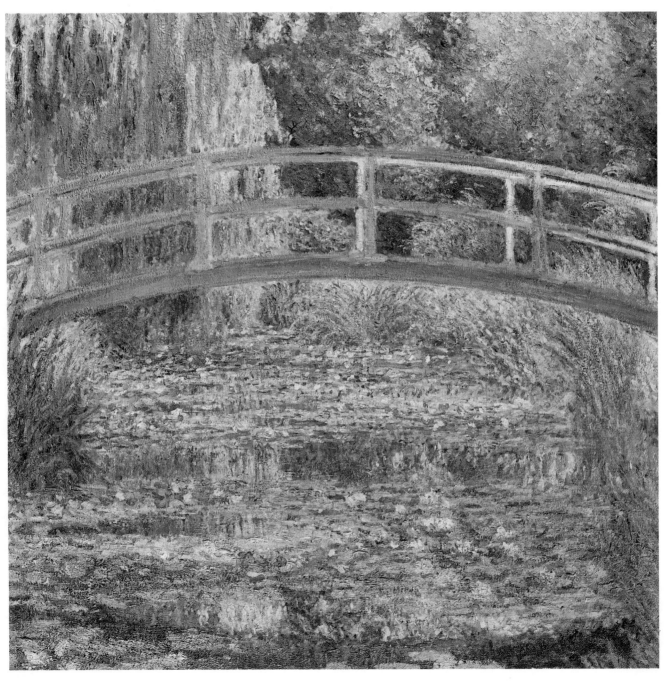

The water studies at Giverny are typical of how, working on a grand scale, Monet found his brush seeming to go its own way, unguided by anything but the mysterious process of poetic recall. The critic Claude Roger-Marx, reviewing an exhibition of 60 such works in 1909, quoted Monet's 'temptation to decorate a salon with the theme of water-lilies, joining them into one – the illusion of a world without end, a sea without horizon or shore.' The realisation of this project called for preparations on a heroic scale. He built a huge studio, and erected large canvases on specially constructed easels by the lily-ponds, which his gardeners shifted for him as the light changed. A group of 19 lily-pond paintings was offered to the French nation in 1917, and a site was found for them in the Orangerie. The National Gallery in London also owns a group, even more loosely painted and seemingly formless, which were found in Monet's studio, apparently forgotten, after his death. It is only in recent times that these works have been comprehensible to visitors. Changing taste, and acceptance of Abstraction, help towards an understanding of this, the great Impressionist's final statement.

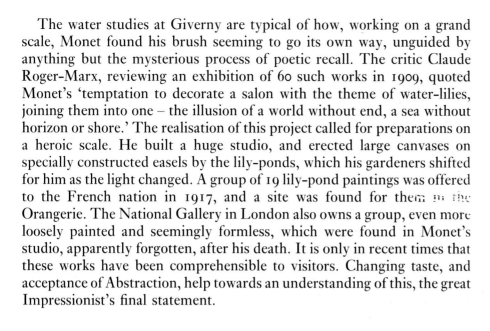

*Monet*. Water-Lilies, *1904. Musée du Louvre, Paris.*

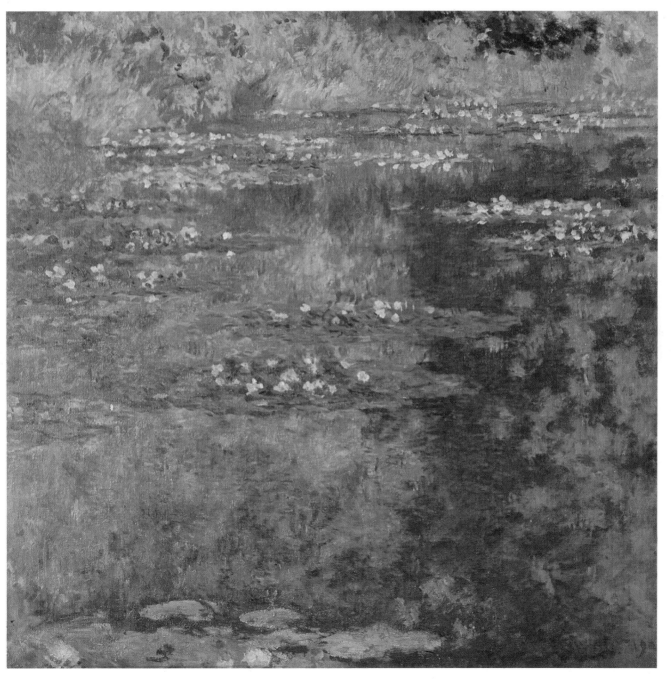

# MONET

As he grew old, Monet was increasingly dismissive of what he called 'easy things that come in a flash': the very things which half a lifetime earlier, he had worked and metaphorically starved for. Having, in a sense, taken the hard work out of painting, he was now conscientiously putting it back again; not in terms of labour, but in abandoning form completely while seeking, in John Rewald's phrase, to retain in a vibrant tissue of subtle nuances the single miracle of light. That he succeeded, there can be no doubt. And though he may never have used the term 'abstract' in connection with his work, it is nowadays applied, admiringly, to the lucent masterpieces which have immortalized Giverny, now restored to its former beauties for a public as ready to see in a painter's garden an original work from his hand as it is to acclaim his canvases on gallery walls. In his time, though late in the day, dealers and collectors were ready to pay big prices for his work: all the *Haystack* paintings sold within three days.

Monet's triumph is to have remained in the vanguard 100 years after laying brush to canvas at Giverny – an artist who prepared our eyes for what was to come, and to whom we have returned as, once again, art is perceived as something to ravish the eye. On visits to London with its 'mysterious mantle', as he called it, of winter fog, his balcony at the Savoy Hotel commanded a view of the Thames towards Charing Cross Station, with the Houses of Parliament in the distance. The painting contains no detail, even in the train puffing across the bridge, its own smoke making a feeble contribution to the enveloping atmosphere of dark pinks and creamy yellows.

One side-effect of Monet's concentration, in the later years, on hues and tones suffused with moisture – laden light – was his difficulty, when painting in southern France, in coping with the Mediterranean brilliance, even in winter. The sun there, he complained, produced a 'glaring, festive light' comparable, in his eyes, to a pigeon's throat or flaming punch. He continued to find in the South important subjects to paint: but his preoccupation with effects never before attempted in art kept him nearer home than ever. His means of achieving 'instantaneity', as he called it, made one of his *Haystack* paintings well-nigh incomprehensible even to

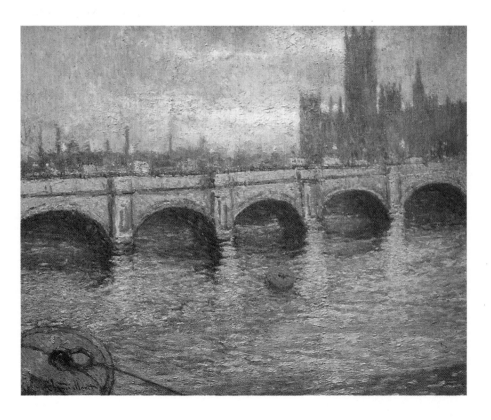

*Monet. A Bridge over the Thames, 1903. Museum Solothurn.*

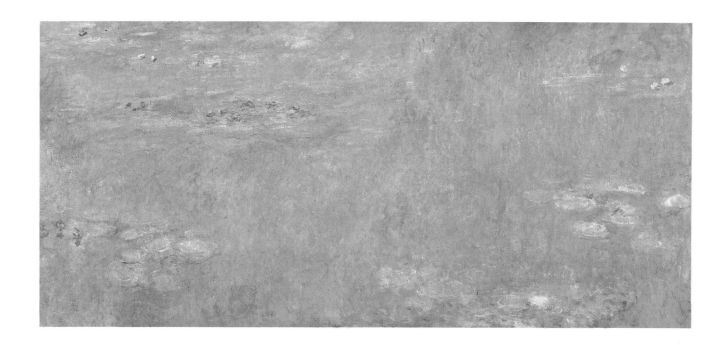

the future Abstract painter, Kandinsky. Confronted by one of them in Moscow in 1895, he was shocked into admitting that he needed the catalogue to tell him he was looking at a picture of a haystack: 'I could not draw the simple consequences from this experience. But what was obviously clear was the unsuspected power, previously hidden from me, of the palette. It surpassed all my dreams. Painting took on a fabulous strength and splendour.'

Perhaps the most remarkable description of Monet's working method is the one left by Guy de Maupassant, a writer whom he much admired. He describes Monet striding out above the cliff at Etretat, on the Normandy coast, trailed by a gaggle of his children, carrying his easel, paints and numerous canvases. He liked to work on half-a-dozen at once, switching from one to another as the light changed. 'I have seen him seize a glittering shower of light on the white cliff,' Maupassant writes, 'and fix yellow tones, which strangely rendered the fugitive effect of that unsiezeable and dazzling brilliance. On another occasion, he took a downpour beating on the sea in his hands and dashed it on the canvas – and indeed it was the rain that he had thus painted.'

An early English writer on the Impressionists, Wynford Dewhurst, visited him in 1903 and found him in his prime, active as ever, and was struck by his keen blue eyes betokening 'the giant within'. Monet looked the part, 'dressed in a soft khaki felt hat and jacket, lavender-coloured silk shirt open at the neck, drab trousers tapering to the ankles and secured there by big horn buttons, a short pair of cowhide boots, his appearance at once practical and quaint . . . In his domain at Giverny, and in his Japanese water-garden across the road and railway (which to his sorrow cuts his little world in twain), each season of the year brings its appointed colour scheme. Nowhere else can be found such a prodigal display of rare and marvellous colour effects, arranged from flowering plants from every quarter of the globe. Like the majority of Impressionists, he is most pleased with schemes of yellow and blue, the gold and sapphire of an artist's dreams. In the neighbouring fields are hundreds of poplars, in regimental lines, which were bought by Monet to avoid the wholesale destruction of the Seine valley a few years ago . . .' That this scene has lately been re-created at Giverny, enabling natural 'Monets' to breathe and bloom, is a mark of a genius that will not be stilled.

*Monet. Water-Lilies, 1916–20. National Gallery, London. Monet's paintings of his water-garden at Giverny have been compared to the late masterpieces of Turner, painted – as were Turner's – at a time when they might have seemed incomprehensible to the public at large. He did away with the footbridge when painting his later versions of the lily pond, to concentrate purely on the water surface and the myriad colours and reflections that made the subject complete in itself. From there it was only a step to abandoning naturalism and giving vent to Abstraction, as in the last of the series, painted when his sight was failing though not his miraculous 'eye'. Of these, 19 are in the Orangerie, Paris. Of the other ten, each two metres high and over four metres wide, the one in the National Gallery, shown here, speaks for them all.*

# 6 Boudin

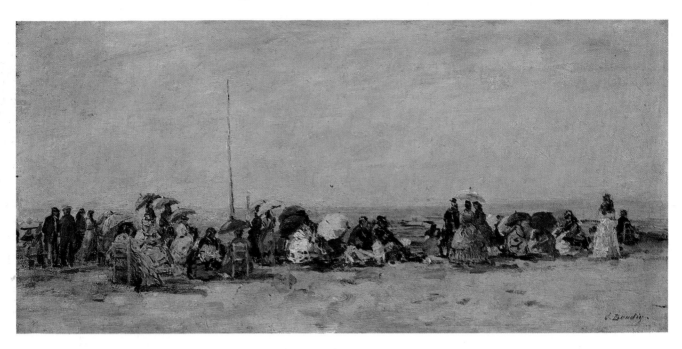

*Boudin.* Beach at Trouville *(a pair to the one opposite). National Gallery, London. Boudin first stayed at Trouville in 1860, and it soon became a favourite subject. It was already an established resort, and growing fast. What attracted Boudin to the seaside was the colourful swirl of the crowd, a constant promenade of elegance and colour. Though he eventually grew tired of what he called the 'masquerade' and 'gilded parasites', he could not resist returning over and again to the same theme.*

Claude Monet remembered all his life the summer day in 1858 when, still in his teens, he walked into the little framer's shop in Le Havre where the proprietor allowed him to hang pencil sketches for the amusement of the customers, and first laid eyes on Eugène Boudin. He had seen his work here and there, and did not think much of it. Boudin, nearly twice the youth's age, glanced through his sketches and said: 'You obviously have talent. Why don't you paint?'

Boudin insisted that the pair of them go painting out of doors together. Monet bought his first paint-box, and they set off, without much enthusiasm on his part, to Rouelles. As he watched Boudin at work, Monet recalled, it was if a veil had been torn from this eyes. In those few minutes he grasped, he said, what painting could be. 'Boudin's absorption in his work, and his independence, were enough to decide the whole future and development of my work.'

The following spring, Monet, in Paris, wrote to the man who had become his mentor and friend, with a message from a painter who also knew Boudin, urging him to send more of his work – 'paintings, grey seascapes, still-lifes and landscapes' – for exhibition. But Boudin was not attracted by the Paris scene. Besides, he had lately made two new friends in Le Havre: Courbet, who had spotted a group of Boudin's little seascapes and at once asked for the artist's address; and Charles Baudelaire, who was enjoying the seaside air with his mother. They all dined together. Courbet, the impassioned Realist, became a life-long admirer of Boudin, the shy, ill-educated son of a seaman. Baudelaire, at that time writing art criticism for the reviews, became the first to recognize Boudin's qualities as a sketcher when he drew attention to his pastel landscapes, prophesying that Boudin would in time achieve the same effects in his finished works. The urging of his supporters in Paris became more insistent until, in 1860, low both in spirits and in ready money, he decided to leave what he called his 'castle' and make a new base for himself in the rue Pigalle. He wrote home that he had set up a studio there, with his two chests of belongings and a view from his window of the windmills of Montmartre. Presently, a pretty and sensible young Breton girl, Marie-Anne Guédès, was to move in and join him for the rest of his life.

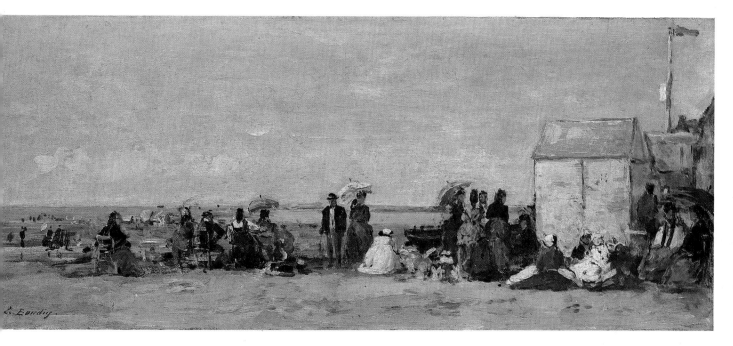

*Boudin.* Beach at Trouville.
*National Gallery, London.*

He was 37 and making ends meet by filling in backgrounds for the popular landscape painter, Constant Troyon, who had more work than he could deal with. 'I can't really grumble,' Boudin wrote home, 'since I haven't yet produced anything worthwhile.' He may have taken heart from the experience of Corot, who at 75 was only then being given his due. Boudin met the artist who, as a young man, had painted Honfleur, where Boudin returned to spend the winter of 1861–62. Jongkind, a kindred spirit, advised him to loosen up his style, a suggestion that Boudin accepted, with happy results.

He was not among the painters who exhibited at the Salon des Refusés in 1863, among them Manet, Pissarro, Jongkind and Whistler. From about this time, he began to produce the work on which his reputation rests: elegant, vivacious groups on the beach at Trouville; scenes of the races at Deauville, done with a delicately flicking brush; seas, sands and skies in finely modulated tones and shades, brim-full of light. 'Our little daubs are forging ahead very steadily,' he reported early in 1865.

He had long yearned to exhibit alongside such contemporaries as Corot and Jongkind, and now he was beginning to do so. Daubigny, who seemed to foresee all that lay ahead, encouraged him. So did Corot – 'Boudin, you are the king of the skies!' The influential critic, Jules-Antoine Castagnary, wrote that he had made himself 'a charming little niche from which no one can dislodge him.' His paintings at the Exposition Universelle, the name given to a multi-national exhibition in Paris in 1867, were commended, and he was even in the running for a medal. But, along with most exhibitors in a bad year for business, he sold nothing. He exhibited the following year at the Exposition du Havre – a return to his native habitat, with Daubigny, Courbet, Manet and Monet, all of whom, as well as Boudin himself, were awarded silver medals.

Boudin's medal-winning exhibit was a characteristic subject, *Beach at Trouville*, in which all his pre-Impressionist instincts are given full play. However, he complained that Trouville was beginning to pall; he was sick, he said of circulating among its local society; he needed a change. There is no hint of such feelings in the bright, deft groups of fully-dressed citizens strolling, gossiping, exercising their little dogs on the immaculate sands.

*Boudin. On the Beach, 1866
(watercolour). Musée d'Orsay,
Paris.*

For sheer brilliance, his sketches of such subjects, often in watercolour, are the equal of any in 19th-century French art. Even his repetitions have the untiring presence of originals. It is impossible to think of them as studio works, so suffused are they in the all-embracing seaside light.

Boudin listed some of the scenes which, over the next year or two, were to flow from his brush: seascapes, beaches, pilgrimages, weddings, churches, interiors, markets, even ferry boats with animals. He found a wealthy patron, a M. Gauchez, who had taken a number of Boudin's works home with him to Brussels. There, instead of hanging them around the house, he put them up for sale, with profitable results. He ordered some seascapes from Boudin, to compete with the more accepted marine artists in the salerooms. Whatever he might have thought of these practices,

*Boudin. The Beach-huts, 1866
(watercolour). Musée d'Orsay,
Paris.*

Boudin was pleased to have a steady flow of work to keep him going.

During the panic of the Prussian advance in 1870, Boudin described the disorderly scene as thousands of men, women and children took to their heels. 'Nuns, nurses, peasants rushing towards Brittany, all the wagons seized or stolen. It was heartrending to see. . .' Boudin himself was caught up in the milling throng and lost all his paintings, a whole summer's work. He then made his way to Brussels, where M. Gauchez helped him out, and then on to Antwerp, where he made a series of paintings of the town and harbour. Eventually, as the disorder subsided, he went to Paris and contacted Courbet, who had escaped the post-Commune firing squads and was now a prisoner on parole. Courbet told him in a letter: 'Do come and see me. Come with Monet, and even the ladies, if they can find it in their hearts.'

Boudin's fortunes were now on the turn. At the end of 1872 he was being feted, he said, 'like a big-wig of the art world. What more could I hope for?' In April 1874 his work hung alongside that of Monet and his friends at Nadar's studio, in a gesture of support for the Impressionists' début. While they probably had less to teach him than some others – he already shared their preference for painting in the open, for free, loose brushwork and natural light – he was not averse to sharing criticism, if he had to, in their cause. His own touch, in the 1870s, comes closer to that of Monet, his tones lighten, little dabs of colour spring out of the picture fully formed, as perfectly-placed accents of detail.

Durand-Ruel took him into his company of artists, and had less difficulty in selling his work than theirs 'I am so busy painting,' he told a friend in 1881, 'that I no longer have time to breath.' Twenty-three of his paintings were among the ones shown by Durand-Ruel in New York in

*Boudin.* The Jetty at Deauville, *1869. Musée d'Orsay, Paris.*

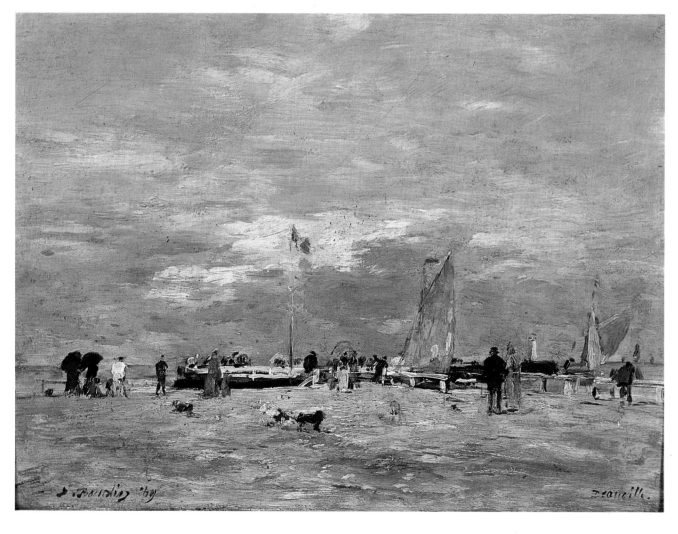

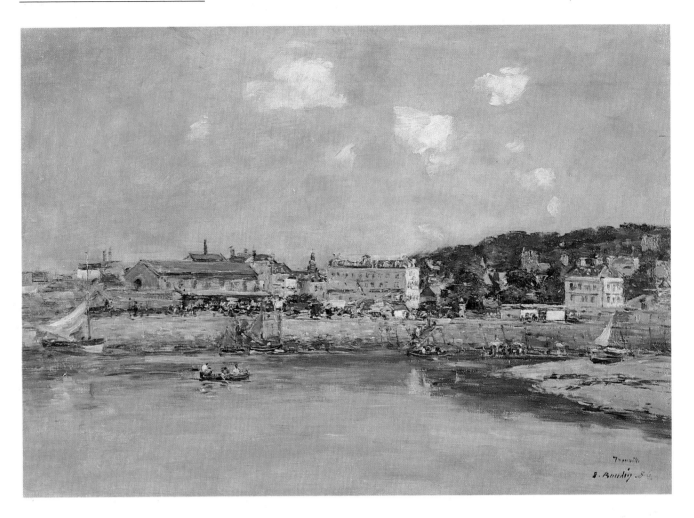

*Boudin*. The Port, Trouville, *1884.*
*Richard Green Gallery, London.*
*Boudin's fortunes improved*
*dramatically in the late 1880s. The*
*critics' reaction to an exhibition of*
*his work held by Durand-Ruel in*
*March 1883 was enthusiastic. 'The*
*paintings,' one of them wrote,*
*'reproduce atmosphere, the play of*
*light on beaches and wet rocks,*
*swirling mists, stormy skies, the*
*uncertainty of watery horizons.' His*
*Salon entry that year won him a*
*silver medal. In 1884 he could*
*afford to build himself a small villa*
*at Deauville.*

1886, at which the Impressionists were introduced to the American public. An exhibition of his work at Le Havre in 1890 sold out. Two years later, his Salon picture, *The Bay at Villefranche*, was bought by the State and he was awarded the Legion of Honour. He painted unflaggingly into the 1890s, until stomach cancer laid him low. In August 1898, he died. Within six months the École des Beaux-Arts mounted an exhibition of over 400 of his paintings, pastels and watercolours, drawn from municipal and private collections. A catalogue of his work compiled in 1973 lists 3,651 oils alone; and in the Louvre there are some 6,000 of his drawings. 'One can still grow old in this profession,' he had remarked towards the end. 'But to grow slack is forbidden . . .'

Boudin has one distinction which lies outside the mainstream of art history: he was the first artist from the Impressionist group to be admitted to a British public collection. By the turn of the century a handful of English enthusiasts for the Impressionist achievement were eager to secure typical examples for the nation. Prominent among these was Frank Rutter, art critic of the *Sunday Times* and editor of the journal *Art News*.

When, in 1905, Durand-Ruel mounted an exhibition of particularly choice Impressionist paintings at the Grafton Galleries, London, Rutter and his supporters opened a public subscription, through Rutter's newspaper, to buy the best Impressionist painting acceptable to the National Gallery. They were obliged to rule out Monet, Renoir, Degas and Cézanne since the National Gallery could not accept works by living artists. Manet, Pissarro and Sisley were dead, but soundings suggested that they would not be welcome. So the choice fell on Boudin – not quite an

Impressionist, perhaps, but daringly close, and a delightful enough artist to start with.

Rutter crossed the Channel to Le Havre, and came back with *The Entrance to Trouville Harbour*, dated 1888, bought from a collector who was well stocked with Boudins. In the autumn it was shown at the Goupil Gallery for the benefit of subscribers, and in January 1906 it was presented to the National Gallery via the National Art Collections Fund (which had not subscribed one penny). So it is that Boudin joined the British art heritage 11 years ahead of Manet (*Eva Gonzalés*), Degas (*Beach Scene*), Pissarro (*View from Louveciennes*), Renoir (*The Umbrellas*), Monet (*Lavacourt, Winter*), Sisley (*The Horse Trough at Marly*) and Morisot (*Summer's Day*) – all through the Lane Bequest – and 19 years ahead of Cézanne (*Self-Portrait*). Every one of the Boudins that have entered the National Gallery's collection since then have been private bequests.

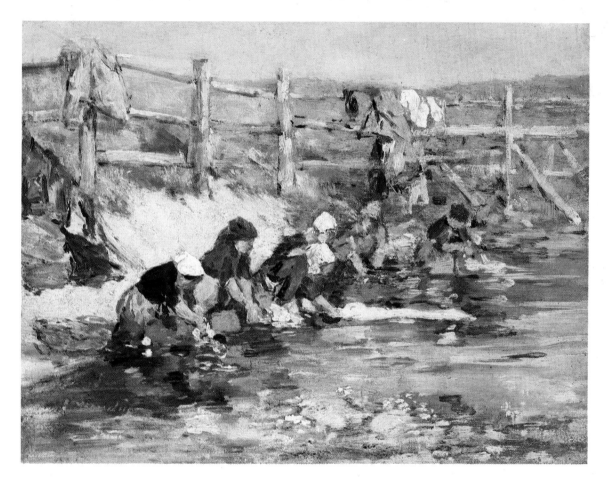

*Boudin.* Laundresses by a Stream, *1885. National Gallery, London.*

# 7 Jongkind

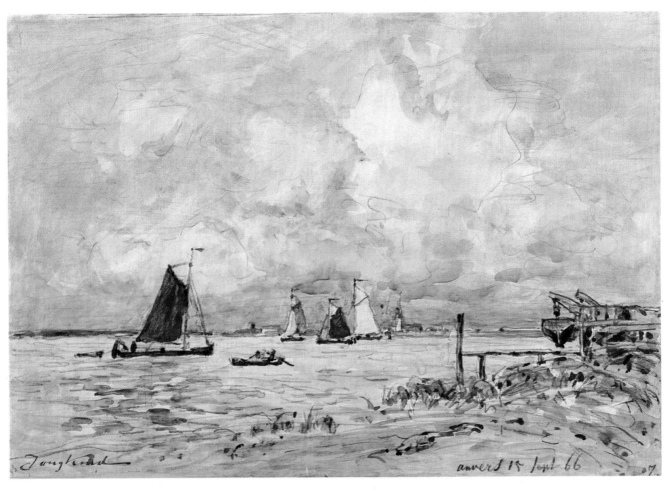

*Jongkind*. Wooden Piles in the River Escaut, *1866. Musée d'Orsay, Paris.*

If Boudin was the first artist to leave a mark on Monet, the second, and no less influential, was the Dutchman, Johan-Barthold Jongkind. Monet was introduced to him in 1862, when, home again after military service in Algeria, he had resumed painting in his home landscape around Le Havre. What he saw of Jongkind's work must have come as a novelty; up till then, no painter known to Monet had embarked on the road he had mapped out for himself. Jongkind, with his quick, bold attack and direct response to light, was already on the same track. Boudin, when he met the Dutchman soon afterwards, took to him as a talented fellow marine artist. The three of them painted in the region around Honfleur, where a sizeable colony of artists were already settled. Courbet knew those parts well, and related how he had been bathing with Whistler, who was staying with him. He explained: 'He is an Englishman and a pupil of mine.'

Boudin, struggling in Paris, now linked Jongkind with Corot and Daubigny as representing the calibre of painter he was having to compete with in the galleries. Jongkind, in the late 1860s, was selling well there, Boudin less so. He wrote that dealers were turning to him for pot-boilers to fill the commercial gap.

He was the eighth son of a Protestant pastor, born in the province of Overijssel in 1819, the same year as Courbet. People remembered him as a tall, well-built, shy and moody fellow, awkward in his movements, speaking French with a thick Dutch accent. However, with a brush in his hand, as the critic Jules Castagnary wrote, he was an artist to his finger-tips: 'With him, everything lies in the impression.' He escaped from an

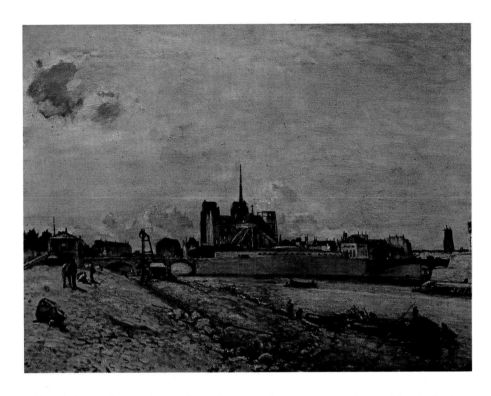

*Jongkind*. View of Notre Dame, Paris, *1863. Private Collection. Jongkind knew how to meet the market by staying within the accepted limits of the Dutch school. But in his habit of painting out of doors he outdid most of the Impressionists themselves.*

office job as a lawyer's clerk at the age of 17 to devote himself to painting, and took lessons at an academy in The Hague while still living at home. His drawing master, Andreas Schelfout, introduced him to the private secretary to the heir to the Dutch throne, Prince William of Orange. This brought him a welcome grant of 200 florins to complete his studies, and was followed by a second stroke of good fortune when, from another source, he was provided with enough funds to study under the distinguished French marine painter, Eugène Isabey. During the summer months he began making sketching trips to Normandy and Brittany, absorbing the seas and skies which were already attracting other painters to that unspoiled part of the north French coast. In 1848 he made his first appearance at the Salon, and found a dealer, Père Martin, who liked his work and kept Jongkind supplied with a modicum of funds.

He was apt to relapse into depressive moods, from which he would try to extricate himself with drink; and it was reports of this kind that prompted Monet at one point to write him off – prematurely as it turned out – as 'quite mad'. A group of artists, Troyon and Rousseau among them, donated paintings to raise money for him in 1860 and collected the useful sum of 6,000 francs. Jongkind paid off his debts, pulled himself together, and returned to his best painting form. In 1863 he exhibited at the Salon des Refusés with Renoir, Monet, Pissarro, Cézanne, Guillaumin, Fantin-Latour, Whistler and some 600 others, contributing to the 'kind of special cheerfulness, the good fresh scent of youth, bravery and passion' remarked on at that historic event by Émile Zola.

Like so many of his countrymen, he fled Paris in 1870, and only returned to Normandy when the crisis was over. Though Jongkind did not exhibit with the Impressionist group, Monet had a very high opinion of his work; it was Jongkind, he said, who completed the instruction he had already had from Boudin. Boudin, a painter of completely different temperament, never tired of acknowledging his debt to the man who, as he put it, forced open the door through which he had entered. Jongkind, he said, 'began to make the public swallow a sort of painting whose rather tough skin

concealed an excellent, very tasty fruit.' The 'tough skin' is surely a reference to Jongkind's outward appearance, so at odds with the refinement of his most characteristic work.

From his teens he was filling sketchbooks with fluent watercolours, dashed down on the paper with quick flips of the brush, of the sort that Baudelaire described as 'the singular shorthand of his painting'. With this gift he was able to catch in a few lines and a single loading of his brush the structural, as well as the atmospheric, elements of a subject, making use of the white surface and the translucent nature of the medium to brilliant effect. These watercolour sketches are in themselves as eloquent an announcement of a new way of looking at nature as any by his more conspicious contemporaries. In works such as his *Landscape at Bas Meudon*, the *Beach at Sainte-Adresse* and his watercolour study of *Fishing vessels at Honfleur*, all from the 1860s, he anticipates the flowering of the Impressionist genius in the next decade. 'One thing that strikes me,' Edmond de Goncourt was remarking in 1882, 'is Jongkind's influence. All present-day landscape painting of any worth descends from him, and his handling of sky, atmosphere and terrain.

In the last years of his life Jongkind was befriended by a couple named Fesser, to whom his dealer, Martin, had introduced him to Paris. Mme. Fesser was a Dutchwoman, and the bond between her and Jongkind was unusually close. With a stable home and daily care, Jongkind rose above his emotional difficulties to produce a succession of fine paintings. When M. Fesser died his son bought a property at Côte-St-André, in Normandy, for his mother and Jongkind to live in.

In 1882 Jongkind was given a one-man show in Paris, which did well, and he was further encouraged by the high prices fetched by paintings of his from the estate of Théophile Bascle, an early collector of his works – from mere hundreds they had risen to thousands of francs. Before long, however, he lapsed into the eccentric habits of old, a famous figure along the Normandy seafront but a shadow of the painter whose example had helped to light the way for others. As his sight began to fail he found

*Jongkind.* Skaters at Overshie, *1867. Richard Green Gallery, London.*

86

*Jongkind.* Environs de la Haye, Holland, *1868. Musée d'Orsay, Paris. Jongkind's work made an immediate impact on Monet, anticipating the direct response to light that lay at the heart of Impressionism. Jules Castagnary, a prominent critic at the time, called Jongkind 'an artist to his fingertips', adding: 'With him, everything lies in the impression.'*

*Jongkind.* Soleils (Sunflowers). *Musée d'Orsay, Paris. There are parallels between Jongkind's career and that of his fellow-countryman, Van Gogh. Jongkind, like Vincent, suffered from bouts of violent depression. In this work, he evokes the famous sunflowers of Van Gogh's last years.*

87

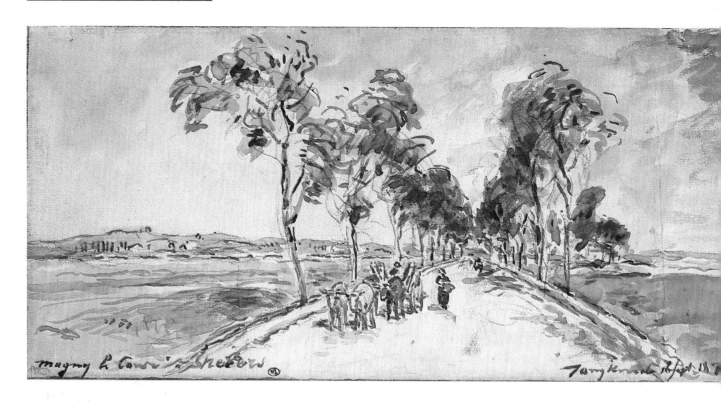

*Jongkind.* The Road to Magny, near Nevers, *1871. Musée d'Orsay, Paris.*

painting burdensome, and returned to the habit of his boyhood, sketching in watercolour, always from nature, the scenes that had made him a painter.

His career parallels, in some ways, that of his fellow-countryman, Van Gogh. Like him, Jongkind had great difficulty in adjusting to the society of his time, was beset by psychological tensions and handicapped by outbreaks of irrational passion. His contacts with the Barbizon painters in the 1860s helped to shape the course of Impressionism, and in his habit of painting out of doors he outdid most of the Impressionists themselves. He died in 1891, by which time the movement he had been part of, without ever joining, was passing into history.

It took other painters to see the true quality of Jongkind's art. Monet, like Boudin, readily acknowledged it, and gave him credit for 'the final training' of his eye. Whatever scant advantages the Impressionists might have enjoyed by exhibiting together were denied him: he was essentially an individual, unsuited by either character or temperament to throwing himself into an enterprise such as the loose-knit group who thought of themselves as likely to sink or swim together. He went his own way, accepting the inevitable with dignity, and giving full rein to the more manic side of his personality as the occasion demanded. Despite these handicaps he could look back, in his declining years, on a career rich in satisfactions as well as disappointments.

His one-man show in 1882, at the gallery of the dealer Detrimont, was an undeniable success. Patrons and collectors who knew his work came back for more. He knew how to please them by staying within the bounds of a disciplined eye and hand. But on his day, with the sunlight throwing brilliant fragments that turn colour into form, he must have known that he was on the brink of a great adventure.

*Jongkind*. The Isère at
Grenoble, *1877. Musée d'Orsay,
Paris. Edmond de Goncourt,
remarking on Jongkind's influence,
declared in 1882 that all
contemporary landscape painting of
any worth descended from him.*

# 8 Renoir

Renoir, the only member of the main group from a working-class background, disliked being referred to as an 'artist'. Mistrusting imagination, and totally devoid of vanity, he thought of himself all his life as a 'workman-painter'.

He had loved his first job as a boy, decorating china and porcelain on a piecework basis. The most popular line was his Marie Antoinettes. 'Good honest work', he called it in later years, more satisfying than any of the honours bestowed on him for being a painter. He was resentful when his ancient craft gave way to a new printing technique which ensured that every Marie Antionette was absolutely identical. For a while he took to decorating fans, painting them with motifs taken from Watteau, Lancret or Boucher in the Louvre. From there it was a short step to learning to paint. In 1861 he joined Charles Gleyre's studio at the École des Beaux-Arts, where he was joined by Monet, Sisley and Bazille. Through Monet he then met Pissarro and Cézanne, who were studying at the Académie Suisse; and by Easter 1863 the four friends from Gleyre's were painting together in the Forest of Fontainebleau.

An older painter, Jules le Coeur, commissioned some pictures from Renoir at this time, of which two – a flower-piece and *Jules le Coeur in Fontainebleau Forest*, dated 1866 – show signs of incipient Impressionism. A painting of a breakfast party in the village inn at Marlotte, outside Fontainebleau, was accepted at the Salon that year, but his two landscapes were turned down. Renoir promptly vowed never to submit a landscape to

*Bazille.* Portrait of Renoir, *1867. Musée des Beaux-Arts, Algiers. This, Bazille's most successful portrait, catches his close friend Renoir's mood somewhere between thought and action. Renoir was to remember Bazille, his early comrade, as 'that gentle knight'.*

**Opposite:** *Renoir.* Jules Le Coeur in Fontainebleau Forest, *1866. Museu de Arte, São Paulo. The discovery of an untouched painting ground close to Paris drew the young Impressionists together. Le Coeur abandoned architecture to become a painter, and had acquired a house at Marlotte, where Renoir, Sisley and Monet all stayed.*

# RENOIR

the Salon again. Soon the critics were recognizing him as a follower of Manet. His paintings of his closest friend, Frédéric Bazille, at his easel, painting a still life of a heron – a subject of which Sisley made an almost identical study at that time – is markedly Manet-like in its low tones and economy of means. Manet's portrait of Zola, exhibited in the Salon that year, 1867, could have prompted Renoir to emulate him in his own style. Manet's touch is still apparent in Renoir's vivid double portrait *The Engaged Couple*, painted the following year, in which Alfred Sisley's bride-to-be (she had already borne him a son) takes his left arm in both hands in a gesture of womanly possession.

Renoir exhibited at the Impressionist exhibitions of 1874 and 1876, and had to put up with the general mauling from the critics. After the second exhibition, the critic of *Le Figaro* penned a particularly scathing notice. 'The innocent passer-by,' he wrote, 'attracted by the flags outside, goes in for a look. But what a cruel sight meets his eyes! Five or six lunatics make up a group of poor wretches who have succumbed to the madness of

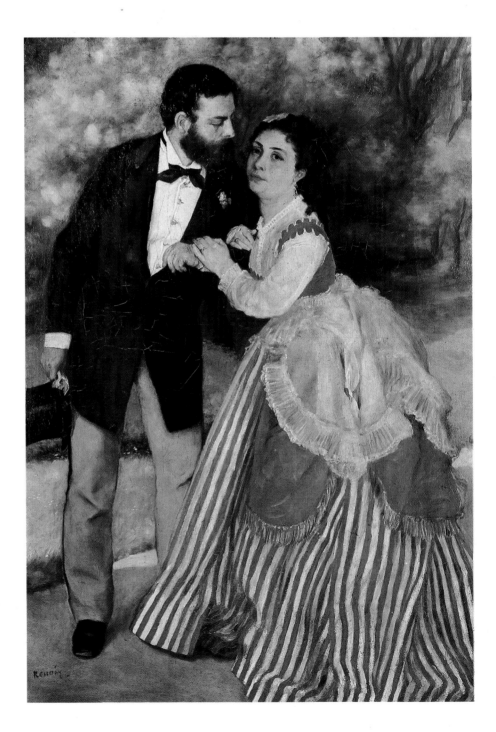

*Renoir.* The Engaged Couple: Alfred Sisley and his Wife, *1868. Wallraf-Richartz-Museum, Cologne. The Impressionists' portraits of one another in their early years are both affectionate and observant. Renoir was fond of Sisley, the Englishman in their midst, and took obvious pleasure in his betrothal to Marie-Eugénie Lescouzec, the girl who was destined to share his struggle for recognition.*

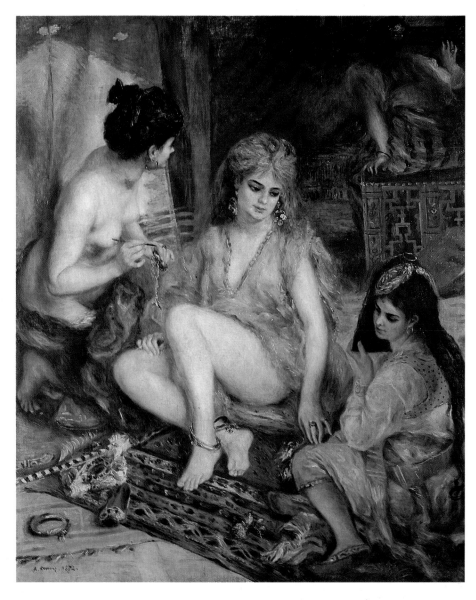

*Renoir*. Parisiennes Dressed as Algerians, *1872. National Museum of Western Art, Tokyo. Matsukata Collection.*

ambition and dared to put on a show of their work . . . There is a woman in the group, as in all the best-known gangs. Her name is Berthe Morisot, and she is a curiosity. She manages to convey a certain feminine grace, despite her outbursts of delirium.' The men were furious at these insults to Berthe Morisot, 'that great lady' as Renoir called her. But, he said, she just laughed.

Though the rejection of the Impressionists' works by the press and professionals was largely on grounds of subject-matter, it also offended accepted standards of taste by appearing sketchy, and to that extent incomplete. The sense of insult was as much to do with this lack of finish as with what the pictures were 'about'. The same attitudes were prevailing in England, where Constable's landscapes were considered coarse, unfinished, lacking the evidence of workmanship that separated the serious painter from the mere dabbler. Turner knew better than to show his 'colour beginnings', and what flowed from them, in public: they would have been met with the same incomprehension as greeted the Impressionists in the 1870s.

Renoir was to some extent an exception: he always took care with his materials, partly because he had trained as an artisan, and also, perhaps, because he did not hold the theoretical aspects of Impressionism in such passionate regard. He did, however, seize the opportunity to paint on white grounds rather than dark ones – a basic change in painterly method which now seems so obvious that the novelty of it in the Impressionists' time

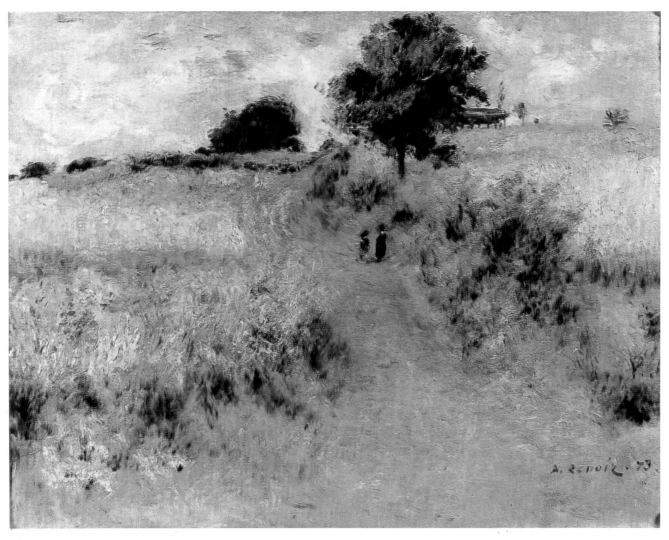

Renoir. The Meadow, *1873.*
Private Collection.

tends to escape us. Painting on white divides the Impressionists, from Manet onwards, from all their predecessors.

Though he was as hard-up as Monet, Renoir chose to earn what he could by doing hack work at his old trade. Always the most cheerful and resilient of the group, he revelled in the life of the cafés and boulevards, the river picnics and the company of friends, all of which he celebrated in paint: in Monet's phrase, ensnaring the light and throwing it directly on to the canvas. Paintings of this character, however, did not find buyers. Renoir's son, Jean, in his biography of his father, tells how all the money the two friends could scrape together went to pay for their studio, a model and coal for the stove. The stove served a double purpose: to warm the girls while cooking the food. One of their sitters happened to be a grocer, who paid them in kind. They could make a sack of beans last a month. Renoir said of those days: 'I have never been happier in my life.'

He was the most footloose of the Impressionist band. 'He cannot stay two years in the same place,' complained one of his intimates. 'His nerves grow impatient, and he needs to try to feel better somewhere else. He has always been like this.' He never bought a place in Paris; the first house he bought was as late as 1895 when his wife, Aline, persuaded him that they should go and live in her native Essoyes, in southern Champagne.

From then on, free of financial strain, he spent the winters at Cagnes, on the Mediterranean coast, where only a few people ever called on him. He was not much more sociable in Essoyes, where the locals looked askance on the bohemian visitors to the comfortable house the Renoirs had bought for themselves, known as Les Collettes. Later Renoir rented a flat in Nice, which he said he preferred to living at home: 'I feel less cut off than at Les

Collettes, where I feel as if I am in a convent.' It was as if his restless spirit kept him at a distance from people, even his close family. He hated not having work to do, not having any bustle in the house – though he equally detested the new-fangled phonograph for destroying silence. He had some irritating mannerisms, and could be rude to his friends, including the dealer Vollard, who had the temerity to write a book about him. He only had to make some chance hostile remark, Renoir complained, and Vollard rushed off to his office to write it down.

He announced his arrival in the first Impressionist exhibition, with *The Box at the Theatre*, with its commanding image of a girl's companion scanning the scene through opera glasses, while her eyes hold the spectator's with a confident stare. His use of black and white determines the strong shape of the group, the cropped edges suggesting the immediacy of a snapshot. 'The eyes of the most beautiful faces,' he observed, 'are always slightly dissimilar. No nose is found exactly above the middle of the mouth. The segments of an orange, the leaves of a tree, or the petals of a flower, are never identical.'

This was one painting at the 1874 exhibition that the critics did not dismiss, tempering their general dislike of the show by confining their remarks to the content of the work. One saw the young woman as 'a typical

*Renoir*. Path Climbing through Long Grass, *1874. Musée d'Orsay, Paris. Renoir may have borrowed this favourite theme from Monet, whose* Wild Poppies *was painted a year earlier than this work.*

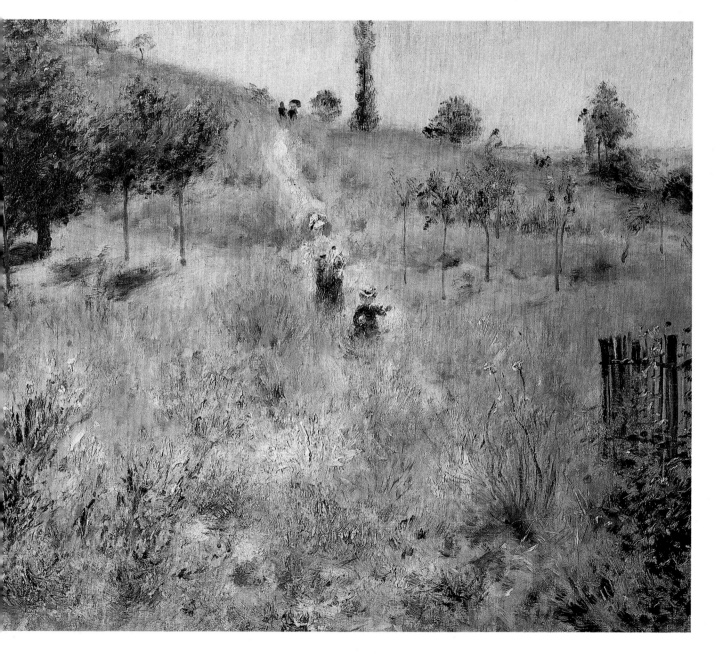

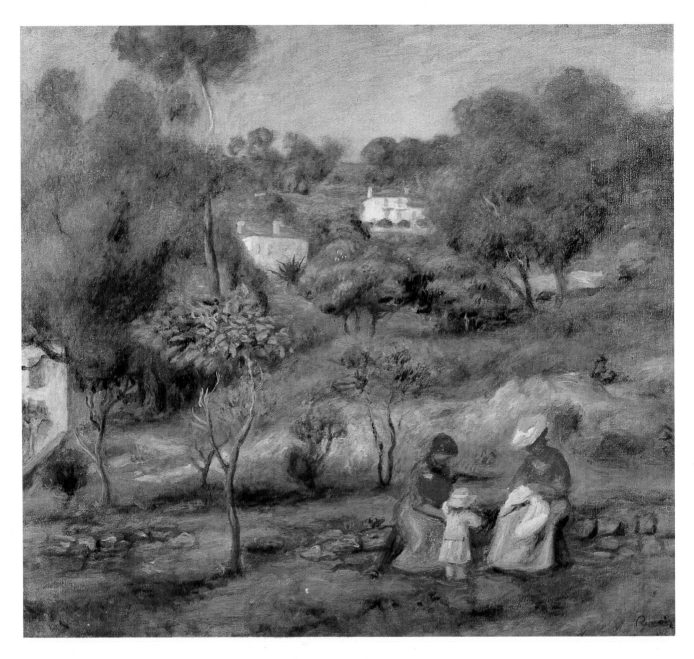

*Renoir*. Landscape at Cagnes, *c.1902. Private Collection. Cagnes, in the Midi, where Renoir spent his last 15 years, suited his simple needs – home cooking, plain living, and the company of the two women whom he never tired of painting, his wife Aline and the maid, Gabrielle. Confined to his house and garden, Renoir spent hours at a time under the trees, painting the little patch that had become his world.*

cocotte, attractive, worthless, delicious and stupid' (she was a model known as Nini, with the inappropriate nickname 'Guele-de-Raie', or 'Fish-face'). For Renoir, it was one of those paintings which he liked to see 'filled to bursting point'. It was actually shown in London the following year by the Impressionists' dealer friend, Durand-Ruel, and found its way back there in 1925, when it joined Samuel Courtauld's collection.

Of his work in those years, the *Moulin de la Galette*, exhibited in the 1877 exhibition, is his acknowledged masterpiece. In it, as Renoir's friend Georges Rivière justly observed, there is 'noise, laughter, movement, sun and the atmosphere of youth'. His review went on: 'It is essentially a Parisian work. The girls are the very ones who elbow us every day and whose babble fills Paris at certain hours. A smile and the flick of the wrist is enough to be pretty; M. Renoir proves it.' Prophetically, in a reference to the kind of historical subjects which still dominated the Salon, he added: 'When, for the hundredth time, we are shown St Louis dealing out justice under an oak, are we the better for it? What documents will these artists who deliver us from such lucubrations bequeath to future centuries?'

The sense of pleasure inherent in Renoir's work might well have been a factor in helping to turn the tide. The Impressionists had no clique to speak up for them; their friend and champion Émile Zola was for five years a lone

voice, and praise from other writers came only after they no longer needed it. Renoir did, however, have one devoted critic in his brother Edmond, an aspiring writer who became managing editor of a newspaper, *La Vie Moderne*, started by the distinguished publisher, Georges Charpentier. Renoir had painted Charpentier's mother in 1869, and the family were well disposed towards him and his friends.

Charpentier, having bought Renoir's *Fisherman on a River Bank*, invited the painter to his house, where such writers as Zola, Maupassant and the Goncourt brothers were welcome guests. Renoir was charmed by the household, and delightedly painted the young daughters who, he said, reminded him of Fragonard. 'I was able to forget the journalists' abuse. I had not only free models but obliging ones.' Edmond, with access to Charpentier's newspaper, wrote several articles in support of the Impressionist painters, his brother in particular.

One of these, written in 1879, gives an account of Renoir's methods as a painter. To Renoir, wrote Edmond, the forests of Fontainebleau were better than the four walls of the studio. 'Atmosphere and surroundings had an enormous influence on him. Having no memory of the kind of servitude to which artists so often bind themselves, he let himself be set in motion by his subjects and above all by the character of the place he was in.' He continued: 'That is the particular quality of his work: he re-stated it

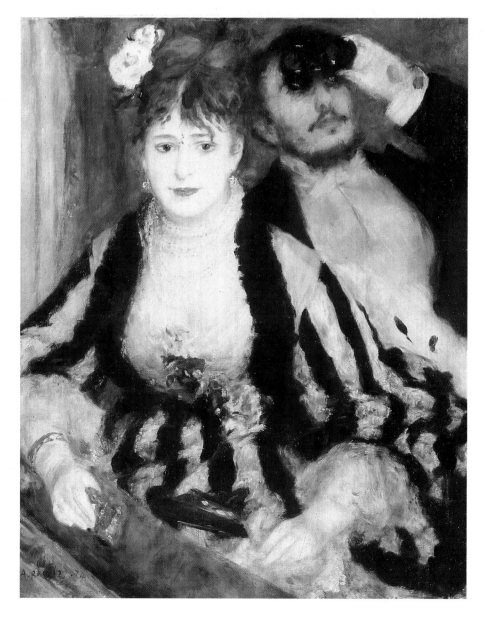

*Renoir. A Box at the Theatre, 1874. Courtauld Institute Galleries, London. Courtauld Collection. The Impressionists made a virtue of their pleasures by celebrating visits to the theatre, the opera and other entertainments with youthful verve. Manet had introduced them to the simplified outlines of Velasquez, which persist in much of their earlier work. Here, Renoir's forthright use of black intensifies the dramatic pallor of the woman's skin.*

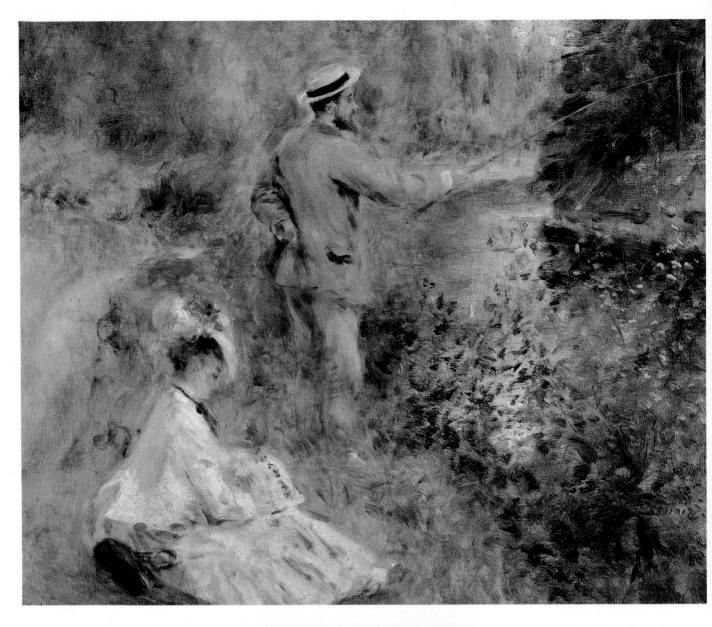

**Above:** *Renoir*. Fisherman on a
Riverbank, *1874. Private
Collection.*

**Left:** *Renoir*. Lise with a Parasol,
*1867. Museum Folkwang, Essen.
This early study of a figure in a
landscape setting was exhibited at
the Paris Salon of 1868. Lise was a
friend of Renoir's who also modelled,
on occasions, for his friends.*

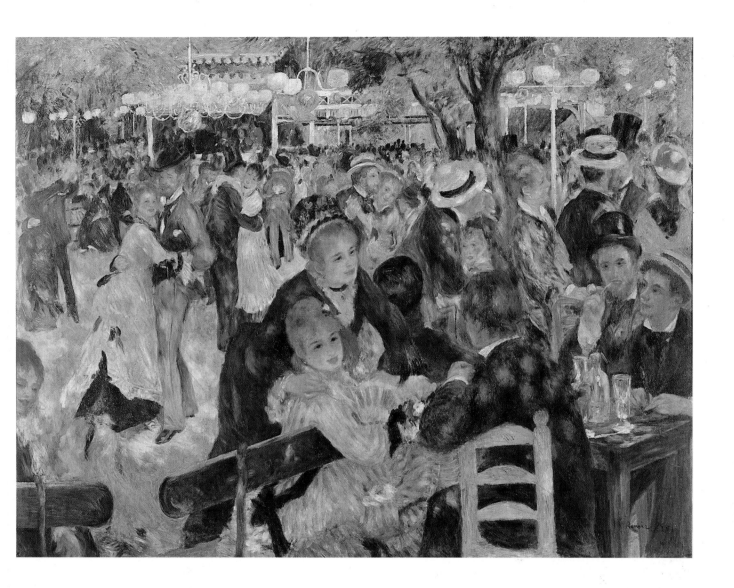

everywhere and at all times, from *Lise*, painted in the forest, to the portrait of *Mme. Charpentier and her Children*, which was painted in her home without the furniture being moved from its normal daily position, and without anything being prepared to give more importance to one part of the picture than another. When he painted the *Moulin de la Galette* he settled down to it for six months, wedded to his whole world which so enchanted him, and for which models in poses were not good enough.' When he painted a portrait he asked his sitter to keep his ordinary clothes, to sit as he always did in his usual position, so that nothing should look uncomfortable or prepared he added.'

Renoir's total refusal to be bound by systems and methods, particularly those urged on him by others, is an essential element in his work. When the painter Laporte told him, 'You must force yourself to draw,' Renoir replied: 'I am like a little cork thrown into the water and carried by the current. I let myself paint as it comes to me.' Gleyre, his teacher, examining a sketch Renoir was working on, said: 'Young man, you are very skilful, very gifted. But no doubt you took up painting to amuse yourself.' Renoir replied: 'Certainly. If it didn't amuse me I wouldn't be doing it.' Degas, who had a lifelong respect for form, regarded Renoir as a law unto himself. 'He can do anything he likes,' he said.

Renoir was the first of the Impressionists to achieve anything like financial success. From 1881, when Durand-Ruel began to find ready buyers for his work, he was able to afford such luxuries as foreign travel, including visits to Italy and North Africa. In Algeria, like Delacroix before

*Renoir.* Le Moulin de la Galette, *1876. Musée d'Orsay, Paris. Renoir's friends make frequent appearances in his paintings of social gatherings such as this one, at a favourite rendezvous near the top of the hill in Montmartre, by the windmill. His friend and biographer, Georges Rivière, has identified all the foreground group and many of the dancers. The entire painting was done on the spot.*

*Renoir*. La Casbah, *known as* Fête Arabe, *1881. Musée d'Orsay, Paris. It was in Algeria, Renoir said, that he 'discovered white', and in this work he uses it to give structure to the swirling composition. Durand-Ruel eventually sold it to Monet, who kept it for the rest of his life.*

him, he found an abundance of paintable subjects bathed in a startling light, colourful and luxuriant. From his first visit he brought back an exuberant painting, the *Fête Arabe* or 'Arab Festival', in which the swarming figures are painted as if from a balcony – a viewpoint which Pissarro was to adopt for his later Paris street scenes, with great success. In Algeria, Renoir said, he 'discovered white' – the white of the burnouses, walls, minarets, even the roads.

This new awareness of white as a compositional element contributed to his increasing sense of structure, which separates such works as the widely-admired *Boating Party*, painted just before his departure, from his earlier and more characteristically Impressionist style. The *Fête Arabe* evidently appealed to Monet, who bought it and kept it for the rest of his life. Renoir was still responsive, when the occasion presented itself, to a typically Impressionist subject, as he showed in Venice that year. His version of the Piazza San Marco, in particular, exhibits the Impressionist dexterity with a *plein-air* subject, its form ensnared in touches of liquid light.

Another product of his summer stay in Italy was the splendid *Bather*, widely known as the 'Blonde Bather' after the rosy tones of the girl's body. Renoir said he painted the picture from a boat in the Bay of Naples, off Capri, using his favourite model and wife-to-be, Aline Charigot. Ingres

*Renoir*. Madame Charpentier, *1876–77. Musée d'Orsay, Paris. Renoir declined to contribute to the 1877 Impressionist exhibition, preferring to show his prestigious* group portrait of the Charpentier family that year at the Salon. This portrait of his patron's wife, Marguerite, dates from the same commission.

# RENOIR

*Renoir.* The Swing, *1876. Musée d'Orsay, Paris. This work, one of Renoir's exhibits at the third Impressionist show in 1877 and bought by Gustave Caillabotte, passed to the Louvre with the rest of his bequest in 1894.*

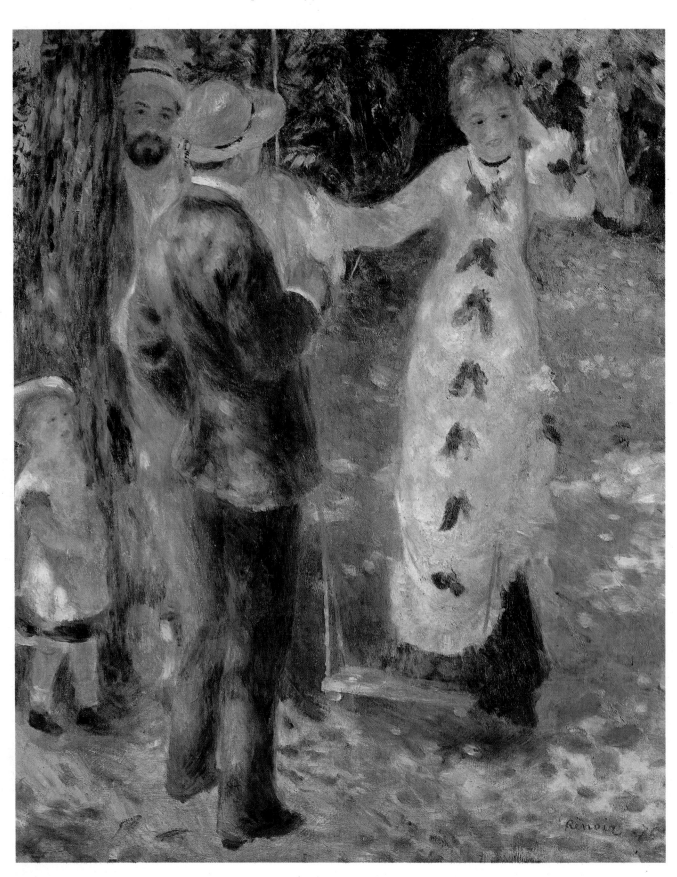

*Renoir.* The Blonde Bather, *1881. Sterling and Francine Clark Institute, Williamstown, Massachusetts. Aline Charigot accompanied Renoir to Italy in the autumn of 1881, and this painting is perhaps the most sensous evocation that even he had made of her, in* which the whiteness of the flesh bathed in soft sunlight stands out from a background of resonant reds and blues. It may be that Renoir gave her a more opulent form than she in fact possessed: her own testimony is that she was quite thin (by her standards) at the time.

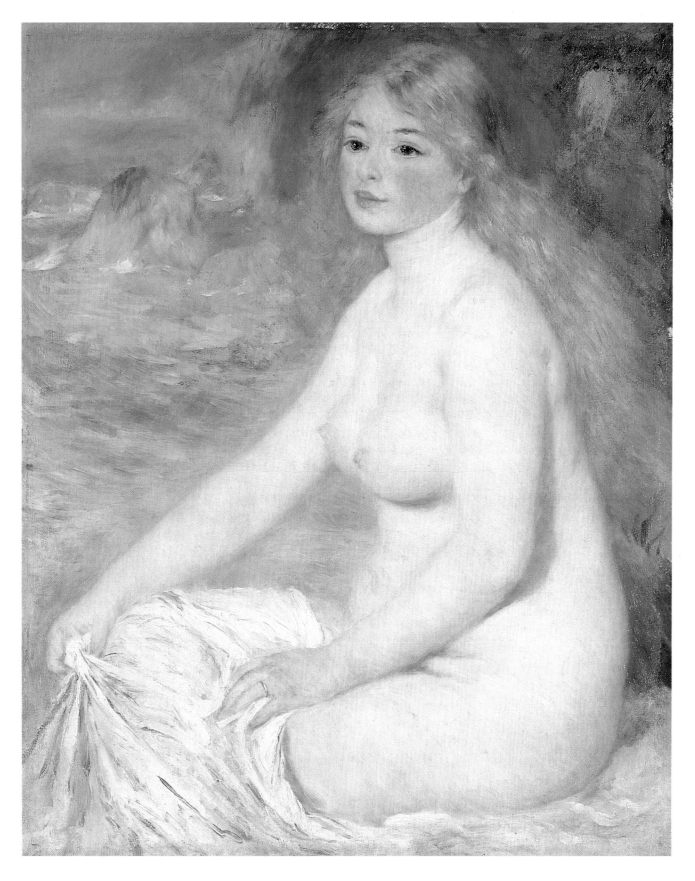

himself would not have faulted this demonstration that classical forms come closest to nature, and hence to true beauty. In its monumental grace it is a conscious tribute to Raphael's frescoes in the Villa Farnesina, which Renoir had lately seen in Rome. Only one small detail fixes it in his own time, the wedding ring on the third finger of Aline's left hand. It was Renoir's concession to the proprieties: he and Aline were not to be married for another nine years.

We are entitled to dwell a little on Aline Charigot, whose face and form grace so many of Renoir's masterly nudes. His son and biographer, Jean Renoir, re-creates her as a perfect example of his father's favourite type of young woman, the 'cat' type: 'You wanted to tickle her under the chin.' She had Renoir's ideal features. He liked women, he said, with small noses rather than large ones, wide mouths, small teeth, fair complexions and blonde hair, and with a tendency to put on fat. The eyes, he added, should be half-way between the top of the head and the tip of the chin, otherwise the brow would indicate an intellectual, or worse. He met Aline, a local dressmaker's daughter with a rich country accent, when she was 19 and she began posing for him almost at once. 'I didn't understand anything about it,' she said later, 'but I loved to watch him paint.' In his turn, Renoir loved her slightly almond-shaped eyes and her light step – 'She could walk on grass without hurting it' – and the way she swept her hair up in a movement that was 'truly round'. So completely did Aline fit Renoir's powerful preconceptions of ideal womanhood that he had begun painting her, it would seem, even before she came on the scene. Jean Renoir credits Aline and Renoir between them with creating the 'Renoir' face long before their children were born, 'an influx of little, round, plump beings with beautiful red cheeks.'

The experience of Italy both impressed and unsettled him. Was Impressionism, after all, a satisfactory end in itself? A painter friend of his with similar doubts, Paul Cézanne, seemed to think not. In 1883 Renoir decided that his art must take another direction. 'I had come to the end of Impressionism, and had arrived at a situation in which I did not know how to paint or draw,' he confessed later. After a period of introspection and experiment he visited Spain in 1886, though briefly, because, as he put it, 'When you have seen Velasquez you lose all desire to paint. You realize everything has already been said.' From then on his style broadened into the loose, flowing, sensuous period of the great nudes and of his glorification of life and nature.

In the most recent assessment of Renoir and his world, a contribution to the definitive exhibition of his work held at the Hayward Gallery, London, in 1985, John House suggests that the practice of painting perplexed him. In the 1880s he had deliberately set about re-learning the methods of drawing and painting by going back to the old masters, feeling that the Impressionist techniques of the 1870s were too imprecise, lacking in form. It was not the first time he had doubts about the way his art was progressing: he was talking about 'true painting' as early as the 1860s and did not always believe in his heart that, with Impressionism, he was on the right track.

Renoir's admirers, who are legion, would be puzzled by the contradiction between his sunny-tempered paintings and these morose self-doubts. One reason may be that, as an anti-intellectual, he refused to accept any cerebral theorizing about the painter's role. Instead, he insisted on craftsmanship, the criterion that brings self-respect to a workman or mechanic, trades towards which he was instinctively sympathetic. He worried constantly that he had not produced enough work of substance – a situation which his wanderings did nothing to rectify, supposing it were true, even if that same restlessness was in search of more and better ideas

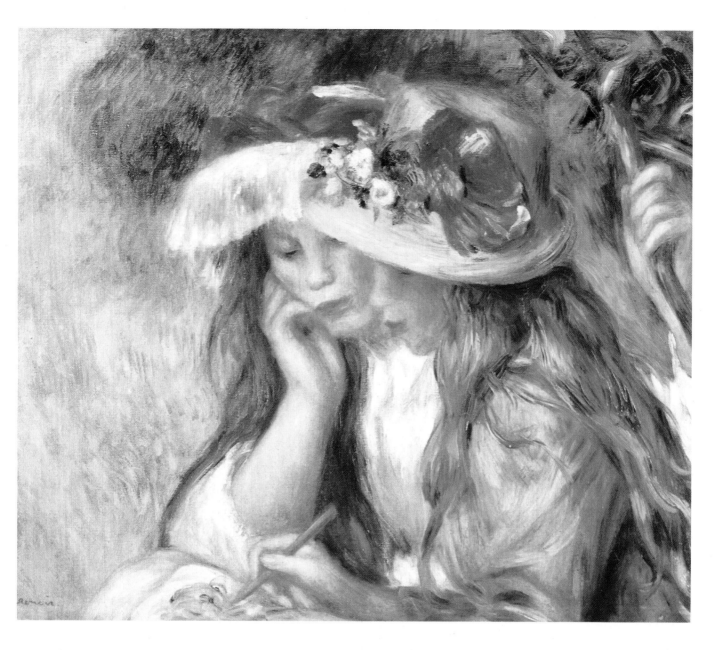

for paintings. Yet he always said he painted for pleasure rather than satisfaction. 'Painting is for decorating walls,' he told an early biographer, 'so it should be as rich as possible. An easel picture should be something likeable, joyous and pretty – yes, pretty. There are enough ugly things in life for us not to add to them. I realize that it is difficult for painting to be accepted as really great whilst remaining joyous. Because Fragonard smiled, people have been quick to say that he is a minor painter. They don't take seriously people who smile.'

Here, Renoir put his finger on the very reason why his paintings give universal pleasure in our own time. They are happy pictures, entertainments, touched with the sentiments that we are glad to respond to – relationships between real, attractive people, whether children or adults, sparky young men or kissable girls. On hand there is sunshine, or flowers, or pets, or a bottle of wine. People bathe in one another's glances and affectionate smiles. The paint itself celebrates this happy fellowship, lingers on the sun-lit limbs and uncombed bathers' hair.

Charm, we know, has undone many a competent painter; it slips, unnoticed by the artist, into mere ingratiation. There are canvases by Renoir in which he comes dangerously close to this cosmetic substitute for feeling. Sensing as much, perhaps, he tended to back off into eighteenth-century formality. He once admitted that, unlike his fellow Impressionists,

*Renoir.* Two Girls Reading in a Garden, *1890. Private Collection. Renoir used these two young girls as models for several paintings in the late 1880s and early 1890s. They are Berthe Morisot's daughter, Julie Manet, and her first cousin, Paulette Gobillard.*

he had no stomach for a fight: 'I should several times have deserted the party if old Monet, who certainly did have it, had not lent me his shoulder for support.'

Though he was not one of the Impressionist intellectuals, he took a serious view of his work and method, and understood from his own observations the components of colour laid on canvas. In painting, as in other arts, he once declared to the art dealer Vollard, no procedure could be contained in a formula. 'You arrive in front of Nature with theories, and Nature throws them to the ground.'

Nothing brings Renoir so tangibly to life as to watch the brush, his own hand, slipping over the curves and shadows of a girl's body, caressing the dappled skin beneath which the blood flows through delicate blue veins. 'You must protect the ends of your fingers,' Renoir told Jean as a child. 'If you expose them you may ruin your sense of touch and deprive yourself of a good deal of pleasure in life.' Translated to the canvas, this tactile impulse gives Renoir's paintings a realism in painting the nude that no other Impressionist ever matched. However, this was not a view taken by some of the Paris art-scribes, on whom Renoir's tributes to womanly flesh sometimes had a reverse effect. Of the *Nude in the Sunlight*, one wrote: 'Would someone kindly explain to M. Renoir that a woman's torso is not a mass of decomposing flesh with the green and purplish blotches that

*Renoir*. The Garden of Montmartre, *(date unknown)*. *Ashmolean Museum, Oxford.*

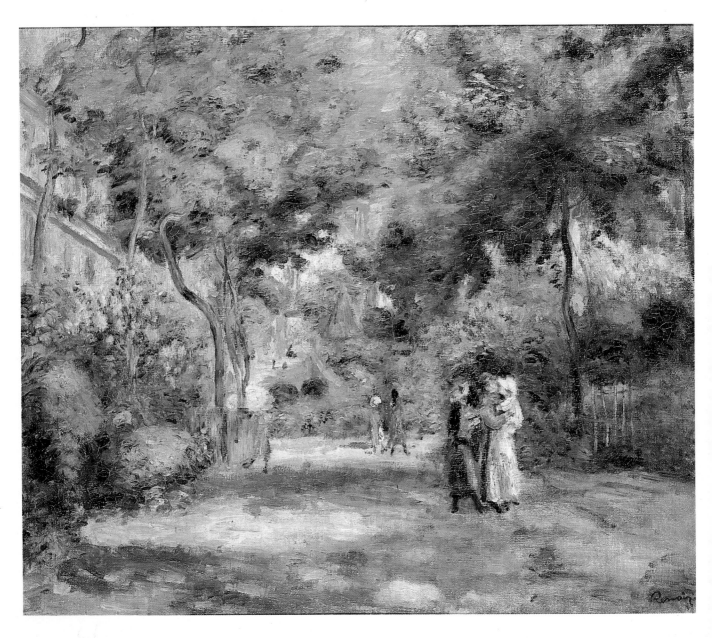

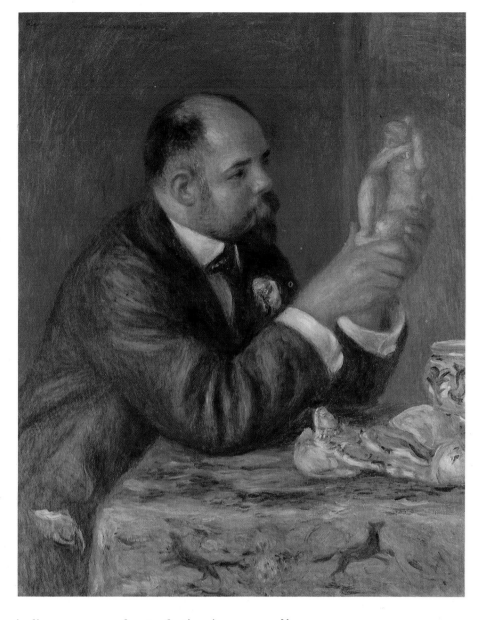

*Renoir*. Portrait of Ambroise
Vollard, *1908. Courtauld Institute
Galleries, London. Courtauld
Collection. As a young dealer,
Vollard was shrewd enough to listen
to Pissarro and Degas, with
profitable results. Cézanne, as well
as Renoir, painted his portrait.*

indicate a state of putrefaction in a corpse?'

His delight in open-air domestic themes is apparent throughout his life.
His *Maternity*, painted in 1886, when he was reverting to the
monumentality of the old masters, sums up his almost carnal attachment to
family flesh and blood. The plump young mother, his devoted Aline, has
the infant Pierre on her lap, feeding him, his right hand clutching his
chubby right toe – a timeless image of motherhood by an artist for whom,
in the words of his son Jean, 'every woman nursing a child was a Virgin by
Raphael.' Equally, we may see in Aline, beneath the skirt and jacket, the
voluptuous form of Renoir's great *Bathers* of the 1880s, for which she
herself was often the model.

When he came to paint his *Judgment of Paris* in 1908 he first posed as
Paris an actor, Pierre Daltour. However, uncomfortable at painting a male
nude from life, he substituted the faithful housemaid, Gabrielle Renard,
with whose body he felt more at ease. 'See how like a boy she is!' he
marvelled. 'What a Paris she will make!' However, in the finished painting
Paris is clothed in a flowing shift.

His raptures on such occasions were uncontainable. 'Ah,' he exclaimed
to Albert André, 'this breast! Is it soft and weighty enough? The pretty fold
beneath it with its golden tone – it's something to get down on one's knees
in front of. If there been no such thing as breasts, I think I think I would
never have painted figures.'

RENOIR

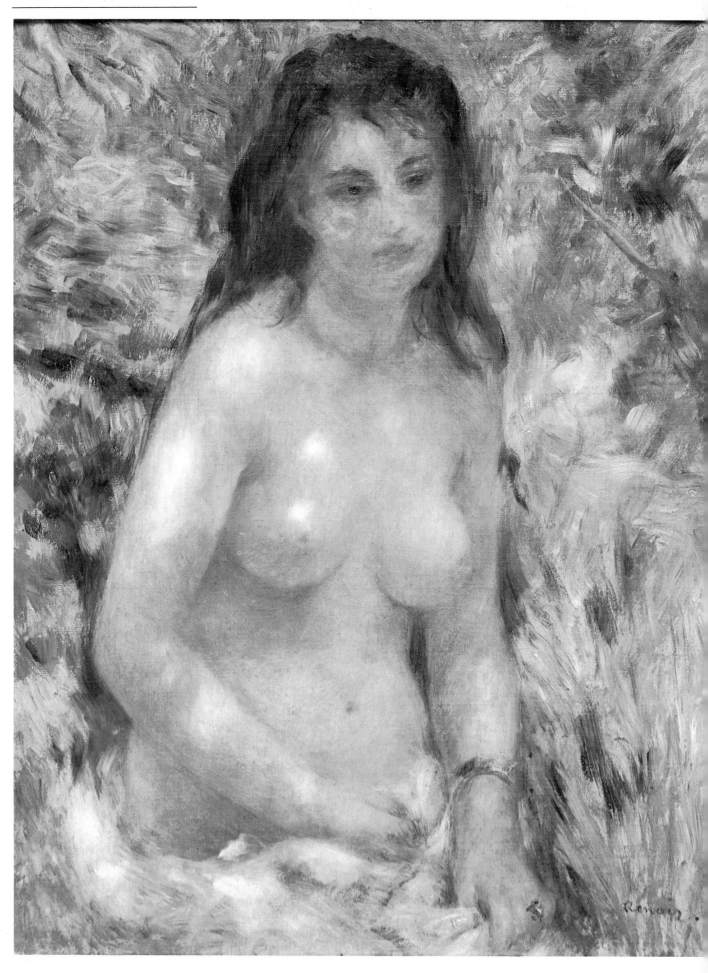

*Renoir.* Nude in the Sunlight, *1875. Musée d'Orsay, Paris. Somewhat provocatively, Renoir exhibited this study at the second Impressionist group show in 1876. It prompted the expected insults from the critics, one of whom complained at the model's 'decomposing flesh* with green and purple blotches'. Its true quality has long since been acknowledged. The first to respond to it was Gustave Caillebotte, who bought it from Renoir shortly after the exhibition and included it in his eventual bequest to the Louvre in 1894.

*Renoir.* Young Girl Combing her Hair, *1894. Lehman Collection, New York. According to his son Jean, Renoir had his own fixed idea of feminine beauty. In his paintings of young women he created an unmistakable 'Renoir' type, of whom Aline Charigot was the incarnation.*

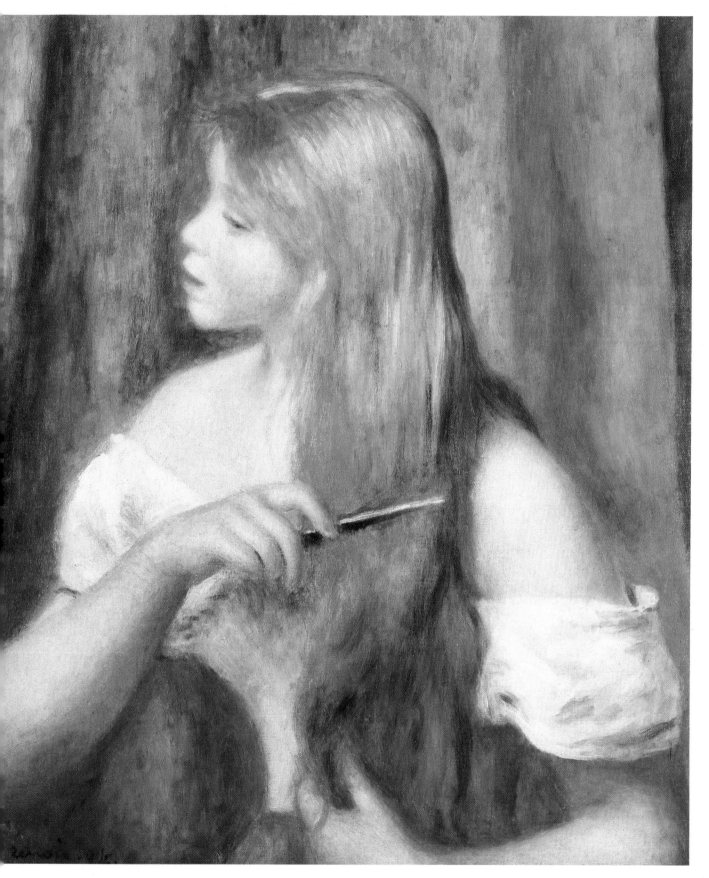

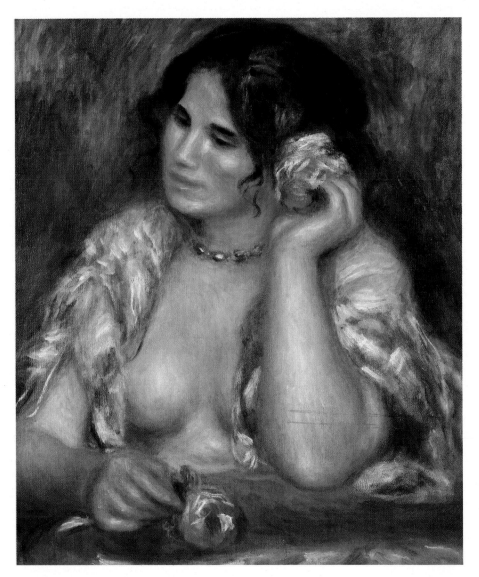

*Renoir.* Gabrielle with a Rose, *1911. Musée d'Orsay, Paris. Gabrielle Renard, who joined the Renoirs as a domestic servant, became a well-loved member of the household. She acted as a model and housekeeper, and understood Renoir's moods and habits better, perhaps, than anyone. In his arthritic old age, one of her attentions was to fix his brushes to his wrists.*

Renoir at this time was searching, as he told Mme. Charpentier, for 'the grandeur and simplicity of the ancients'. The love which he lavished on the body of Aline in paint is palpably heartfelt. Above all, he saw womanly beauty as ideal, an incarnation both of longing and of human desire.

His old age, around his rugged stone house in its leafy grounds, was spent as much in grumbling as in painting. He refused to go to Paris, where everyone wanted to meet him now that he had become famous. At home, he said, with a good fire to sit by, local butter, and better bread than any you could get in Paris, there was no need to be anywhere else. He made his own bed every morning, lit the fires and swept the studio. He was only happy with women around him, but railed against such unnatural fads as high heels and corsets. In time, an afflication in his left eye, the result of a cold, gave his face a somewhat frightening look. Rheumatism bunched his fingers, but did not stop him from painting: he simply had his women tie the brushes to his wrist.

Jean Renoir describes a new young model whom some friends found for him: Andrée Hessling, known as Dédée, 16 years old, whose skin 'took the light' better than any model, Renoir said, than he had painted in his life. 'She cast over my father the revivifying spell of her joyous youth. She helped him to interpret on his canvas the tremendous cry of love at the end of his life.'

This was Renoir's last work on the female form, *Les Baigneuses*, painted in 1918 and modelled on the celebrated earlier version of 1887, now in the Philadelphia Museum of Art. He painted it in his garden studio, with the

*Renoir*. Woman Tying her Shoelace, *c.1916. Courtauld Institute Galleries, London. Courtauld Collection.*

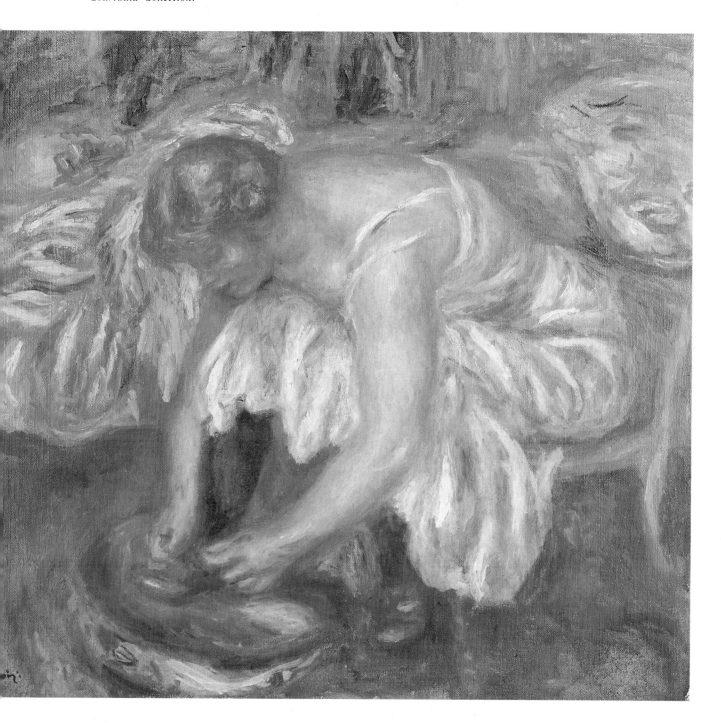

huge canvas on rollers to enable him to reach all parts of the surface. The model for the 'tremendous cry of love' was the beautiful Dédée, whom Jean was to marry after his father died. It is a powerful evocation of Rubens, the painter whom Delacroix had recommended the young Manet to study at the outset of that master's career. Renoir, with his powerful attachment to his classical forbears, poured into the painting, a double nude, all that he had searched for in his life.

In due course, his sons donated it to the national collection as a monument to their father's career. The gentlemen of the Louvre, however, had their doubts. They thought the colours too loud, and declined it. After a while they changed their minds, and the great *Baigneuses*, Renoir's last gesture in paint, passed into the keeping of the French nation.

*Renoir*. Mother and Child, *1892.*
*National Gallery of Scotland,*
*Edinburgh.*

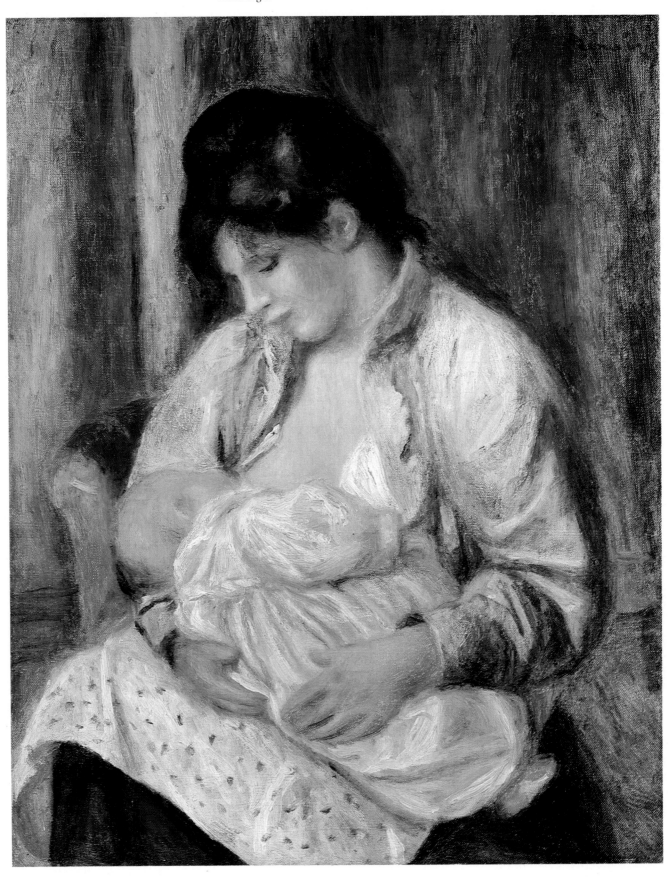

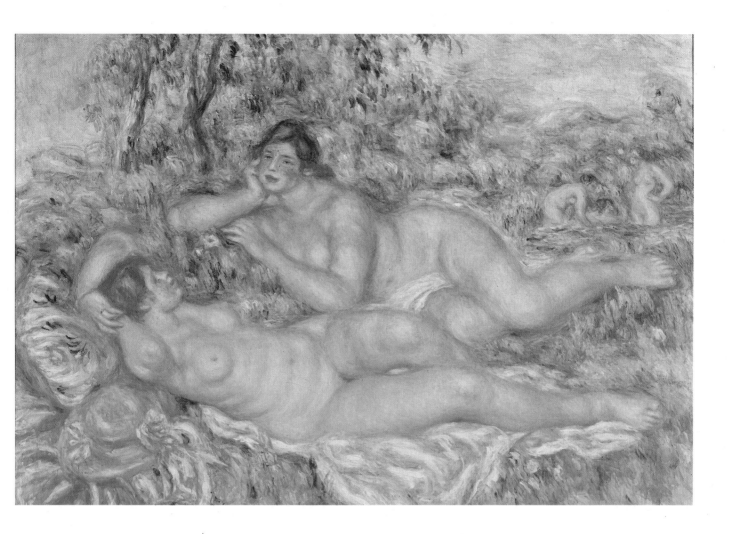

*Renoir.* Bathers, *1918–19. Musée d' Orsay, Paris. Renoir became convinced that the nude was 'one of the most essential forms of art', an opinion which strengthened over the years and prompted him to paint this valedictory Baigneuses. It was presented to the state by his sons in their father's name.*

# 9 Bazille

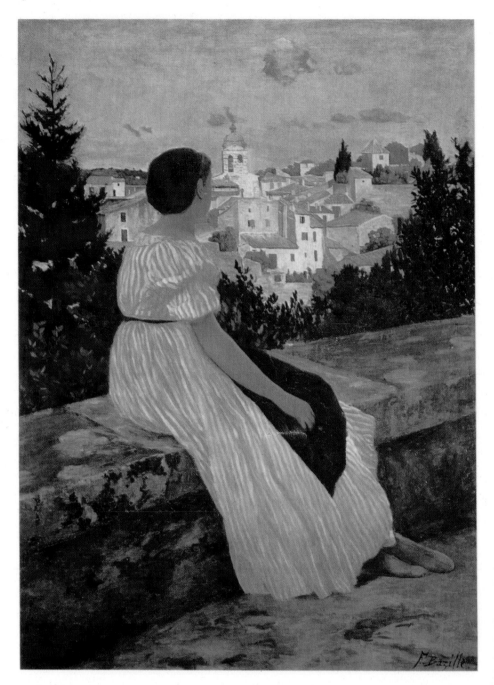

*Bazille*. The Pink Dress, *1865. Musée d'Orsay, Paris. Setting a figure in a natural outdoor landscape was a typically Impressionist subject. Bazille's first attempts owed much to the example of Monet's* Women in a Garden.

Monet, Sisley and Renoir, toiling in the studio of Charles Gleyre towards the end of 1862, were joined by a tall young man of Renoir's age, well-dressed and obviously of good family – the sort who gives the impression of having had his valet break his shoes in for him, as Renoir put it. This was Frédéric Bazille, from Montpelier, in the south of France, where his family were wealthy landowners. He had started studying medicine there, but persuaded his family to let him come to Paris and enrol at Gleyre's, on condition that he continued his medical studies in the afternoons.

His stylish manner and provocative conversation made him popular at once. Zola, when he met him, called him 'a very handsome fellow, of fine stock, haughty, formidable in argument, but essentially good and kind.' He was already announcing that big, classical compositions of the kind favoured by the Salon were on the way out, and that the future lay in

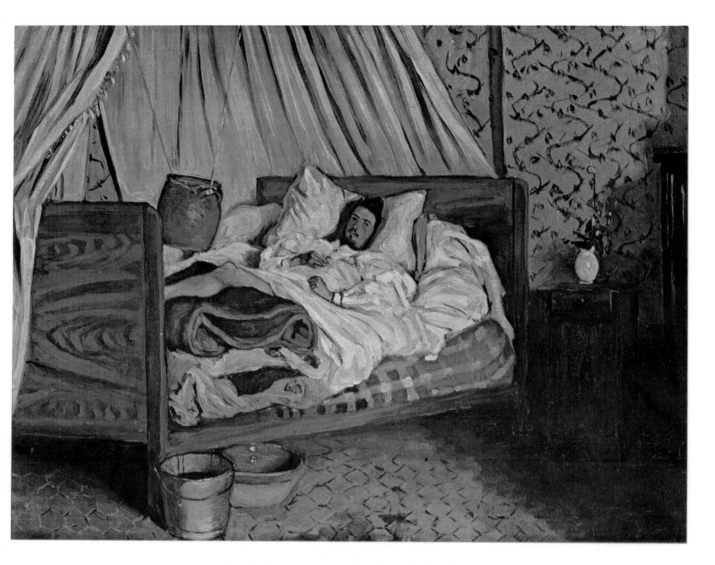

everyday scenes of ordinary people. He began following Monet's practice of painting in the open air, notably in the forest of Fontainebleau, just outside the city, in the Easter holidays of 1863. Meanwhile, he continued to attend medical school in the afternoons but not, apparently, with much effect since he failed his examinations two years later. That summer, Monet introduced Bazille to his native Normandy, where they painted around Honfleur.

By now, he and Monet were often painting together. Bazille appears twice in Monet's *Déjeuner sur l'Herbe* of 1866, once as a standing figure at the left-hand side of the picture, and again lying on one elbow at the other. When Monet injured his leg, and retired, furious, to his bed at their country guest house, Bazille, to keep him quiet, painted him propped up on pillows, visibly disgruntled. Bazille, calling on his shaky medical knowledge, rigged up a contraption by means of which water, in a large container, was supported over the injured limb, constantly dripping the contents on it, which then theoretically drained into other vessels standing at the foot of the bed – an unconventional picture of Monet which now hangs in the Musée d'Orsay.

Back in his own studio, where Renoir was now also installed, Bazille wrote home: 'Monet has fallen upon me from the skies, with a collection of magnificent canvases.' When Bazille moved to a new studio in the winter of 1867, taking Renoir with him, Renoir painted him at his easel, busy with a

*Bazille. Monet after his Accident, 1865. Musée d'Orsay, Paris. Shortly after inviting Bazille to join him in the Forest of Fontainebleau, Monet injured his leg and was confined to bed. Bazille, a lapsed medical student, fixed up a contraption for dripping water on to the limb, and made this painting of the frustrated patient's confinement.*

*Renoir.* Bazille at his Easel, *1867. Musée d'Orsay, Paris. This portrait of Bazille shows the long-legged artist painting a still-life of dead birds. His friend Sisley, who had moved in with Bazille, painted an almost identical version of the same subject at the time.*

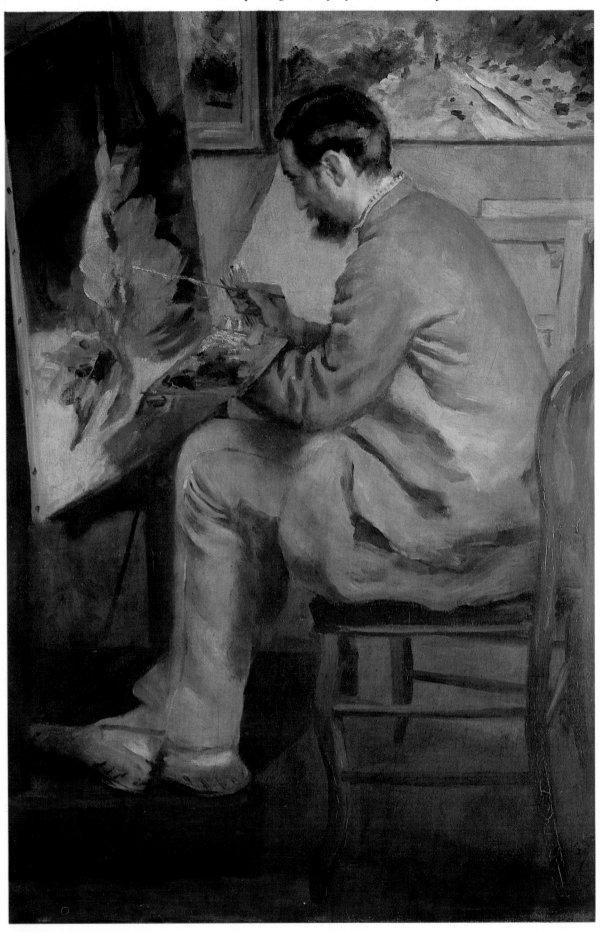

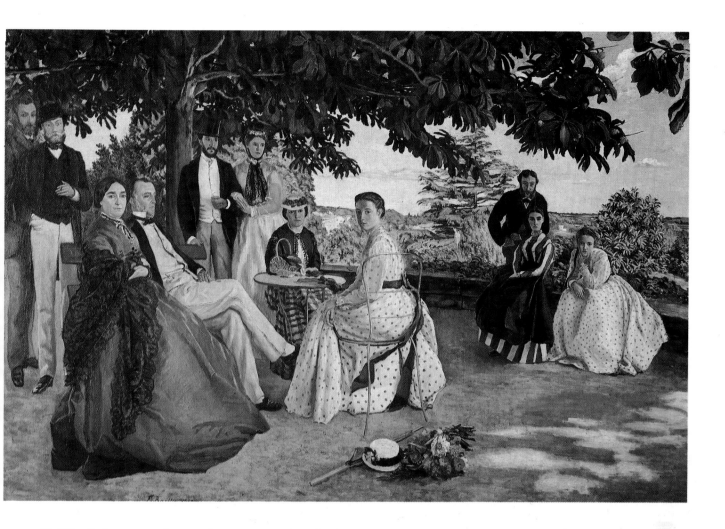

still-life of a heron, a picture that was to end up in the possession of Manet.

As Bazille's close friend, Renoir remembered those days well, and the daydreams they shared. 'He had a great deal of talent, and courage, too. You need plenty of it when you have money, if you want to avoid being a society man. Our discovery of nature turned our heads.' Bazille had already visited Manet, with whose family his parents had a distant acquaintance, in his studio, and was well informed of their hero's work and ideas. It was Bazille, too, who first brought the young Englishman, Alfred Sisley, to Gleyre's studio – another recruit who wanted to 'set fire to the firemen'. Pissarro, the other important Impressionist-to-be, was introduced by Bazille through Manet. Gleyre may well have wondered what was brewing in his non-revolutionary establishment. When, in the life class, he caught sight of one of his young women pupils painting a touch of red on the nipples, his face, according to Renoir, turned bright scarlet. 'It's indecent!' exclaimed the master. 'I am for free love and Courbet,' the maiden replied.

Bazille and Monet appear to have sat side by side on the beach at Le Havre in 1865, painting an identical stretch of coast under a lowering sky, with small boats scudding in the choppy water. Bazille, by now Monet's ardent admirer, thought so highly of his friend's ambitious set-piece *Women in a Garden*, that he bought it, to help him tackle a large canvas of his own family posing on the terrace of their summer house outside Montpelier. Each of the figures looks out of the picture with that incurious expression of Manet's model in the *Déjeuner* of 1863, but with no obvious relationship to the others.

In 1869 the Salon accepted his *View of the Village*, in which a young girl in a red sash sits under a tree over-looking a southern township bathed in a soft sunlight. The artist's friends were enthusiastic: Bazille had succeeded in placing a figure, with complete naturalness, in an outdoor setting,

*Bazille. The Artist's Family on a Terrace, 1867. Musée d'Orsay, Paris. The setting for this group portrait of his family was the terrace of Bazille's parents' estate near Montpelier. Bazille exhiibited it at the Salon of 1868.*

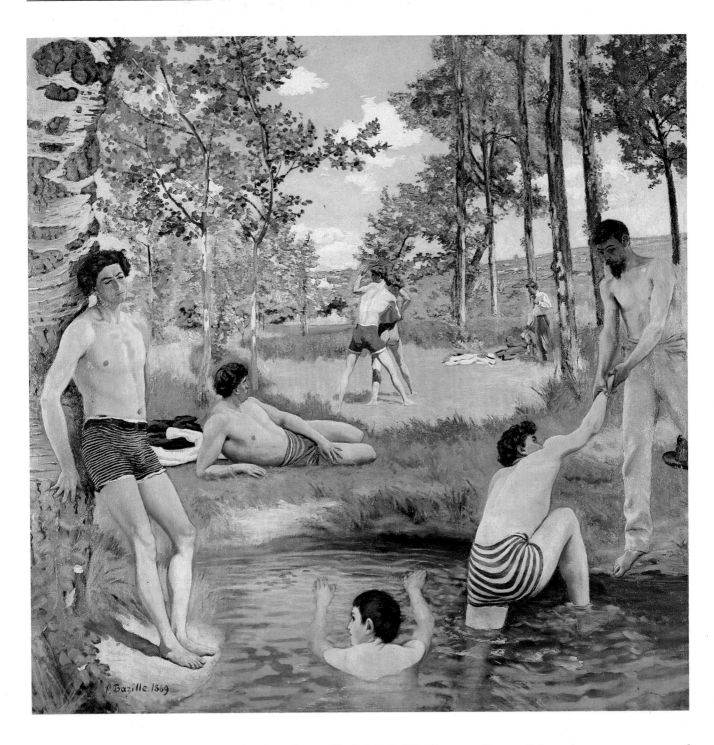

*Bazille.* Summer Scene, *1869. The Harvard University Art Museums (Fogg Art Museum), Cambridge, Massachusetts. Gift of M. and Mme. F. Meynier de Salinelles. Painted partly in the studio and partly out of doors, this work was Bazille's exhibit at the Salon of 1870, shortly before being killed in the Prussian advance on Paris as an officer in the Zouaves.*

leaving the studio behind. His *Summer Scene* of the same year, a group of young men disporting themselves around a pool, exhibited at the Salon of 1870, though still some distance from the Impressionism of Monet and Renoir by that date, is perhaps Bazille's most individual work. It is a celebration of manly exercise, in which the healthy bodies occupy a natural place in a summer landscape washed with light.

In the same year, reverting to the exotic romanticism of Delacroix, he painted *Black Woman with Peonies*, which seems to hark back to the masterpiece which helped to set French painting on its revolutionary course: Manet's *Olympia*. The black servant in Manet's picture, bearing her bouquet of flowers, is transmuted in Bazille's imagination to a subject in her own right.

Bazille's mind was full of ideas for group exhibitions, which he passed on to his family in a letter written in the spring of 1867. He would not send anything more to the Salon, he had decided: it was ridiculous to be exposed to the whims of mere administrators. 'A dozen young men think the same way as me,' he declared. We can guess some of their names: the four friends at Gleyre's, plus Pissarro, Manet, Degas, Berthe Morisot. Bazille listed some of the painters who would be invited to exhibit with them, including Courbet, Corot, and the Barbizon painters Diaz and Daubigny, adding: 'With these people, and Monet, who is stronger than all of them, we are sure to succeed.' Unfortunately for this heady idea, Bazille and his friends were not able to raise the necessary funds to buy their own studio, so it had to be dropped.

All the same, the notion of a like-minded group of artists, all moving in the same direction and with ambitions in common, refused to die. In that first, excited idea was the germ of what later became a reality – a fraternity of artists, of varying skills and temperaments, who would show their work together, scorning the traditionally approved art channels, sinking their inevitable disagreements in a common cause.

Whether Bazille would have remained in the van of such movement is open to question. Despite his close ties with Monet, Renoir, Sisley and the rest, there is in his work a residual conservatism, a hesitancy, that he might have found hard in the end, to eradicate from his painting. As it was, there was no time left to find out. When the Prussians marched on Paris he immediately volunteered for military service in the Zouaves, an elite regiment renowned for its *esprit de corps* in action. After a short training course in Algeria he was commissioned and posted to a regiment fighting a desperate withdrawal action south of Fontainebleau forest. There, on an icy road at Beaune-la-Rolande, on 20 November 1870, he was killed by a sniper's bullet. They buried him under the snow. His father set out from Montpelier to find his body, and brought it home on a cart. His friends were desolated. Years later, Renoir still mourned him, 'that gentle knight, so pure in heart; the friend of my youth.'

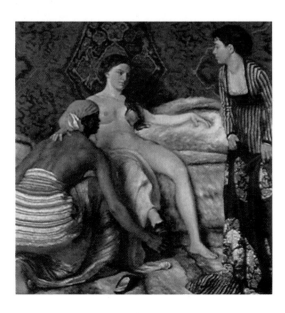

*Bazille.* La Toilette, *1870. Musée Fabre, Montpelier. The Salon jury rejected this costume piece, which shows Bazile responding to the exoticism of one of the Impressionists' heroes, Delacroix.*

# 10 Pissarro

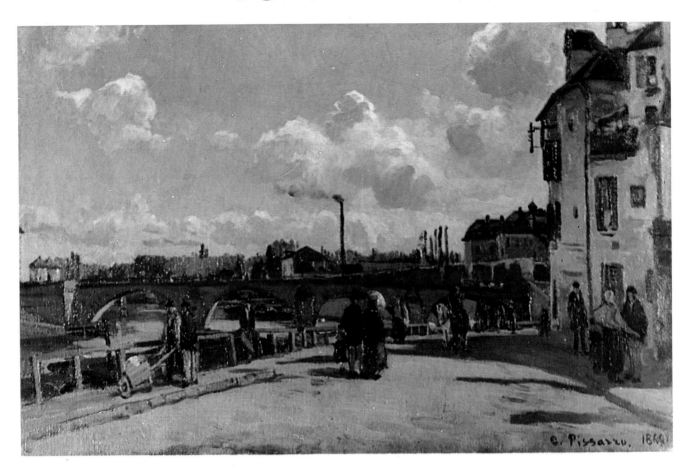

*Pissarro.* The Quay Pothuis at Pontoise, *1868. Städtische Kunsthalle Manhheim. Corot's influence is apparent in this broadly treated scene, with its unforced realism and luminous sense of space, Pissarro had two views of Pontoise accepted at the Salon this year, thanks partly to the support of Daubigny, who was on the jury.*

If the Impressionists had ever thought of instituting an Order of Merit for painters, the first holder would surely have been Camille Pissarro. He was the true believer who exhibited at every one of their exhibitions – the only one of them who did so – and who dignified, by the quality of his intellect, the unashamed quest for pleasure that shines in their most typical works.

Pissarro was an Anarchist, in much the same sense that other people might be Quakers. His insistence that the human spirit owes nothing to institutions sustained him all his life. Unfailingly charitable, he was able to say of Degas (there was probably no man in Paris more antithetical) that he was 'a terrible man, but sincere and trustworthy.' As for his own work, Cézanne, whom he helped and encouraged through many a crisis, declared: 'If he had gone on painting as he was doing in 1870 he would have outclassed us all.' To Cézanne, who was destined to re-direct the course of European art, he was 'that humble and colossal Pissarro'.

He was born in the Virgin Islands, the son of a Jewish–French shopkeeper of Spanish or Portugese descent who sent him to be educated in Paris. There he decided to be a painter, and after some exotic wanderings returned to Paris to enrol at the École des Beaux-Arts and the Académie Suisse. The Great Exhibition of 1855 opened his eyes to Corot, Daubigny and Courbet, who between them influenced his early landscapes. He was accepted at the Salon throughout the 1860s without, however, making his mark on the critics, one of whom suggested that, in his *Banks of the Marne in Winter*, he was trying to be satirical.

An exception was Émile Zola, who recognized in Pissarro's work at the 1866 Salon qualities which, from the outset, were destined to deny him an easy popularity. 'You should realize,' he told Pissarro, 'that you will please

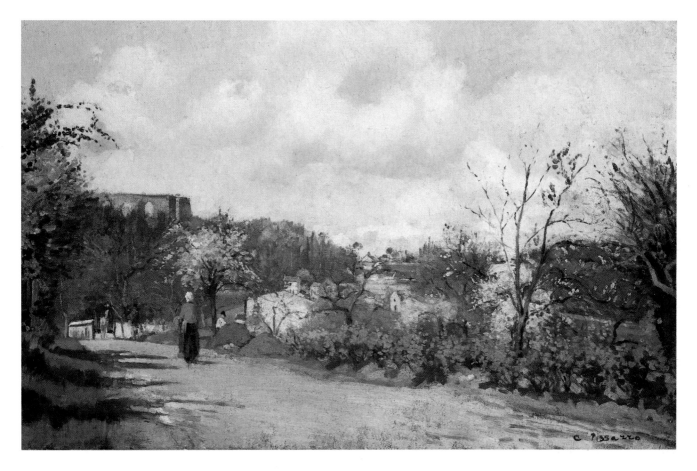

no one and that your picture will be found too bare, too black – nothing whatever to delight the eye, an austere and serious kind of painting, an extreme concern for truth and accuracy, a rugged and strong will.' Two years later Zola again hit the nail on the head, pointing out how Pissarro had 'none of the petty skills of his fellow exhibitors', and that he was unconcerned with tricks of the trade, adding rhetorically: 'How on earth can one expect such a man, and such pictures, to be popular?'

This innate gravity, part of Pissarro's intellectual and moral grip on life, has come between him and the public at large, especially when compared with the vivacity of most other members of the Impressionist group. It leads to the realization that he is one of those artists whose work needs to be seen rather than merely talked about: his qualities are apparent only in confrontation with his paintings, face to face. The supposed dourness is then seen for what it is, the expression of an unwavering spirit.

Zola, who appreciated this quality in Pissarro, called him 'a fiercer revolutionary than Monet'. It was he, ahead of the other Impressionists, who first put an Impressionist description into words, when he inscribed a drawing made in 1869 as 'a view looking through a completely transparent haze, the colours melted into one another and flickering.' This becomes particularly apt when applied to Pissarro's early studies of the semi-industrial landscape along the Oise, in which smoking chimneys create atmospheres unseen in nature and factories loom in residential streets.

In his first appearances at the Salon he was catalogued as 'a pupil of Corot'. As his style moved towards the individual realism he was striving for, so his unsold pictures piled up. As a father with other mouths to feed – he was living with Julie Vellay, who had been in service at his parents' home – he was forced to take odd jobs to make ends meet.

*Pissarro. A View from Louveciennes, 1870. National Gallery, London. Pissarro's move to Louveciennes in 1869 marks the beginnings of Impressionism as the influence of Corot gave way to that of Monet. Louveciennes was only a couple of miles from the boating resort of La Grenouillère, where Monet and Renoir painted side by side. Practically all Pissarro's paintings from this decisive period were lost or destroyed during the Prussian occupation in 1870. With them went proof of Pissarro's achievement, as Cézanne was to claim for him, as 'the first Impressionist'.*

# PISSARRO

In those hard times he met Monet, Renoir, Sisley and Bazille when they were at Gleyre's, and he was one of the signatories of their petition for a separate Salon when he and the rest of the group were rejected in 1867. He shared their pleasure in the rural suburbs around Paris, notably Pontoise and Louveciennes, where his landscapes brightened. Like Sisley, he preferred the quiet river banks, winding lanes and rustling fields of the region to the pleasures of city life. He found in the Hermitage district of Pontoise a landscape of modest houses, old palings spattered with soot and pigeon droppings, where women in faded blue cotton hung the linen out to dry, bordering on small farms and orchards and facing the river Oise – all scenes that he delighted to paint. Two paintings of this kind were accepted at the Salon of 1868, where Daubigny was now on the jury and doing his best to let the younger painters in.

In 1870, with Julie and their two young children (they were to have eight in all), he fled from the advancing Prussians to London, where his half-sister lived. He painted 12 London subjects in the next 12 months, in the style of his Hermitage landscapes. The family were staying in Palace Road, Norwood, and Pissarro found congenial suburban subjects all around. One, at Sydenham, includes the Crystal Palace, originally erected in Hyde Park for the Great Exhibition of 1851 and subsequently moved to a dominant site at the top of Sydenham Hill. Also nearby was Lordship Lane railway station, where he painted a view from the footbridge with a puffing train approaching. He found Norwood a 'charming' part of London; and

*Pissarro. Road in Louveciennes, 1870. Formerly in the Mellon Collection.*

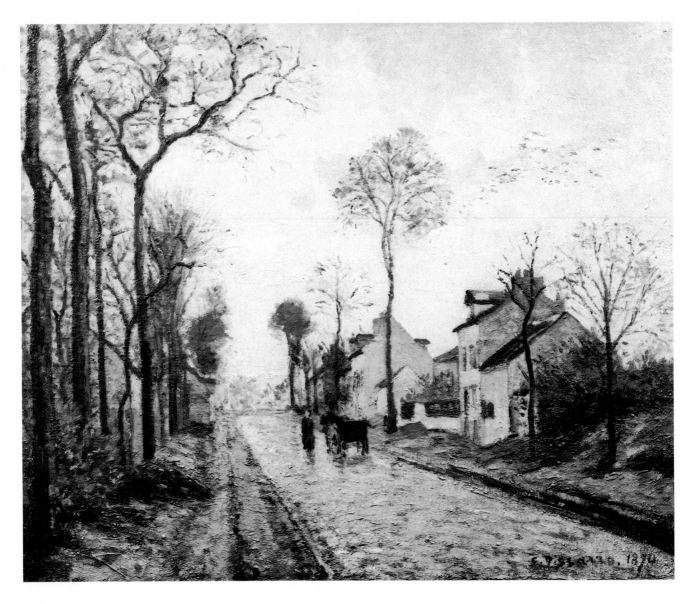

perhaps he developed a particularly soft spot for it.

Not only were members of his family living there – his mother, brother, half-sisters, nephews and neices – but in June 1870 he and Julie were married in the local registry office. He was also seeing a good deal of Monet, who was lodging in Kensington. Altogether, Pissarro seems to have made himself very much at home. Indifferent to any obstruction he might be causing, he would set up his easel in the middle of the road, where the

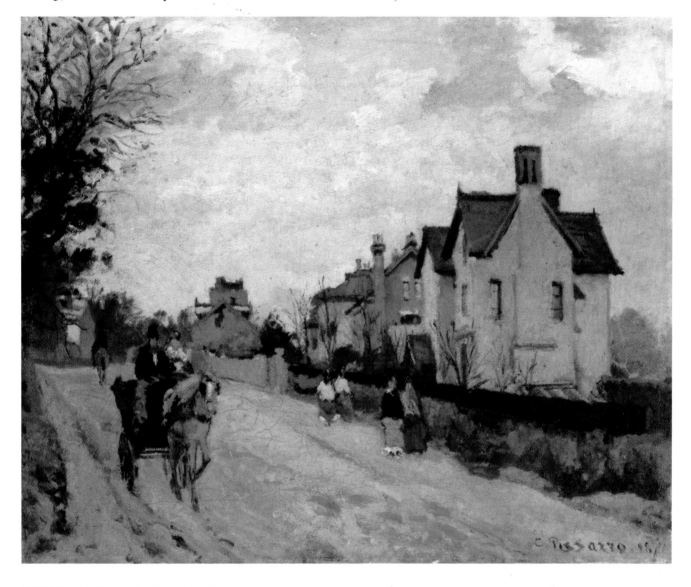

**Above:** *Pissarro.* Street in Upper Norwood, *1871. Neue Pinakothek, Munich.*

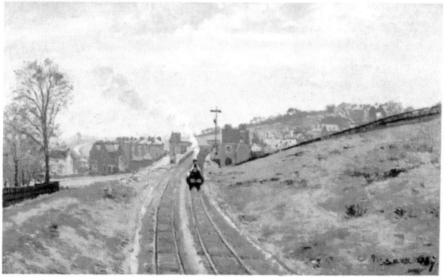

*Pissarro.* Penge Station, *1870. Courtauld Institute of Art, London. Courtauld Collection. The subject has been more accurately identified as Lordship Lane railway station, long since demolished, in Upper Norwood, on the former Crystal Palace line. Pissarro would have found this view from a footbridge to the south of the station.*

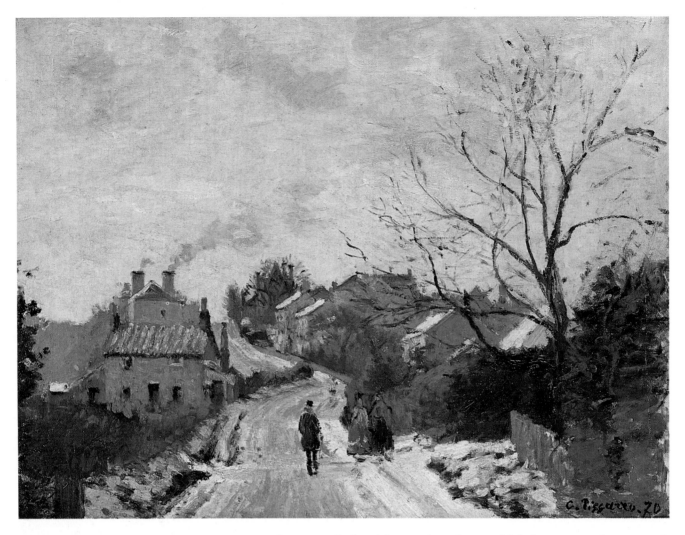

*Pissarro.* Lower Norwood under Snow, *1870. National Gallery, London. Self-exiled at the outbreak of the Franco-Prussian war, Pissarro found congenial subjects in suburban London, sometimes in company with Monet, who had also taken flight. He thought Norwood, where the family rented a small house, 'charming'. The presence of relatives, the Isaacsons, nearby, also helped to make the exile endurable.*

passers-by marvelled at his wooden clogs, which he wore to keep out the winter slush. The English Christmas made a deep impression on him: for years he was to recall its family jollifications, with the pudding blazing and a log on the fire.

There were other French painters in London at the time, among them Daubigny, Legros and Bonvin. There was even a gallery devoted to French art, run by Durand-Ruel, which had recently shown works by Delacroix, Diaz, Corot, Millet and Courbet. On 10 December an exhibition opened there of a group advertised as the Society of French Artists, from which a reviewer cautiously told his English readers there was 'much to be learned'. A second hanging the following March included a couple of works by Pissarro, a *Snow Effect* and *Upper Norwood*, and two by Monet. Both artists were thankful to be able to earn precious funds so far from home. Pissarro recalled that Monet worked in the parks, while he himself studied the effects of fog, snow and springtime.

One subject that brought out the Impressionist lyricism in him was Dulwich College, the public school down the hill from the Crystal Palace, where one of his London nephews, Alfred Isaacson, was due to start the following September. It has the spontaneity of a sketch dashed off in a bright Parisian light.

That summer, both he and Monet entered works for the Royal Academy, and were disappointed. But they took the opportunity to see, for the first time, works by the great English masters. Both men already admired Gainsborough, Lawrence and Reynolds, but they were particularly struck by Turner, Constable and John Crome, the Norwich master, in whom they recognized a shared aim in *plein air* painting and in catching fugitive effects. Pissarro, confronted by Constable's *Haywain* and

the *Leaping Horse*, was impressed by their apparent spontaneity, rough textures and flecks of light. He later retorted that Monet had marvelled at 'the delicate, magical colours' in Turner's paintings, and how the two friends analyzed his technique. Pissarro later played down suggestions of a connection between Impressionism and the English School. It was true, he said, that seeing Turner and Constable had been useful to them, but the basis for their own art was 'unquestionably the French tradition'.

In France things were going badly. There was news from home that Louveciennes had been badly damaged in the fighting around Paris, the houses burned, roofs broken, the Pissarro home reduced to a shell. Some of his things had been saved: two beds, a wash-stand, a desk, and 'about 40 paintings'. Horses had been stabled on the ground floor, and the Prussian soldiers had lived upstairs. A neighbour wrote a few days later: 'We have preserved some paintings. Only there are some which these gentlemen, rather than dirtying their feet, lay on the ground in the garden as a carpet.' Those lost and ruined paintings were Pissarro's contribution to the birth of Impressionism. Not one survived to mark his early comradeship with Monet, Renoir, Sisley and Bazille.

Back in Paris, the friends found the situation deeply depressing, despite the declaration of a new Republic. The same people seemed to be in authority, there was censorship and favouritism, snobbery and reaction, as before. The Salon was, if anything, more unsympathetic to new painting than ever. Courbet had been fined and sentenced for his supposed

### PISSARRO

*Pissarro*. Entrance to the Village of Voisins. *1872. Musée d'Orsay, Paris. Back at Louveciennes, and trying to pick up his career as a painter, Pissarro found his home a wreck and most of his possessions gone. He produced a succession of paintings of Louveciennes which celebrate his homecoming to 'great and hospitable France', in which Impressionism is absorbed into his distinctive palette.*

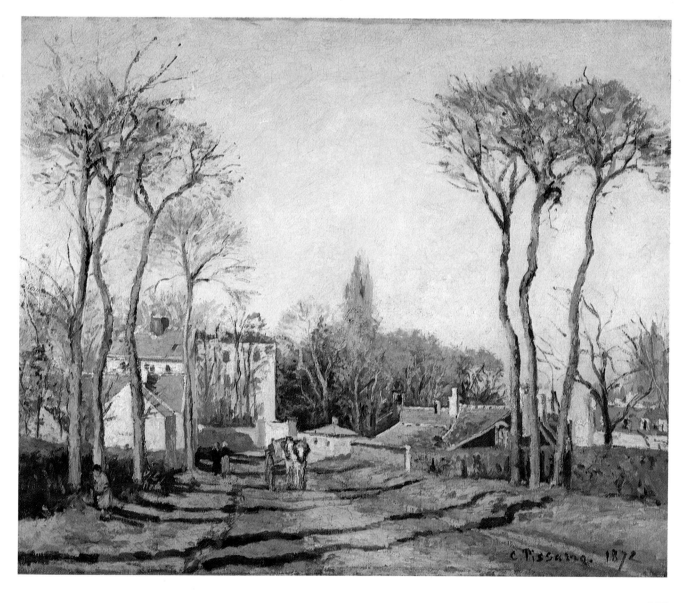

# PISSARRO

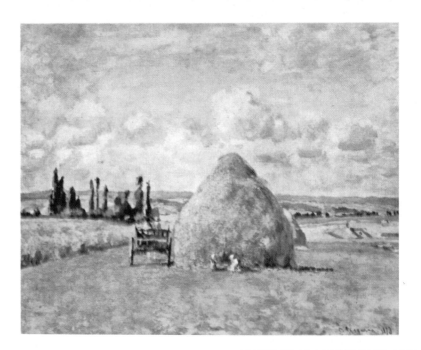

**Right:** *Pissarro.* The Haystack, Pontoise, *1873. Durand-Ruel & Cie, Paris. The novelty of this composition, with its bold central feature around which an entire landscape seems to revolve, indicates Pissarro's growing confidence in the Impressionist method as capable of expressing not merely the evanescence of light and colour, but also the essence of form.*

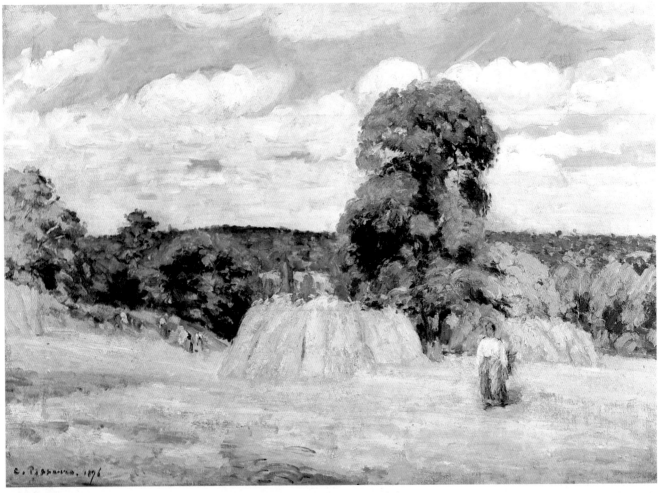

*Pissarro.* The Harvest at Montfoucault, *1876. Musée d'Orsay, Paris. This work, shown at the third Impressionist exhibition in April 1877, was among the collection of his friends' paintings which Gustave Caillebotte bequeathed to the French state in 1894.*

involvement with the Commune. Bazille had not come home from the war. The economy was at its lowest ebb for a generation, in the wake of a lost war and its gruesome aftermath: twenty thousand Communards and sympathizers shot out of hand.

Pissarro, like all his group, came close to destitution; and the times were made still more grievous by the deaths of two of his children. Things cheered up a little when a socialist sympathizer, Julien Tanguy, opened an art shop locally, which soon became a sort of soup-kitchen for indigent painters. He allowed them credit for materials, taking an occasional picture as payment in kind, even providing an impromptu meal. In the six years

from 1874, Pissarro virtually lived off Tanguy's indulgence, running up a bill of over 2000 francs and letting him have paintings for 50 francs each. Suddenly a new way out presented itself: to hold a lottery for one of Pissarro's pictures. A hundred tickets at twenty sous, or one franc, would at least be some relief. Pissarro agreed. The hundred tickets found willing punters, mostly among the little servant girls of the Quarter. When the winner's name was called, at the pastry shop of the instigator, Eugène Murer, one of the girls rushed up to claim her prize. As she caught sight of it, standing among the delicacies, fruit tarts and cream buns behind the counter, her face fell. 'If it's all the same to you,' she said at last, 'I'd rather have a cream bun. . .'

Pissarro began spending time with Cézanne, helping him to move away from the muscular Romanticism of Courbet to the lighter Impressionist touch. From Pissarro, Cézanne learned the secrets of broken brush-strokes and enveloping light. Pissarro's tireless attention to his difficult friend, and his steadying influence, set Cézanne on the way to becoming his equal as a technician. In a portrait of Cézanne in 1874, Pissarro shows him in heavy winter garb, fur-hatted, untidily bearded, and inserts into the background various references to the politics of the time, such as a caricature of the prime minister, Thiers, delivering a re-born France, and a cutting from a newspaper praising Courbet as a martyr. A self-portrait by Pissarro at this time shows him, aged 43, with a patriarchal beard prematurely flecked with grey.

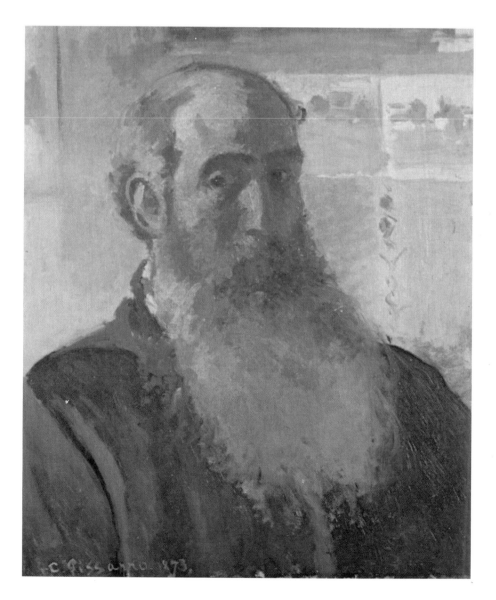

*Pissarro.* Self-Portrait *1873. Musée d'Orsay, Paris.*

# PISSARRO

In a burst of activity he painted a number of rustic genre scenes – peasants in their kitchens, or spinning, or feeding hens – in hopes of reaching a new market; again, with no success. Re-joined by Cézanne, he took to the palette knife on his friend's advice, and in *The Climbing Path, L'Hermitage*, artfully conveyed with touches of the blade its several different levels of terrain. He and Cézanne were by now close enough in their approach and technique to suggest that each was influencing the other. But when Cézanne tried to persuade Pissarro to join him at Aix, recommending a sun that made silhouettes not only in black and white but also in blue, red, brown and violet, Pissarro was not tempted. He preferred the vapour-laden airs of the Val d'Oise to the ruthless sunlight of the south.

In the second Impressionist exhibition in 1876, held in part of Durand-Ruel's gallery on the rue le Peletier, 18 artists showed 240 pictures between them, of which Monet had a dozen, Renoir seven and Pissarro only five, including some delicate studies of snow and fog. As usual, the group were savaged by the press, Pissarro being singled out for painting 'violet trees and sky the colour of fresh butter'. But he was not without supporters. A young painter who had inherited his father's fortune, Gustave Caillebotte, arrived on the scene and began buying Impressionist pictures. Victor Chocquet, a customs inspector, spent every sou he could afford from his modest salary on them. An opera singer, Jean-Baptiste Faure, became an enthusiastic collector. Charpentier, the publisher, also bought several. Durand-Ruel did his best to bring the Impressionists' names to the fore, buying when he could hardly afford to, and adding to his unsold stock.

*Pissarro. Orchard in Pontoise, 1877. Musée d'Orsay, Paris. A view of the orchard behind Pissarro's house at Pontoise, shown at the fourth Impressionist exhibition in 1879.*

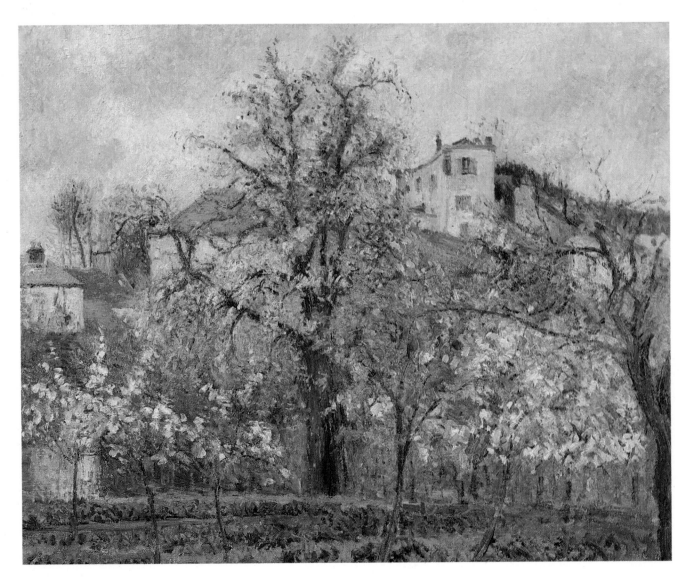

*Pissarro.* The Climbing Path l'Hermitage, *1877. National Gallery, London. The scene of a hillside off the rue Vielle de l'Hermitage is so densely painted as to obscure the two figures on the* track to the left, and even the presence of further buildings to the right. It left the Pissarro family's collection only in *1913*, by which time its value had risen to *13,000* francs.

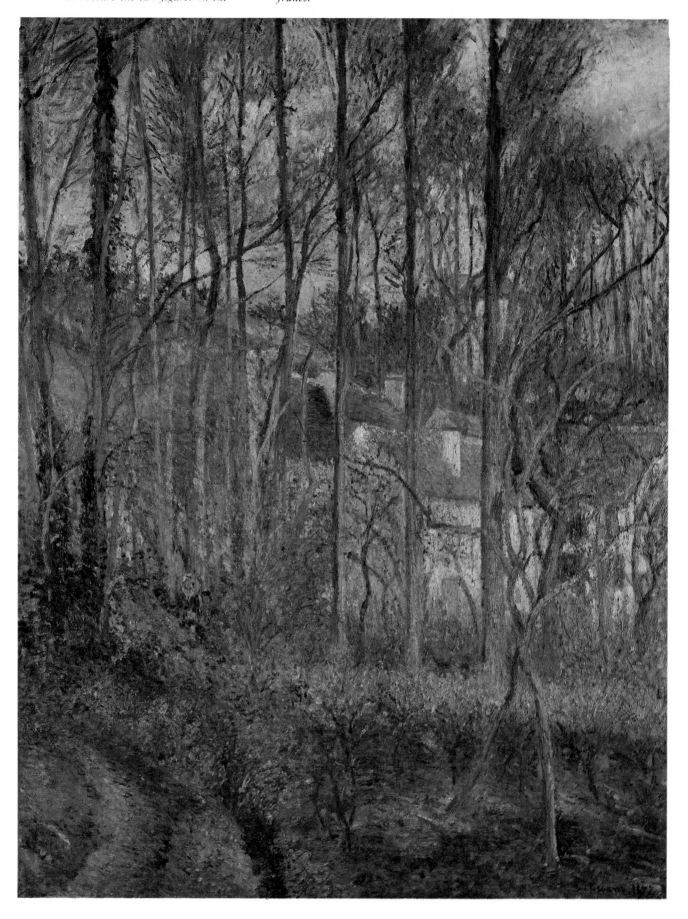

# PISSARRO

He was one of these dealers, uncommon at any time, who elevate their trade above the morals of the market-place by connoisseurship and a readiness to look beyond what appears to be their immediate interest. Durand-Ruel said he would prefer to fight speculators rather than join them. Between 1870 and 1875 he organized ten exhibitions in London, including works by all the group, and lost some of his best clients for doing so. On returning to Paris he found the economic situation so bad that he was obliged to stop buying. To meet his bills he had to sell, at a loss, some fine works by Corot, Delacroix, Millet and Rousseau, as well as earlier French masters. After gradually restoring his business by careful dealing in 'safe' artists, he began buying Impressionists again in 1880.

The 1880s were a no less critical decade. The longed-for breakthrough was still a distant prospect, and as individuals each one of the Impressionists was faced with uncertainty as to which direction to take. Pissarro, the 'hard-line' Impressionist, submitted himself to a ruthless analysis of the aims and ideals he had set out with, while watching his companions disengaging from what he had once supposed were their shared beliefs. Still he reached the same conclusion that he had started out with: if he had to begin all over again, he said, he would follow the same road. As a measure of the disenchantment being felt at this juncture, Monet himself was making it known that he was giving up the struggle. Hearing that the group were intending to mount another joint exhibition that year, he declined to take part, on the grounds that he had not painted anything worth showing.

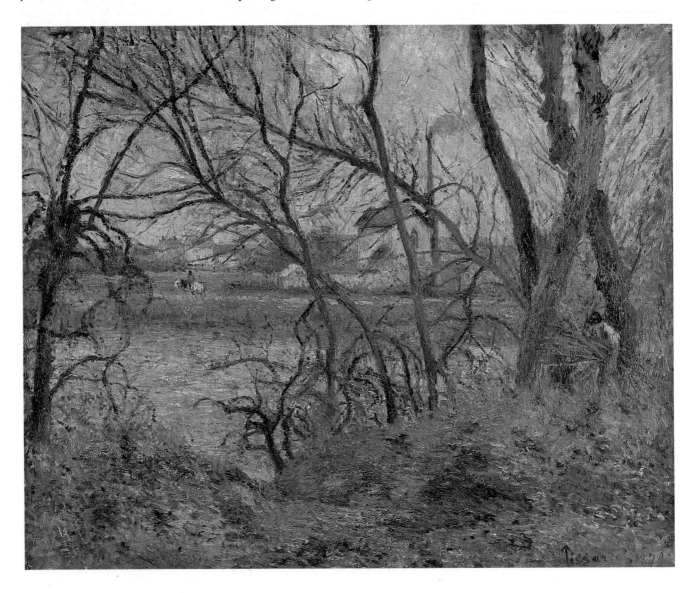

*Pissarro*. A Grey Day, Banks of the Oise, *1878. Musée d'Orsay, Paris. The grey day has not resulted in a grey picture: Pissarro's command of his medium, and the fusion of light and mood, give this modest subject a notable dignity and presence.*

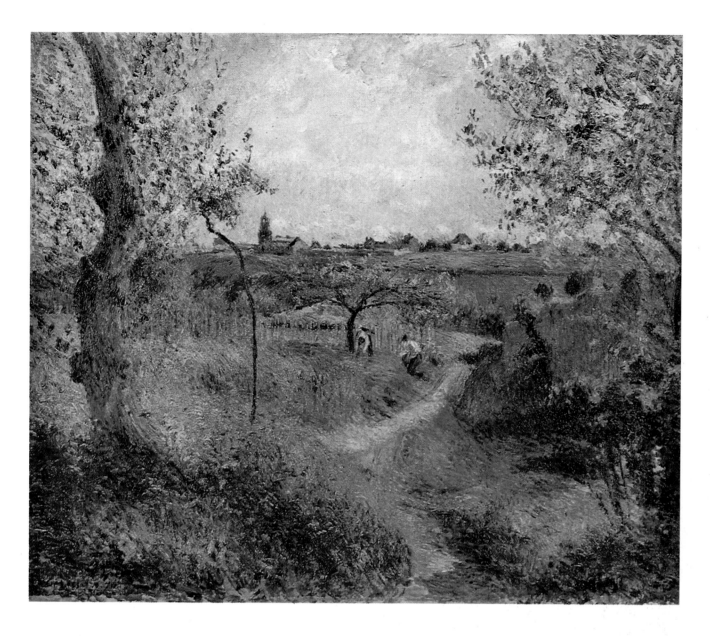

As it turned out, the 1879 exhibition was well attended: ten thousand people came, and each of the exhibitors received a useful share of the receipts, Pissarro among them. Degas, in his resentment towards those who had not supported the show, stirred up ill-feeling in the group. Pissarro, loyal but troubled, began looking at a variant of the group's technique, which its inventors were calling Neo-Impressionism: the use of small vari-coloured dots which, at a few paces, mixed on the retina, creating a new concept, Pointillism.

After the sixth Impressionist exhibition in 1881, Pissarro spent a summer with Cézanne at Pontoise. They were joined by Gauguin, who, escaping from his office desk, took up the cause with enthusiasm. It was he who arranged the seventh Impressionist exhibition, in the process making an enemy of the prickly Degas for urging that it should be open to Impressionists of all complexions, to show that they were not a band of individuals but a movement. Pissarro and Gauguin, though of vastly different temperaments, appear to have struck up a genuine relationship. There is a drawing in the Louvre in which each has made a pencil study of the other, on the same sheet. But Pissarro could not help disapproving of the other's mercenary appetite – 'Not that I think we shouldn't try to sell our work, but I regard it as a waste of time to think only of selling. One forgets art and exaggerates one's own value,' he wrote to Lucien his son.

Meanwhile, he was troubled by what he regarded as his own 'unpolished

*Pissarro. A Path across the Fields, 1879. Musée d'Orsay, Paris. In 1879 Renoir and Sisley refused to support the Impressionist group exhibition, and Monet said he was on the point of giving up. More than 10,000 people attended the show, to which Pissarro contributed 38 works. His share of the proceeds, which were divided equally among the exhibitors, was 439 francs.*

# PISSARRO

and rough execution'. This may have been a factor in his sudden conversion to Pointillism. In superficial terms it did brighten his technique; but it was to prove a dead end, as the Pointillists themselves discovered, and Pissarro's digression from the trodden path led him nowhere. It dismayed his old friends – illogically, since some of them were themselves looking for ways out – and upset even the faithful Durand-Ruel, who refused to buy any of Pissarro's paintings in the Pointillist manner. Pissarro's response, having put Neo-Impressionism behind him, was to put more *brio* ('vigour') into his old, familiar style, lighten his palette and turn to urban street-scenes. These were painted mostly from a lofty viewpoint that gave a panoramic sweep to the composition, in which figures, horses, omnibuses and carriages below were picked out in bright, bustling perspective. At once the critics responded favourably. Gustave Geoffroy, one of the Impressionists' early supporters (he had written, in defence of their first exhibition: 'One more step and their paintings would have been handed over to the firing squad') called attention to Pissarro's feeling for 'the largeness of the world, the agitation of human existence, the tumult of the boulevards.' The new works began to sell well.

In 1900 a Great Centennial Exhibition was held in Paris, at which the Impressionists were given a room to themselves in the new Grand Palais. The paintings, chosen by Durand-Ruel, included works by Monet, Renoir, Sisley (who by then had died) and Pissarro. The young Matisse, who had been commissioned to decorate the gallery, asked Pissarro, 'What is an Impressionist?' He replied, 'A painter who never makes the same

*Pissarro. The Little Country Maid, 1882. Tate Gallery, London. In 1882 Pissarro moved from Pontoise to Osny, nearby, where he was joined by Gauguin. In this work he adopts the sharply-cropped composition that entered Impressionism through photography, and a touch which anticipates the Pointillism of a few years later. On the wall hang a still-life in pastel and a Japanese watercolour. The child has been identified as the artist's fourth son, Ludovic-Rodolphe. The painting was bequeathed to the national collection by the artist's son Lucien, who worked in England.*

**Right:** *Pissarro. The Pork Butcher, 1883. Tate Gallery, London. As his style tended towards Pointillism, Pissarro moved away from Impressionist techniques. He had not turned his back on his friends, but was excited by the prospect of a new departure. For The Pork Butcher he would have drawn on the weekly market at Pontoise: there is a glimpse of the local church in the background.*

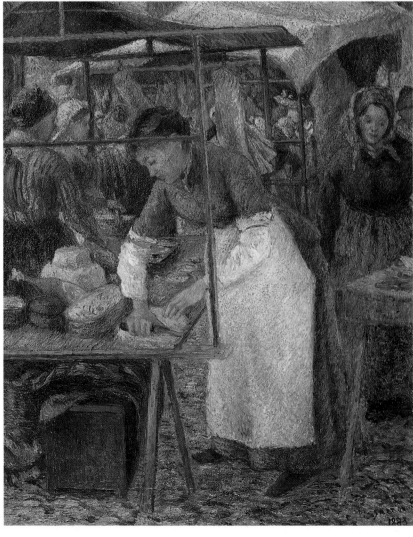

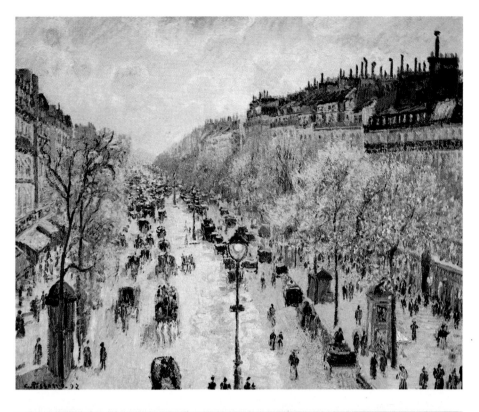

*Pissarro.* Boulevard Montmartre
in the Spring, *1897. Private
Collection. Landscapes scenes came
less easily to Pissarro in his old age
than scenes of city life, such as this
painting and the one below, which
were both painted in the same year.*

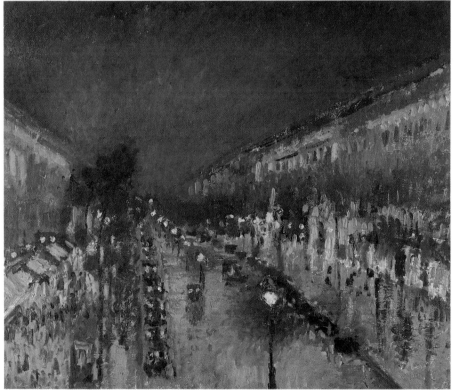

*Pissarro.* Boulevard Montmartre at
Night, *1897. National Gallery,
London.*

picture twice.' By then the fight seemed to be over, and the suffering with
it. Pissarro and his family were enjoying relative prosperity. In 1900 his
earnings were 44,000 francs, an unheard of sum by his standards. A year
later a single work of his fetched 10,000 francs at auction. In 1903, two of
his paintings were bought by the Louvre. On 13 November that year he
died. They buried him in the family plot. Monet, Renoir, Vollard and
Durand-Ruel were among the old friends who saw him laid to rest.

Some time later, when Julie, who inherited half his estate, complained to
Lucien that some people were calling his works old-fashioned, Lucien
replied: 'Don't worry about father, he will not be forgotten.'

133

# 11 Sisley

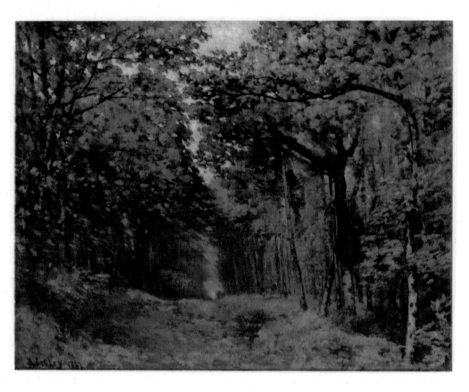

*Sisley.* Avenue of Chestnut Trees near La Celle St. Cloud, *1867. Southampton Art Gallery.*

In Frédéric Bazille's *The Artist's Studio*, painted in 1870, he gives a glimpse of half-a-dozen of his circle in those formative years of wild ambition and ready friendship. The studio is hung with a couple of still lifes and three larger, framed paintings of figure subjects, including two nudes. A group of young men, formally dressed, are present. Edmund Maître, who shared Bazille's passion for music, is playing the piano in one corner. The lanky form of Bazille is in the centre, showing a picture to Manet and Monet. On the steps is Zola, having a word over the banister with a seated figure who is almost squashed out of the picture.

That figure is Alfred Sisley, the Englishman who had given up a career in his father's business in London to be a painter. His father had provided him with enough support to come to Paris, find suitable lodgings, and sit down in Charles Gleyre's painting classes with the likes of Monet and Renoir, in a class ranging from grizzled veterans of the art-circuit to unruly adolescents looking for a bit of fun. Gleyre's classes were well attended, partly because he was no martinet, and partly also because he did not seem to mind if some of his poorer pupils could not keep up with the fees. Sisley, it appears, was among the more conscientious of Gleyre's pupils (like Renoir and Bazille, but unlike Monet) and even had ambitions to pull off the prestigious Prix de Rome. Gleyre, though a dutiful teacher in the academic mould, was too negligent to correct his students' exercises; Renoir said later that he was 'no help at all', with his stuffy ways and objection to bright colour. He added: 'While the others larked about, I sat quietly in my place, attentive and docile, studying the model,' adding mischievously, 'and it was I whom they called the revolutionary!' He, Sisley and their group probably learned more from Monet – he, after all, had already painted with Boudin and Jongkind – than they did from Gleyre, who anyway closed down his establishment in 1864. Abandoning the student life, Sisley and Renoir began living and working together in Paris and in the Forest of Fontainebleau, with Sisley, in all probablity,

*Sisley.* View of Montmartre, *1869.*
*Musée Municipale, Grenoble. A*
*view from the Cité des Fleurs, before*
*urban development overwhelmed the*
*scene. Montmartre, however, did not*
*lose its hold on artists' affections:*
*within 20 years it was to be*
*immortalized by Toulouse-Lautrec.*

*Sisley.* The Canal St Martin, Paris,
*1870. Musée d'Orsay, Paris. .*
*Sisley's genius in painting water*
*enabled him to use it as a second*
*source of light (see page 136 for*
*another version of this Parisian*
*water way, painted two years later).*
*As usual with Sisley, atmosphere*
*prevails over incident and detail.*

**Right:** *Sisley*. The Canal St
Martin, Paris, *1872. Musée
d'Orsay, Paris.*

**Below:** *Sisley*. Square in
Argenteuil, *1872. Musée d'Orsay,
Paris.*

paying the bills out of the allowance from his father in the City.

In 1866 he married a Parisienne, Marie Eugénie Lescouzec, a well-bred girl, according to Renoir, who had had to take up posing when her family suffered some financial misfortune. The young couple's children, Pierre and Jeanne, make their first appearance in *The Lesson*, painted in 1871. Meanwhile, fatherhood did not prevent Sisley from keeping up his visits to the Café Guerbois for conversations among the Batignolles set, whose common bond was 'a contempt for official art and a determination to seek the truth away from the beaten track', as John Rewald has called it. There is a painting of them by Fantin-Latour, *A Studio in the Batignolles*, showing Manet at his easel with Renoir; the poet Astruc; Émile Zola, Maître, a philosopher and musician, Bazille, Monet, and the German painter Otto Scholderer. We might wonder why Fantin-Latour left out Pissarro, already a prominent member of the company, and young Sisley. Both were among the group with Monet, Renoir and Berthe Morisot, who tried their luck by putting some of their paintings up for auction at the Drouot Galleries – an occasion which ended in one outraged spectator calling Berthe Morisot a streetwalker. Pissarro punched the offender in the face, a brawl started, and someone called the police. (Not a single picture was sold.)

Sisley's world is not so much that of the cafés and boulevards as of the quiet countryside, especially along rivers and water-meadows. His paintings have a quietude which gives them a distinctive mood, achieved by his sure touch with both colour and tone. They are undemonstrative pictures, reflections of a private nature. The lack of documentation in his life can be partly attributed to his preferred solitariness – though from all

## SISLEY

*Sisley*. Footbridge at Argenteuil, *1872. Musée d'Orsay, Paris. This original view, showing the rolling countryside beyond the ranks of the small houses, was shown at the third Impressionist exhibition in 1877.*

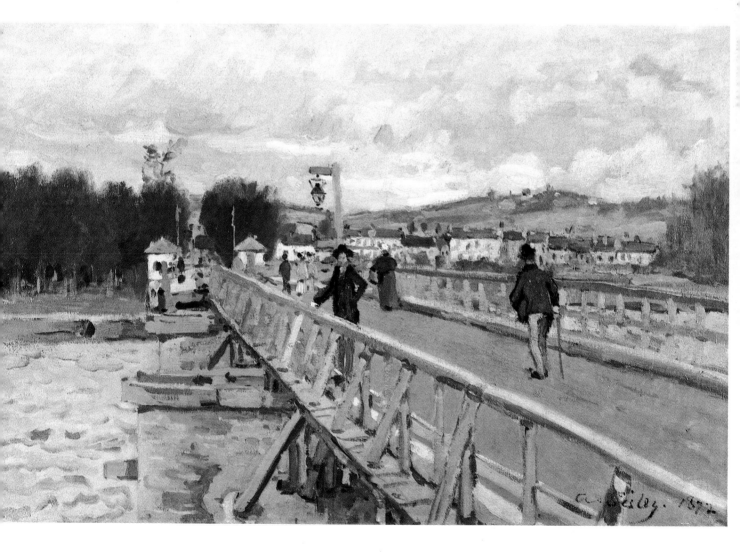

accounts he was vivacious enough in his own home, a life shared with his attractive wife, whom it is tempting to identify as the girlish figure who graces several of Sisley's landscapes in 1866.

By degrees, after a conventional start, Sisley began to find his own style and palette. Increasingly, his free but carefully varied brushwork and feeling for suffused light give his best work an air of contained energy, an undramatic mastery which recalls Corot. His Salon pictures of 1866, two views of the views of the village of Marlotte, are pitched in the 'safe' area between tradition and innovation. They were the first pictures of Sisley's to be accepted for the Salon, and they succeeded more by charm than by effort, painted in beguiling low tones enlivened by sudden touches of colour. In Sisley's early work the structure often seems flabby, however well realized the passages of natural description. The impact of Monet does not appear until 1869, when Sisley seemed more ready to leave the studio and work out-of-doors. Encouraged by his friends, and by Durand-Ruel who began buying some of his pictures, he strove to mend his fortunes after the collapse of 1870. To save on expenses he moved his home from Paris to the semi-rural suburbs, first to Louveciennes, then to Marly-le-Roi and Sêvres. His favourite painting ground became the narrow reaches of the Seine with their towpaths, bridges and tranquil river traffic. His eye for interestingly solid forms – pillars, bridges and arches, ironwork – also becomes apparent.

In 1870 he scored his first public success, acceptance at the Salon. Four years later, on a visit to England, he painted several versions of the bridge at Hampton Court, then newly built, including one of the structures seen from underneath. A pair of scullers slide by, dwarfed by the pillars and beams.

*Sisley*. The Bridge at Hampton Court, *1874. Wallraf-Richartz Museum, Cologne. Sisley spent four months in England during the summer and early autumn of 1874, and found the light there no less sympathetic than in suburban Paris.*

In the same year he painted the aqueduct at Marly, in which a passing horseman contributes the necessary counterpoint of grace and motion. Some of his last paintings, in the 1890s, were to return to the observation of light on mass. His oil studies of the church of Notre-Dame, at Moret, show the effect of light on the ancient stones, first in sunshine and then in rain; a response, perhaps, to Monet's paintings of Rouen Cathedral, which he might have had a chance of seeing in his friend's studio.

The 1870s were to be his great decade, in both output and sustained quality. His work took on a new confidence and freedom of touch that put it in the same category as Monet and Renoir, in which the animation of the subject is given cohesion by a suffusion of delicate light. There is nothing in his earlier work – such as remains of it – to prepare us for the *Isle Saint-Denis* of 1872, the *Wheatfields near Argenteuil* of 1873, or the supremely delicate *Misty Morning* a year later. His paintings of floods along the swollen Seine, a favourite subject, have no equal except in Pissarro. As his palette gradually brightened, it reached an exuberant pitch in his *Regatta at Molesey*, painted on a visit to England in 1874, which gleams with Turner-ish radiance.

There is also a notable strengthening of the skies, which, however sombrely painted, remain in Sisley's pictures a source of light. True to his eye, he continued to paint what he saw, not what he knew to be there – an essentially Impressionist principle to which he remained as loyal as the arch-Impressionist, Pissarro. A letter survives in which Sisley explains how a picture can be painted in more than one manner – tiny touches to capture the sparkling quality of light on water, smoother passages for fields and skies. A critic writing at the time, Jules Laforgue, might have been describing Sisley's art when he wrote of the Impressionists' abandoning the 'three supreme illusions' of academic painting: line, perspective and studio lighting. He went on: 'Where the one sees only the external outline of objects, the other – the Impressionist – sees the living lines, not put together geometrically but in a thousand irregular strokes which, seen at a distance, establish life. Where the one sees things placed in perspective planes, according to theoretical design, the other – the Impressionist again – sees perspective conveyed by a thousand little touches of tone and brush, and by all kinds of atmospheric states.'

Sisley exhibited at the historic debut in 1874 in Nadar's studio; he showed five paintings, the same number as Pissarro and Monet. Between them, the Impressionists-to-be acounted for 64 of the 165 works accepted by the committee. One of the less contemptuous of the critics, Armand Silvestre, concentrating on Monet, Sisley, Pissarro and Degas, wrote: 'A blond light bathes them and everything is joyfulness, clarity, feasts of spring, golden evenings or blooming apple trees. Their canvasses seem to open windows on a gay countryside, on the river carrying speedy scudding boats, on the sky streaked with light vapours, on cheerful and charming life.' He then proceeded to find fault with them for holding that 'in nature everything is of equal beauty'. Sisley would have been content to take his medicine in the company of his friends, and also the barbed compliment of Jules Antoine Castagnary, a critic of some weight, that 'these young men have a way of understanding nature which is neither boring nor banal', while adding that 'the famous Salon des Réfuses, which one cannot recall without laughing, was a Louvre compared to this exhibition.'

By the 1880s critics were beginning to accept Impressionism on its own terms. Sisley, among the rest, attracted comment as a true innovator in a kind of painting described by a German commentator as 'rendering the fleeting impact which our surroundings make on us. This method leaves out a number of details, and above all tries to capture a whole, a mood, regardless of how incomplete it may seem according to ordinary

*Sisley*. Wheatfields at Argenteuil, *1873. Kunsthalle, Hamburg. Sisley spent the two years of war and siege in Paris, then moved out to paint with Renoir at Louveciennes. He was among the handful of modern French painters whom Durand-Ruel exhibited in his London gallery in 1871 and 1872. At the time he painted this grandly confident landscape he was destitute, his father having died in bankruptcy. The following year, 1874, he joined the rest of the group in the first Impressionist exhibition.*

conceptions.' Of a work by Sisley, a coastline with villas, he added that it was so delicately light and shimmering, so harmonious in composition, that he could find no fault with it. 'Here is no attempt to paint anything which could not, at will, be made out by the naked eye. The painting achieves its effect by its airy lightness and unique harmony.'

Sisley, however, could still find few buyers. Only Durand-Ruel's encouragement, and the arrival on the scene of the enthusiastic Victor Chocquet, the customs official and private collector, held out any promise of better times. Chocquet became a friend as well as a loyal patron. It was Renoir who found him, and who helped him to circumvent the vigilant Mme. Chocquet in the course of his transactions. Both he and Cézanne painted Chocquet's portrait, and other members of the group had dealings with him.

Sisley exhibited in the next two Impressionist exhibitions, 1876 and 1877, but with no success. With debts mounting, he left Marly and moved the family to Sèvres, and was one of the impecunious painters, Pissarro among them, who were helped by the warm-hearted restaurant owner and pastry fancier, Eugène Murer. Nothing changed. Sisley was too dispirited to offer his work for the fourth Impressionist exhibition in 1879, but thought he would try the Salon again. As he told Théodore Duret, 'It's true our exhibitions have served a purpose by making us known, so they have

*Sisley*. Regatta at Molesey, *1874. Musée d'Orsay, Paris. Here Sisley invests an English sporting event with a French élan, the racing oarsmen in their white vests as fleeting as the gleams of light on the Thames.*

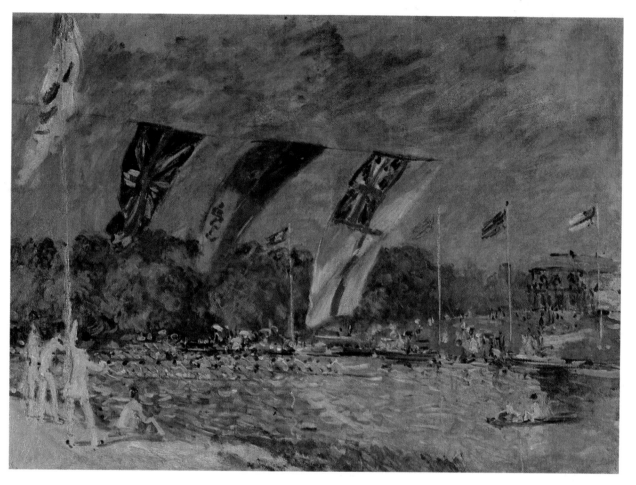

*Sisley*. Misty Morning, *1874. Musée d'Orsay, Paris.*

# SISLEY

**Above:** *Sisley.* The Rest by the
Stream, *1878. Musée d'Orsay,
Paris. The figure in a landscape, one
of the first themes to identify the
budding Impressionists, becomes in
this work a summer idyll in the
peace of rural France.*

**Right:** *Sisley.* The Watering-place
at Port-Marly, *c.1875. National
Gallery, London. A favourite theme
of Sisley's was the conjunction of
elements, one of them water, shown
here against the rugged outlines of
posts and walls.*

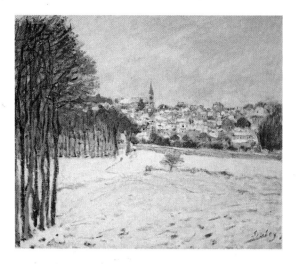

*Sisley.* Snow at Marly-le-Roi, *1873. Musée d'Orsay, Paris.*

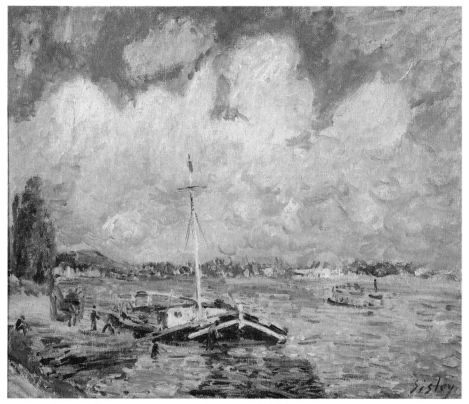

*Sisley.* Boats on the Seine, *c.1877. Courtauld Institute Galleries, London. Courtauld Collection.*

been useful. But I don't feel we should isolate ourselves any longer. It will be a long time before any of our shows carries as much prestige as the official ones.'

Both the paintings he submitted to the Salon that year were turned down. Now penniless, he was evicted from his home, wife, children and all. Renoir's patron, Georges Charpentier, promptly sent him enough money to enable him to move into another apartment. From there, looking for a suburban area where rents were cheaper, he moved to Moret-sur-Loing, south of Paris, close to Marlotte, which was to be his home for the rest of his life.

Durand-Ruel, who held stocks of paintings by all members of the group, suggested a change: instead of joint exhibitions, he proposed a series of one-man shows, beginning 1883. None of the painters thought much of this idea; it was contrary to all their principles of unity. Sisley, as desperate as any of them to sell his pictures, nevertheless had little faith in their dealer's change of heart. Experience showed, he told Durand-Ruel, that collective exhibitions were more often successful than one-man shows, adding that he did not believe that 'the moment we stop being nomads and

have a definitive establishment in a good location, we should think of starting another exhibition trying something different.' The object, he argued, was not so much to show a lot of paintings as to do what was necessary to sell the ones they produced. But only Degas protested so furiously that he was left out. That year Durand-Ruel mounted exhibitions of Boudin, Renoir, Pissarro, Monet and Sisley in Paris.

Meanwhile, he had been making efforts to sell the Impressionists in London, first in the summer of 1882 and again the following year, when works included eleven by Pissarro, nine by Renoir, and eight by Sisley, along with others by Manet, Monet and Degas' American friend and model, Mary Cassatt. As usual, the exhibition was badly reviewed, following an exhibition in Bond Street of etchings by Whistler, presented in a dramatic decor of white and lemon yellow, which had helped to put the critics in an anti-modernist mood. 'It is something for Londoners to have in their midst a source of comic entertainment,' scoffed the *Morning Post*, 'which Parisians heartily enjoy.' Pissarro wrote to Monet: 'Sales are at a standstill in London and Paris. My show' – the one-man show in Paris – 'did nothing as far as receipts are concerned. As for Sisley, it is even worse – nothing, nothing at all.' Pissarro would have been particularly upset by the failure of Sisley's paintings to sell, as he had helped to choose them.

Nor was it the end of this dismal spell. Durand-Ruel, who had been paying Sisley small regular sums to keep him from total penury, taking paintings in exchange, was suddenly faced with a crisis of his own; his backers, a French insurance company, went bankrupt. The payments to Sisley dried up, and the dealer was left with a huge stock of apparently unsaleable paintings. In November 1885 Sisley appealed to him that he could not pay the butcher and the baker, and did not know how he was going to get through the winter. Again Durand-Ruel managed to help. Sisley, disregarding pleas to exhibit at the eighth – and, as it turned out, final – Impressionist exhibition, doggedly kept on painting.

Something, sometime, had to break this cycle of despair. The next year, 1886, Durand-Ruel took three hundred Impressionist paintings from his stock to New York. There were 50 by Monet, 42 by Pissarro, 38 by Renoir, 17 by Manet, 23 by Boudin, 15 by Sisley, plus a group by Seurat and his friends. He saw this venture, rightly, as crucial both for his own business

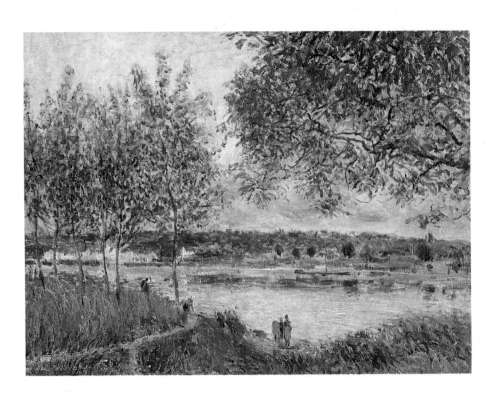

*Sisley.* Path to the Old Ferry at By, *c.1880. Tate Gallery, London.*

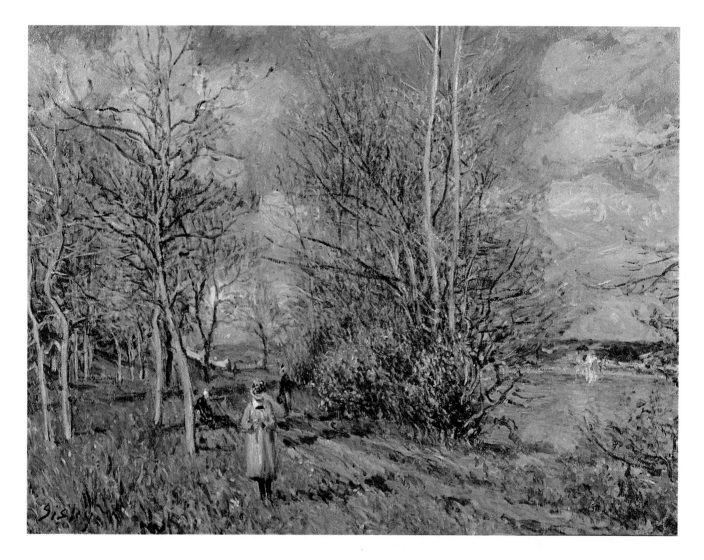

and for the whole modern movement in French painting. Despite the usual witticisms, New Yorkers received the exhibits in a friendlier spirit than Durand-Ruel was by now accustomed to. Thanks to this, and also to the efforts of Mary Cassatt in promoting the artists in her own social circles, the exhibition was a financial success. In terms of hard cash, there was not much for Durand-Ruel, to distribute among his needy artists; but at least he brought back better news.

Durand-Ruel rebuilt his stock of Impressionists over the next two years, then mounted an exhibition in Paris of works by Pissarro, Renoir and Sisley. Monet, a notable absentee, had acquired a new dealer, Vincent Van Gogh's brother, Theo. Sisley's *September Morning* was bought at that exhibition for the French national collection, whereupon the delighted artist, in a rush of gratitude, at once applied to become a citizen of France. Durand-Ruel continued to have faith in him – Sisley was painting, if anything, better than ever – and gave him a one-man show in New York in 1889. Pissarro, after lunching with him April that year, reported in a letter to Lucien: 'I had not seen him for at least two months. He seems so happy at the moment, he is floating.'

Sisley must have relished such fleeting moments, for fleeting they were. In New York, his paintings did not find buyers, unlike Renoir's. He quarrelled with Durand-Ruel over the prices he was charging, perhaps unfairly, given the dealer's proven faith in his work. Another dealer, Georges Petit, Durand-Ruel's main rival, took him on and mounted a retrospective exhibition in 1897, consisting of 150 paintings. Not one was sold. By now physically as well as mentally at a low ebb, Sisley made his last crossing of the Channel to paint in South Wales. He had never painted the

*Sisley*. Small Meadows in Spring, *c.1885. Tate Gallery, London. The Seine and its riverside were within a stroll of Sisley's home at Moret-sur-Loing. A glimpse of water through trees was a favourite motif for much of his life.*

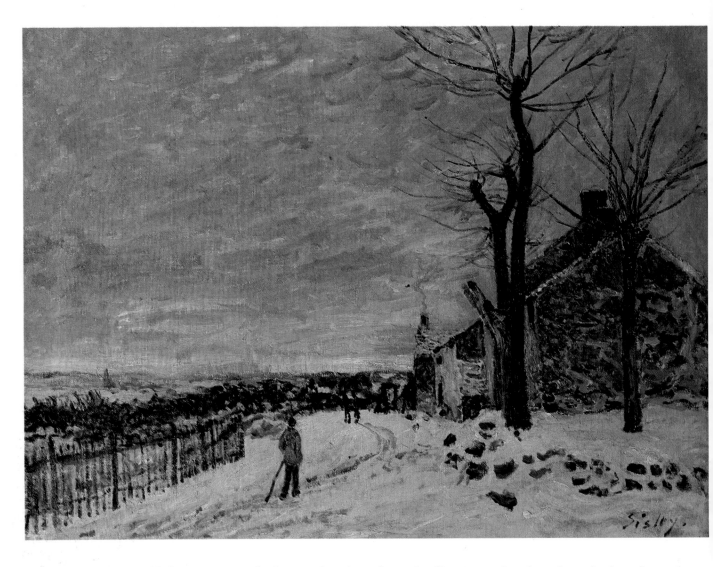

*Sisley.* Snow at Veneux-Nadon, *c.1880. Musée d'Orsay, Paris. This is the kind of weather, daunting for any but the most dedicated artist, that caused Sisley to suffer from bouts of facial paralysis, and which hastened his end. As his strength failed he lost touch with his old friends, for some of whom the hard times, by then, were over.*

sea before, or beaches along the Gower peninsular where bathers braved the treacherous tide.

During the last decade of the Impressionists' struggle for recognition, Sisley, though wholeheartedly in sympathy with them, remained shut off, a background figure in what had once been a close circle of like-minded friends. His disappointments seemed to drive him even deeper into himself, and the unexpected poverty he had to accept following his comfortable upbringing and the collapse of his family's finances seems to have changed his sunny-tempered optimism to bleak unsociability. His old companions – not all of them easy to get along with – found him increasingly morose. This must have been due largely to a partial paralysis of the face, caused by painting out-of-doors in freezing weather. Equally, though, it can be attributed to his permanent state of depression over his apparent lack of success as a painter, the humiliation of having to beg pittances from his dealer, and, towards the end, envy of the friends and equals who were at last making their name. Asked which contemporary artists he liked best, he named Delacroix, Corot, Millet, Rousseau and Corbet – not one of his lifelong comrades.

On his return from his last visit to his native land, his wife, overwhelmed by a strange weakness, languished and died. Sisley was also ill, suffering from cancer of the throat. Towards the end, he sent for Monet, who hurried to him at once, begging him to do what he could for the children.

He died on 28 January 1899, and was buried in the graveyard of the church at Moret. Monet, Renoir, Pissarro and other friends who cared for him were there. Afterwards, Monet set about securing the posterity his friend deserved, insisting that Alfred Sisley was a great neglected painter. He helped to organize a sale of the work left in Sisley's studio, as a means of raising money for the children. Dealers and collectors descended on Moret-sur-Loing. Everything was sold. Within a year, a painting for which he had once accepted 100 francs was sold for 45,000. It was the *Flood at Port Marly*, one of three versions which he painted in 1876. It is now in the Louvre.

Sisley has the distinction of being grouped with Monet and Pissarro as one of the three most consistently 'pure' Impressionists. His apparent ease and sureness of touch were the result of careful thought and preparation, not of a quick, instinctive genius. In this he is closest to Pissarro, and in many respects his equal. Eugène Murer, whose support had helped both Pissarro and Sisley through desperate times, ranked him as 'the most sensitive of the Impressionists, with the soul and brush of a poet.' Pissarro, in a letter to his son Julien written a week before Sisley died, said: 'Sisley, I hear, is seriously ill. He is a great and beautiful artist, in my opinion a master equal to the greatest.'

*Sisley*. Barge during floods at Port Marly, *1876. Musée d'Orsay, Paris. His series of paintings of flood at Port Marly are Sisley's unique contribution to the Impressionist achievement. In them, the human predicament is secondary: the event is an act of God, impassive, indifferent, and with its own dignity.*

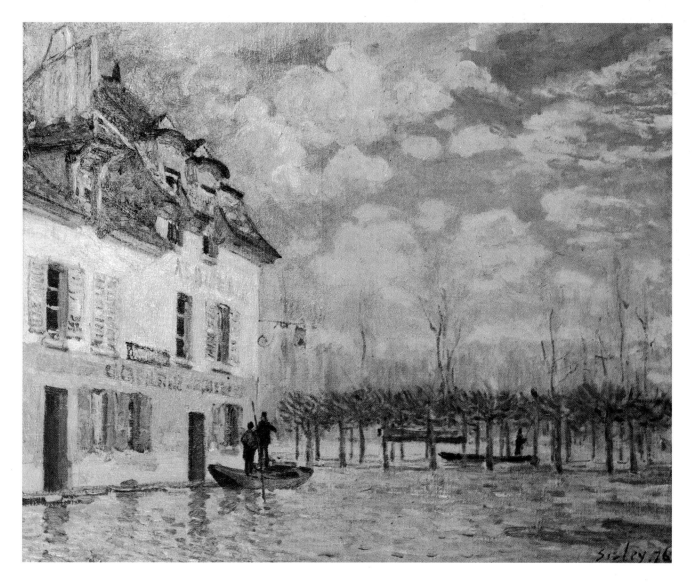

# 12 Cassatt

**Above:** *Cassat.* Mother and Child. *Musée d'Orsay, Paris. Mary Cassatt's studies of maternal love are poignantly realistic for a woman who was childless herself, and by all accounts of a spinsterly disposition. She was much respected by the Impressionists and their friends, whose eventual acceptance, notably in the United States, had much to do with her bringing their work to collectors' attention when they most needed it.*

**Right:** *Degas.* Miss Cassatt at the Louvre, *1880. Philadelphia Museum of Art, Pennsylvania: the Henry P. McIlhenny Collection. In memory of Frances P. McIlhenny. Degas and Mary Cassatt enjoyed a close, and probably platonic, relationship. They admired each other's work, and she makes appearances in his paintings as a willing model, on outings, or shopping, sometimes trying on a hat, with a delighted Degas, one imagines, sketching such feminine moments for future use. Her dress was always, it seems, neat and ladylike, as this study suggests.*

Mary Cassatt, who figures in Degas' life as a close companion, and in his work as a stand-in model, was born in Allegheny, now Pittsburg, U.S.A., in 1844, the daughter of a successful stockbroker and property speculator. When she was seven years old her parents moved with her to Paris, and on returning to Pennsylvania allowed her to attend the city's academy of fine arts. In 1866, she prevailed on her parents to let her return to Paris to complete her art education. She worked first in the studio of Charles Chaplin, a fashionable and well-connected painter, at the same time spending hours, as was expected of art students, copying works in the Louvre. Meanwhile, she became familiar with the work of the current avant-garde among French artists, including Courbet and Manet.

In 1870, caught up, like everyone else in Paris, by the Franco-Prussian war, she hastened back home. Two years later, when it was safe to return, she sailed back to Europe. But before settling again in Paris she spent eight months in Italy, studying the old masters and taking further lessons, followed by shorter stays in Madrid, where she studied the masterpieces in

the Prado, and Seville. At length, after a further stay in Antwerp, to acquaint herself with the Netherlandish and Flemish Schools, she arrived in Paris.

Though she was successful in having works accepted for the Salon for five successive years, her own painting at this period lacked any great individuality. But her art, and her life, were about to change. Among her widening circle of friends and acquaintances in the Paris art world, she met Degas. He was already a hero of hers: his pastels, which she had seen in the window of a picture dealer on the boulevard Haussmann, had caught her eye. 'I used to go and flatten my nose against the window and absorb all I could of his art,' she said. He, recognizing in Mary Cassatt a likely recruit to the band of secessionists from his bête noire, the Salon, took to her at once. For her part, she looked forward to freedom from the vagaries of Salon juries and absolute independence as an artist, like the rest of Degas' circle. 'I had already recognized who were my true masters – Manet, Courbet and Degas,' she confessed. She took leave of anything to do with Salon painting and, in her own words, began to live.

Much of her character comes through in the likenesses of her that Degas includes in such works as *At the Milliner's*, a pastel of 1882, in which she is shown trying on a green hat to match her suit. She was not conventionally good-looking, but her face reveals an alert intelligence and a sense of humour, both of which were much to Degas' taste. She was fond of clothes and dressed well. Degas seems to have enjoyed accompanying her on shopping trips, and to have used her as a model on such excursions. Her trim, rather angular form can be glimpsed in his paintings, visiting the Louvre with her sister Lydia, or as a chic figure half-hidden behind a pillar, leaning on a rolled-up umbrella. In *Mary Cassatt Holding Cards*, Degas catches the half-wistful expression of a spinsterly woman devoid of vanity, her blue eyes withdrawn.

There is still conjecture about their relationship, but it was no artist-and-model liaison. Both she and Degas had the protective pride of individual spirits. Respect for each other was enough to seal a friendship between two unusually self-sufficient characters. 'Oh, I am independent,' she told an American friend. 'I can live alone and I love to work. Sometimes it made him furious that he could not find a chink in my armour.' Evidently, however, something came between them, and their relationship cooled. The woman of whom Degas had remarked, on seeing her paintings for the first time, 'This is real – there is someone who feels as I do', was less dependent on his companionship than perhaps he imagined.

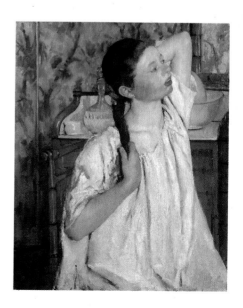

*Cassatt. Girl Arranging her Hair, 1886. National Gallery of Art, Washington DC, Chester Dale Collection. Degas was instantly struck when Cassatt showed him this painting. 'What drawing! What style!' he exclaimed, and acquired it for himself.*

Much of his subject-matter was denied to her as a woman, such as the raucous show-business scene with its backstage goings-on, even the circus and the racecourse. Some of her subjects under Degas' influence reflect an eye for social behaviour akin to his. In a painting showing a woman at the opera, exhibited in 1880, the eye is drawn first to the opera glasses held to her eyes, and then to a balding gentleman in a neighbouring box, leaning forward intently, his glasses trained, unknown to her, on the lady. *Girl Arranging Her Hair*, which was shown in the eighth Impressionist exhibition, though superficially a Degas subject, contains nothing of his keyhole curiosity. The girl sits at an unseen mirror, decorous in her nightgown, her uplifted arm revealing nothing of her form. The model's ordinary little face conveys no sexual charge, but her presence is not to be denied. This is the kind of work Pissarro might have had in mind when he reported to Lucien on a 'very impressive show' Mary Cassatt had had at Durand-Ruel's, adding, 'She really is very able.'

Her strong sense of colour and design is apparent in the prints she made in the 1890s, based on the flat, strong patterns of the Japanese masters whom she and Degas had discovered together. Her colour aquatints of

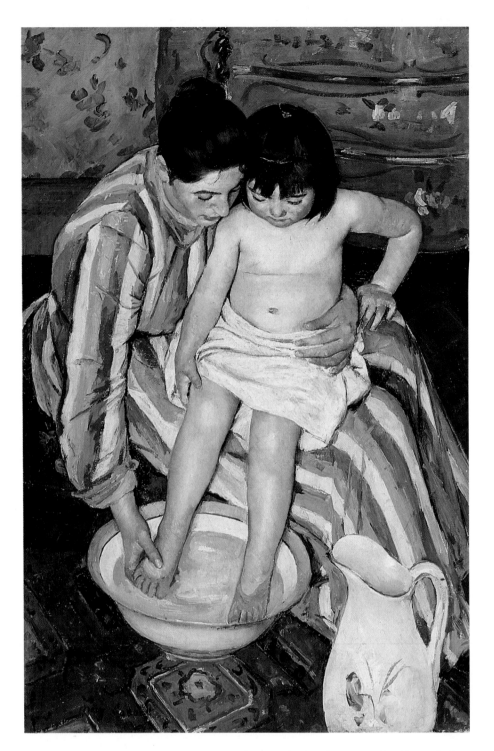

*Cassatt.* The Bath, *1891–92. Oil on canvas, 99.2 × 66.1 cm, Art Institute of Chicago, Illinois. Robert A. Waller Fund, 1910. 2. Mary Cassatt was encouraged by the support of Degas and Durand-Ruel, the Impressionists' dealer, to hold an exhibition of nearly 100 of her works in Paris in 1893, as a prelude to an opening in New York. Surprising as it may seem today, the American début was a failure. 'I am very much disappointed that my compatriots have so little liking for my work,' she wrote to a friend. Ninety years later the great public collections in America, and many of the best-known private ones, compete for her paintings in the salerooms. She has become one of America's favourite artists.*

domestic scenes – a woman sealing a letter, sitting by a cot, feeding a baby, or standing at a washing-up bowl – combine the abstraction of the medium with the elegant realism that distinguishes the best of her work. She described her involvement in the process of print-making in a letter, referring to it as 'great work'. Sometimes, she said, she and the printer would work a full day together and still produce only eight or ten proofs at the end of it. Her method was to draw an outline in drypoint and translate this to two other plates, making three in all, then paint the colours to be applied on each plate for each impression. Durand-Ruel included ten such plates in a small 'one-man' exhibition of her work in April 1891. She was delighted to feel that she deserved such a show, even if (as happened) nobody bought any of the prints: it encouraged her to embark on what she regarded as a second artistic career.

It would have pleased her, at the end of her life, to know that her contribution to the Impressionist cause was acknowledged both in France,

where she was awarded the Legion of Honour, and in her native United States. What was not widely known was that she had helped Degas out of a financial difficulty, and also helped to save the Impressionists' dealer and champion, Paul Durand-Ruel, from bankruptcy in 1876 by arranging a loan which put him on his feet again, enabling him to keep buying their work. She was also able, in her quiet way, to steer American friends and visitors towards the Impressionists long before they became known in the United States. The Havemeyers were among those who listened to her advice; their collection now hangs in the Metropolitan Museum of Art, New York.

Mary Cassatt also played a part in encouraging Durand-Ruel to introduce the Impressionists to New York, at a time when most of them were still struggling. He left in March 1886 with some 300 works, covering the entire Impressionist epoch from Manet to Seurat. The presence of many prominent collectors at the opening, including William Rockefeller, elder brother of John D. Rockefeller, and other notables coaxed into attending by the Cassatt family, bestowed on the event a distinction unknown in Paris. It may also have impressed the critics, who gave the show a relatively respectful press. Other potential buyers had seen their first Impressionists at the Cassatt home in Paris, and she made sure they did not miss their opportunity. Durand-Ruel returned to Paris convinced that the tide was about to turn. That exhibition, and another in the following year, he claimed later, had saved him. Renoir put it just as bluntly. 'Perhaps we owe it to the Americans,' he said at the end of his life, 'that we did not die of hunger.'

Mary Cassatt lived long enough to see her friends' works honoured and their fortunes made. Her own paintings, hanging in great American collections, join their names with hers.

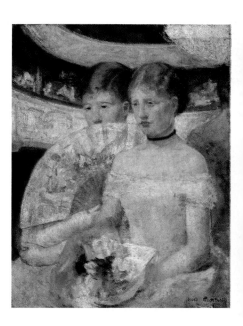

*Cassatt.* The Loge, *1886. National Gallery of Art, Washington DC. Chester Dale Collection.*

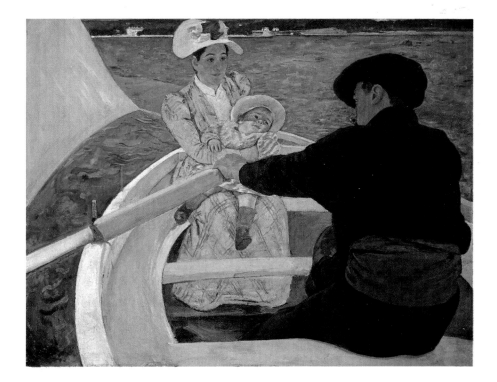

*Cassatt.* The Boating Party, *1893–94. National Gallery of Art, Washington DC. Chester Dale Collection.*

# 13 Cézanne

*Cézanne. A Modern Olympia,
1872–73. Musée d'Orsay, Paris.
This was one of the most provocative
works shown at the first
Impressionist exhibition in 1874, and
prompted the charge that the public
were being deceived by a group of
charlatans. Based on Manet's
already legendary* Olympia *of 1863,
it has none of the painterly qualities
on which Cézanne's reputation now
rests. Instead, he seems to have
attempted a sardonic parody of
Manet's masterpiece, in which the
painter/voyeur enjoys an erotic
disrobing of the naked model. The
picture was owned by Dr. Gachet,
the physician and close friend of
the Impressionists, who was warned
that it might be returned to him torn
to pieces.*

By the 1880s the first flush of Impressionism was over. The criticism aimed at it even by friendly commentators, of wilfully slapdash and insubstantial painting, had their effect. Monet expressed himself as no longer satisfied with the quick, outdoor impression, and undertook to introduce what he called 'more serious qualities'. Renoir, who held that the language of art evolves of its own volition, mistrusted art labels, and who by now could barely bring himself to use the term 'Impressionism', was going his own way, while fellow-travelling in group exhibitions for old times' sake. Degas, enjoying a late burst of creative energy, and supporting the group's exhibitions, no longer painted out of doors. Even Pissarro, guardian of the Impressionists' conscience, admitted in the end that 'the unity which the human spirit gives to vision' could only be achieved in the studio, the place where, in his mature view, a painter's previously scattered impressions are coordinated in a work of art. By the end of the 19th century there was a readiness among the middle-ageing painters to go back to traditional sources, while taking advantage of the benefits of the Impressionist method.

Pre-eminent among these was Cézanne. He had made his mark in the

first Impressionist exhibition of 1874 with two controversial works. One of these showed a woman, half-crouching, half-sprawling on a bed, her nudity abruptly exposed by an apparently naked negress plucking back the coverlet, while a clothed and bearded onlooker gazed up at her from a deep divan. It was called *A Modern Olympia*, an obvious derivation from Manet's sensational exhibit at the Salon of 1865. The other was a painting executed largely with a palette knife, of a house and farm buildings bathed in a soft, golden light, called *House of the Hanged Man*. Each, in different degrees, forced itself on the spectator: the *Olympia* with its eroticism, its distortions, and its violent, careless colours, and the landscape with its fierce honesty of non-picturesque treatment. The critic of the journal *L'Artiste*, while letting Monet, Renoir and Degas off lightly, called the *Olympia* a nightmare and Cézanne 'a bit of a madman, afflicted with painting delirium tremens'. As for the other work, 'M. Cézanne will allow us to pass in silence over his *House of the Hanged Man*.'

Cézanne cannot have been surprised or unduly disappointed. For years he had been trying to get accepted at the Salon, where his chances were not improved by his habit of trundling his paintings round in a barrow, dressed like a hawker, as if to demonstrate his contempt for the whole rigmarole. The *Modern Olympia*, even to a 20th-century eye, seems almost wilfully provocative. It is a sardonic jest, a *jeu d'ésprit*, with a sting in it. The *House of the Hanged Man*, being less contentious, merely lumped him with

# CÉZANNE

*Cézanne*. The House of the Hanged Man. *1872–73. Musée d'Orsay, Paris. In contrast to* A Modern Olympia, *this work, Cézanne's other exhibit in 1874, reveals his concern for solidity and mass, at the same time reflecting the pictorial influence of Pissarro, Cézanne's mentor and close friend. It eventually joined the large group of Impressionist paintings collected by the customs official Victor Chocquet.*

Pissarro and Monet. (It was to find a buyer, however, in Victor Chocquet.) Taken together, the two works sum up the kind of painter Cézanne already was, and the fervent, contradictory nature that was to lead him, in the end, to greatness.

He came from Aix-en-Provence, the son of a self-made man who expected his son to make his way in the world preferably – and not very originally – as a lawyer, but who eventually agreed to let him try his hand as a painter. Cézanne came to Paris and dutifully attended the daily life class at the Académie Suisse, at the same time acquainting himself with the masters in the Louvre. He was neither fluent nor easily satisfied, and his frustrations drove him to outbursts of passion which disconcerted his friends. Émile Zola predicted that, though Cézanne might have the makings of a great painter, he would never have the genius to become one: 'the least obstacle makes him despair.'

Cézanne's father was in many ways typical of the dominant class that had emerged under the Republic, the urban bourgeoisie. It was they who felt the benefits of a régime in which a mercenary monarch could sit on a vacated throne as if the stirring events of the Revolution had never happened. Citizens like Louis-Auguste Cézanne, hat-maker, financier, investor and banker, were the mainstay of the Second Empire, products of events which had given working-class families a chance to come up in the world at a time when the Industrial Revolution was creating an urban middle class.

Some, having scrambled up, might acquire a chateau or a country estate; others, like Cézanne's father, were more inclined to marry a shopgirl and keep their money in the bank. As a big man in a small town he would not have endeared himself either to the class he sprang from or from the one which he and his kind were supplanting all over France. And perhaps the

*Cézanne. Bather Diving, 1867–70. National Museum of Wales, Cardiff. Cézanne, who later was to use the male figure for exploring his ideas of weight and form, has here used the medium of watercolour. In 1866 he wrote to Zola that a picture he was painting was 'not doing too badly, but the days seem long. I must buy a box of watercolours so that I can paint when I am not working on my picture.'*

son of Louis-Auguste did have a fairly normal boyhood. He was sent first to a grammar school, then to the Collège Bourbon, where the curriculum included drawing, and where he won prizes for mathematics, Latin and Greek. His familiarity with the classics was later to enrich both his work and his well-disguised intellect.

His closest friend at school was Émile Zola, born in Paris of a French mother and half-Italian father. Zola was to remember their schooldays for the awakening of intelligence, against the odds, amid a 'brutal mob of dunces' and his friend's moody swings from high spirits to deep depression. The less likeable side of him, Zola said, was due to 'the evil demon that clouded his thoughts'. In his adolescent years Cézanne turned to writing cryptic poems, some of them illustrated with his own sketches, which he sent to Zola. One that survives shows a family sitting down to a meal of a severed human head, with the children crying for more.

Predictably, Cézanne found his law studies intolerable, and told Zola so. His friend replied urging him to make up his mind – 'really be a lawyer or really be an artist'. Cézanne's father than had the foresight to equip him with a studio at the family's home, and gave him permission to attend art classes when not groaning over his law books. One of the pictures he painted at this time, called *Kiss of the Muse*, became his mother's favourite. She carried it with her wherever the family went. Perhaps it helped to

*Cézanne.* Paul Alexis Reading to Zola, *1869–70. Museu de Arte, São Paulo. Alexis, an admirer of Zola, called on him in the autumn of 1869. The painting, a double portrait, is set in the garden of Zola's house in the rue de la Condamine. Zola's wife found it in the attic after Zola's death in 1902.*

155

# CÉZANNE

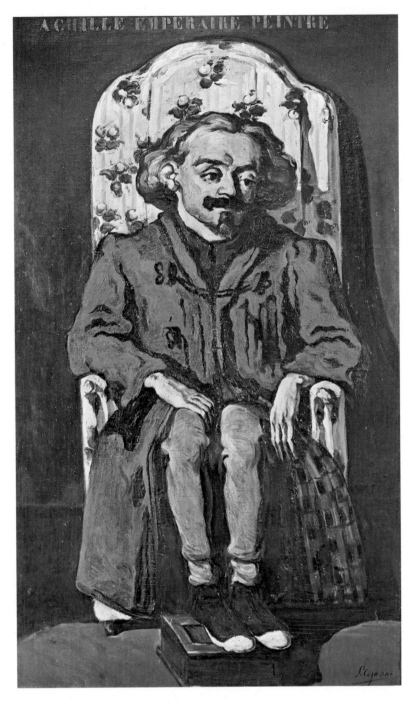

ACHILLE EMPERAIRE PEINTRE

*Cézanne*. Portrait of Achille Emperaire, *1868–70. Musée d'Orsay, Paris. Cezanne's readiness to shock the jurors of the Salon led him to submit this uncomfortable, life-size work in 1870 at the very last minute, for maximum effect. It was duly rejected.*

soften his father's heart, for suddenly Cézanne was hurrying to Paris and the Atelier Suisse, in preparation for the École des Beaux-Arts.

Unlike the young set who swirled around Manet, he did not start with a vague idea of his direction, or with an intuitive talent, only with a burning ambition to make his mark. He set his sights on the Salon, like everyone else, but he was out to make sensations rather than gains. His early work stood no chance at the Salon with its impertinent variations on neo-classical themes, furious brushwork and malevolent colouring. Naturalism was acceptable at the Salon; but not of the kind that animates Cézanne's portrait of his painter friend, Achille Emperaire, a dwarf, whom he painted life-size with his little legs propped up on a box, which Cézanne submitted in 1870. Pictures of deformed people painted with honesty and affection were not especially welcome. This one was rejected, along with Cézanne's second entry, a disturbingly angular nude.

Though Cézanne worked closely with the Impressionist group for some five years, and especially with Pissarro, he never acquired their cheerful facility and lightness of touch. This was due in equal parts to his own view

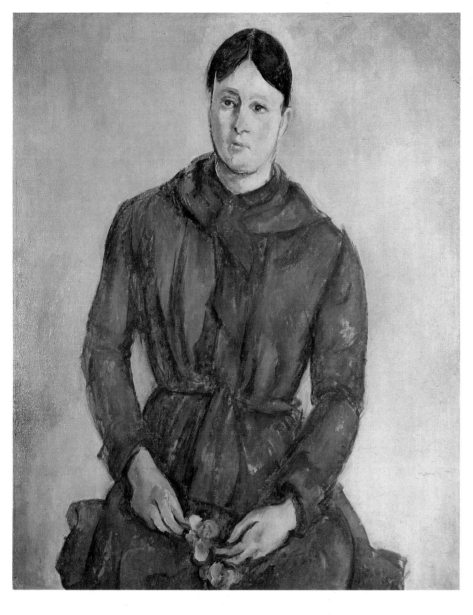

*Cézanne.* Madame Cézanne in Red, *c.1890. Museo de Arte, São Paulo.*

of painting, which diverged from theirs at several points, and to his method of working, which was slow to the point of self-torture. Rilke, the German poet, left a vivid pen-picture describing how Cézanne 'gave himself entirely, his whole strength behind each stroke of the brush. You only needed to see him at work, painfully tense, his face as if in prayer, to realise how much of his spirit went into the task. He would shake all over, his face heavy with unseen thoughts, his chest sunken, his shoulders hunched, his hands trembling until the moment came. Then, firm and fast, they began to work gently, always from right to left, as if with a will of their own.'

This monkish intensity was Cézanne's means of mastering the complexities of form by sheer application of the intellect. It was also the result of his unsatisfactory home life. His father treated him as a child into his middle age, and kept him as short of money as any of his Impressionist friends. He once referred to his family as 'the most disgusting people in the world'; yet without them there was nobody in his life to lean on. His repressions took significant forms, such as hatred of being touched, fear of an early death, and a neurotic uneasiness with women – he could hardly bear to look at a model in the nude.

Among his companions he affected a rustic gruffness that disguised his feelings, and a disdain for those who, by his standards, tended to put on airs. Monet remembered how Cézanne, joining the company, would shake hands all round, but in the presence of the well-groomed Manet would take

*Cézanne.* Self-portrait, *c.1880.*
*National Gallery, London.*

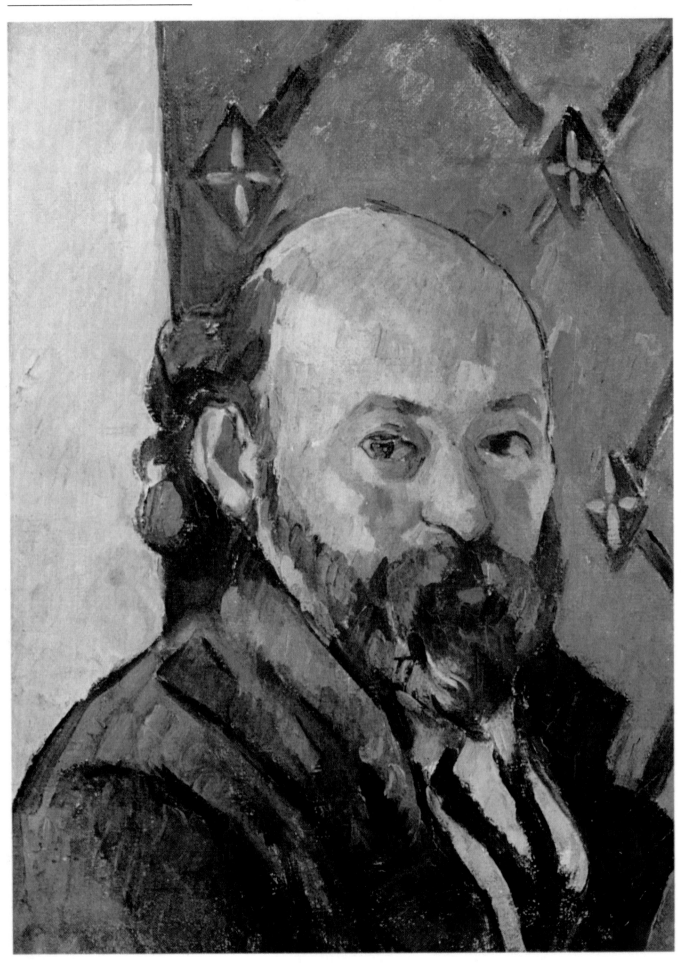

off his hat, explaining that he could not offer his hand as he had not washed for a week. This brand of ironic raillery made him difficult company. Only Pissarro, with his almost saintly forbearance, was able to treat him on intimate terms. On his occasional visits to the Café Guerbois in the early days, he did not join in the usual discussions on art and life, having a distaste for all theory. When he did speak up it was with the vehemence of deep conviction. Then, if contradicted, he would get up and go. His favoured attire was a set of workman's overalls, a linen jacket plastered with oil paint and a battered peasant hat. His piercingly honest self-portraits show him as a lonely, gaunt individual of indefinite age, his eyes red-rimmed and features half-hidden by a shaggy beard.

When he was nearly 70 he wrote to the painter Émile Bernard: 'The main thing is just to put down what you see. Those outlines done in black are quite wrong. The answer lies in consulting nature.' Those may sound like Impressionist sentiments; but Cézanne, once he had found himself, was not a man to conform to anyone else's rules. He even interpreted the lessons he learned from Pissarro in his own terms. Gradually, these hardened into a perception that colour could itself produce form, and that form in turn must be more than one dimensional. His dogged attention to what he was looking at, whether a figure study such as the *Card Player* or *Les Grands Baigneuses*, a still life or a landscape, brought him into a wholly novel relationship with his subject matter. Short brush-strokes, he found,

# CÉZANNE

*Cézanne.* The Card Players, *c.1893. Courtauld Institute Galleries, London. Courtauld Collection. There are no fewer than five versions of this subject, which Cézanne based on 17th-century paintings in the museum of his hometown, Aix. His interest in figures as elements in a composition, rather than as individuals, dates from this series.*

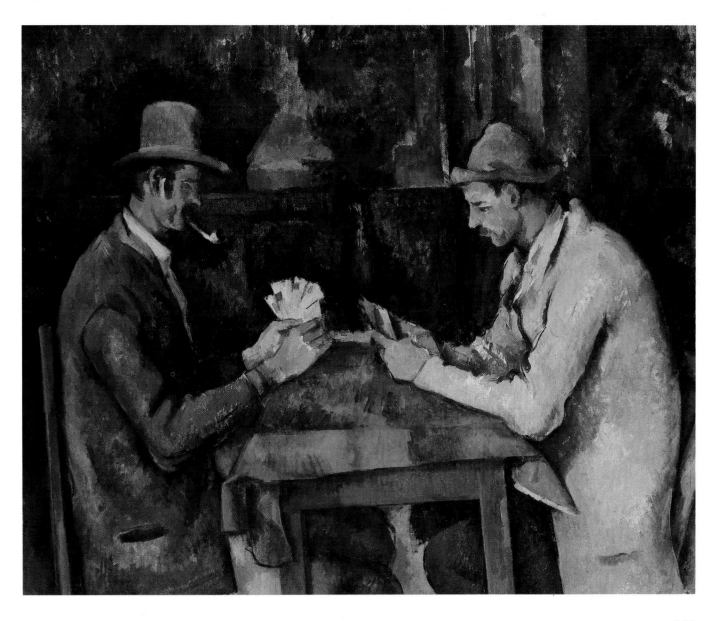

# CÉZANNE

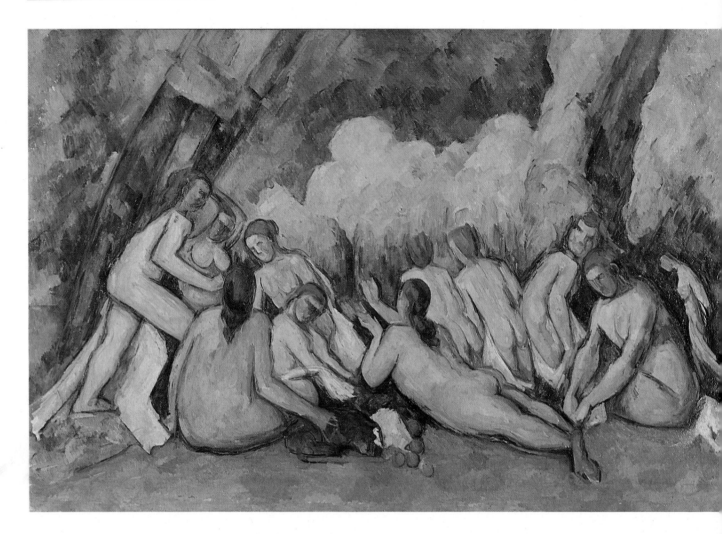

*Cézanne. Bathers, 1901–1905. National Gallery London. This is one of three works of similar grandeur from Cézanne's last years, when he was paying ever closer attention to the old masters, reproductions of whose works he pinned on his studio walls. Impressionism is now subsumed in a return to classical forms.*

could not only animate the subject, as the Impressionists had discovered, but also, when applied in parallel diagonals, bring rhythm and unity. Again, colours laid side by side could achieve brilliant Impressionist effects; but colours in which one plane falls on top of another achieved something more significant – solidity and structure. In Cézanne's later work, colour does not dissolve shapes, as in 'pure' Impressionism – it gives them weight and form. All this accounts for the deep-rooted quality of his work, harking back to the old masters, dismissing the accretion of centuries and pointing to Cézanne's declared aim of stripping away literary and extraneous allusions and arriving at the essence of painting itself.

In his explorations of the painter's true function he confined himself to relatively simple images. He distrusted the element of decoration which he recognized in the Impressionists; and he did not share their preoccupation with the undemanding pleasures of life, the everyday humanity that helps to make the world go round. His dictum, 'Just put down what you see' meant something different to Cézanne, since he put his own eyes to different use from other painters. He was forever seeking the form that underlies natural objects rather than their appearance; he even called his work 'constructions after nature'. To see things as they really are meant divesting them of all sentimental associations. He was as incapable of allowing an element of ingratiation into a picture as into a personal relationship.

This lack of easy communication makes his work less accessible, as we say nowadays, than that of the Impressionists among whom he started on

his way; but this was nothing more than he had expected. After exhibiting with them in 1877 for the last time, he withdrew to Aix, and all but vanished from the metropolitan scene. Renoir and Monet sometimes visited him and brought back stories of the self-inflicted rigours of his life and work. In 1886 he came into his inheritance when his father died (he and his two sisters shared a fortune of two million francs) but it seemed to mean nothing to him. He continued to tramp the fields looking for subjects, destroying countless sketches in sudden rages, or discarding them among rocks, frightening off unwelcome visitors, alternating between excitement and despair.

In 1895 the dealer Ambroise Vollard, encouraged by Pissarro, decided to hold a retrospective exhibition of his works in Paris. Nobody at the time seemed to know where Cézanne was to be found. Vollard tracked him down, talked to him, and received in due course 150 rolled-up canvases. When the exhibition opened in November it made a powerful impact, not so much on the public as on other artists. Pissarro wrote to Lucien: 'My enthusiasm is nothing compared with Renoir's. Even Degas succumbed to

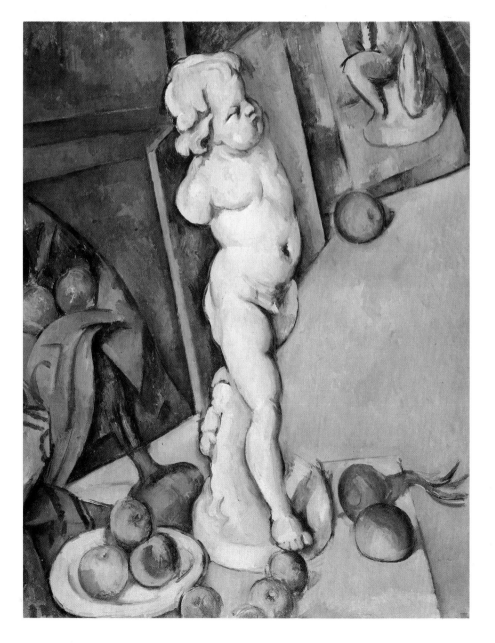

*Cézanne*. Still-Life with Cupid, *1895. Courtauld Institute Galleries, London. Cézanne acquired a plaster statuette after Puget's* Cupid *towards the end of his life, and made various studies of it in the studio.*

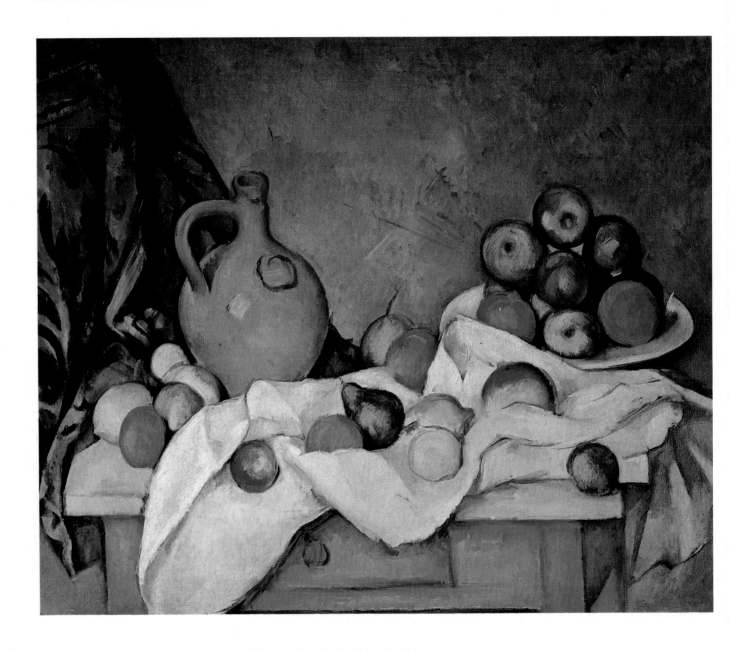

*Cézanne.* Still-Life with Curtain,
Pitcher and Fruit Dish, *1893–94.*
*Collection of Mrs. John Hay*
*Whitney.*

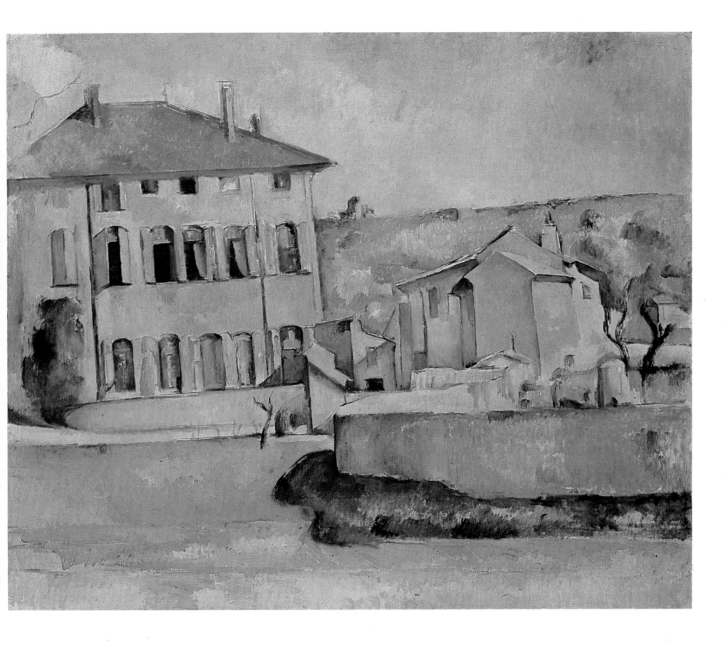

*Cézanne.* House at Jas de Bouffan,
*1882–83. National Gallery of Art,
Prague.*

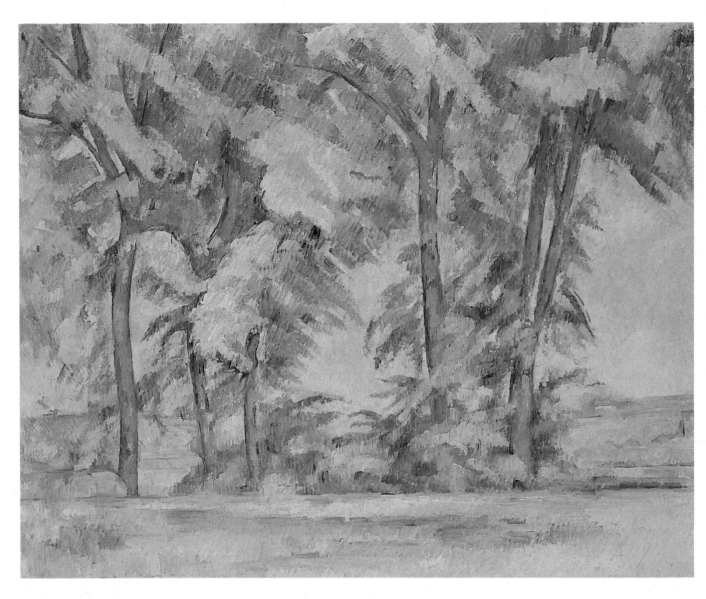

*Cézanne.* Trees at the Jas de
Bouffan, *1885–87. Courtauld
Institute Galleries, London
Courtauld Collection.*

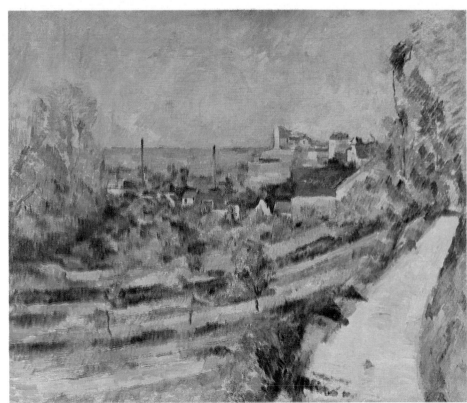

*Cézanne.* L'Estaque: The Village
and the Sea, *1879–83. Rosengart
Collection, Lucerne. L'Estaque was
a village on the Mediterranean
coast, just outside Marseilles, where
Cézanne's mother owned a property.*

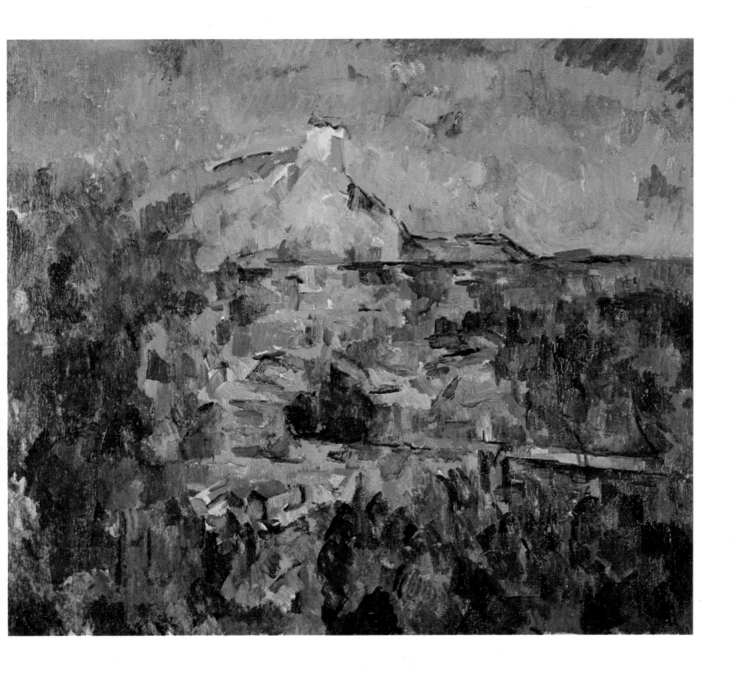

the charm of this refined savage. Monet, all of us – were we wrong?'

Cézanne found a late, inexhaustible theme on his own rural doorstep – Mont Sainte-Victoire. He made over 60 versions of it in the last two years of his life. At first he could only sit in front of this stunning subject, as he called it, unable to pick up a brush. Then, in the evening light, he realized that what might appear to be areas of concave shadow were in reality convex, vanishing from the centre, evaporating, becoming fluid. In the heat of the day these blocks of shadow had been afire, he noted. Now, at evening, there was still fire in them. 'Shadow, light, seem to recoil from them, as if in fear.' In these extraordinary works, blocks of pure colour, dispelling shadows, become substitutes for natural light, and colour itself becomes the embodiment of form. Actuality is caught and sealed in a non-naturalistic work of art. This was Cézanne's professed ambition, 'to make of Impressionism something durable, like the art of the museums.' Monte Sainte-Victorie has become his monument.

*Cézanne.* Mont Sainte-Victoire, *1904–06. Oeffentliche Kunstsammlung Basel, Kunstmuseum. The theme that is Cézanne's monument, one of the glories of his native Provence, occupied him for over a decade. Impressionism is not entirely banished; but instead of breaking colour into splinters of light he turns it into a means of description in which structure is paramount. Each time he sat down to paint the scene, stroke by deliberate stroke, he treated it as a different subject, if not a different place, in time.*

# 14 Gauguin

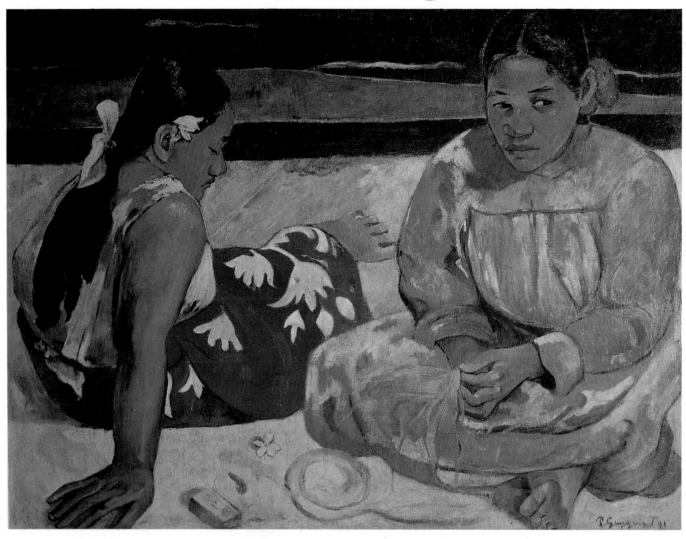

*Gauguin.* Two Women on a Beach, *1891. Musée d'Orsay, Paris.*

Paul Gauguin's career as a painter was based on the example of the Barbizon School, who brought French landscape painting out of the studio into the green woods and lofty skies around Fontainebleu in the 1850s. When he discovered Impressionism, it was with a mind already stocked with images from his early life of travels in more colourful landscapes than rural France. He had spent four years as a child with his mother's Spanish-Peruvian family in Lima; and in his teens had sailed as crew member of a merchantman to Rio de Janeiro, Bahia, and other distant ports of call before returning to Paris and a job in a brokerage firm, where he quickly began to prosper. By then he was a seasoned 'Sunday' painter, restless in his job, with no idea of what fate had in store for him.

The themes, colours and construction of Gauguin's later work, by which he is best known, tend to overshadow the Impressionistic borrowings of his work in the 1880s. By then Monet's style had assumed a deliberate roughness of structure and technique; Degas was engrossed in his pastels of women at their private rituals (he never exhibited publicly after 1886); Renoir was showing a renewed concern for detail and a less mellifluous pigment; Cézanne was working out his notions of weight and form. If Gauguin looked back to the beginnings of the revolution, it was to Manet's *Olympia*, which he copied in 1891.

His arrival on the scene could hardly have been better timed. Impressionism was threatened by an increasing appetite in intellectual and

literary circles for theosophical notions of the one-ness of art, life and sensations and the search for metaphors in which these ideas could be expressed. The Impressionists' demonstration that truth can be captured in a glance began to look insubstantial, even if their paintings were by now beginning to be understood and, increasingly, enjoyed. Gauguin was both steeped in the Impressionists (he had his own collection of their works) and resistant to the idea that what matters in art is the sensation activated by the painter's eye. For him, as for Cézanne, the painter's function went deeper, into what he called 'the mysterious centre of the mind'.

The story of his life has become a fable. After 12 years of marriage and well-paid servitude in a stockbroker's office, he abandoned his career to become a full-time painter. He was drawn particularly to Pissarro, with whom he went painting in Pontoise, which led to his exhibiting in the Impressionists' exhibitions of 1880, 1882 and 1886. When he decided to join Pissarro at Rouen, it was in the hope that the city's bourgeoisie would be keen to buy his paintings. Now free of his job, he was able to paint every day, he said; and with the cost of living much less than in Paris, he assumed he would be able to make the change without much damage to his domestic situation. Pissarro was concerned at his friend's mercenary attitude. 'Gauguin disturbs me,' he wrote to Lucien early in 1884. 'He is so deeply commercial. I haven't the heart to point out to him how false and unpromising this attitude is. Not that I think he shouldn't try to sell, but I regard it as a waste of time to think only about selling: one forgets one's art and exaggerates one's value.'

Unhappily for Gauguin's expectations, the citizens of Rouen showed no interest in him. His Danish wife, Mette, reduced to living with an unsuccessful artist instead of a well-off man of business, decided she would take the three children back to Denmark. Gauguin held on for a while, cashing in an insurance policy to keep himself going, then accepted his fate and followed her. Self-exiled, he kept up a correspondence with Pissarro, trying to seal a new-found relationship with the Impressionist group by urging loyalty on to the waverers and hinting that there was room for 'some younger and less experienced ones', meaning himself, 'whose convictions can add to the nucleus.' His quarrelsome nature ensured that he made few friends outside his immediate circle, and he had no success in his efforts to get the Danes interested in Impressionism. Meanwhile, the family income consisted of the 60 francs a month his wife was earning by translating a novel by Zola.

Though Pissarro, generous as ever in helping a fellow artist, had made a mark on Gauguin, it was Cézanne whom he most admired. He also shared Cézanne's desire to get away from art-politics and the attentions of people he had little time for. Cézanne's refuge was Aix, his home town in Provence, where he worked at his own problems in total seclusion. Gauguin took such an interest in this that Cézanne began to suspect that he was after his 'secrets'. He himself, moving away from the optical precepts of Impressionism towards ways of combining painting from nature with an intellectual re-appraisal of form, continued to tell everyone that the best way for young artists to find new themes was in faraway, and preferably exotic, places where no painters had been before. Degas, certainly, saw something in Gauguin that impressed him, and began buying his work – unlike Monet, who was to admit that he never took Gauguin seriously.

At Pont-Aven, in Brittany, Gauguin's first paintings were in the mode of Pissarro, with a *plein-air* feeling about them. He then moved towards figure subjects, combining compositional shapes and brushwork in a rhythmic, stylized design, as in *The Breton Shepherdess*, painted in 1886, which looks beyond pastoral Impressionism to a synthesis of colour, pattern and pictorial form.

*Gauguin.* Snow, Rue Carcel,
*c.1883. Ny Carlsberg Glyptotek,
Copenhagen. This view of the
artist's garden owes an obvious debt
to Pissarro, with its naturalistic,
open-air treatment of an essentially
suburban theme.*

*Gauguin.* Self-portrait in front of an Easel, *1884–85. Private Collection. Gauguin's failure to make an impact in Paris obliged him to join Mette, his Danish wife, in Copenhagen, where she was giving French lessons to keep the family in funds. Gauguin invests this study with his own searching will.*

*Gauguin. The Beach at Dieppe,
1885. Ny Carlsberg Glyptotek,
Copenhagen. Still under Pissarro's
influence, Gauguin painted his beach
scene in the late summer, a year
before making a fresh start at Pont-
Aven, on the coast of Brittany.*

In the following year, on his first visit to the tropics since his early youth,
he painted in Martinique his first exotic landscape, using intense colour in
small areas with an impressive command of scale. He applied the same
technique to a further group of paintings at Pont-Aven in 1888, and
brought his new style to a triumphant pitch in *The Garden at Arles*, painted
when he was sharing rooms with Van Gogh late in 1888; an imaginary
subject, in which perspective is made to give way to a strong, flat pattern
which brings all elements in the composition into the same plane. Gauguin
described the essence of the scene in a letter to his friend and painting
partner, Émile Bernard. 'The women here have a Greek beauty; their
shawls create folds like those in primitive paintings. . . There is a source
here for a beautiful modern style.' Van Gogh, at this time still content to
learn from Gauguin, instantly picked up the same procedure for a work
which he called *Souvenir of the Garden at Etten*. In November, Gauguin
painted Vincent at his easel: a noble work, now in Amsterdam, of which

*Gauguin.* Martinique Landscape,
*1887. National Gallery of Scotland,
Edinburgh. In April 1887 Gauguin
had set out for Panama to live (as
he told his wife Mette) 'like a
savage'. This exotic but controlled
landscape owes virtually nothing to
Impressionism, which for Gauguin
did not long survive his voluntary
exile from France.*

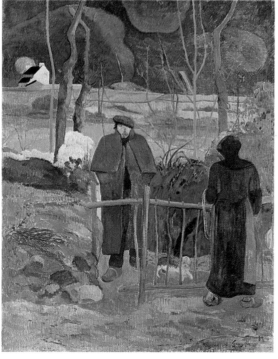

*Gauguin.* Bonjour Monsieur
Gauguin, *1889. National Gallery,
Prague.*

*Van Gogh*. Souvenir of the Garden at Etten, *1888. Hermitage Museum, Leningrad, USSR.*

Van Gogh said, 'It is certainly me, but me gone mad.'

Artists had been making their way to Brittany since the early years of the century, among them Boudin, Daubigny, Monet and Whistler. It was a natural painting ground, with its rugged coast and sweeping beaches with Atlantic rollers. Its people were simple and devout, living close to their ancient faiths. It made a strong appeal to Gauguin, to whom it represented a retreat from polite, urban existence, and he took to it at once. 'When wooden shoes ring on this stone,' he wrote to his wife, 'I hear the muffled, dull and powerful tone which I try to achieve in painting.' It was also inexpensive, a consideration that weighed heavily with Gauguin in his state of unexpected penury. He found at Pont-Aven a small artists' colony, including an assortment of Danes, Englishmen and Americans.

Émile Bernard, wandering around France looking for somewhere to settle, lighted on the place, heard about Gauguin, who had quickly assumed leadership of the group, met him and showed him his work. He found him disagreeable. But Gauguin was so struck by Bernard's *Breton Women in a Green Meadow*, with its dual viewpoint and narrow range of blue, green and black, that he borrowed the necessary colours from the nineteen-year-old artist (including Prussian blue, which Gauguin had never used) and painted the remarkable *Jacob Wrestling with the Angel*: 'two wrestlers borrowed from a Japanese album transmogrified into a vision', as Bernard resentfully described it.

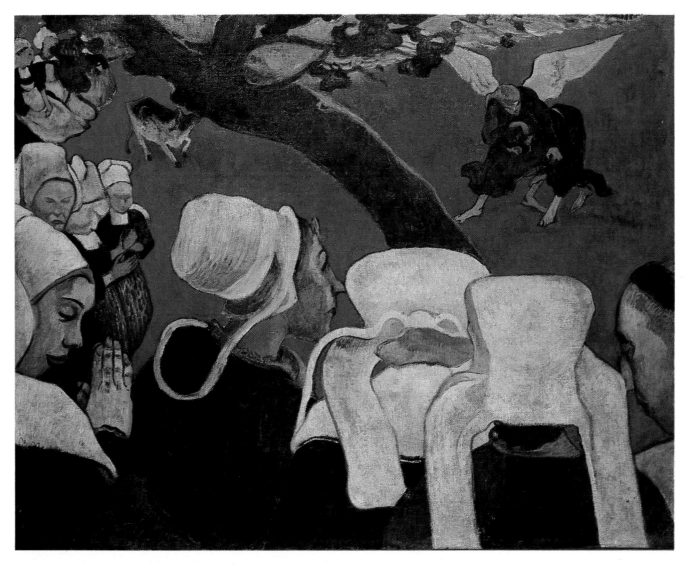

**Above:** *Gauguin.* Vision after the Sermon (Jacob Wrestling with the Angel), *1888. National Gallery of Scotland, Edinburgh.*

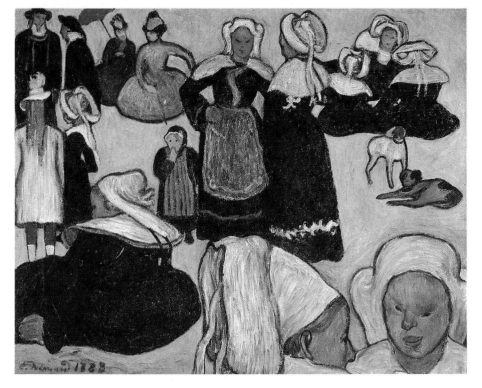

*Émile Bernard.* Breton Women in Green Garden, *1888. Private Collection. The youthful Bernard – he was only 20 years old when he joined Gauguin at Arles – had already devised his own style, variously based on Gothic stained glass, medieval textiles and Japanese prints, and tending towards two-dimensional form. Under Bernard's influence, Gauguin painted* Vision after the Sermon – *a total change of direction. Bernard remarked, with understandable tartness, that Gauguin had 'borrowed a couple of wrestlers from a Japanese album and turned them into a vision'.*

# GAUGUIN

Gauguin's idea of what painting should be about was transformed by this single experience. He had listened to Bernard's description of a new theory – representing what the mind perceives of a particular scene, rather than the eye – with interest. From now on, it was to be his own approach – 'not the colour theory I had told him about,' Bernard said later, 'but the actual style of my *Breton Women in a Green Meadow*, having first committed himself to a red background instead of the yellow-green which I had used. In the foreground he put the same large figures with monumental bonnets.' Gauguin had claimed the method, made it his own, and set out to develop it. From then on he rejected Impressionism for a new concept, Syntheticism. It was a tricky path, he admitted, full of pitfalls, adding: 'But at bottom it is something which is in my nature, and one must always follow one's temperament. I am well aware that I shall be understood less and less. To the general public I shall be a riddle, to a few others I shall be a poet.'

Gauguin held a one-man show in Paris in that year, and in 1889 showed some of his Pont Aven pictures in a group exhibition at the Café Volpin with Bonnard, Vuillard, Roussel, Maurice Denis and Valatton, who dubbed themselves the 'Nabis' – a word coined from a Hebrew term meaning 'prophets'. It generated attention, and though Gauguin made no sales he emerged as the accepted leader of the new Symbolist movement. By now he was making plans for a visit to Tahiti, and invited Émile

*Gauguin.* Harvest: Le Pouldu, *1890. Tate Gallery, London. A work from the formative period of Gauguin's contact with the young Émile Bernard at Pont-Aven. Gauguin was to claim the style as his own, despite bitter protestations by Bernard that it was he, not the older artist, who was the originator of the new synthesis of form and colour.

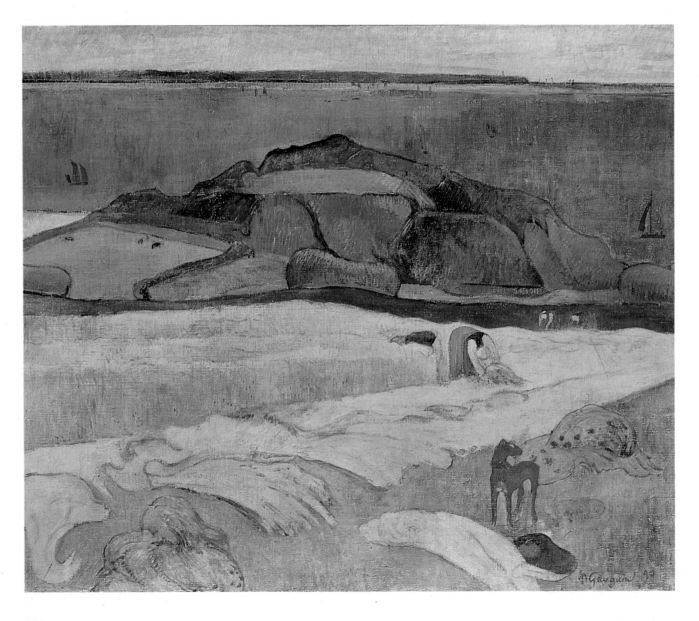

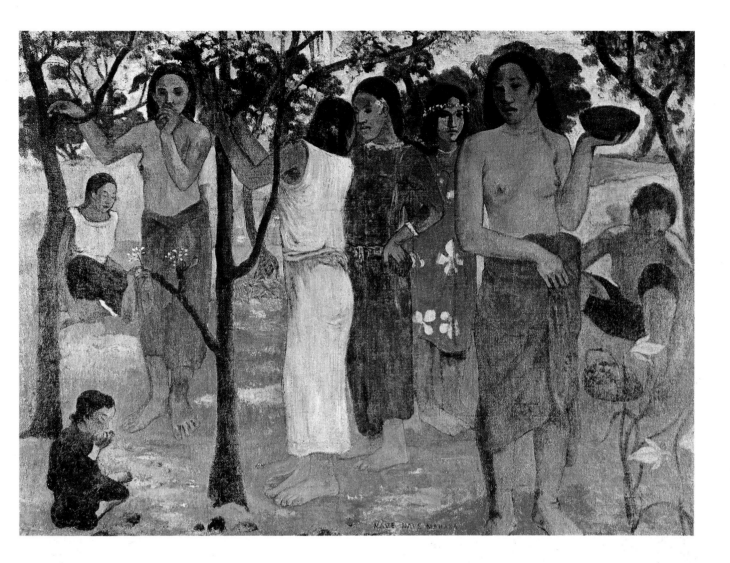

Bernard to go with him ('Without money, you will find a secure existence in a better world. If you pull a few strings you might even obtain a free trip'). But the young man, though sorely tempted, confessed to being in love with a girl who, if he left her, was quite capable of killing herself; 'so my life is ruined, lost.'

Gauguin set off alone. For him, the adventure was to become an idyll, laced with the bitter-sweetness of his attachment to Tehura, a young Tahitian whose beauty inspired a succession of poignant images of the painter's illusory paradise. He also painted a handful of landscapes which revert to something akin to Impressionism, the light softened by sweet shadows. After a few months Gauguin fell ill, and the local doctor despaired of his life. He wrote home for money, including news of his paintings: 'My canvases appall me. Never will the public accept them . . . If people are afraid of my former works in a drawing room, what will they say of my new ones?' The crisis passed, and Gauguin decided to stay another year, sustained by Mette's efforts to sell some of the paintings he had left in Paris, and cheered by the recognition, in an article on the Symbolists which Mette sent him, of his part in synthesizing 'the soul of the artist and the soul of nature'. The article looked forward to the 'new, superb and singular works' he would bring back with him from his exotic exile.

His images of a hot, rank world peopled with vividly clothed women, who gaze out of his canvases with secretive eyes, are among the most penetrating of modern times. Some have the monumentality of ancient goddesses, such as *Te aa no Areois* – Queen of the Areois – and *Ia Orana Maria*, in both of which the title is inscribed in the corner like a magic

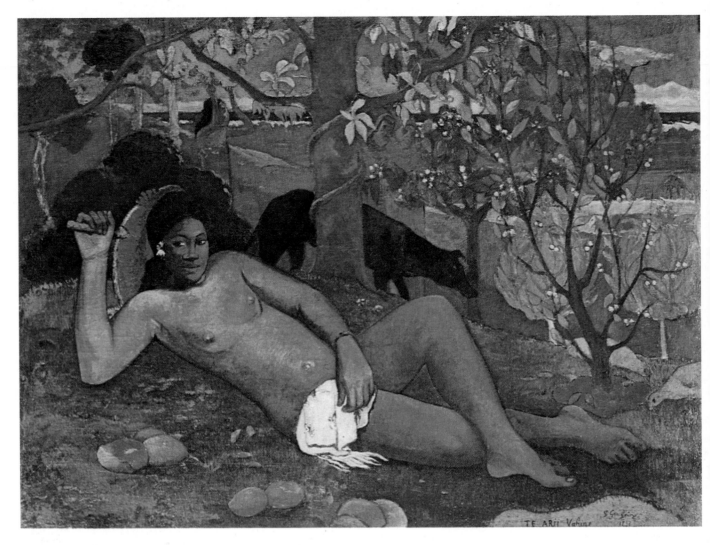

*Gauguin.* Te Arii Vahine (The Woman Chief), *1896. Pushkin Museum, Moscow. Gauguin described this work as his best to date: 'I have never before made anything of such a majestic sonority,' he wrote. The model's pose is reminiscent of Manet's* Olympia.

incantation. In others, the domestic life of the natives – already doomed, we sense, to western pollution – brings us close to the human scale on which they lived but in which the figures still look like players stage-managed by the stranger in their midst. Nothing is revealed about them: they retain their innate dignity and calm, obliging us with a sight of their flesh, which means little to them, but rarely of their minds. Gauguin himself could seldom get closer to them than this. He knew 'the soil and the aroma' of the island, but knowing the Tahitians whom he painted 'in a very enigmatic fashion' took him the entire time he spent there.

There are mysteries in some of the Tahitian paintings that only he could have unlocked. *Nafea Faaipoipo* – When Will You Marry? – is one of them; the two young women, locked in a knotted design, commune with us, the viewers, rather than with one another. In *Manaou Tupapau* – The Spirit of the Dead – a naked girl, face downwards on a couch, seems to have her eye on us. The background figure, in profile, stares straight ahead. Gauguin told Mette the story of this picture. He came in one night to find Tehura waiting for him on the bed, stretched out on her stomach, her eyes wide with fear of the dark.

Gauguin wrote: 'Her fright must be pretended, if not explained, and this in the character of the person, a Tahitian, people very much afraid of the spirits of the dead. There are some flowers in the background, but being imagined they must not be real. I made them resemble sparks – the Polynesians believe the phosphorescence of the night is the spirits of the

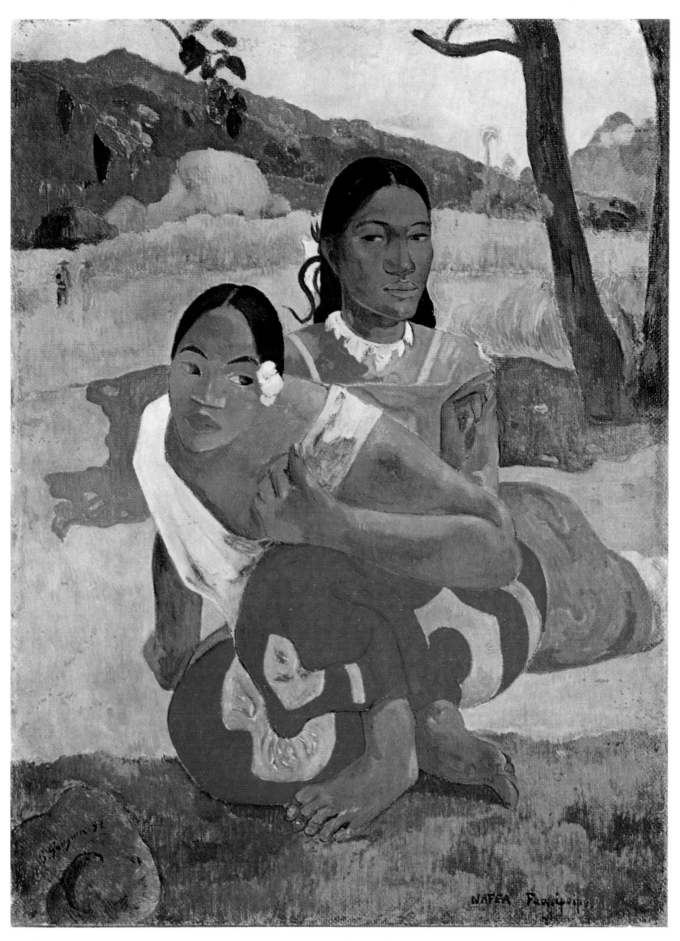

*Gauguin.* Nafea Faaipoipo? (When
Will You Marry?), *1892. Rudolphe
Staechelin Foundation, Basel.
Gauguin carried the mysteries of*
*Tahitian life into his paintings, in
which the distance between the model
and ourselves enhances the poignant
nature of the scene.*

dead . . . I made the ghost a small, harmless woman, because the girl can only see the spirit of the dead linked with the dead person, a human being like herself.' Summing up, Gauguin told Mette: 'The musical parts are undulating horizontal lines, which are lighted by greenish sparks. The literary part is the spirit of a living soul united with the spirit of the dead, Day and Night.' Could he at that distance from his roots have recalled a painting by Frédéric Bazille, painted in the bright Impressionist spring, *Nude Boy on the Grass?* He lies, eyes closed, in the identical pose to the naked Tehura.

Gauguin died in May 1903 on the island of his exile. In October of that year a summary of his achievement appeared in the review *L'Orient*, written by the painter Maurice Denis. Gauguin, he wrote, was 'the unquestioned master who won our admiration by his talent, his fluency, his gestures, his physical strength, his harshness, his unflagging imagination, his strong head for drink, his romantic bearing. . . He wanted to convey character; to express the 'inner idea' even in what was ugly.' But the Impressionist idea, Denis continued, was by no means obsolete. 'We could subsist on what we learned from Renoir or Degas. Gauguin transmitted their lessons to us, enriched what he had borrowed from the classical traditions and from Cézanne. He revealed Cézanne's achievement to us, not as that of an independent genius, an unofficial follower of Manet, but as what it really is: the end product of long exertion, the necessary result of a great crisis.'

Impressionism in Gauguin had contributed sunshine, diffused light, freedom of composition, the sense of the outdoors as revealed by Corot, the love of bright colour, and the influence of Japanese painting. He gave artists 'the right to lyricism', to exaggerate any impressions which justify the metaphors of art.

*Gauguin.* Nevermore, *1897.*
*Courtauld Institute Galleries,*
*London. Courtauld Collection. This*
*is one of two paintings (the other is*
Manaou Tupapau) *based on the*
*fear induced in the Tahitian mind by*
*the spirits of the dead, who they*
*believed came alive at night.*
*'Nevermore' is the cry of the girl,*
*whom Gauguin had left alone with*
*her fears, without a light.*

# 15 Van Gogh

Van Gogh. Restaurant de la Sirène, Joinville, 1887. Musée d'Orsay, Paris. Though Van Gogh responded to Paris, and to the lingering attractions of Impressionism, in the autumn of 1887 he wrote to his sister: 'You have to be strong to stand life in Paris.' He went on: 'I intend as soon as possible to go south for a while – there's even more colour there, and more sun.' It was the sun that he craved, and a place where 'the colours of the spectrum are not misted over as they are in the north.'

When Vincent Van Gogh entered the world of the Impressionists in 1886 he was 36, and had been painting for only eight years. Until then the formative influences on his mind and imagination had been the very reverse of the Impressionists' dedication to light, movement and the pleasures of daily life.

His birthplace, Groot-Zundert in Holland, a flat expanse of country criss-crossed by canals, was populated by stolid burghers with an unquestioning belief in the biblical verities. Vincent's father was a clergyman, and brought up his children according to the rigid faith of his kind. When he was 12, Vincent was sent to boarding school at Zevenbergen, where he stayed four years. His earliest exposure to art was working in the packing department at the Hague office of the Paris picture dealers, Goupil – his brother Theo, who worked for the firm in Paris, had persuaded Goupil to take him on. The merchandise that Vincent would have handled was prosaic, commonplace art, of the kind that has its place in every age and every generation, hardly of a kind to fuel any ambitions of his own. When he was 12 he was promoted to the London branch; and it was from there, in an alien urban environment, that he took up sketching,

sending his little drawings home for the family's amusement.

In London he began looking seriously, but uncritically, at pictures, became a great admirer of the English black-and-white illustrators in the popular magazines, and also fell in love with his landlord's daughter, a traumatic episode that did nothing for his self-confidence or for his future relations with women. He returned to Paris, took a room in Montmartre, and consoled himself with ardent readings from the Bible.

In London again in 1871 he found two unsatisfactory jobs teaching French, then returned to Holland convinced that his vocation lay in a life of selflessness and piety. He appointed himself as an itinerant missionary in one of the most depressed industrial regions of the country, the coal-mining community of the Borinage. His life at this time was wholly dedicated to the miners, sick or exhausted from their labours, living lives of dire servitude and little hope. Vincent took on the role of hair-shirted social worker and counsellor, sparing himself nothing. He began painting. 'Christ was the greatest of artists!' he declared to Theo, adding: 'I often long to go back to pictures.' His drawings of miners, and of the existence they endured, were social documents, torn from the heart.

His quest for a vocation led him at length to The Hague, where he

*Van Gogh.* Peach Trees in Blossom (Souvenir de Mauve), *1888. Riksmuseum, Kröller-Müller Stichtung, Otterlo. This painting of spring blossom that followed the snow in Arles was dedicated by the artist to his uncle, the painter Antoine Mauve, news of whose death reached him as he returned home with it to his lodgings.*

# VAN GOGH

moved in to the studio of a kinsman, Anton Mauve, a well-regarded painter, who tried to lead him away from socio-religious themes towards a study of the old masters. He failed, and it was left to Theo, once again, to release him. At last he began to spend most of his time painting, and before long, all of it. His work was dark-toned, in the Dutch tradition, and earthy. Describing *The Potato-Eaters*, a typical work of this, his first period, he said: 'I have tried to emphasize that these people eating their potatoes by lamp light have dug the earth with those very hands that they put in the dish. So my picture speaks of manual labour, and how they have honestly earned their food.'

After a spell in Antwerp he went to Paris and moved in with Theo, who was still working in Goupils' office there, and joined the studio of Cormon, where he met Toulouse-Lautrec, Émile Bonnard and Gauguin, and discovered, without much liking, the paintings of Degas. By now, 1886, the Impressionists were freely to be seen. His eye fell on Pissarro, Renoir, Sisley, as well as on their immediate successors, Seurat, Signac and their circle, already being known as 'neo-Impressionists'. It was Pissarro, recalling their meeting, who uttered the famous judgement that, the moment he laid eyes on Van Gogh, 'I knew he would either go mad or surpass us all. But I did not know he would do both.'

Van Gogh now had barely six years left. Perhaps, by his standards, Paris was not the place to get on with what he had to do. He wrote to his sister: 'I still go on having the most impossible, and not very seemly, affairs, from which I emerge as a rule damaged and shamed and little else.' Meanwhile, he was absorbing some of the influences that made their way into the Impressionists' work from Manet onwards, such as the street-life and boulevards, informal corners of the city, and – more persistently than these – the revelations of Japanese art. The clear, flat colours so akin to the Impressionists' own ideas of colour and design, made a strong appeal to Van Gogh. He liked to pin reproductions of them on his walls, and began to work some of them into his paintings.

But Paris soon palled. He began to suffer from depression and longed for a change of scene, even escape from Theo, whose love for him could not prevent tensions and strains between them. On 20 February, 1888 he suddenly took the train to Arles in the south of France, and the splendours and miseries waiting for him there.

Impressionism, which illuminated Van Gogh's sense of what painting could attain to, fell short of what he wanted to achieve. He was seized by an overwhelming sense of the supremacy of colour. Colour, he wrote to Theo from Arles, after painting a Provencal orchard in full blossom, 'is like enthusiasm in life.' That picture of two pink trees against a sky of glorious blue and white, he declared, was probably the best landscape he had ever done. When he arrived back at his lodgings with it, there was a letter waiting for him from his sister, telling him of the death of his uncle, the painter Antoine Mauve, under whose kindly eye Vincent had made some of his first figure studies at The Hague. 'Something, I don't know what, took hold of me,' he wrote to Theo, 'and brought a lump to my throat, and I wrote on my picture: 'Souvenir de Mauve, Vincent.' If you agree, we will send it, such as it is, to Mme Mauve. I don't know what they will say about it at home, but that does not matter to us. . . .'

In the fecund, flamboyant world around him that spring of 1888 Vincent loaded his palette with colour. He painted the now-famous *Drawbridge at Langlois*, over the canal that links Arles and Bouc, with a little cart crossing it and a group of women washing linen on the bank, in more vibrant colours than he had ever used before; an image that reminded him of home, translated in a rapturous alien light. He went to the bullfight that spring and painted the arena, hiding the bull in a swirl of dust and concentrating

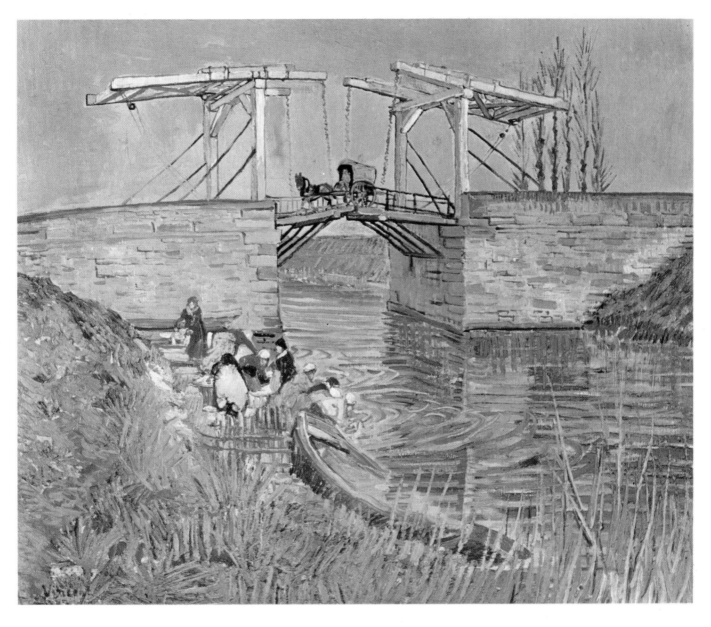

on a group of women in the foreground whose expressions leave us in no doubt as to Vincent's own feelings at the spectacle.

In June he was at Saintes-Maries-de-la-Mer, a fishing village to the south of Arles, which meant crossing the Camargue. He noted the colours of the sea: 'You don't always know if it is green or violet or blue, because the next moment it has taken on a tinge of pink or grey.' He painted the fishing boats on a flat sandy beach, pretty as flowers, in a style that reveals his attachment to the woodblock manner of the Japanese masters. In new lodgings, the Yellow House, he hung on his bedroom wall that summer portraits of the Belgian poet and painter Eugène Boch and of a locally-garrisoned lieutenant of the Zouaves, Milliet, who with the village postman, Joseph Roulin, and his son Armand, had become a frequent companion. The full-face painting of Armand Roulin is a masterly simplification of colour forms, the yellow jacket strongly outlined against a blank green ground, with both colours, tinged with touches of red, in the sensitive study of the face. A group of Vincent's modest possessions is immortalized in the *Still-life with Coffee-pot*, in which the black pot, a chequered milk-jug, a couple of plates, two oranges and three lemons are

*Van Gogh. The Drawbridge at Langois (Pont de l'Anglois), 1888. Riksmuseum, Kröller-Müller Stichtung, Otterlo. Painted in March, in an already warming light, this little bridge has since been replaced and is in a different position.*

183

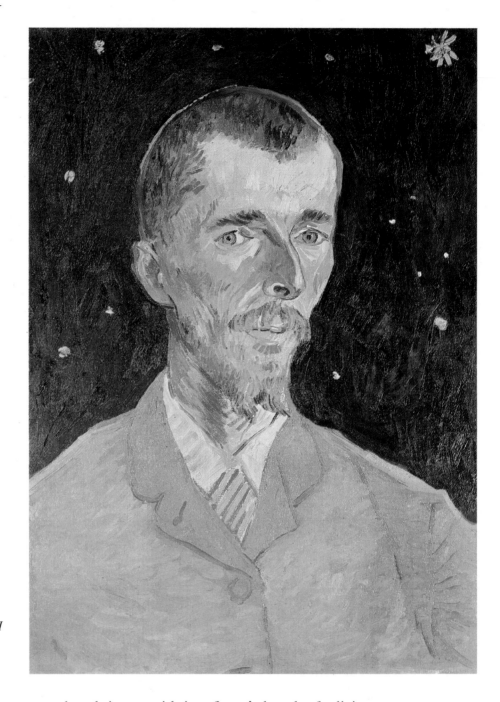

*Van Gogh*. Portrait of Eugene Boch, *1888. Musée d'Orsay, Paris. Boch was a Belgian painter whom Van Gogh met at Arles, became friends with, and painted before Boch left to paint in the Borinage, the grim coal-mining country that had torn at Vincent's heart some years before. 'Your portrait,' he wrote to Boch, 'is in my bedroom along with that of Milliet, the Zouave, which I have just finished. I should like you to exchange one of your studies of the coal-mines for something of mine. . .'*

enough to bring us with in a finger's length of a living scene.

In June of that year, Vincent's soldier friend went on leave to Paris, taking with him a number of paintings to show Theo. He has left his own account of the stranger who became his friend and insisted that he learned to draw. 'An odd fellow,' he called Vincent, 'his face a bit sunburnt, as if he had been serving up-country in Africa . . . Of course he was an artist – he drew very well indeed. He was a charming companion when he wanted to be, which was not every day . . . As soon as he started painting I would leave him alone, otherwise he would start arguing. When he lost his temper you would think he had gone mad.'

Milliet did not approve of Vincent's way of painting. Instead of stroking his canvas, he said, he attacked it: 'sometimes he was a real savage.' Milliet would have recognized Van Gogh's picture of himself, *Painter on the Road to Tarascon*, painted in August 1888, laden with painting tackle, canvases and satchels under his arms, in floppy gear and a battered broad-brimmed

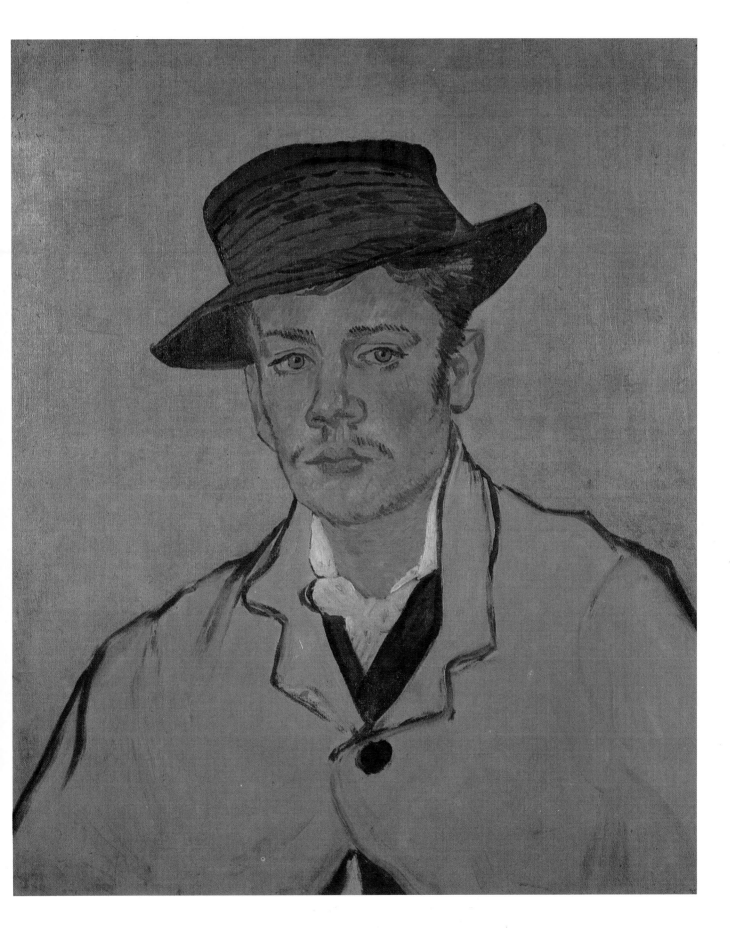

*Van Gogh.* **Portrait of Armand Roulin**, *1888. Museum Folkwang, Essen. Van Gogh painted the entire Roulin family, his neighbours at Arles, within the space of a few weeks: Joseph, the post office official in his handsome blue uniform and gold braid; Madame Roulin; their son Armand, shown here; and the couple's chubby infant. Vincent told Bernard that he could not resist the Roulins, 'that series of bipeds', as he called them, 'from the baby to the woman with yellow hair and sunburned brick-red face.'*

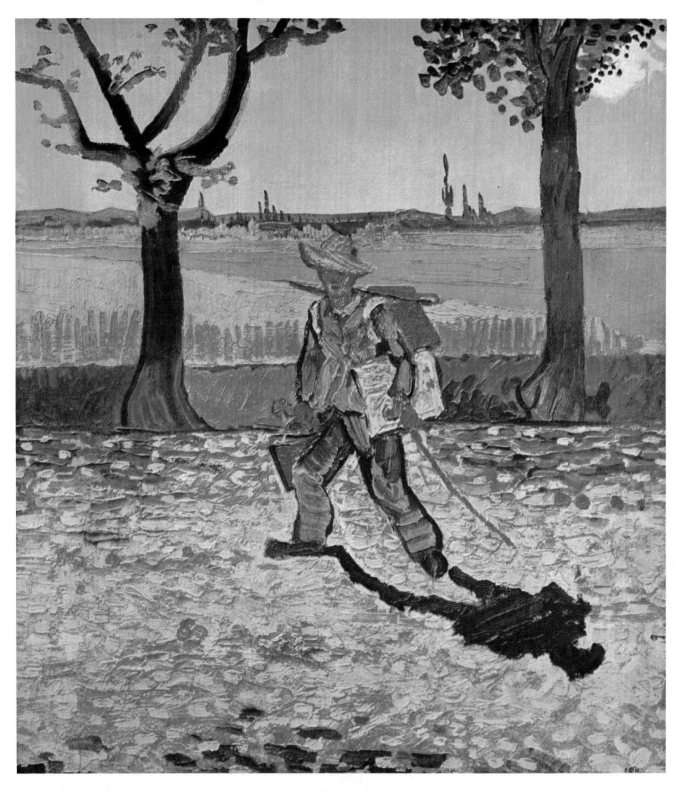

*Van Gogh.* The Painter on the Road to Tarascon, *1888. Formerly in the Kaiser Friedrich Museum at Magdeburg and destroyed in the Second World War. In the autumn of 1888 Vincent sent 36 pictures to his brother Theo, among them this one – 'a rough sketch I made of myself laden with boxes, props and canvas on the sunny road to Tarascon'. Fortunately, it was photographed in colour before its destruction in 1945.*

hat. The painting, destroyed during Hitler's war, was given a ghostly reincarnation in 1957 when Francis Bacon made two studies of it, in his own style, as a memorial portrait.

Van Gogh's own account of his approach to painting, soon after his arrival at Arles, makes it clear that, for all the highly-charged excitement that it conveys, it was none the less deliberate. 'Everyone will think I work too fast,' he told Theo. 'Don't believe a word of it. Is it not emotion, the sincerity of our feelings for nature, that draws us? Don't think I would artificially keep up a feverish state, but do understand that I am in the midst of complicated calculations, which results in a rapid succession of canvases, but worked out long beforehand.'

Walking around the countryside, he would look for likely subjects,

ponder how he might deal with them, then return, his mind made up, and transfer them to canvas, choosing or arranging his colours to suit both the nature of the day and his own mood at the time. As the art historian John Rewald has put it: 'The minute Van Gogh put up his easel in the field and secured it against the ever-blowing mistral, his hand began to obey two masters: the eye which wandered scrutinizingly over the landscape, observing each detail, each nuance, and the mind which had already prepared a synthetic imagine of the spectacle that nature spread out before him.' This approach to this work, charged with the emotion and dynamism that were integral in all his actions, accounts for its power to move us in a different age, even a different culture, from the one that had bred him. The image and the means are one and the same.

As autumn approached, Van Gogh began to be intrigued by the problem of painting night scenes, in which the source of light ceases to be the sky and ordinary objects lose their forms while remaining half-perceived in the gathering dark. In *The Starry Night*, in which he painted the Rhône by the light of the candles stuck in his hatband, the stars are bursts of golden sparks, the sky a mat of rectangular brush-strokes, the water a deep blue curtain striped with the reflections from the stars. For the *Café Terrace at Night*, painted in the same month, he again stuffed candles in his hat, but this time the scene was bathed in the artificial light of gas lamps, casting a

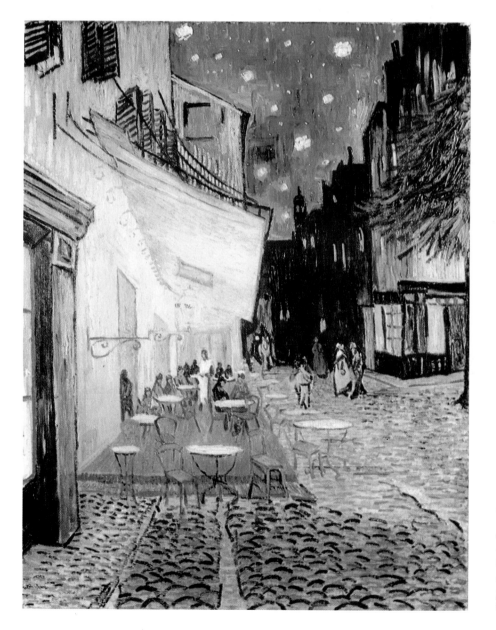

*Van Gogh. Café Terrace at Night. (Place du Forum, Arles), 1888. Riksmuseum, Kröller-Müller Stichtung, Otterlo. Van Gogh made two studies of the cafe in the Place du Forum at night. Painted from outside, the artificial light seems to prevail over the nocturnal blue. Of his view of the interior, in which drinkers slump at the tables and the clock stands at a quarter past midnight, he wrote: 'I have tried to express the idea that the cafe is a place where one can ruin oneself, go mad, or commit a crime.'*

# VAN GOGH

*Gauguin. Les Aylscamps, Arles, 1888, Musée d'Orsay, Paris.*

glow revealing almost as much colour as it might by day. The two strongest colours, yellow and blue, occupy dominant positions and affect the tones of all the details, such as surfaces of coffee tables and cobble stones. The figures, half-obscured, are captured in peremptory strokes. And by brilliantly reversing the way the light falls on cobbles, he describes them as light where their shadows would be, and dark on their rounded surface, an illusion which the eye accepts on the instant.

On 20 October he welcomed an eagerly-awaited visitor – Paul Gauguin, whom he had met in Paris two years earlier, had accompanied on visits to the galleries, and whose Martinique paintings he had admired at Theo's gallery. He longed for the worldly Gauguin's conversation and for happy excursions together in a countryside which had become, for him, a fount of creative ideas. Between them, they might found a school of artists based here in the South. Instead, he found Gauguin taciturn, condescending and insensitive. 'I find it all small, paltry, the landscape and the people,' Gauguin reported loftily to Émile Bernard. Van Gogh, who also knew Bernard, wrote to him that he was interested in Gauguin as being the opposite of 'those decadent and rotten Parisian boulevardiers'. Here, without a doubt, he said he was in the presence of 'a virginal being with the instincts of a savage.' He must have shown this letter to Gauguin, who added a comment of his own: 'Don't listen to Vincent; as you know, admiration comes easily to him, and indulgence ditto. . .' Soon, Gauguin was complaining about his friend's untidiness and 'his brain afire with the Bible'. Still, they remained on good enough terms to share their expenses and the domestic chores (Gauguin turned out to be an excellent cook). From Theo came news for Gauguin that he had sold some of his pictures – money was on the way.

In the weeks before winter set in the two of them painted amicably, though rarely together. Van Gogh's *The Red Vineyard*, a work which he valued highly, the *Souvenir in the Garden at Etten*, and the *Alyscamps, Leaves Falling*, belong to this period. Gauguin found typical subjects in his *Vineyard at Arles with Breton Woman*, *The Sower*, and the *Washerwoman at Arles*.

In those months Vincent admitted to being tempted towards Gauguin's mode of abstraction. But he told Bernard: 'It's an enchanted territory, old man, and one quickly finds oneself up against a wall.' He and Gauguin each had their favourites among French painters. Vincent, Gauguin discovered, admired Daumier, Daubigny and Rousseau, all of whom he, Gauguin, said he could not tolerate. On the other hand, Vincent disliked Ingres and Degas, both of whom Gauguin admired. He began to feel, that, between their two turbulent temperaments, a struggle was brewing. His fears were realized when, after a quarrel that ended in violence, Gauguin told Vincent he was going back to Paris. He, deeply agitated, prevailed on Gauguin to stay. But the tension between them mounted; and on Sunday, 23 December 1888 there occurred the famous self-maiming, by which Van Gogh tried to expel his hallucinatory fears with a slash of the razor.

By 7 January 1889, he was ready to leave hospital, and began to paint; two self-portraits, done from the mirror images reversed, show the bandaged ear as the right instead of the left. *Self-portrait with a Bandaged Ear* reveals a gaunt pale face in a winter cap.

In the 18 months that he left himself, Van Gogh painted 150 pictures. For most of that time he was in voluntary confinement in the asylum at Saint-Remy, 15 miles from Arles. He had two rooms there, a bedroom and a studio, mere cells with bars across the windows. He painted the park and the garden, where he was allowed to sit, the olives and cypress trees, the wall surrounding the place, with its glimpse of free, rolling countryside beyond, under a noble sun in a golden sky. He painted prisoners exercising

*Van Gogh.* Self-portrait with Bandaged Ear, *1889. Courtauld Institute Galleries, London. Courtauld Collection. The calmly matter-of-fact manner in which Van Gogh painted his bandaged head,* *from a mirror image, contains no suggestion of mental stress. He is as detached from his subject as if the tell-tale bandage (he cut off the lobe of the left ear, not the right) were just another detail.*

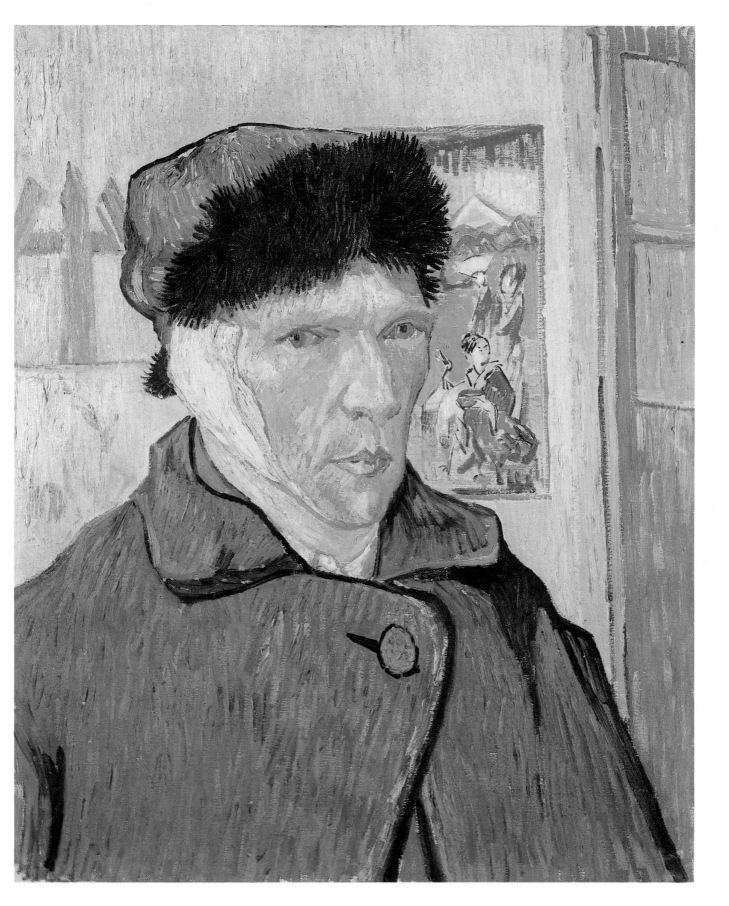

# VAN GOGH

in a brick-walled yard, after Gustav Doré, and the figure of an old man seated, fists to his eyes, on a yellow chair, which he called *The Threshold of Eternity*. He painted the inside of the asylum, its corridor and vestibule, its arched window with bottles standing on the sill; *The Siesta*, after Millet, and a reminiscence of the North, in which green clouds flecked with red roll across a green sky.

One night, in June 1889, he imagined a starry sky in which heavenly catherine wheels swooped above huddled homesteads. Then, after several relapses, he was able to leave. Theo took over, and put him in the care of Dr Paul-Ferdinand Gachet at Anvers-sur-Oise, just outside Paris. Vincent arrived, looking 'much stronger than Theo', according to his family. Under Gachet's care his spirits recovered, and his work took on a less disjointed rhythm. Theo invited an old friend to lunch: Toulouse-Lautrec, with whom Vincent had roistered in Montmartre.

There followed a stupendous burst of activity: some sixty paintings between May and July, as vigorous and disciplined as any in his career, and covering landscapes, portraits, flower studies, wheat-fields, a harvest, village scenes, peasant women, fields of poppies. To his family, Vincent seemed to be through his crisis, on top of things at last. Dr Gachet and his

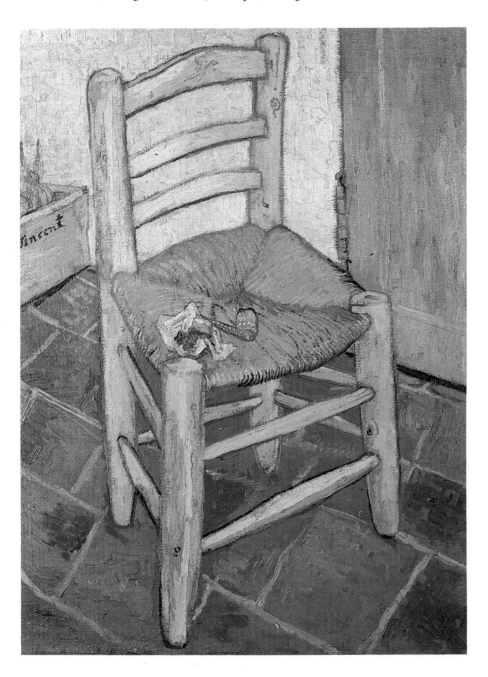

*Van Gogh.* Vincent's Chair, with Pipe, *1888–89. National Gallery, London. Van Gogh's attachment to a couple of commonplace possessions is such that they seem to exude his presence in an otherwise empty room.*

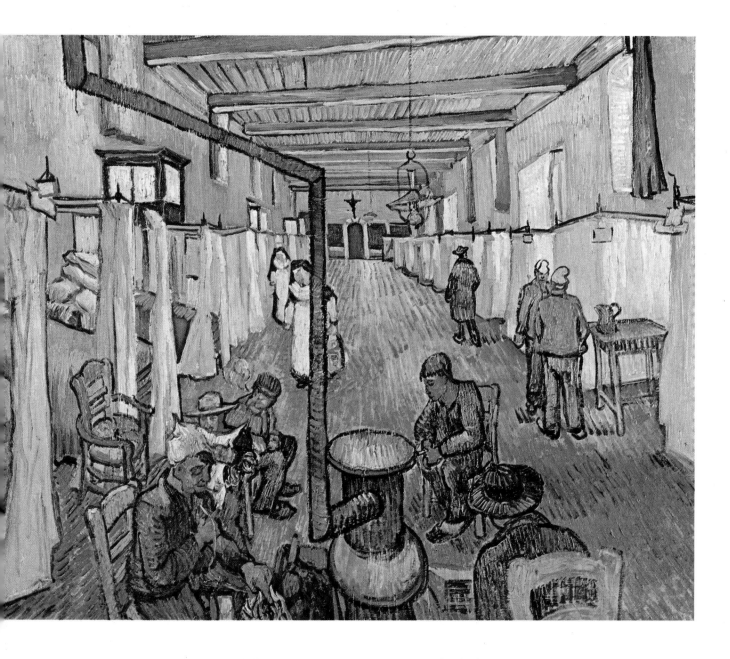

*Van Gogh.* The Hospital at Arles, *1889. Oskar Reinhart Collection 'Am Römerholz', Winterthur. Inside the hospital buildings, and in its park and kitchen garden, Vincent enjoyed a relative degree of freedom to walk and paint. He described other patients, who were confined to the main hall of the house, as looking 'like passengers in the third-class waiting room of a railway station.' He told one of the warders, Jean-François Poulet: 'Before I came here I offered pictures to butchers and grocers for something to eat. One or two of them gave me something, but they wouldn't take the pictures.'*

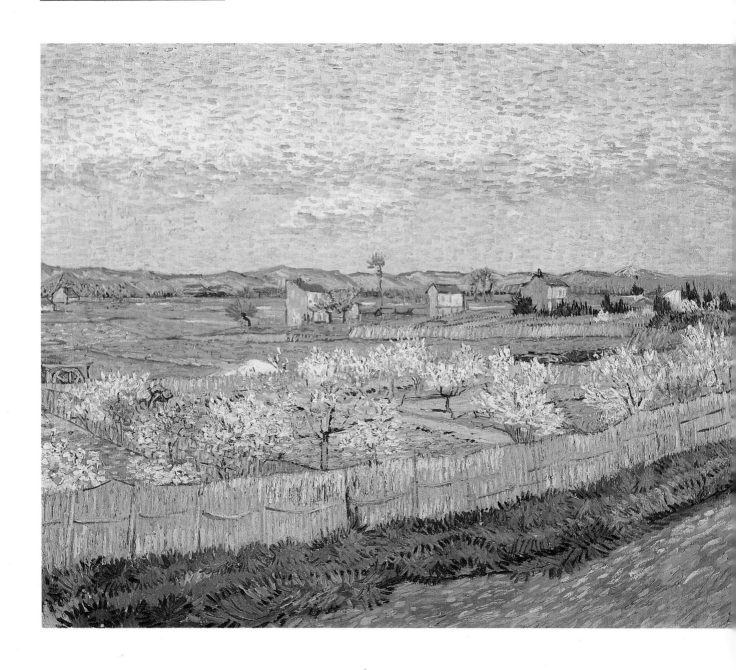

*Van Gogh*. Peach Blossom in the
Crau, *1889. Courtauld Institute
Galleries, London. Courtauld
Collection.*

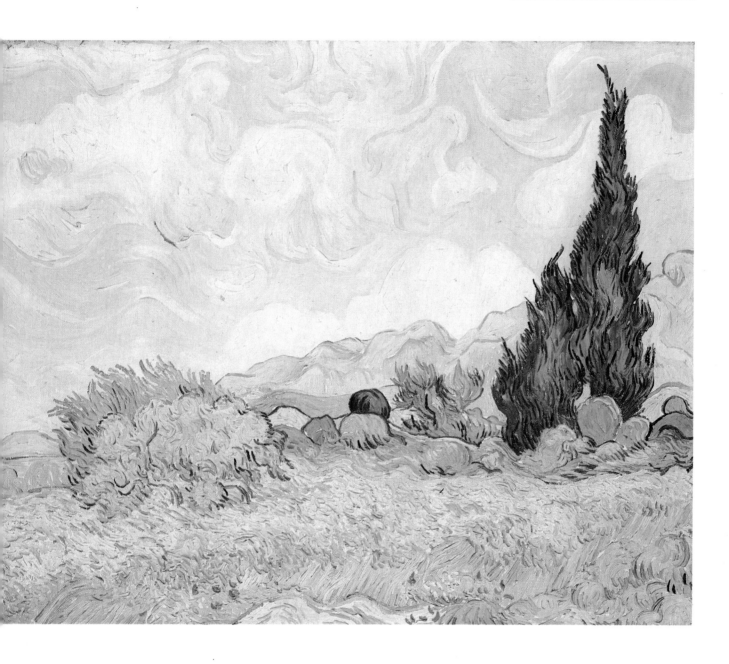

*Van Gogh.* Cornfield and Cypresses, Saint-Remy, *1889.* National Gallery, London. *Just how far from Impressionism his work had been thrust by his involvement with the springs of passion is apparent from the late, great landscapes, in which Van Gogh re-asserts the primacy of feeling.*

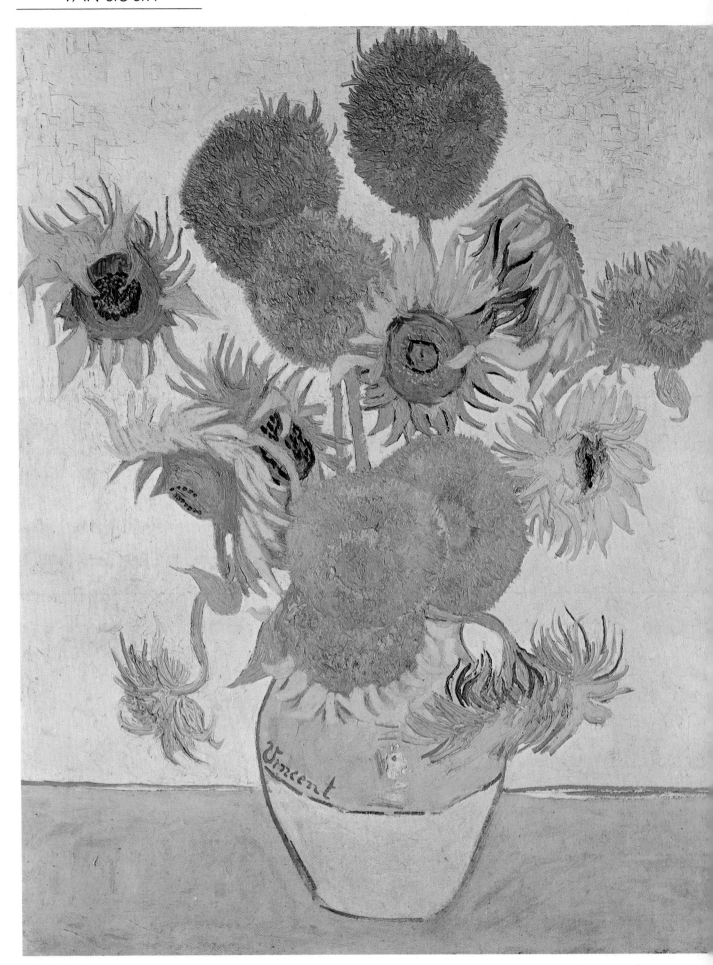

*Van Gogh. Sunflowers, 1888. National Gallery, London. While waiting for Gauguin to join him at Arles in August 1888, Van Gogh painted a series of sunflower studies from blooms brought in from the surrounding fields. One of these, the largest, was sold at Christies,* *London, in March 1987 for the astonishing sum of £25,500,000. Van Gogh had hoped that 'some Scot or American' might pay 500 francs, or £25, for such a work. But the* Sunflowers, *like all his other paintings, remained unsold at his death 12 months later.*

*Van Gogh. Cottages at Cordeville, 1890. Musée d'Orsay, Paris.*

family knew better. Outbursts of irrational rage, and sometimes violence, could flare up at any time. One evening he was late returning, and was eventually seen approaching long after supper, staggering in big strides, his head strangely tilted. He limped indoors, ignoring everybody, climbed the stairs to his room, and lay down with his face to the wall. At last he gasped, 'I've shot myself. I only hope I haven't botched it.'

They buried him on Thursday, 30 July 1890. Theo sobbed helplessly throughout the funeral. Within six months he, too, had died: of the same madness, some said, as destroyed his brother. Theo's death, it has since been agreed, was from epilepsy, which ran in his mother's family. Both brothers shared the fateful inheritance.

# 16 Toulouse-Lautrec

*Toulouse-Lautrec.* Artilleryman Saddling a Horse, *1879. Musée Toulouse-Lautrec, Albi. Lautrec's boyhood gave him a first-hand acquaintance with stable-craft and with the grace and movement of his mounts, before the accidents that made him a cripple.*

**Right:** *Toulouse-Lautrec.* La Toilette, *1896. Musée d'Orsay, Paris.*

Van Gogh, toiling through academic exercises in the Paris studio of Fernand Cormon, an artist whose speciality was solemn prehistoric subjects, struck up a friendship with a fellow student, Henri de Toulouse-Lautrec. Lautrec could afford to rent a studio in the rue Tourlaque, where Van Gogh began to visit him, occasionally joining him on his visits to the more lurid entertainments of Montmartre. For Vincent, these experiences were consumed in his private rages. For his new friend, they became the stuff of art.

He was born Henri-Marie-Raymond Toulouse-Lautrec-Monfa, in the family's ancient seat at Albi, a descendant of nobles who in the Middle Ages held sway over a wide area of southern France. His parents were first cousins; a circumstance that crippled him for life when, as a boy, he broke both his legs in minor accidents, which left him, in his father's terms, unworthy to carry on the family name. Instead of riding, shooting and cutting a dash in high places, Lautrec was obliged to balance on a child's legs his man's body and powerful head. As his father regarded him as a freak, he soon became reconciled to making his condition less a handicap than a virtue. It became his entrée into the lives of café entertainers, music-

hall performers, and of the sorority of prostitutes, who admitted him to their salons as an amusing pet. In return he painted them not as types but as people, less a voyeur than a sympathetic friend.

Familiarity with Lautrec's work has linked him in the popular mind with the Impressionists, parts of whose lives and interests overlapped with his. But the contact was relatively brief: he was outlived by all of them except Manet and Sisley. He was closer in age to Van Gogh, Gauguin and the Neo-Impressionists than to Monet and his circle, and in style to Degas, with his strong graphic line. Technically, and in his choice of materials, Lautrec soon moved away from Impressionism and its sunny good humour in favour of an essentially indoor light, heightened by a gas lamp or a naked flare. More directly even than Degas, he turned his observation of men and women into an instrument of almost journalistic topicality, catching the nuances and gestures that betray character in ways which, a hundred years later, can still take us by surprise. A dancer flings her veil in a gesture that blurs her face; a girl lets her shift drop to her knees, not looking; the top-of-the bill favourite, Yvette Guilbert, takes a bow that dissolves her supple form; an acrobat, defying perspective, flings herself through a paper hoop.

In dismissing the Impressionists' idea of light, Lautrec also did away with their notions of colour. In the world he painted, from the gas-lit theatricality of the music-hall to the mock-grandeur of a popular brothel, the Impressionists' natural palette was inadequate. The sombre, chalky or lurid tones which Lautrec used to such effect were chosen for their suggestion of mood and place, heightening the raffish novelty of the subject or the implied irony behind a performer's mask. Lautrec's backgrounds, whether of wallpaper or some indeterminate equivalent, are typically in sour greens, sometimes streaked with harsh yellow or muddy pink. In his lithographs he abandons natural colours altogether: a green used for the lettering is also made to serve as the colour of a man's hair, or an area of white paper might be left to describe the flouncy intricacies of a dancer's skirts. In fixing the denizens of *fin-de-siècle* Paris in a theatrical milieu of their own making, he succeeds in showing their lives as one unending cabaret.

Lautrec, like Degas, enjoyed being in the front row, as if the entertainment were for his benefit alone. Whatever satisfactions this might have provided for Lautrec the night-hawk, as a painter he manages to stay neutral, uninvolved. Unlike Degas' key-hole observations of women who seem not to know they are being looked at, Lautrec does not let his personal curiosity show through. In his own day, this characteristic could be as confusing as, earlier, the Impressionists' provocative naturalness had been. An interviewer who managed to coax a few words out of Lautrec at an exhibition held in 1891 in the rue Le Peletier, under the title 'Impressionists and Symbolists', reported that Lautrec said he did not belong to any school, adding, 'I work in my corner. I admire Degas and Forain,' and giving a little chuckle. 'He is very much the man of his paintings, which exhale a pointed irony,' the writer went on. 'Do not his women, dreaming in melancholy mood on the sofas of public brothels, betray qualities of a truly cruel observation?'

To our eyes, they do not. Lautrec may not spare the women their signs of wear and tear, or their essential loneliness, but he does not cheat them of what remains of their femininity and poise. In the celebrated *Salon at the rue des Moulins*, for which he made several preliminary sketches, the women sit in their plushy parlour awaiting clients with dignity unimpaired. Each is clearly an individual. There is no sense of caricature or levity. In another context, they could almost be relaxing together in an hotel suite at a business convention, their husbands having a drink together somewhere downstairs. Even the state of undress of the one on the right, of

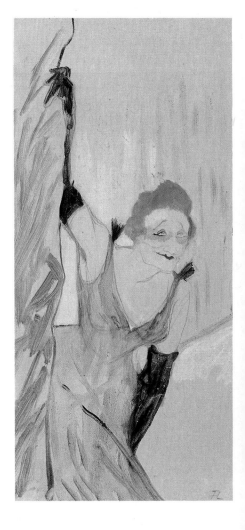

*Toulouse-Lautrec. Yvette Guilbert Taking a Bow, 1894. Musée Toulouse-Lautrec, Albi. Though not an obvious beauty, Yvette Guilbert was the unchallenged star of the Paris music-hall in Lautrec's time. Her willowy body, husky voice and trick of making obscenities palatable kept her at the top of the bill for 20 years.*

# TOULOUSE-LAUTREC

*Toulouse-Lautrec.* Les Ambassadeurs: Aristide Bruant, *1892. Bruant started a cabaret in Montmartre in 1885, with himself as the star performer: his speciality was songs about the misery and morals of the slums. He became fashionable, went up in the world, retired after ten years, and made a rousing comeback at the age of 73. Lautrec was a crony of his, and, as in this poster, made several versions of his sardonic, theatrical looks.*

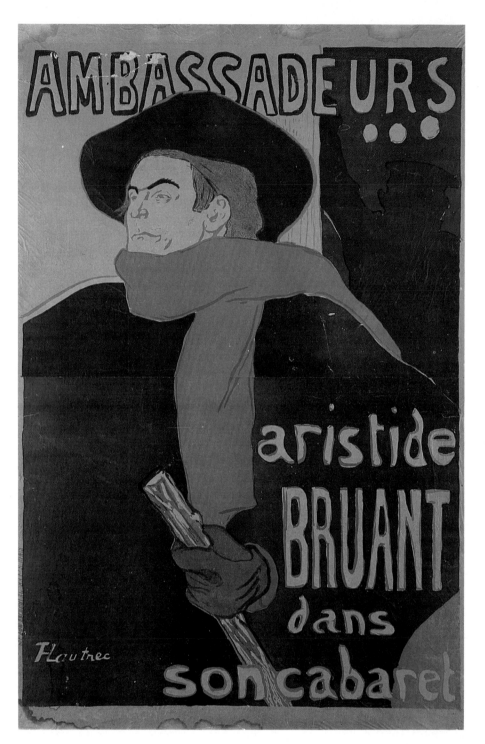

*Toulouse-Lautrec.* The Laundryman Calling at the Brothel, *1894. Musée Toulouse-Lautrec, Albi. Brothel-keeping, as Lautrec had every opportunity to observe, was a business. Checking the laundry bills was just another routine that caught his eye.*

whom we are given only half a view, is not outrageous in this atmosphere of professional *sang-froid*.

In other paintings Lautrec suggests the vulnerable status of women living on the edges of a man's world: the situation that Manet describes, unforgettably, in the *Bar at the Folies Bérgère*. In *The Barmaid*, a brilliant pastel in the collection of his works at Albi, Lautrec shows a podgy, bowler-hatted customer fingering the cane held between his knees, while the barmaid, dressed with the severity of a nurse but with a pretty mouth, registers obvious shock, as at a proposition. Between them, on the shining counter, stands a half-filled glass. Lautrec uses the same scene in the lithograph *En Quarante*, though there the lady who is being eyed by her escort looks as though she could take care of herself.

It is typical of Lautrec that barmaids and waitresses should so appeal to him: more likely than not, they were the only class of women, outside the bordellos, whom he habitually met. One such, a performer at the café

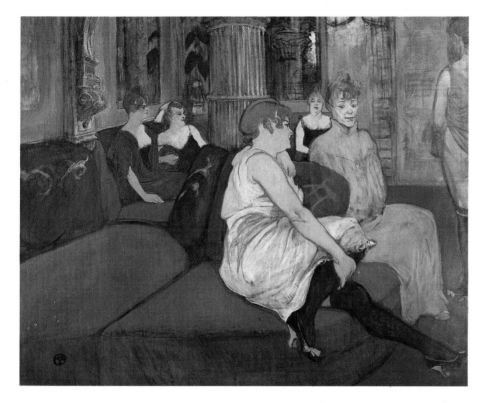

*Toulouse-Lautrec.* The Salon at the Rue des Moulin, *1894. Musée Toulouse-Lautrec, Albi. Lautrec regarded this painting as his definitive version of Paris's most famous brothel, where he was very much at home, even using it on occasion as his address. The women, as always in his sharply-observed interiors, are painted with both candour and respect.*

concert at Le Havre, is the subject of an exuberant late portrait, *The English Girl from The Star, Le Havre,* whom Lautrec encountered towards the end of his life. With her fair complexion, merry eyes and shock of blonde hair, she makes perhaps the strongest subject since Lily Grenier, one of Degas' favourite models, whom Lautrec had painted 11 years previously. The strong-faced Lily, a lock of red hair falling over one eye, is clad in a kimono, more suggested than described, though missing nothing in drama.

In the loveless world of the licensed houses, Lautrec discerns a tenderness between women who by look, touch or embrace make their feelings known. One of his favourite music-hall performers, Cha-U-Kao, the clowness, is seen dancing with another woman in *Dance at the Moulin Rouge.* A group of works dated 1893 show bedroom scenes of embracing women, one of whom has short, boyish hair. Related works in the Tate Gallery and at Albi show the same group together in langorous communion, and the subject recurs in subsequent years.

Cha-U-Kao is the subject of four particularly impressive works in 1895. In one of them she is securing her ample bust in the bodice of a purple

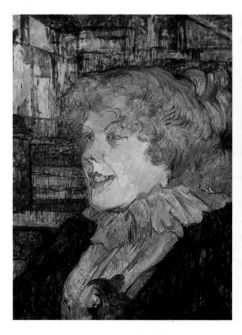

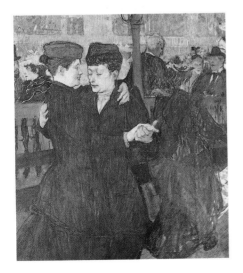

*Toulouse-Lautrec.* At the Moulin Rouge (The Waltzers), *1892. National Gallery, Prague. One of the dancers in masculine garb is the female clown, Cha-U-Kao, who worked at the Moulin Rouge and makes frequent appearances in Lautrec's work. The figure with her back to the couple is Jane Avril, a dancer who shot to fame on the strength of Lautrec's poster of her.*

*Toulouse-Lautrec.* The English Girl from The Star, Le Havre, *1899. Musée Toulouse-Lautrec, Albi. Her name was Miss Molly and she sang at the sailors' bar. Lautrec persuaded her to sit for this vivacious study – the opposite of the used-up women of the Paris bars.*

*Toulouse-Lautrec.* Cha-U-Kao Fastening her Bodice, *1895. Musée d'Orsay, Paris. Lautrec, with his entrée to the salons and dressing rooms, was as close an observer of* the female toilette as Degas who saw him as an equal. 'Well, Lautrec,' Degas remarked after looking round an exhibition of his work, 'I see you are one of us.'

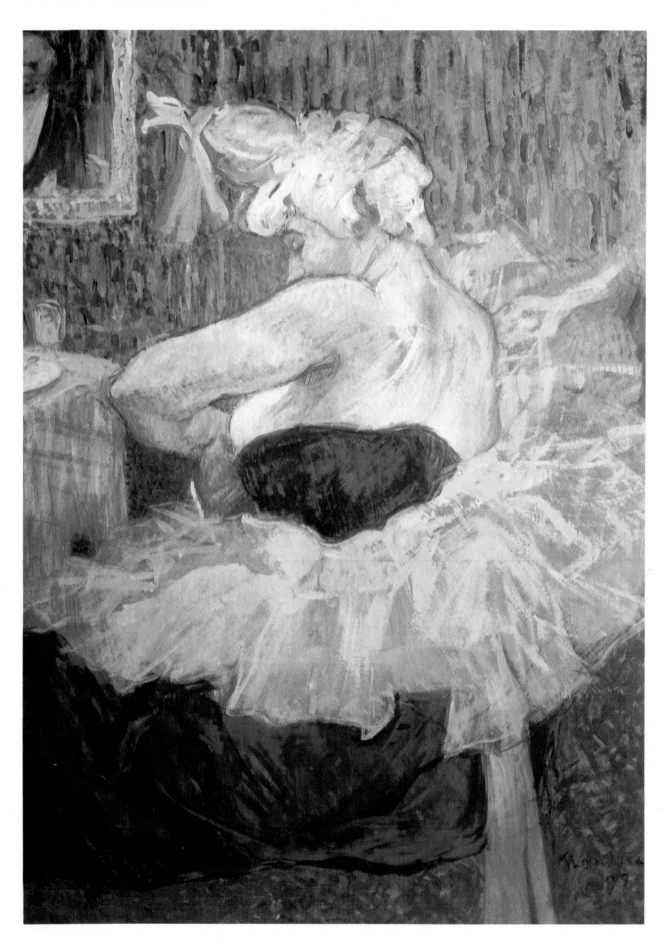

*Toulouse-Lautrec.* La Goulue at the Moulin Rouge. *Poster, 1891. It was this colour lithograph that launched Lautrec as a poster artist. Its popularity had much to do with the fame of La Goulue, whose dance routine included showing a glimpse of bare skin just above her garter. Her partner is Valentin-le-Désossé, 'Valentine the Boneless', whose amazing thinness, shabby frock coat and top hat worn over his beaky nose made him a conspicuous performer.*

costume with a skirt of yellow voile that seems to engulf her figure like a flame. This painting was bought direct from the artist by a noted collector who did not have the courage to hang it with his other treasures, confining it to a small unvisited room. In 1911 it passed to the Louvre; but it was a further three years before they felt able to show it. A similar reticence had surrounded an exhibition of Lautrec's work at the Goupil Gallery, formerly run by Theo Van Gogh, in 1893. Degas was among those who accepted an invitation to attend the show, which was held in an upstairs room away from prying strangers. 'Well, Lautrec,' said Degas affably when he had looked around, 'I see you are one of us.'

In the following year Lautrec found himself in distinguished company at Durand-Ruel's, where a number of his lithographs were shown alongside a group of works by Manet. Lautrec's mastery of the new printing processes that were emerging at the time opened a new and adventurous method of publicizing his work, especially relating to the music hall and nightlife of the city. Colour lithography transformed the art of the poster almost overnight, and Lautrec was the first major artist to take advantage of its possibilities.

# TOULOUSE-LAUTREC

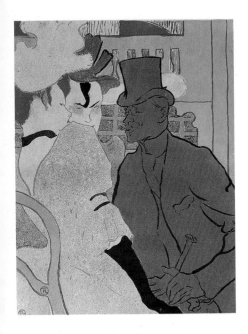

*Toulouse-Lautrec.* An Englishman at the Moulin Rouge, *1892. Musée Toulouse-Lautrec, Albi. In this lithograph Lautrec catches the likeness of a typical 'masher' from across the Channel, unmistakably English from his topper and cane to his confident moustache, making a call backstage.*

His first attempt, a poster for the Moulin Rouge, was an instant success, and he followed it with colour lithographs of La Goulue and her sister, drawn directly on to the lithographic stone. It was a method he was to use for his print-making from that day. *An Englishman at the Moulin Rouge, Le Coiffeur* and other prints followed: 45 in one year. The first themes were all of cabaret dancers, actresses, singers. One of his posters, showing Jane Avril, a chorus girl at the Moulin Rouge, is credited with setting her on the road to stardom. She was described as slim, agile, with a creamy white complexion; and she danced, one enthusiast wrote, 'like an orchid in ecstasy'. For May Belfort, a little Irish songstress at the Petit Casino, Lautrec designed a poster wholly in red, which was a particular hit with the public and at the box office.

Yvette Guilbert, a star in her own right, whom Lautrec greatly admired, was another entertainer to be immortalized in his lithographs. He made two series for her, which appeared four years apart. The *chanteuse* and actress, looking at the proofs, sent him a note of appreciation, adding: 'But for heaven's sake, don't make me so horribly ugly! Just a little less . . .' Later she threatened to take legal proceedings against Lautrec; but the series received such a rapturous welcome from the public that she changed her mind. In the print room of the Louvre there is a series of quick sketches of Mme Guilbert made by Lautrec direct from performances on stage. At Albi there is a study of her black, elbow-length gloves, which graphically evokes her sinuous presence. Lautrec brought his series of lithographs of women to a close with a limited edition, which he called simply *Elles*. It is his tribute, as an artist, to the women whose often pitiable lives he had shared on equal terms, treating their scented workplaces as his own.

The rigours of nocturnal life, and an addiction to alcohol, steadily reduced him to a shell of his earlier self. Venereal disease, sleeplessness and mental exhaustion brought his work to a standstill. As with his friend Van Gogh, the cure was seen as a spell of mental care, in which male nurses hauled him about and sedated him with drugs. The supposed madness was nothing of the kind, but in 1899 the horror of his situation came close to unbalancing his mind.

After a spell with no beverage but water, confined to a cell-like room, he began to recover and sent for his paints. His friend Maurice Joyant,

*Toulouse-Lautrec.* Woman at the Tub, *from 'Elles', 1896. The album of ten lithographs called simply 'Elles' is an anthology of subjects from the brothels, though only two of them are overtly suggestive of that world. Five of the lithographs are in colour, the others are in black and white.*

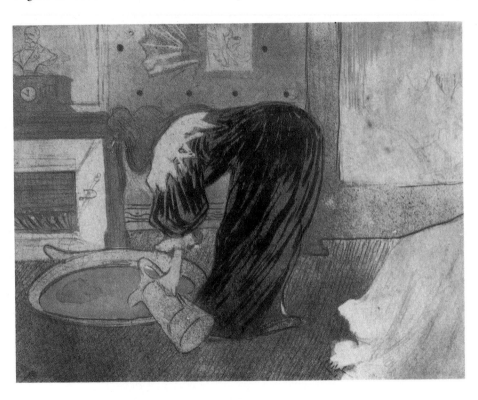

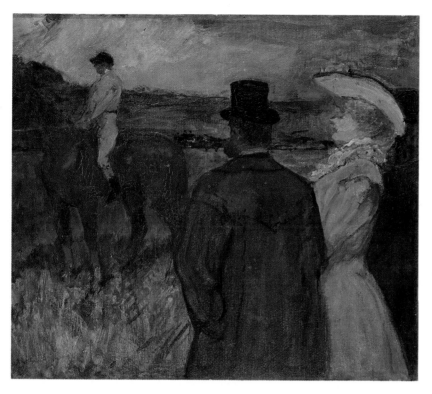

*Toulouse-Lautrec. At the Races, 1899. Musée Toulouse-Lautrec, Albi.*

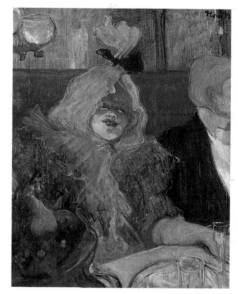

*Toulouse-Lautrec. A Private Room at the Rat Mort, 1899. Courtauld Institute Galleries, London. Courtauld Collection. The lady is Lucy Jordan, a demi-mondaine of note, and the rendezvous a restaurant near the Place Pigalle often frequented by Lautrec and his hangers-on. The meaty dish arriving from the left is perhaps symbolic.*

director of the Gimpel Gallery, commissioned a series of circus illustrations, a favourite theme, which Lautrec tackled with renewed interest. He produced a set of crayon drawings of such quality that they helped to persuade the doctors that his seizure was over. After some weeks he was released, though kept under surveillance. It was these circus drawings, he told Joyant, that secured his freedom. He made for Normandy, staying in Le Havre, where he joined the waterside bar life and fell for the barmaid at the Star. At the end of July he went south to Bordeaux, where he stayed with his mother at Château Malromé, amid the vineyards.

Returning to Paris in the autumn, he revisited his old haunts, went to the races at Longchamp, called on la Goulue and other friends on the show-business circuit, painting busily. These late works include some fine portrait studies, among them *A Private Room at the Rat Mort*, which is dominated by a carnivorous-looking blonde, Lucy Jourdain; some richly-coloured scenes from a now-forgotten opera, 'Messalina'; and Mlle Cocyte in the title role of Offenbach's *La Belle Hélène*. Meanwhile, he began sorting the pictures in his studio, stamping them with his monogram and finishing some that he had abandoned on their stretchers. Joyant, seeing him off for Archachon, felt sure the two of them would not meet again. In August 1899 his sojourn by the sea was dramatically interrupted by a stroke. His mother hurried to fetch him back to the Château de Malromé, where, half-paralysed, he attempted a few last paintings. He died on 9 September, two months short of his 37th birthday.

The obituarists were divided. Some represented him as a victim of his subject matter, 'an eccentric and deformed individual whose approach to the world around him was coloured by his own physiological defects', as one newspaper put it. Another acknowledged his talent but saw it as 'an evil gift with pernicious and depressing effects'. *La Dépêche* was fairer: 'In spite of all the adversities he suffered, he retained an inner nobility that was worthy of his noble birth.' Perhaps the *Journal de Paris* came nearest to the judgement of posterity. 'What he saw was no compliment to society at the end of the 19th century. But he went in search of reality . . . His ambition was not merely to paint pictures, but also to illustrate psychological truths. For this reason he will always be the master of an unknown epoch.'

# 17 Whistler

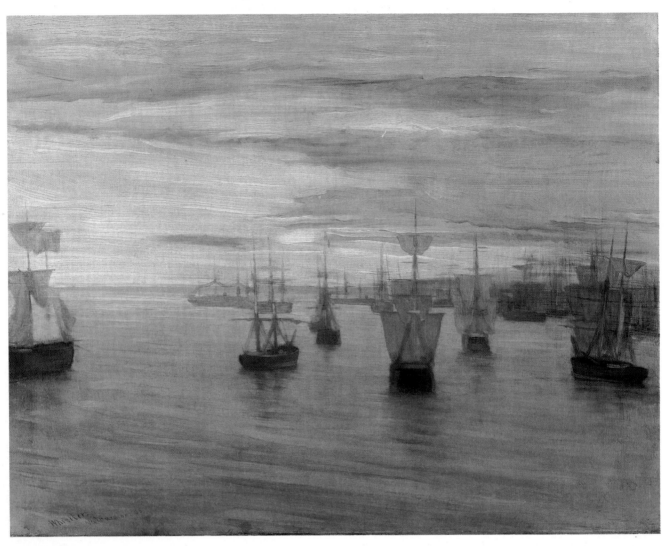

*Whistler.* Crepuscule in Flesh Colour and Green: Valparaiso, *1866. Tate Gallery, London. Whistler made a voyage to South America this year, setting off in February and returning in September, and brought back three paintings done in Valparaiso. This one, to which he gave a typically abstract title, shows vessels in the harbour on a calm evening with fading light. The sky was painted in long, liquid strokes and the sea very thinly, as if for a sketch, at a single sitting.*

James McNeill Whistler, an expatriate from America, arrived in Paris in November 1855 and enrolled in evening classes at the École Imperiale to study drawing. From there he went to join Charles Gleyre's academy – anticipating Monet, Renoir, Sisley and Bazille – where the instruction, though strictly on classical lines, left pupils with some initiative in choosing subjects. From the beginning he was essentially an aesthete, with fastidious tastes in art, as in other good things in life, including witty conversation and stylish company including that of pretty women; the best, it could be said, was good enough for him.

He had chosen Paris because he sensed that there, in the intellectual climate of the 1850s, changes for the better in the realm of the arts were possible. In particular, the avant garde, encouraged by Courbet's public example, were already talking excitedly of 'realism'. Whistler's early Paris paintings, in which the figures are grouped in seemingly impromptu attitudes in domestic settings, reflect the prevailing tendency, in his circle of young French painters, towards the artful informality that was to distinguish the work of Manet a decade later.

His famous and once scandalous *Symphony in White*, now in the National Gallery of Art, Washington, was much admired by the younger set when it was shown at the Salon des Refusés in 1863. It shows a slender, titian-haired young woman in a full-length white dress standing on a bear-skin, the creature's head glowering out of the picture. With its light and

airy tones and its mixture, in the girl, of maidenhood and slight dishevelment, it was much to the liking of Whistler's circle, who would have recognized the model as Joanna Hefferman, known as Jo, his current mistress. The title, too, is significant: Whistler had a penchant for musical titles and made use of them throughout his career.

The *Symphony in White* is the first of a succession of works in which he moves beyond realism for its own sake into imaginative symbolism. Like Manet, again, Whistler was influenced by Velasquez in achieving both mood and harmony, and in his dramatic use of black. He was also caught up in the rage for Japanese art, a persistent element in Impressionism from Manet to Mary Cassatt. In such paintings as *Purple and Rose* and *Caprice in the Purple and Gold*, both from 1864, he makes brilliant use of Japanese motifs. He even uses them in open-air subjects: in *Symphony in Grey and Green: the Ocean*, a few years later he introduces in the foreground a dainty cluster of flatly-drawn oriental twigs and leaves in an otherwise naturalistic painting, and signs it with a Japanese monogram. The Japanese influence persists in other paintings of the 1860s, among them *Variations in Blue and Green*, in which a group of swiftly-painted women in oriental postures are looking into a stream. Remarkably, all perspective has been ignored, and the brushstrokes make no attempt at realism except to reveal the artist's hand in every stroke.

With his highly-developed flair for designing his own exhibitions, he held a showing of his Venetian etchings at the Fine Arts Society, in Bond Street, in 1883, just ahead of Durand-Ruel's exhibition of Impressionists in the same vicinity. He insisted that the mouldings, skirting board, carpets and fireplace of the gallery should be yellow, and the walls white to a height of ten feet. The etchings were in white frames, and buttercups in yellow pots were placed all round the gallery. To keep up the theme, the artist himself turned up wearing yellow socks, and presented arrivals with yellow

*Whistler*. Nocturne in Blue and Silver: Cremorne Lights, *1872. Tate Gallery, London. The scene is the view from Battersea to the Chelsea side of the river, with the tower of Old Chelsea church on the distant skyline. Three years before the first Impressionist exhibition in Paris, Whistler found the London critics full of praise for this unconventional townscape. The* Times *said it supported Whistler's view that painting was akin to music, 'and should be content with moulding our moods and stirring our imaginations.'*

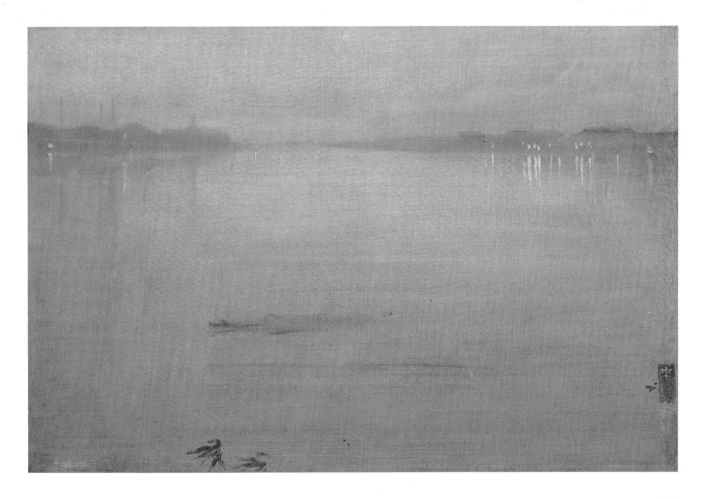

# WHISTLER

paper butterflies. At the private view there was a visit from the Prince and Princess of Wales, and Whistler showed them around himself.

The Whistler butterfly – in modern terms, his logo – was everywhere. People were amused. Some of them even looked at the etchings. The newspapers wrote off the event as just another publicity stunt for modern art. The catalogue, enlivened by press cuttings describing those prints that had already attracted the critics' notice, was handed put by a flunkey in yellow livery. It was a sell-out, and went into three editions. Pissarro wrote to Lucien from Paris how much he regretted not being there to see Whistler's drypoints, and recommended his printmaker son to study the etcher-showman's method, with its' suppleness, pithiness, delicacy and charm.'

Whistler's orientalism soon threatened to take him over. Not only was he clothing his models in Japanese gowns, and inventing 'Madame Butterfly' interiors, but he also liked to have oriental objects around him, such as Japanese woodcuts, Chinese blue and white china, ornamental screens and fans, giant oriental jars, kimonos to hang on the studio walls. His models, on occasion, were obliged to dress their hair in Japanese style. The Japanese influence is even apparent in the famous *Nocturne in Black and Gold*, a falling rocket in an exotic sky, the work which drew from John Ruskin the taunt that Whistler, with 'cockney impudence', had asked 200 guineas for 'flinging a pot of paint in the public's face – a charge that provoked one of the most celebrated libel cases in British history – one from which Whistler emerged, vindicated but bankrupt, with one farthing's damages, but with his reputation as a public entertainer much enhanced.

*Whistler*. Three Figures: Pink and Grey, *1879. Tate Gallery, London. Whistler made three versions of this composition, one of which is now in the Freer Gallery of Art, Washington. The poet Swinburne, who visited Whistlers's studio at the time, remarked on the 'soft brilliant floor-work and wall-work of a garden balcony, serving to set forth the flowers and figures of flower-like women.'* Pink and Grey *was eventually presented to the Tate in memory of the artist.*

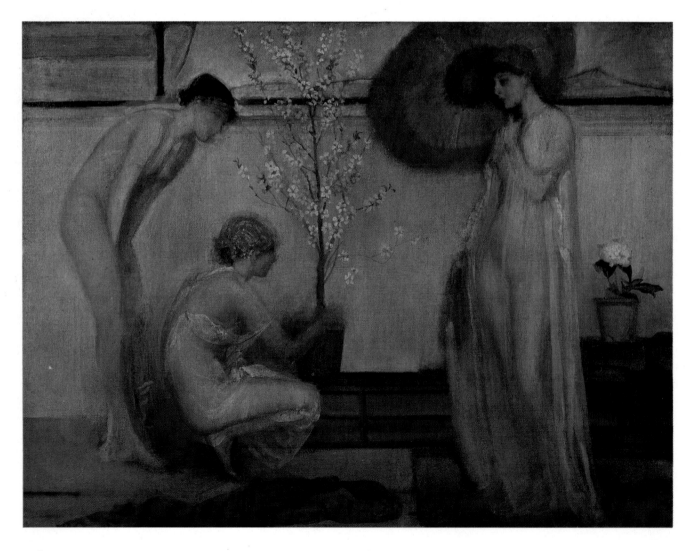

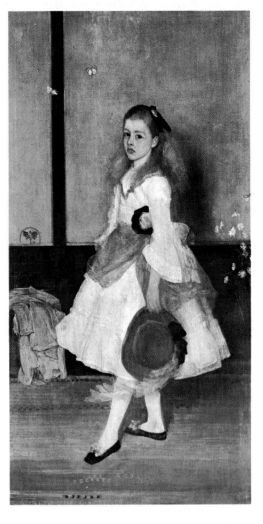

*Whistler.* Harmony in Grey and Green: Miss Cicely Alexander, *1872. Tate Gallery, London. The eight-year-old subject of this much-admired portrait complained many years later that Whistler kept her standing so long in one position that she got 'very tired and cross and often finished the day in tears'. Later, they became good friends: 'He used to come to my father's house and make at once for the portrait with his eye-glass up.'*

*Whistler.* Miss May Alexander, *1872. Tate Gallery, London. Agnes Mary Alexander, Cicely's elder sister, was persuaded by her father to wear riding habit for this portrait, and by Whistler to wear a picture hat. It was one of the works which he was obliged to sell at the time of his bankruptcy following his legal battle with Ruskin in 1878. It was retrieved some ten years later.*

William Morris Rossetti, brother of the Pre-Raphaelite painter, drew attention to the 'heavy rich darkness of the clump of trees to the left, contrasting with the opaque obscurity of the sky, itself enhanced by the falling shower of fire-flakes, felt and realized with great truth.' That is how it still strikes us; but in its day it was an affront to the values of High Art. Whistler soon sold the picture to an American collector, and was solvent again. 'You will be pleased to hear,' he wrote to a friend, 'that the cheque for the Pot of Paint four times over has been paid into the bank.'

In much of his work Whistler seems to be flirting with Impressionism. There are small, crisp oils that would keep many a Boudin company; portrait subjects that recall Degas or Manet; and other works in the mood of the Symbolists, with a twilit atmosphere in which details fade but the shadowy form remains. He mastered the elusive light of Venice in his etchings and pastels, and depicted the streets and houses of his urban habitat with as much attention as a Monet or Pissarro. Yet in all this he remains closer to the conventions than to his contemporaries, an individual rather than a member of any coterie, whether in Paris or London.

In a characteristically dogmatic statement, which he called 'Red Rags', he described his ideal – to make painting 'the poetry of sight, as music is the poetry of sound.' Art, in Whistler's view, should stand alone, appealing to the artistic sense of eye or ear, without confounding this with emotion foreign to it, such as devotion, pity, love, patriotism, none of which, he said, had a part to play in art. That was why he insisted on calling his works 'arrangements' or 'harmonies', he said. This disengagement from the content of his work separates him from the Impressionists, while accepting from them that subjects drawn from everyday life can rise above the anecdotal or the banal, communicating meanings in the present that would not have been possible in the past. Whistler, as an artist and public performer, would never have wished to be any closer to the Impressionists than that.

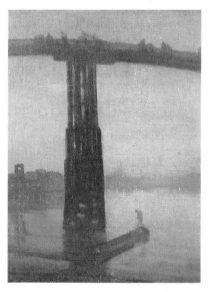

*Whistler.* Nocturne in Blue and Gold: Old Battersea Bridge, *c.1872–73. Tate Gallery, London. Whistler's dramatic view of the bridge as seen from water-level gives it an exotic, Japanese appearance. In the background, work is proceeding on the new Albert Bridge. The spatter of gold may represent fireworks. This picture was shown at Whistler's famous trial for allegedly insulting the public, as evidence for the defence. It was a picture, he said, 'which many are pleased with and which I myself prize.'*

# 18 Sargent

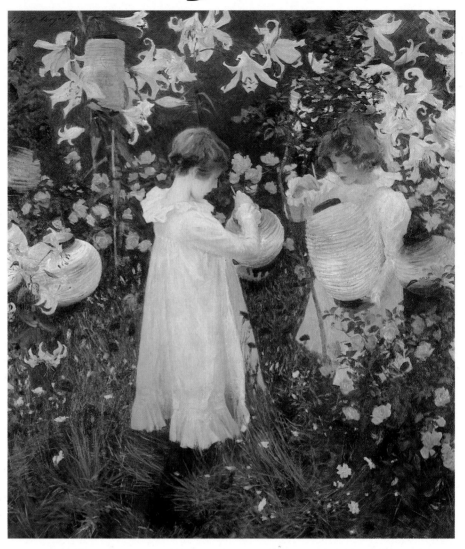

*Sargent*. Carnation, Lily, Lily, Rose, *1885–86. Tate Gallery, London. The comfort of the English shires prompted Sargent to look around him with a relaxed eye – an eye that owed much to his contact with Monet. A popular song provided the title to this carefree work, painted while staying with friends in the Cotswold village of Broadway.*

Whistler was not the only American painter to be making his way in Paris during the Impressionist period. John Singer Sargent, more than 20 years his junior, was attracting notice at the Salon in the 1870s, after being trained by the energetic French portrait painter, Carolus-Duran, in what Sargent described as 'a very broad, powerful and realistic style'. From him he also acquired an enthusiasm for the Spanish masters, and from looking at Manet and Degas he picked up a superficially adept version of the new 'Velasquez' manner.

Sargent had been born in Florence, was well-grounded in Spanish, Italian and French art (he was 21 before he paid his first visit to the United States) and regarded himself as a product of European culture. A woman friend described him as 'extremely serious, a great maker-up of theories'. He was also personable, a fine pianist, and of gentlemanly manners. Though obviously well-versed in classical techniques, he was essentially a modern: he once described himself as 'an impressionist and an intransigent'.

In 1884 he was suddenly catapulted into a scandal. He had become obsessed with a compulsion to paint a prominent Parisian socialite, Madame Gautreau, née Virginie Avegno, of Louisiana, wife of a French banker and shipping magnate. She was 23, an arresting woman to look at, with a dead-white skin and electrifying figure. Sargent persuaded her to sit

for her portrait, and after several false starts found a daring pose for her, in undulating profile, wearing a low-cut black gown.

When the Salon opened, *Madame Gautreau* caused such an outcry that the artist, the lady and the lady's mother were virtually put to flight. Sargent himself was forced to escape down corridors and dodge behind doors. Madame Gautreau followed him back to his studio, weeping. Her mother protested that her daughter was ruined. 'She will die of shame!' she cried. Sargent, unnerved, hurried off to England, where almost nobody knew him, and took refuge in the country. There are two footnotes to this story. One is that another painter, Gustave Courtois, exhibited a portrait of the lady seven years later, but with her sexual charge defused (that version is now in the Louvre). The other is that Sargent later re-titled his portrait of her *Madame X*.

His Impressionist period began with his hurried departure from Paris, and ended when he left England for the United States six years later. He had not wanted to leave, but the Madame Gautreau affair had saddled him, he feared, with the kind of reputation that is bad for business. England, he hoped, would produce a new circle of patrons. He had already painted a number of outdoor studies in Nice, in which the authentic Impressionist touch is apparent. In the summer of 1884 he enjoyed the hospitality of the Vickers family, near Petworth in Sussex, where he began painting with a sunnier palette. Two years later, in the attractive Cotswold village of Broadway, he found subjects more pleasing than any in Paris, notably the

*Sargent.* Monet Painting at the Edge of a Wood, *c. 1887. Tate Gallery, London. Sargent met Monet in Paris, at the second Impressionist exhibition in 1876, painted him a couple of times, and called on him at Giverny. There is no doubt that he was imbued, to an extent, with Monet's lambent spirit. This study shows the great Impressionist at work – typically, out of doors.*

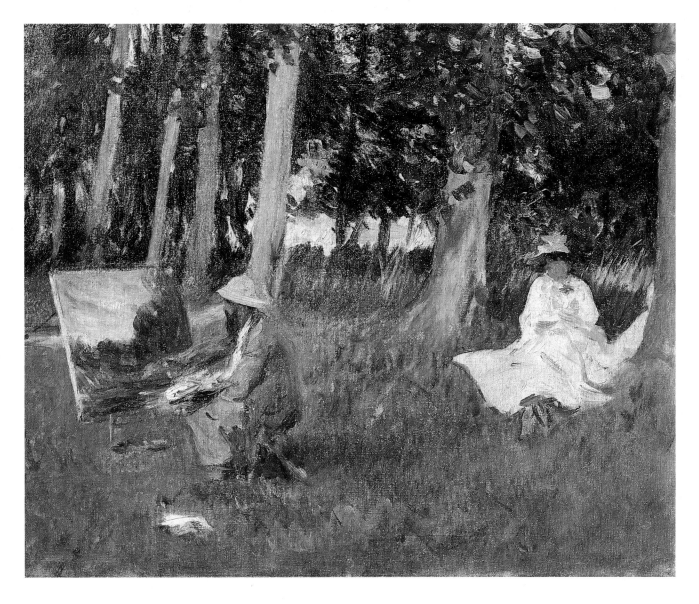

# SARGENT

typically English girlishness of an artist friend's young daughters, Dorothy and Polly, whom he painted together in a large composition, *Carnation, Lily, Lily, Rose*. The title was taken from a now-forgotten popular song, and Sargent himself later made fun of it. Also at Broadway he painted *Home Fields*, an Impressionistic exercise in what one critic described as the 'dab and dot school, of which Mr Sargent is the arch-apostle'. An undeniably Monet-ish study, *A Morning Walk*, followed in 1888, painted at Calcot, on the Thames near Reading. It shows the painter's young sister, Violet, amid sun-flecked greenery, holding a parasol, prompting *The Times* to remark: 'It is true that only a few are as marvellous in their choice of colours as M. Monet, but Mr John Sargent has for once gone rather far in this direction.'

He had met Monet at the second Impressionist group exhibition in 1876, painted him on at least two occasions, and visited him at Giverny three times between 1887 and 1891. When Monet mounted a campaign among his friends to buy Manet's *Olympia* for the Louvre, Sargent made a donation. He also bought four Monets himself, and wrote to Monet of his 'voluptuous stupefaction' in the presence of his work. When Monet visited England during an exhibition at the New England Art Club, where two of his paintings were showing, he gave his address as Sargent's studio in Tile Street, Chelsea. It would be stretching the facts to deduce from these contacts that Sargent and Monet were close friends; but the Impressionist influence on Sargent's work of the 1880s surely came from him.

There is a pen picture of Sargent by George Henschel, a fellow-guest at Henley in the summer of 1887, which recalls the paintings of Monet and his group made from boats in their early days. Sargent built a floating studio on a punt, where he disported himself along the Thames in white

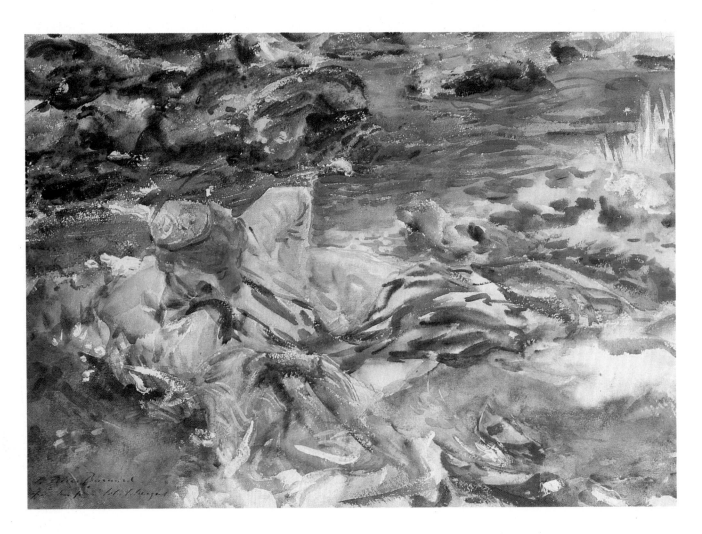

*Sargent*. Woman in Turkish Costume, *1907. Victoria and Albert Museum, London. This watercolour shows Polly Barnard, daughter of the illustrator Fred Barnard, in Turkish dress beside a brook in the Val d'Aosta. She and her sister Dorothy had posed for* Carnation, Lily, Lily, Rose *eight years before, and had now joined the Sargents on a summer holiday in the Alps.*

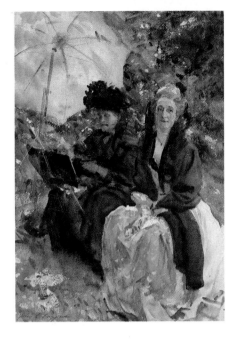

flannels, a silk scarf round his waist and a straw hat with a red ribbon. Monet would have lifted his boater to such a figure poling through the shallows of the Seine at Argenteuil.

Sargent's boating scenes of this period, such as his painting of Paul Helleu sketching in a punt, accompanied by his wife, recall many an Impressionist's excursion afloat, usually with a visibly bored young woman in attendance. Monet obviously got on well with Sargent, but there are suggestions that the great man did not encourage notions that the English-American was 'one of them'. Pissarro wrote in a letter to Lucien that Monet had found Sargent 'very kind', adding: 'As for his painting, that, of course, we cannot approve of. He is not an enthusiast but rather an adroit performer.'

Sargent's own idea of what constituted professional standards in painting was based on the primacy of a trained eye. In the late 1880s it enabled him to produce a succession of works which put him, however momentarily, in the company of Renoir and Monet. They range from studies of landscapes energized by sunlight to dappled garden scenes, portraits, flower studies, and an occasional still-life reminiscent of Manet. His method in those fruitful few years was described by Edmund Gosse, one of his Cotswold circle. Sargent would emerge, Gosse wrote, carrying a large easel, advance a little into the open, then suddenly plant himself down nowhere in particular – behind a barn, opposite a wall, or in the middle of a field. His object, Sargent explained, was to get in the habit of reproducing whatever met his eye without any previous rearrangement of detail. The painter's business, he maintained, was 'not to pick and choose, but to render the effect before him, whatever it may be.'

He may well have noticed, in the post-Impressionist era that was then unfolding, a falling away from the representational art which he believed in. He could indulge in the Monet-esque delights of the kind he found among his friends in one of the prettiest parts of England, without letting go of the discipline in which he was trained. But he would not permit the modern movement to carry him away.

When Roger Fry mounted his eye-opening exhibition of post-Impressionist painting at the Grafton Gallery, London, in 1910, Sargent declined to have anything to do with it, on the grounds that his sympathies were in exactly the opposite direction. 'The fact is, I am absolutely sceptical as to their having any claim whatever to being works of art,' he told Fry. With that, John Singer Sargent, by then a pillar of the British art establishment, a Royal Academician and public figure, swept Cézanne, Seurat, Gauguin and Van Gogh out of his life.

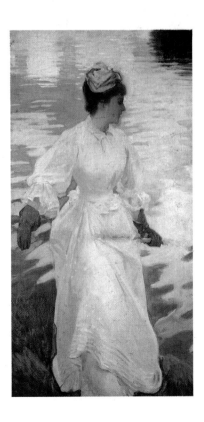

# 19 Seurat and Signac

*Seurat.* Une Baignade, Asnières (Bathers), *1883–84 National Gallery, London. The setting is the left bank of the Seine at Asnières, an industrial suburb of Paris. The bathers are workaday citizens on a free afternoon, grouped in attitudes of private reverie, dulled by the sun and the sliding Seine. The perfectly balanced composition, and the Pointillist technique, make this a monument in the history of Western art.*

In May 1884 a young Frenchman barely out of art school, Georges Seurat, presented a huge work, two by three metres in size, at the first exhibition of the Salon des Artistes Indépendents in the Tuileries, titled *Une Baignade, Asnières.* Unequivocally 'modern', it owed its everyday outdoor subject – figures lounging on a suburban river bank, with a not-too-distant industrial skyline – and its immediate confrontation with light, to Impressionism. But a closer study of the brushwork disclosed that, instead of the normal application of paint on canvas, choosing the perceived colours and laying them on in variegated brushstrokes, the artist had laid a myriad of tiny touches of paint side by side, so that at a distance they fused in the eye as unbroken passages of colour. The painting revealed itself as owing structure and tonal balance to a minutely worked-out process, a quasi-scientific application of classical principles, realism supported by illusion – the very reverse of the spontaneity of Impressionism, yet making an Impressionistic impact on the eye. *Une Baignade* (otherwise known as 'The Bathing Place' or simply 'Bathers') had the presence of a masterpiece. Félix Fénéon, the most perceptive art critic of his day, singled it out at once, and had the satisfaction of seeing how its logical consequences followed in the next three decades. 'Much as I delighted in them,' he told John Rewald, 'the initial spice of surprise was never repeated.'

Seurat, born in Paris to well-off parents, had been given the conventional education for a young man of his class. But an interest in art revealed itself in his early schooldays, during which he was taken to the

Louvre and to the small commercial galleries, some of which were beginning to deal in the work of the younger, more adventurous painters. By the time he was 15 he was attending evening classes, and in 1876 he enrolled at the École des Beaux-Arts. His teacher there, Henri Lehmann, was a Salon painter in the classical tradition passed on by Ingres, with its emphasis on scrupulously academic drawing. Seurat must have disappointed him, since he eventually left with no particular commendation. By 1879 he was established in a studio of his own, and after 12 months of military service in Brest, on the Brittany coast, he returned to a concentrated course of drawing in black and white, balancing dark and light masses, with particular attention to the ways in which they interpenetrate and reflect each other's density.

In 1883 he submitted to the Salon a portrait drawing of his friend and fellow-student, Edmond Aman-Jean, done in conté crayon, which prefigures the drawings done over the next 12 months as studies for the great *Baignade*. That drawing was the only work of his ever to be accepted by the Salon jury. By then he had made his first acquaintance with the Impressionists; but his intellectual curiosity was more taken with the journals of Delacroix, in which the great Romantic discusses the ideas that led him to define his position as: 'I am a rebel, not a revolutionary'. There followed the set of painstaking drawings and studies for the *Baignade*, groundwork for the work to come.

Seurat's intellectual approach was based on his own theories of colour and on the philosophy of Positivism, popular at the time, which held that reality itself is subject to scientific laws. He set himself the task of finding a formula to translate light, colour and the artist's subjective emotion on to a two-dimensional surface. Out of these experiments came a new concept in art: Pointillism. It arrived just as Impressionism was entering its last phase, when some of the original members were at odds with one another and refusing to exhibit under the old name. A group exhibition had been held in 1882, but in 1883 there was only the series of one-man shows organized by Durand-Ruel. The following year – the year of Seurat's début – there was to be no Impressionist exhibition, nor in 1885.

Pissarro, as always, did his best to rally the troops; and in 1886, having met Seurat and his close friend Signac, he invited them both to show with the Impressionists that year. Monet, Renoir, Sisley and Caillebotte refused to join in, and a split opened between Pissarro and the rest that never finally healed. Pissarro himself was indulging in the Pointillist 'heresy', though he saw it as nothing of the kind. However, when the eighth group exhibition opened, Degas insisted that the word 'Impressionist' should be left out of the title.

One of Seurat's exhibits was the now famous *Sunday Afternoon on the Island of the Grand Jatte*. Instead of the working-class figures in the *Baignade*, Seurat peoples the scene with dressy ladies and gentlemen, turning it into a society picture, which accounts for a large part of its fascination for later generations. There are deliberate aberrations of scale and perspective, and the wind is blowing from two directions at once, all of which is undoubtedly intentional. The surface of the painting, as it shifts and teases, exerts a dream-like fascination, defying us to deny or contradict the evidence of our eyes, carefully stage-managed to Seurat's satisfaction. Oil sketches of the location, done in preparation for the painting, show Seurat accurately laying out his *mise-en-scène* without the people.

The *Grande Jatte*, derided by the critics on its first appearance, has not ceased to excite comment and analysis over the years. John Russell has called it 'one of those great pictures in which every generation finds the meaning best suited to it.' (Of how many Impressionist paintings may that be said?). Pissarro, agonizing over the relevance or otherwise of Seurat's

# SEURAT AND SIGNAC

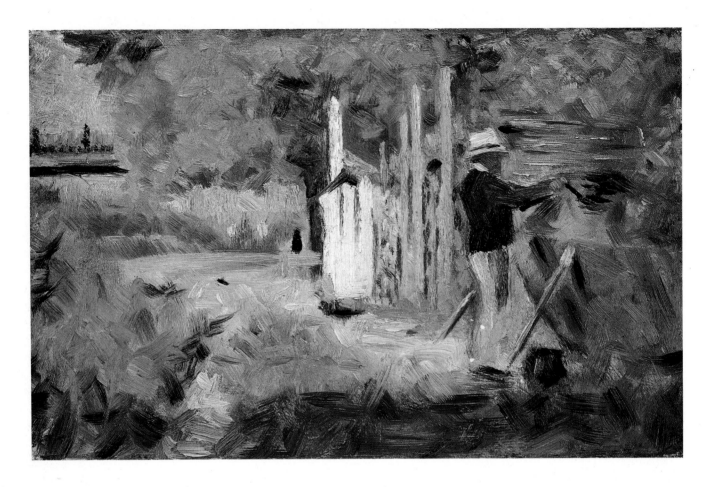

*Seurat*. Man Painting his Boat, *1883. Courtauld Institute Galleries, London. Courtauld Collection. For his preliminary colour studies for the* Baignade, *Seurat reverted to broad, quick brush-strokes of the kind used for this vigorous little panel.*

dots as units in an Impressionist style of painting, wondered how to combine the purity and simplicity of the dot with the freshness of sensation. The dot, he acknowledged, was thin, diaphanous, monotonous, even in Seurat. Van Gogh, when he reached Arles, told his brother Théo that he had embarked on a large work which reminded him of 'beautiful big canvases' he had seen in Seurat's studio. One of these was *La Parade du Cirque* ('The Circus Parade') a wonderfully stylized tableau lit by gas-flares, with a clown, centre-stage, playing the trombone.

With half-a-dozen other impressive works to his name, and regardless of the almost universal derision of most of the press, Seurat had begun to attract admiring followers. Of these, Paul Signac, who was with Seurat almost from the beginning, emerged as the most talented. He was an attractive, spirited young man, certain that his and Seurat's ideas were not only right but scientifically proveable.

Born in 1863, he was both the youngest and the most energetic of the artists who advanced Seurat's notion of Pontillism, or 'Divisionism' as he preferred to call it. He had begun painting in the 1870s, first under the influence of Monet, whose friend Guillaumin became a close companion on sketching expeditions around Montmartre and along the rivers and coasts, where he learned to sail. He visited the first Impressionist exhibition at the age of 16, and had the temerity to sit down and begin making his own copies of some of the works. After seeing some paintings in the Pointillist style by Émile Bernard, he made himself known to the artist as joint inventor, with Seurat, of the new technique, and took him to see some of his own work. Bernard was not impressed: he actually turned

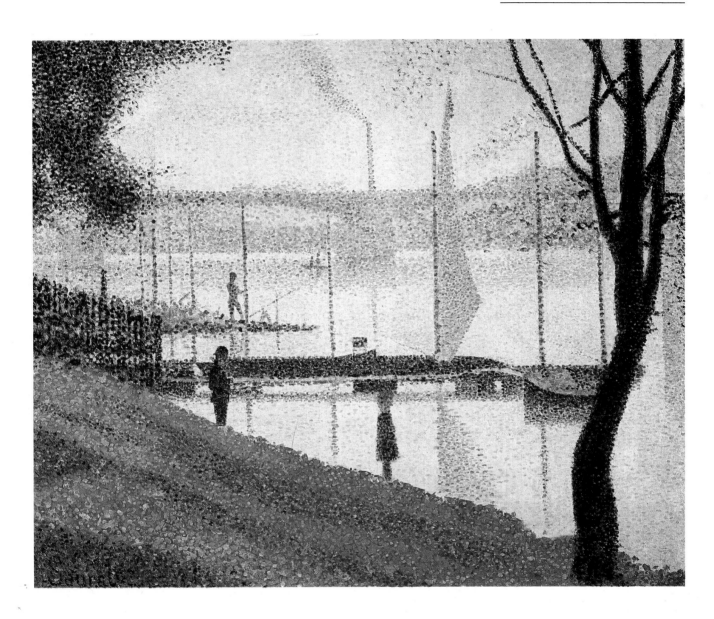

**Above:** *Seurat*. The Bridge at Courbevoire, *1886–87. Courtauld Institute Galleries, London. Courtauld Collection. Seurat's mind, as much analytical as creative, makes a geometric composition seem as natural as any Impressionist equivalent, with such familiar elements as the river bank, the jetty, stationary yachts, and the distant chimney – ever-present reminders that this is a place where the modern world is not far away.*

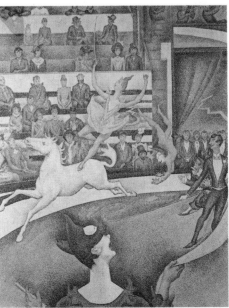

**Left:** *Seurat,* The Circus, *1891. Musée d'Orsay, Paris. The poetic worldliness of the great* Baignade *gives way, in this more self-conscious exercise, to cleverness of a different order. Seurat's life was not long enough for him to take his precepts any further.*

against Pointillism after this encounter with Signac, and never used the style again.

Signac had a more cordial relationship with the normally unsociable Van Gogh, who for a time experimented with the dot technique, calling it 'a real discovery'. At the age of 22, Seurat's irrepressible disciple was a prominent exhibitor at the final Impressionist exhibition of 1886, an occasion that marks the end of Impressionism as a collective contribution and the beginning of what was dubbed Neo-Impressionism.

Signac, meanwhile, had much to do with Pissarro's waverings. Seurat and he, along with others of their group, were convinced anarchists. So was Pissarro, which helped to harmonize artistic tensions within the ranks. Signac's reasons for putting his faith in anarchism included, he said, the suffering of the masses; logic, kindness and honesty; physiological laws (the rights of the stomach, brain etc); and the need to feel happiness all around oneself. It was quite a vogue among artists and intellectuals. Rather touchingly, they looked forward to a time when their brushes and pens would be held in as high esteem as the hammer, the sickle and the plough.

Art politics flourished in this combative atmosphere. Pissarro's doubts about his own work made him crave for peace of mind, he said, to carry out a couple of large landscapes. He wrote to Lucien: 'Seurat, Signac, all our young friends, like only my works, and Madame Morisot's a little. Seurat, who is colder, more logical and more moderate, does not hesitate to declare that we have the right position.'

Signac by now was inclining towards more colour, and seemed to be

*Signac*. Le Port, St. Tropez, *1900. Marlborough Fine Art (London) Ltd.*

moving away from the mathematics of the faith towards a more decorative emphasis. Both were preparing for the Salon des Indépendents in March 1891 when Seurat took to his bed with a sore throat. Two days later, on 30 March, he died.

The family gave half the paintings in his studio, the accumulation of ten years, to his widow. Signac helped to catalogue them all, from large canvases to sketchbook drawings. 'It is possible that the name of Seurat, without ever having been well-known, will some day be forgotten,' wrote an obituarist who knew him, 'but I declare that he was one of the forces in the art of our time, worth more than all the others of his age, and that with him vanishes one more of our hopes of seeing a new art emerge,' he said. Pissarro wrote that, with the passing of Seurat, Pointillism was finished, but that 'its consequences will prove to be of the utmost importance in art. Seurat really added something.'

*Signac.* Paris, *1910. Marlborough Fine Art (London) Ltd. These sketches, combining line and watercolour in scintillating combinations, are typical of Signac's work at the turn of the century: he is one of the few painters of his time whose drawings are valued as highly as his finished works in other media. He habitually used the medium for working on the spot. As a great admirer of Jongkind, whose watercolour sketches showed Monet the way to mastering the brilliant passage of light, he developed his own command of the medium to a point where he could dispense with an under-drawing. He favoured subjects with the sparkle of the ocean in them, carrying the example of his three favourite artists – Monet, Jongkind and Turner – into our own times.*

# 20 Bonnard and Vuillard

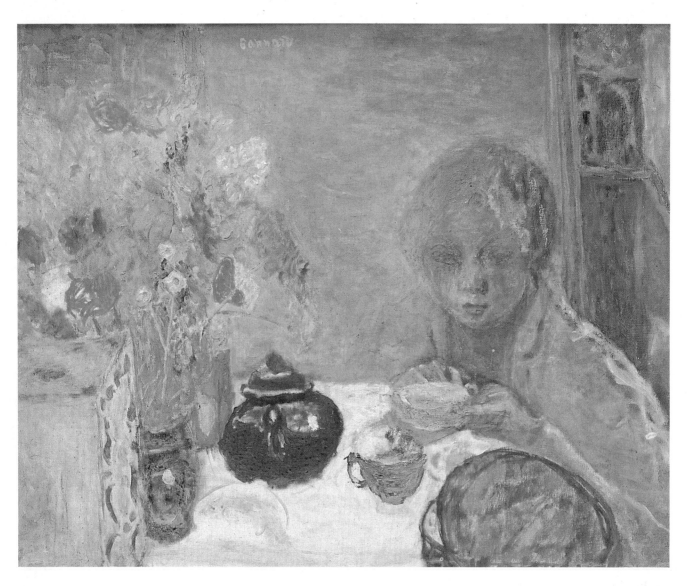

*Bonnard*. The Breakfast, *1907.*
*Musée du Petit Palais, Paris.*

A few days before Seurat's death, an exhibition opened at the Salon des Indépendants, organized by Paul Signac. Many of the young members of the Neo-Impressionist movement were represented, including the 24-year-old Pierre Bonnard, who showed a group of nine works.

He was the son of a Parisian civil servant, who would have preferred his son to persevere with his law studies rather than take up painting. At the Académie Julien, Bonnard joined a circle of aspiring artists that included Paul Sérusier and Maurice Denis – both, as devotées of Gauguin, future members of the avant-garde Nabis group. Bonnard was shortly afterwards admitted to the École des Beaux-Arts, where he underwent the disciplines of classical training and also made two further friends, Ker-Xavier Roussel (another future 'Nabi') and Edouard Vuillard. Impressionism, by this time, was no longer regarded by young artists as a 'progressive' way to paint, except in the forms revealed by Cézanne, in which structure could be discerned beneath a subtly suggestive surface. As a tribure to their idol, Maurice Denis painted a large group portrait, *Homage à Cézanne*, which was shown at the 1901 Salon, including some of Cézanne's most devoted supporters at that time. Bonnard was there, along with Vuillard and Denis himself, also Degas.

The decade was one in which the basis of Impressionism was being developed in several directions, its influences re-worked and applied over a broader field of pictorial language. At this early stage, Bonnard was deeply influenced by Japanese printmaking, with flat planes of colour and highly individual perspectives. Japanese art was taken seriously in the 1880s. There were scholarly treaties on techniques, a monthly magazine, *Le Japon Artistique*, and major exhibitions at the Galéries Georges Petit, at the Exposition Universelle of 1889, and at the École des Beaux-Arts a year later. Bonnard's exhibits at the Salon des Indépendants prompted one critic to describe him as without a doubt 'the most Japanese of all French painters'.

For all his popularity among the younger set, Bonnard stood aside from the art factions of the time. 'I do not belong to any school,' he declared, 'I simply want to do something that is personal to myself.' He took a close interest in mass-produced printed images, which reinforced his belief in the expressive power of colour. Colour alone, he decided, could convey light, form and character; values need not be added. His own posters, screens and lithographs for the art magazine *La Revue Blanche*, and some highly successful designs for the theatre, reflected this simplified notion of colour painting. They brought him to the notice of the dealer Ambroise Vollard, who encouraged and promoted his work in the 1890s. In that time of proliferating art groups, he was named as one of the Fauves – literally, 'Wild Beasts' – who with Matisse at their head ushered in the new century with a hectic outburst of colour.

Bonnard's Paris street scenes of this period evoke the bustle and charm of a living city, with bright colours – pink, almond-green, turquoise, yellow – complementing the rain-laden tones of winter. The figures are caught in brisk, chunky attitudes; horses, cabs and dogs populate the streets. The portfolio of Bonnard's lithographs showing scenes of Parisian life, published by Vollard, sums up all that was enjoyable in the life of a young artist on his way to the top. He designed costumes for productions at the arts theatre run by Paul Fort, modelled marionettes, and painted sets for his friends' plays, including the first performance of Alfred Jarry's proto-surrealist comedy, *Ubi Roi*.

André Gide, on a visit to the Salon d'Automne in 1905, was particularly taken by the Bonnards. He found in them, he said, 'feelings of wit, mischief and bizarre excitement', whether the subject was an omnibus, a dog, a cat, or a pair of steps. This humour, levity even, in Bonnard's early work also impressed the stage-struck Lugné-Poe, who with Vuillard and Denis shared the studio at 28 rue Pigalle that Bonnard had found for them all. According to him, Bonnard was the humorist of the company: his nonchalant gaiety and spontaneous wit, he said, came out strongly in his paintings at that time. 'They were decorative in intention, but there was a satirical element in them which he was to abandon later.' Another member of their circle remembered Bonnard as prodigiously gifted but concealing the element of genius behind a sort of boyish playfulness. 'He liked to work intuitively, wielding the brush with passion, under remote control by thought and will.'

Before long, Bonnard was turning to the Impressionist view of subject-matter taken in at a glance: 'What I am after is the first impression, all one sees on first entering a room,' he wrote. On the other hand, he stopped painting from nature, recognizing a drawback in confronting a subject direct: the presence of the object, as he saw it, could cramp his hand in the very act of painting. As the whole point of painting, he argued, is an idea, to be confronted by a physical object while painting was to risk involvement in what was seen, to the disadvantage of the more precious element, the idea. Instead, he began to paint largely from memory, but with the aid of

*Bonnard. The Table, 1925. Tate Gallery, London.*

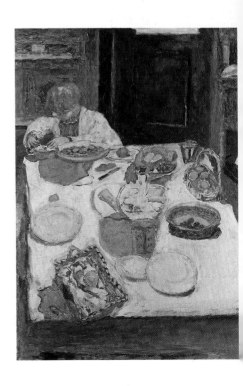

# BONNARD AND
# VUILLARD

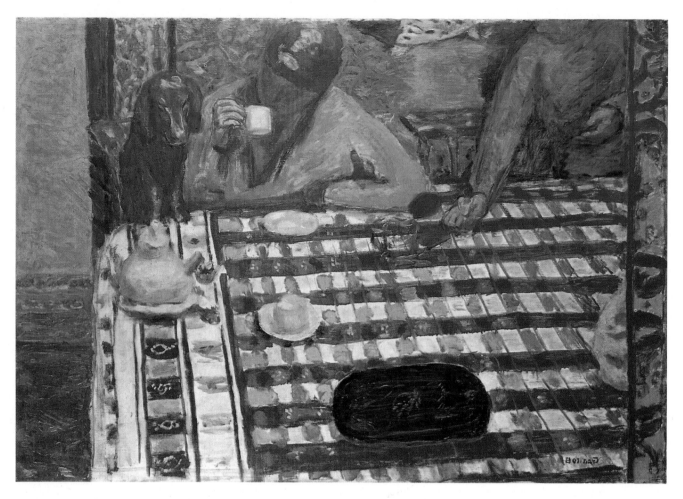

*Bonnard.* Le Café, *1915. Tate Gallery, London. At the date of this work, Bonnard was pondering which direction to take: 'I must learn everything over again, forgetting all I know.' Colour, he feared had 'turned his head', and he was sacrificing form to it. As one means of introducing structure he took to including horizontal or vertical lines as window frames, tables and doors.*

preliminary drawings. These became indispensable to him as records of visual experience, set down on the instant, and recoverable when he needed to use them. He drew incessantly – figures seen in streets, parks or on country walks, eating at table, spotted from windows, on beaches or boats; still-lifes, unposed, on window sills or kitchen tables, entire landscapes, sometimes on the scale of the Alps, compressed to postcard dimensions; and quick studies of the ever-present Marthe at her toilette or in the bath. Any handy piece of paper would serve, from office stationery to used envelopes. If a favourite blunt pencil was not handy, he would improvise with a burnt match-stick. In some of these rapid studies of light, tone, and essential detail, suggestions of colour might also be noted. To turn these energetic scraps into paintings, Bonnard would simply wait until one or another of them surfaced in its own time, prompted by the creative impulse. Drawing, to Bonnard, was sensation; colour was reasoning. Together they give his paintings, with their intensely personal way of seeing, their distinctive presence and design.

One of his maxims, that art can never dispense with nature, infuses Bonnard's landscapes with an almost reverential light. He looked at the world, as has been said by one admiring critic, Antoine Terrasse, 'as if he were witnessing the first day of Creation: the revelation of a sudden, new-born splendour filling the whole of Space.' Through Boudin in his early days, Bonnard discovered Deauville and Trouville, where the northern coastal light pleased him even more than the brilliance of the Mediterranean. It was the play of light, rather than sunny saturation, that

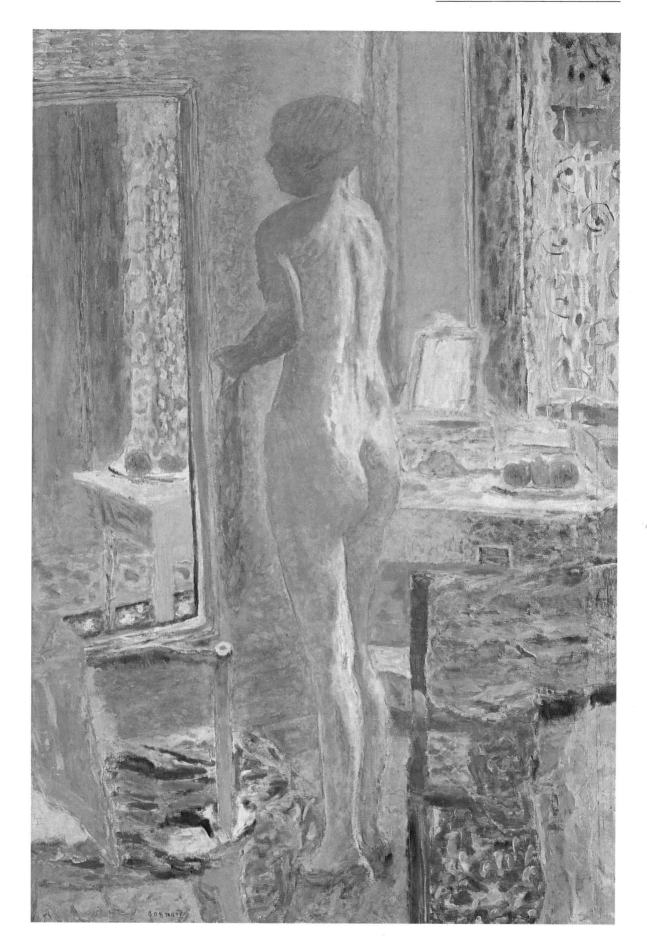

*Bonnard.* Nude in front of a Mirror, *1933. Galleria Internazionale d'Arte Moderne, Venice.*

# BONNARD AND VUILLARD

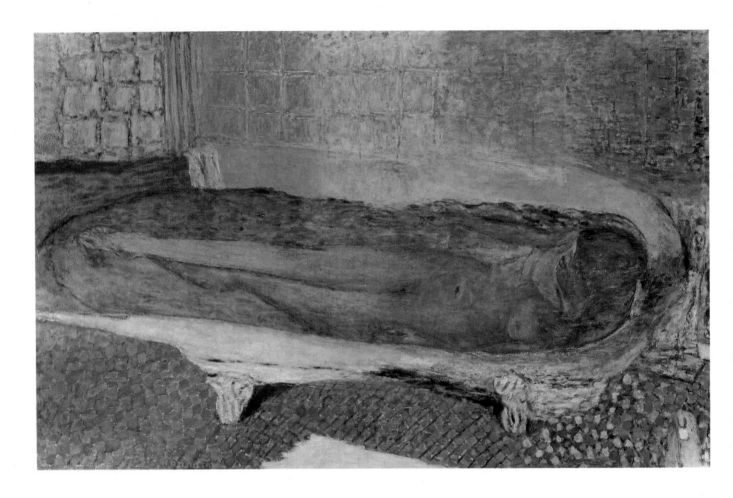

*Bonnard.* Nude in the Bath, *1937. Musée du Petit Palais, Paris. The nude was to Bonnard what water-lilies were to Monet: a theme in which form dissolves into a spectrum of fragmented light.*

appealed to his painter's eye and poet's mind; the light that casts colour into shadows, as the first Impressionists had discovered for themselves a generation before.

His preoccupation with the nude dates from the turn of the century, when he painted mildly erotic studies of young women lounging on tumbled beds, as in *Woman with Black Stockings* (1900) or *The Red Garters* (1904), in a looser, more naturalistic style than his 'Japanese' period. This led to what were to become the best-known subjects of his career, the almost continuous series of nude paintings of his mistress, later his wife, Marthe de Meligny. She was an obsessive washer and bather, seemingly more at home in the bath than reclining, fully-clothed, in an armchair. Bonnard made of these daily occasions not so much a subject as a theme. The misty, naked form floats in a haze of colours, sensuous yet incorporeal, sometimes reduced to little more than her own reflection in the lingering steam which unites the prosaic details of the bathroom – coloured tiles, a glass, a towel – in poetic reverie. Bonnard's bathroom nudes are no less sublime, as exercises in late Impressionism, than the wondrous water-lilies of Monet.

A large retrospective exhibition of his work was held at the Orangerie, Paris, in 1947, the year he died. In 1940 he had been granted the rare distinction, for a foreign artist, of being elected to the Royal Academy, where a definitive exhibition of his works was hold in 1966. It was a handsome tribute to an artist by then acknowledged as the most important 'pure painter' of his generation.

Edouard Vuillard, born in the same year as Bonnard, was reconciled to following his father's career as a professional soldier, on the grounds, he said, that he could think of no other job in which he could possibly distinguish himself. His father, after an honourable military career, was invalided out while still short of retirement age, to become a tax-collector in Cuiseaux, in the Saône-et-Loire. The family moved to Paris in 1877, and Edouard succeeded in winning a scholarship to the Lycée Condorcet, one of the city's leading schools.

Three of his equally bright schoolfellows – Ker-Xavier Roussel, Lugné-Poe and Maurice Denis, all destined to shine in the avant-garde a few years later – were instrumental in turning Vuillard's ambitions in a different direction. When Roussel left to study painting, Vuillard went with him; and in 1889, as if to allay his family's misgivings, he got a crayon drawing of his grandmother into the Salon at his first attempt. He met Bonnard as a fellow student at the Académie Julian, and it was not long before their ever-widening group were nicknamed the 'Nabis', or Prophets, probably in

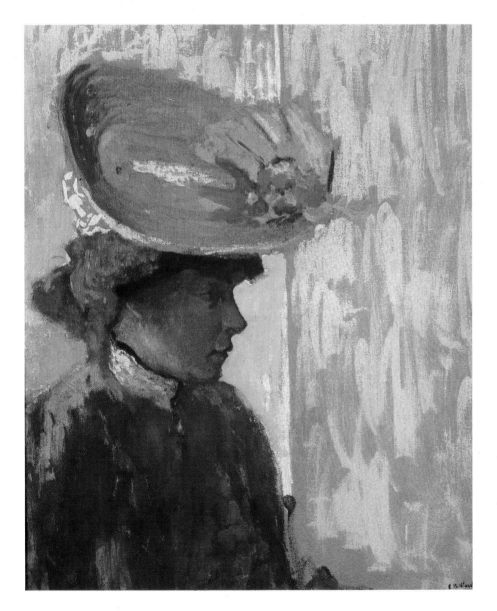

*Vuillard.* Model with a Big Hat. *Marlborough Fine Art (London) Ltd. Vuillard never subscribed to any of the art theories of his day, preferring to work within the confines of a life spent mainly at home, making a virtue of the closeted themes that became known as* Intimisme. *As a survivor of the age of Impressionism, he shared, in his modest way, in its honours.*

# BONNARD AND VUILLARD

joking reference to their earnest community of purpose.

Vuillard made a quieter start than some of his friends. He confined his painting to domestic scenes, influenced, like Bonnard's work at the time, by the revelation of Japanese art, though with the individual sense of place that was to mark his whole career. The critic Félix Fenéon, reviewing a joint exhibition in 1891, found Vuillard 'indecisive, with passages of fashionable handling, highlights of a literary sort, and once or twice a sweet colour chord that comes off charmingly.'

He lived a relatively quiet life with his mother in Paris, and spent the summers with such friends as the Nathansons, who published the influential art journal, *La Revue Blanche*, or with the Hessels, who bought the occasional picture from him. He remained in close touch with his fellow Nabis, sharing in their joint enterprises, and entered his work for the wildly mixed exhibitions of the time. His exposure to the theatre, which was then undergoing a drastic overhaul at the hands of Lugné-Poe and his kind, presented Vuillard with interesting new material, and also the confidence to work on a larger scale than he was used to, as a scene-painter. This was also the explosive age of Ibsen, whose *Rosmersholm* was given its first French performance at Lugné-Poe's Theatre de l'Oeuvre in October 1883. Vuillard designed the programme, illustrated it with his own drawings, as well as designed the scenery; there is an air of refined theatricality about

*Vuillard.* Mother and Child, *c.1899. Glasgow Art Gallery and Museum.*

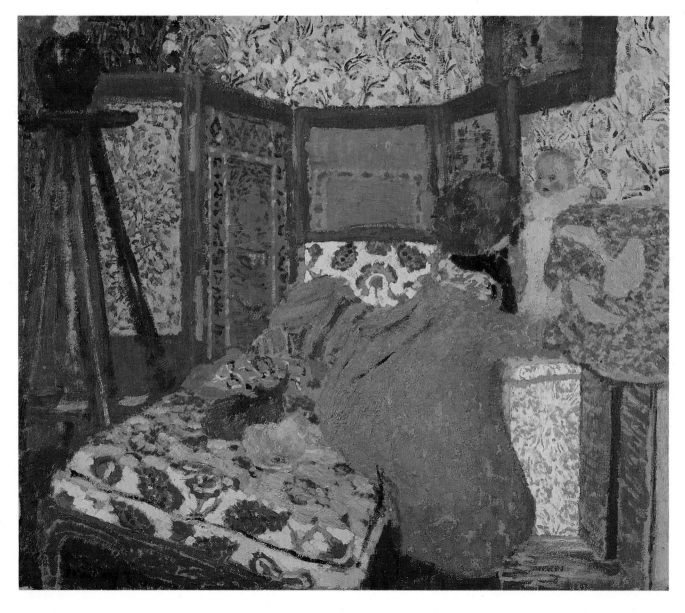

his panel subjects of the Nineties, as if he were imagining them taking place on the stage.

Meanwhile, as a fervent admirer of the poetry of Mallarmé, he was busying himself in the affairs of the literary set. Mallarmé, just before he died, invited Vuillard to illustrate his *Herodiade*, a work of appropriately chilling solemnity for a writer taking the last few steps to his grave. Vuillard himself had a somewhat funereal quietness about him. A friend remembered him from the 1890s as sober and dignified to the point of austerity, the apartment and studios where he worked invariably monastic. 'Vuillard,' he concluded, 'takes everything to heart.'

Amid the art crazes of the day, Vuillard remained uncommitted to any 'ism'. He was content to explore the mysteries of colour in all its gradations and manifestations, staying clear of theoretical solutions and holding back from the excited experiments of his fellow-Nabis and the Fauves. He and Bonnard remained friends. But their work never brought them together. Vuillard lived on in Paris, satisfied with the city's parks as an urban, well-tamed landscape, and treating them as such whenever he painted them. He rarely travelled. As time passed his celebrity as a survivor from the age of the Impressionists brought him respect and recognition. He was elected to the Académie des Beaux-Arts in 1937 and was given a retrospective at the Musée des Arts a year later.

His work retains much of the attraction that made his name early in life; partly, perhaps, from nostalgia, that potent emotion of our time, and partly out of regard for an artist who, as Paul Signac put it, was engaged in the same search and was involved, like all his generation of artists, in 'the cruel dilemma of representation'.

His art, like the man, is private and discreet, more given to allusions than to statements. His interiors are bathed in softly shaded light, the furnishings neither plain nor pretentious, the figures arranged at a distance from each other, self-contained. There are ferns in pots and bottles on tables, half-obscured pictures on patterned walls, old women wearing hats indoors, younger ones on plump couches, passing the time. Occasionally Vuillard offers a self-portrait; a face that looks as if it was never young, eyes absorbed, the beard lank, the face of someone who has settled for what he knows, and no longer hankers after sensations. Vuillard's enclosed art mirrors his sheltered life. Lugné-Poe once called him 'loving-kindness personified'. Signac, again, remarked on his feeling for 'the timbre of things'. That comes close to Vuillard's somewhat cryptic sense of reality, in one sense far from that of Bonnard, but in another achieving intimacy of an equally painterly kind: intimacy of the soul.

# The Painters, their Friends and Contemporaries

### Baudelaire, Charles

In addition to his remarkable work as a poet, Baudelaire – born 21 April 1821 – was a critic of great discernment. His reviews of the Salon exhibitions reflect his impatience with the mediocrity that the Impressionists were to challenge. An admirer of Delacroix, a champion of Constantin Guys and of Daumier, he recognized Manet's 'taste for modern truth'. In 1862 Manet made a witty etching of Baudelaire in profile, which he included in his *Concert in the Tuileries Gardens*, one of his formative early studies of everyday life. Baudelaire died on 31 August 1867.

### Bazille, Jean-Frédéric

Born at Montpelier on 6 December 1841, the son of a professional family who wanted him to become a doctor. He broke off his medical studies to start painting in Paris, entering Gleyre's studio in 1862 where he met Monet, Renoir and Sisley. He shared lodgings with Renoir, whom he subsidized from his allowance, and every summer returned to Montpelier to paint. The most obvious influence on his style is Manet. In 1867 he bought a painting from Monet's studio, *Women in the Garden*, for which he paid 2,500 francs, payable in monthly instalments. A popular member of the Café Guerbois set, he appears in Manet's *Déjeuner sur l'Herbe* and in Fantin-Latour's *The Studio at Batignolles*. At the outbreak of the Franco-Prussian war in 1870 he enlisted in the Zouaves, and was killed in action on 28 November in the same year.

### Bernard, Émile

Born in 1868, he was an early friend of Toulouse-Lautrec, Gauguin and Van Gogh, also of Cézanne and Odilon Redon. His paintings at Pont-Aven, Brittany, under the influence of Gauguin, are among the most significant and original of the Symbolist period. Later, he devoted more time to writing and criticism than to painting. His correspondence with the leading artists of his time is a valuable source of critical evaluation in the formative years of the Modern Movement. He died in 1941.

### Bonnard, Pierre

Born in 1867, he gave up law to become a painter, and had early success as a member of the Neo-Impressionist group that included Maurice and Edouard Vuillard, with whom he exhibited at the Salon des Indépendants. After experimental beginnings he turned to a decorative Impressionism in the line of Monet and Renoir, though with an underlying feeling for structure. His mature style is a synthesis of acute observation, recalled in the studio, and a masterful use of colour in the 'pure' Impressionist tradition. He died in 1947.

Bernard *by Toulouse-Lautrec, 1885.*
*Tate Gallery, London.*

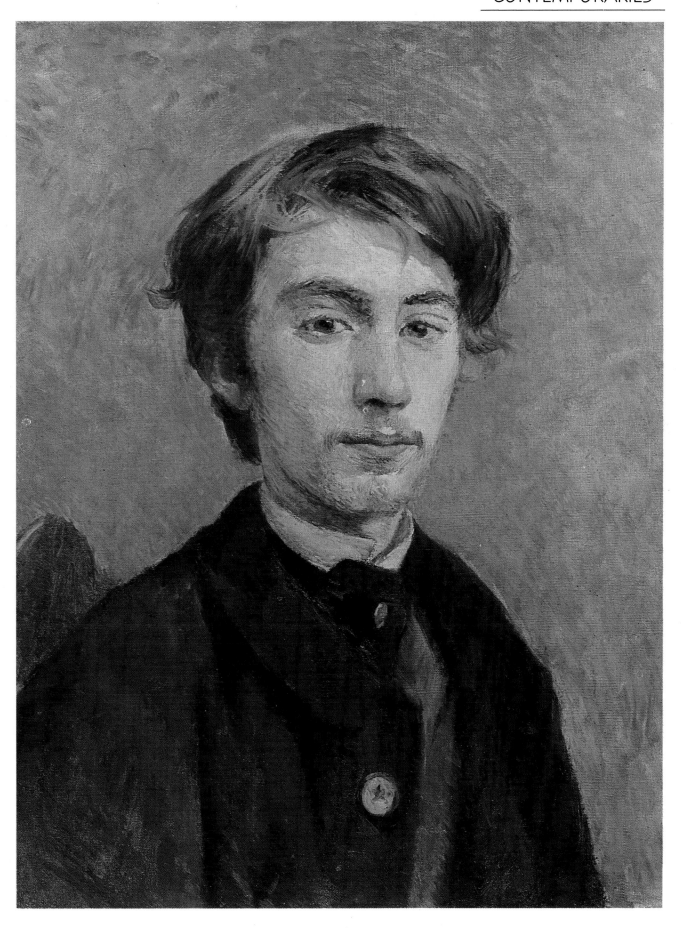

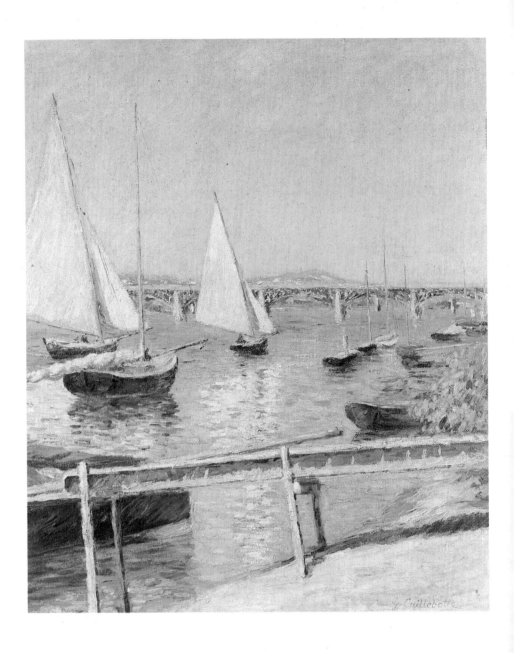

*Caillabotte*. Yachts at Argenteuil,
*1888. Musée d'Orsay, Paris.*

### Boudin, Eugéne-Louis

Born at Honfleur on 12 July 1824, the son of a ship's captain. Boudin began painting in his twenties and was awarded a grant to study in Paris. Strongly influenced by Corot, he exhibited at the Salon in 1859. His encounter with the youthful Monet encouraged Monet to start painting open-air scenes. He also learned from Jongkind, who painted in Normandy and along the Channel coast. Boudin's bright palette and breezy style bring him close to the Impressionists, with whom he exhibited as a token of support at the first of their exhibitions in 1874. He never formally joined them, but was a kindred spirit until his death in Deauville in 1898.

### Caillebotte, Gustave

A painter, born in 1848, who was close to the Impressionists and exhibited with them in five of their exhibitions between 1876 to 1882. As well as painting he collected his friends' pictures, which he intended should pass to the French state on his death. The bequest consisted of no less than 65 works, including 8 by Renoir, 16 by Monet, 5 by Cézanne, 7 by Degas. When Caillebotte died in 1894 they were officially rejected, in terms of outrage and contempt. Renoir, executor of the will, was forced to weed out the paintings to which the authorities most violently objected – well over half. Only in 1928 was the entire collection admitted to the Louvre.

## Cassatt, Mary

Born in 1845, the daughter of a Pennsylvanian banker of French ancestry. She spent her schooldays in France and subsequently travelled in Europe before settling in Paris, where she exhibited in the Salons of 1872 and 1974. Degas showed an interest in her work and the two became close. As his model she figures in several of Degas' works. She aligned herself with the Impressionists and exhibited with them four times between 1879 and 1886. Mary Cassatt was largely instrumental, through her access to well-placed Americans, in securing recognition for the Impressionists in the United States. She died at Beauvais on 19 June 1926.

## Cézanne, Paul

Born at Aix-en-Provence on 19 January 1839, the son of a self-made business man in the town who intended him for the law. Cézanne left for Paris to study painting in 1861, failed the entrance examinations of the École des Beaux-Arts and joined the Académie Suisse. There he met Pissarro, whose support and advice helped to keep him at work. He exhibited with the Impressionists only twice: in the first show, and in 1877. Thereafter he went his own way. He died at Aix on 22 October 1906.

*Cézanne.* Rocks at L'Estaque, *1882–85. Museu de Arte, São Paulo.*

Victor Chocquet *by Cézanne,*
*1876–77. Columbus Gallery of Fine*
*Arts, Columbus, Ohio (Museum*
*Purchase, Howard Fund).*

## Chocquet, Victor

Born in 1821, Chocquet entered the Impressionist circle in 1875 when he attended the auction at the Hôtel Drouot of works by Renoir, Monet, Sisley and Berthe Morisot, which the group had organized in a desperate effort to make some sales. A customs official with only his modest salary to spend on collecting, he already owned a number of pictures by Delacroix. He met Renoir, who subsequently painted two portraits of Chocquet himself. Renoir introduced him to Cézanne's work, and Chocquet at once became an enthusiastic supporter. He next met Monet, whose work he also began to collect. He died in 1891 and his widow inherited his collection. When it was sold after her death it included 35 Cézannes, 12 Monets, 14 Renoirs, 5 Manets and one painting each by Sisley and Pissarro.

## Corot, Jean-Baptiste Camille

Born in Paris on 16 July 1796. After training as a conventional landscape painter he took to sketching out of doors, developing his own style of lyrical romanticism. The freshness and directness of his work put him alongside Constable, whose painting *The Hay Wain* he might have seen at the Salon of 1824, when Bonington also exhibited there. Boudin and the young Impressionists respected him for seeking his subjects, as they did, in the open air, though he preferred to finish them in the studio. Pissarro had more to do with him than the other members of the group, except perhaps Berthe Morisot, whom Corot particularly liked and encouraged. He died on 22 February 1875.

*Corot.* The Bridge at Nantes, *Musée du Louvre, Paris.*

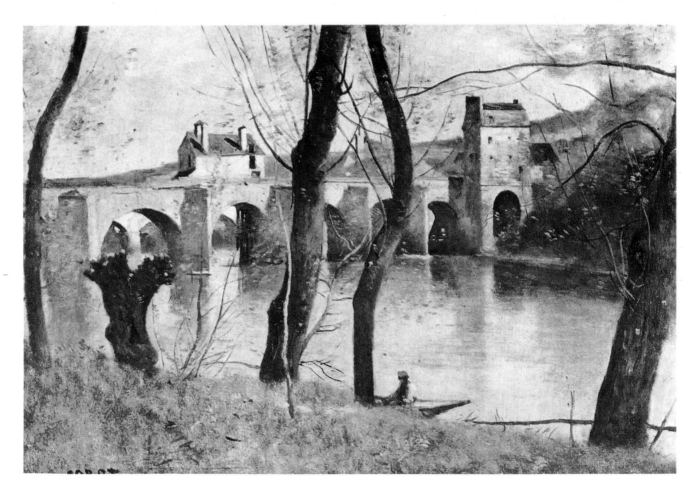

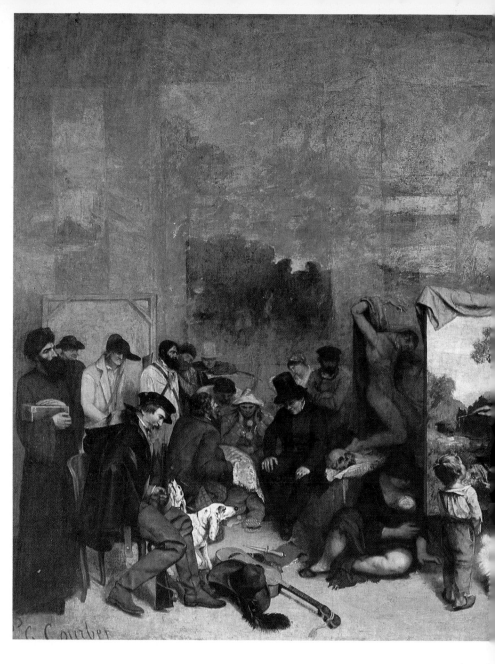

*Courbet*. The Artist's Studio, *1855.*
*Musée d'Orsay, Paris.*

### Courbet, Gustave

A major figure in the development of French painting in the pre-Impressionist epoch. Born in 1819 of peasant stock, a convinced atheist and socialist, he was also a genuine realist, at odds with the French art authorities all his life, and an inspiration to a generation of younger painters, notably the original Impressionist group. His involvement in the destruction of Napoleon's column during the Paris Commune led to his downfall. He took refuge in Switzerland, where he died in 1877.

### Couture, Thomas

An historical and portrait painter, born in 1815. A pupil of Gros, he owes his place in art history to the fact that he gave lessons to Manet, Fantin-Latour and Puvis de Chavannes. He died in 1879.

### Daubigny, Charles-François

Born on 15 February 1817, the son of a landscape artist. Daubigny found himself as a painter when he started working in the Barbizon manner, largely out of doors. His riverside scenes and tranquil landscapes were accepted at the Salon, but he had great sympathy with the Impressionists – all younger painters – and their aims. He was particularly helpful to Pissarro and Monet when he met them, as a fellow refugee, in London during the Franco-Prussian war. He died on 19 February 1878.

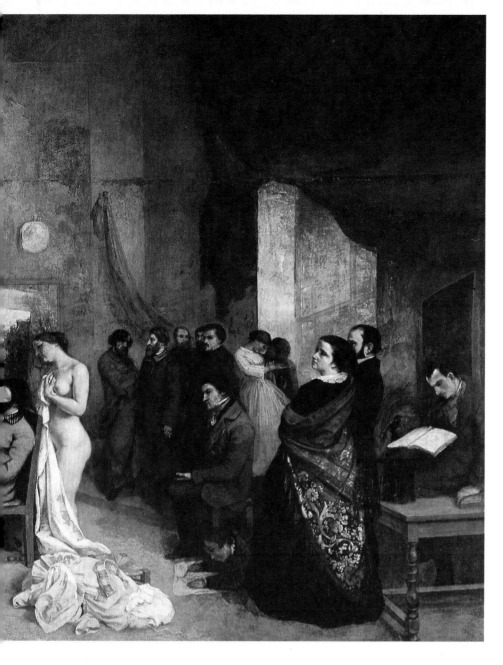

*Daubigny*. Landscape with Cattle,
*1872. National Gallery, London.*

## Daumier, Honoré

Born in 1810, he became the leading cartoonist of his day and a vigorous antagonist of the Establishment: a cartoon of King Louis Philippe earned him a six-months' gaol sentence in 1832. Other favourite targets included the corruption of the courts and the social customs of the new bourgeoisie. His political lithographs for the *Charivari* are unsurpassed, and his oil paintings stand apart for their vigorous realism and energy. He was befriended by his fellow artists, among them Delacroix and Corot, who helped him in his destitute old age. He died in 1879.

## Degas, Hilaire-Germain Edgar

Born on 19 June 1834, into a prosperous banking family. Enrolled at the École des Beaux-Arts in 1855 and learned the qualities of draughtsmanship from Ingres. A feeling for realism of the kind introduced by the camera, and an eye for quick, journalistic compositions, give his work a startling modernity. An early friend of the Impressionists, and a co-exhibitor, he moved away from them as his career progressed. His masterly drawings, paintings and sculptures of figure subjects, caught with an unerring eye for natural movement and gesture, are lasting contributions to European art. He died on 27 September 1917.

*Degas.* Self-portrait, *1854–55.*
*Musée d'Orsay, Paris.*

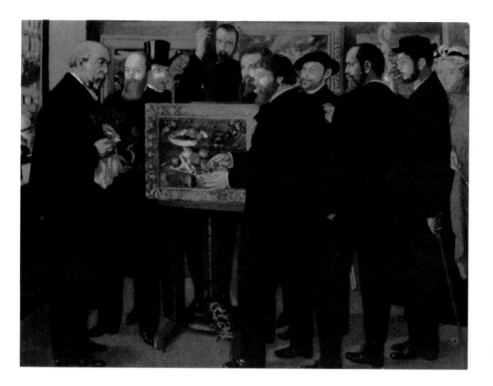

*Denis.* Hommage to Cézanne, *1900. Louvre, Paris.*

### Denis, Maurice

Born in Granville in 1870, one of the generation of French painters whose careers began in the wake of Impressionism. In 1901 he painted his *Hommage to Cézanne*, a large canvas which was exhibited at the Salon, showing a group of artists – Redon, Vuillard, Bonnard and Denis himself – gathered round a still-life by Cézanne. Denis became a leading Symbolist painter and exponent of modern art theory. He died in 1943.

### Durand-Ruel, Paul

A picture dealer, born in 1831, who began by buying works of the Barbizon painters and also supported Courbet. He took an interest in the Impressionists from their earliest appearances and bought their work, notably 23 paintings from Manet's studio in 1872, for which he paid 35,000 francs. At an exhibition which he arranged in London the same year, he showed 13 Manets, 9 Pissarros, 3 works by Degas, 4 by Monet – with an almost total lack of success. He had better fortune in Paris the following year, but the market then went into a deep depression and he came close to bankruptcy. Salvation came from America, where after an uncertain start the Impressionists began to find patrons. He died, prosperous and vindicated, in 1922.

### Fantin-Latour, Ignace Henri

Born at Grenoble on 14 January 1836. He was taught by his father and in Courbet's studio. An early champion of Manet, and a member of the Café Guerbois circle, he exhibited at the Salon des Refusés in 1863 but never attached himself to the Impressionist movement. His flower studies are his most admired contributions of his time. He died on 25 August 1904.

### Fisher, Mark

Born in Boston, Massachusetts in 1841. He studied at Gleyre's atelier in Paris from 1863, where he was a contemporary of Sisley, Monet and Bazille. Pissarro called him 'the first of our imitators'. He came to England in 1872, married and settled in London, where he quickly achieved a reputation. A number of Fishers were in the famous collection of Impressionists bought by the dealer Hugh Lane. He died in April 1923.

# THE PAINTERS, THEIR FRIENDS AND CONTEMPORARIES

Dr Paul Gachet *by Vincent Van Gogh, 1880. Private collection, USA.*

## Gachet, Dr Paul

Born in 1828, an early friend of Courbet and Victor Hugo, patron of French painters and etchers, and an habitué of the cafés which Manet and his circle liked to frequent in their early days, Dr. Gachet was also an active republican and socialist, with advanced views on medical practices of all kinds. He often attended his patients in exchange for a painting, and looked after Van Gogh during the final phase of his mental illness. He died in 1909.

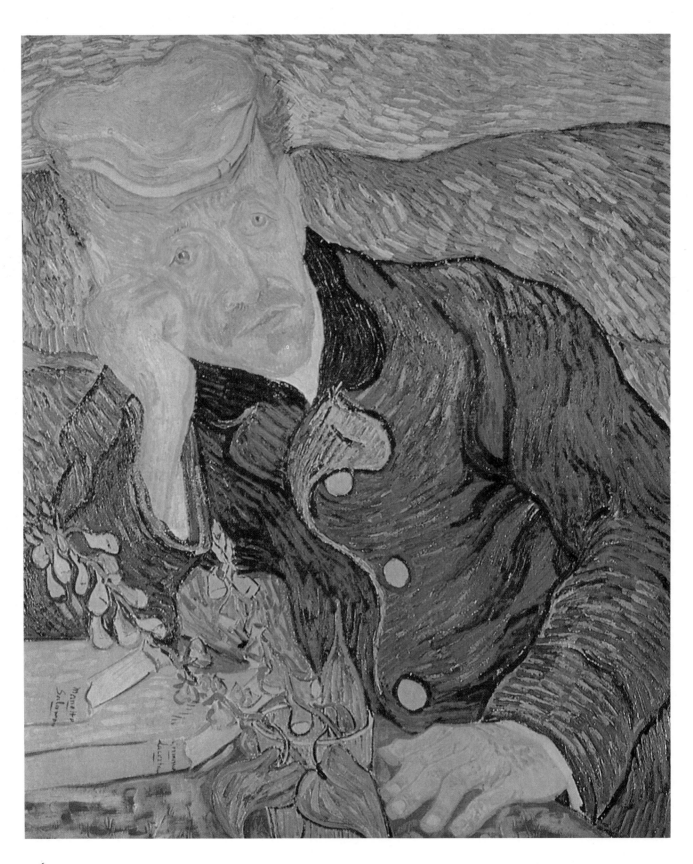

*Gauguin.* Te Reroia, *1897.*
*Courtauld Institute, London.*
*Courtauld Collection.*

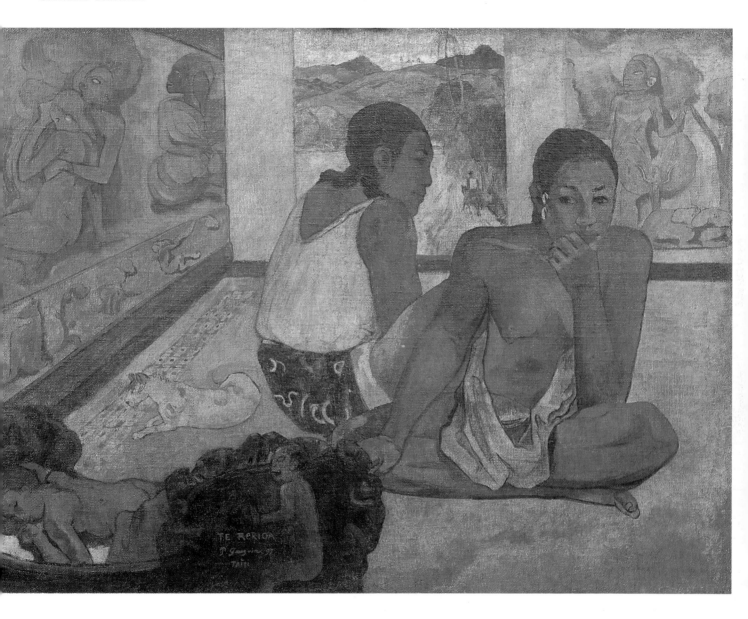

## *Gauguin, Paul*

Born on 4 June 1848, the son of a journalist. As a youth, Gauguin first went
to sea then into a stockbroker's office. He married, began to do well in his
job, then gave it all up to be a painter. He attached himself to Pissarro at
Pontoise and showed with the Impressionists at their exhibitions in 1880,
1881, 1882 and 1886. His move to Pont-Aven, Brittany, led him to the
symbolism which was his point of departure from the Impressionist idea.
His exposure to the genius of Van Gogh, whom he stayed with in Arles, left
its mark. His South Seas paintings set the seal on a life of explosive
achievement. He died at Atuana, in the Marquesas Islands, on 8 May 1903.

### Gleyre, Charles

A painter and teacher, born in 1808, in whose studio Renoir, Sisley, Monet, Whistler and Bazille studied in their early days. The tuition included painting from the nude every morning except Sunday, and for two hours every afternoon except Saturday. The pupils were of all ages, talents and temperaments, and discipline was minimal. Gleyre disliked lecturing, and seldom corrected the students' work, leaving them, as Renoir said, pretty much to their own devices. He placed great emphasis on drawing, usually at the expense of colour. To one student who ventured to use a certain red in his picture, Gleyre exclaimed: 'Be careful not to become another Delacroix!' He died in 1874.

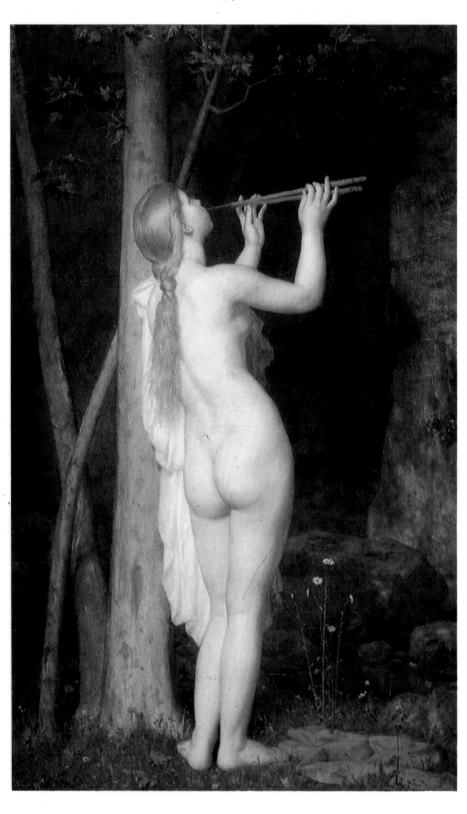

*Gleyre.* La Charmeuse, *1868.*
*Oeffentliche Kunstammlung Basel,*
*Kunstmuseum.*

238

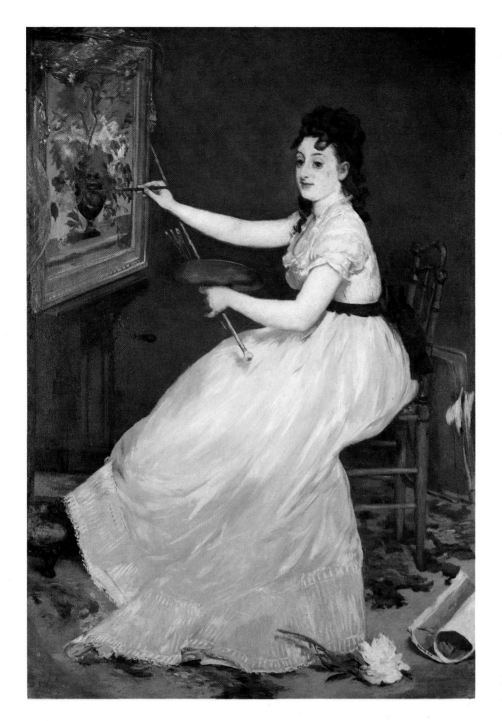

Éva Gonzalès *by Manet, 1870.*
*National Gallery, London.*

### Gonzalès, Eva

Manet's only pupil, whom he met in 1863, when she was 20 and taking instruction from Chaplin. Manet asked her to sit for him, and exhibited the resulting painting at the Salon of 1870, where she too had a painting accepted, very much in Manet's style. In 1878 she married the engraver, Henri Guérard. The death of Manet on 5 May 1883, occurred just after she had given birth to a baby. Two days after the funeral she died of an embolism.

### Guillaumin, Armand

Born at Moulins in 1841, Guillaumin is a less familiar figure than the other Impressionists, but he was an active and accomplished member of their circle. He was at the Académie Suisse with Pissarro and Cézanne, and later worked as a clerk in the municipal offices and as a ditch-digger to finance his painting. In 1891 he had the good fortune to win 100,000 francs in the city lottery. He died in Paris in 1927, having in his time worked with the leading painters of the age, from Pissarro and Cézanne to Signac and Van Gogh.

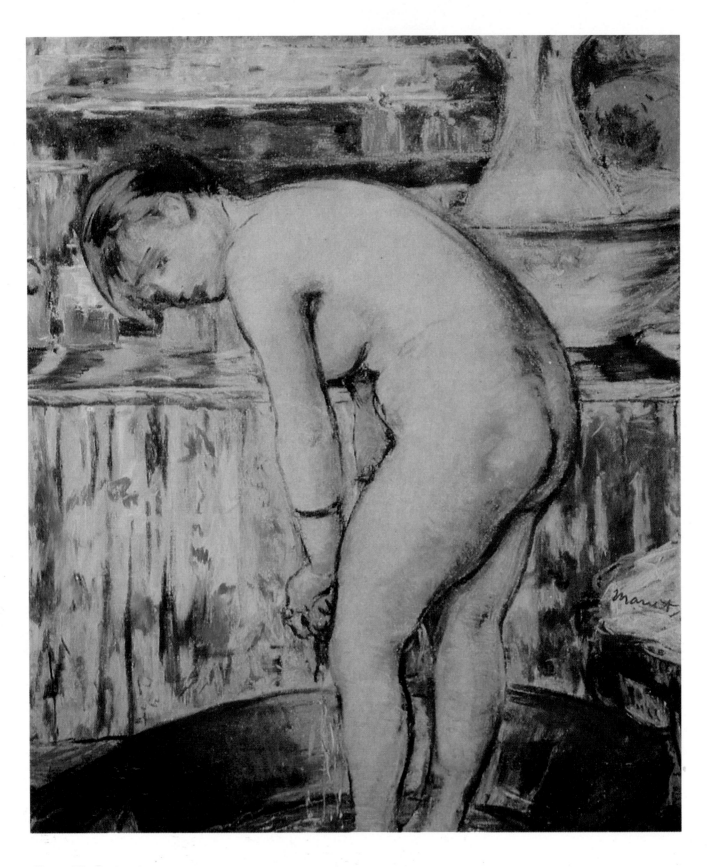

*Manet.* The Bath, *1878. Musée du Louvre, Paris.*

## Jongkind, Johan-Barthold

A Dutchman, born near Rotterdam on 3 June 1819. Jongkind trained as a landscape painter and moved to Paris in 1846. There he met Eugène Isabey, a painter of watercolour landscapes and marine subjects, who introduced him to the Normandy coast. Jongkind exhibited at the Salon des Refusés in Paris in 1863 and made an impact on the Impressionists, who recognized in his quick, direct style an approach to painting that was close to their own. He died on 19 February 1891.

### Mallarmé, Stéphane

Born in 1842 in Paris, where he became friendly with the Impressionists, particularly Manet. His attempts to bring into his poems an equivalent sense of light and movement set him apart from other Symbolist poets of his time. His *L'Apres Midi d'un Faune*, written in 1875, inspired Debussy's famous prelude of that name. He died in 1898.

### Manet, Edouard

Born on 23 January 1832, the elder son of a magistrate and a mother with diplomatic connections. There was no parental objection to his wish to be a painter, which was quickened by his travels and experiences as a naval cadet. He entered Couture's studio, studied in the Louvre, travelled around Europe, and in 1859 offered his *Absinth Drinker* for the Salon. It was rejected. After such controversial exhibits as *Le Déjeuner sur l'Herbe* and *Olympia*, he became the hero of the younger set. Though he never exhibited with the Impressionists, he remained their champion and inspiration. He died on 30 April 1883.

### Millet, Jean-François

Born in 1814, son of a Normandy peasant, he joined Theodore Rousseau at Barbizon, near Fontainebleau in 1849, and from then on made his theme the harsh reality of the peasant's life, enhanced by his own view of the dignity of labour. As a realist he was honoured by the Impressionists; who did not, however, emulate his distinctively sombre subject matter.

Mallarmé *by Manet, 1876. Musée d'Orsay, Paris.*

*Millet.* The Wood Sawyers, *1850–52. Victoria and Albert Museum, London.*

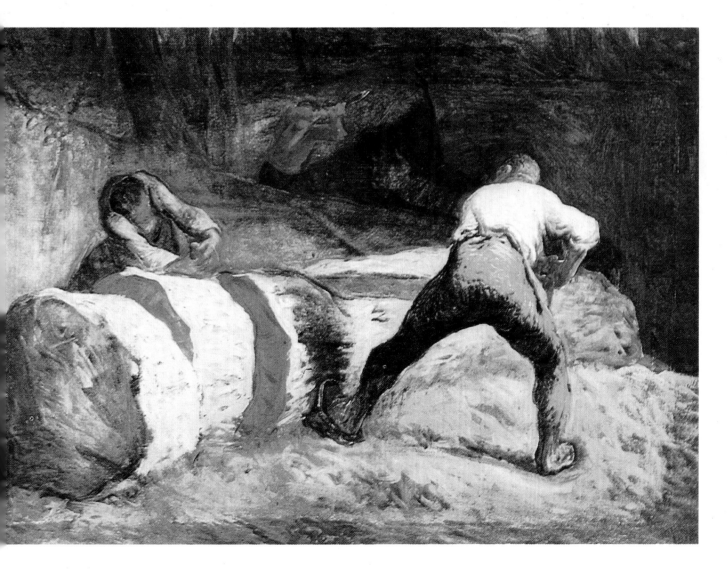

*Monet.* Self-portrait, *1917. Musée d'Orsay, Paris.*

### Monet, Claude Oscar

Born on 14 November 1840, the son of a grocer who moved his business from Paris to Le Havre, where Monet spent his boyhood. He met Boudin who encouraged him to paint, and after military service he entered Gleyre's studio – his introduction to Renoir, Sisley and Bazille. After 1870 and an interlude in London, he went to live at Argenteuil, and there, with Renoir, brought Impressionism to a peak of brilliance and achievement. As he grew older his manner broadened into near – abstraction, ending in the spectacular water-lily paintings executed at Giverny. He died there on 5 December 1926.

### Morisot, Berthe

Born on 14 January 1841, a daughter of the Prefect of Bourges. The family moved to Paris, where all the sisters took drawing lessons. Berthe, the most talented, was given painting instruction by Corot. A meeting with Manet was her introduction to the world of the Impressionists, as well as a decisive influence on her own development as a painter. She exhibited at the first Impressionist show in 1874, and in the same year married Manet's younger brother, Eugène. She was a loyal contributor to all the subsequent Impressionist exhibitions except in 1879, when she gave birth to her daughter, Julie, who in due course married the painter Georges Roualt. She died on 2 March 1895.

*Pissarro.* The Coach at Louveciennes, *1870. Musée d'Orsay, Paris.*

### Nadar, Félix

Best remembered as the photographer friend of the early Impressionists: he lent them his gallery for their first group exhibition in 1874. Born in 1810, Nadar was a pioneering photographer in his own right. Daumier made a lithograph for *Le Boulevard* in 1862 showing Nadar aloft in a balloon, his camera on its tripod, taking pictures above the rooftops of Paris, with the caption: 'Nadar Raising Photography to the Height of Art'. He died in 1910, venerable but poor.

### Pissarro, Camille

Born on 10 July 1830 in the Virgin Islands, Pissarro was sent to France as a child of twelve to complete his education. Back in the colony, his appetite for painting increased, and his parents agreed that he could return to Paris. After attending the École des Beaux-Arts and the Académie Suisse he began painting in the open air, and rapidly became a close friend of Monet and his circle. His struggles to bring his art to the high standards which he encouraged in others brought him near to despair. After a flirtation with Pointillism he reverted to the Impressionist style, remaining the truest of the group to the ideas which, as younger men, had bound them together. He died on 12 November 1903.

### Pissarro, Lucien

Born in Paris in 1863, the eldest son of Camille Pissarro, Lucien moved to London in 1890 where he was active in the New English Art Club and in the Camden Town Group. He also made a reputation with his book printing and designs. His father's letters to him are a fruitful source of Impressionist history and ideas. He died in Heywood, Somerset, in 1944.

### Puvis de Chavannes, Pierre

Born in 1824, he became noted as the foremost mural painter of his time, working on large canvases which were then mounted on walls, usually re-workings of subjects from the antique. They were much admired by Seurat, Gauguin and Toulouse-Lautrec for their Post-Impressionist manner, the colours flat and pale and the subjects redolent of Symbolism. He died in 1898.

*Puvis de Chavannes*. The Sacred Grove, *1883–84. Musée des Beaux-Arts, Lyons.*

### Redon, Odilon

Born in Bordeaux in 1840, Redon learned etching and engraving and studied at the École des Beaux-Arts in the 1860s. He became friends with Fantin-Latour, who introduced him to the Impressionist circle. His sympathies were not all with them and their ideas, however, since he inclined to the 'inner eye' concept rather than to naturalism. His ideas encouraged the growth of Symbolism in the 1890s and influenced Gauguin at a formative stage. The main impact of his highly individual manner was on Post-Impressionism. He died in 1916.

### Renoir, Pierre-Auguste

Born in Limoges on 25 February 1841. His father, a tailor, moved the family to Paris, where Renoir first worked at a porcelain factory decorating the wares. He spent his wages on artists' equipment, and on lessons at Gleyre's studio, where he met Monet, Sisley and Bazille. With Monet he shared the heroic but impoverished 1870s, and regularly exhibited with the group. Acceptance came at last, not through the Impressionists' exhibitions but at the Salon, where his portrait of Mme. Charpentier and her children was shown in 1879. Renoir went his own way in the 1880s, looking for more durable forms than Impressionism offered. He died at Cagnes, his home in Southern France, on 3 December 1919.

*Renoir.* Mosque in Algiers, *1882. Private Collection.*

## Roussel, Ker-Xavier

Born in 1867, he trained at the Académie Julian in Paris, was a friend of Bonnard and of Vuillard, whose sister he later married, and a member of the Nabis. He was one of the painters included in Maurice Denis' historic painting, *Homage à Cézanne*, of 1900. He died in 1944.

## Russell, John Peter

An Australian, born in 1858, who came to London and enrolled at the Slade in 1881. He moved to Paris in 1884 and was befriended by Van Gogh, and joined the circle of Rodin, Bernard and Anquetin. The main influence on his work was Monet, whom he visited in Belle-Isle, Brittany, where he made his home until 1908. He then returned to Sydney and obscurity, and died in 1930, the 'unknown Impressionist'.

## Sargent, John Singer

Born in Florence on 12 January 1856, of American parents, his father being a doctor from Boston. He studied in Florence and in Paris, where in 1876 he started his career as a painter in Monet's circle. His full-length portrait of Mme. Pierre Gautreau, a notable Parisienne of uncertain reputation, caused a scandal when it was shown at the Salon in 1884, and virtually drove Sargent out of Paris. He settled in Chelsea, to become a brilliantly successful portrait painter of the Edwardian era and an important link between British painters and the School of Paris. He died 18 April 1925.

## Sérusier, Paul

Born in 1864, he was an early follower of Gauguin, whom he met at Pont-Aven in 1888. He became one of the Nabis, with Bonnard, Denis, Roussel and Vuillard, and eventually retired to Brittany, where he wrote a book on art theory. He died in 1927.

## Seurat, Georges

Born on 2 December 1859. Seurat studied at the École des Beaux-Arts. His first major work, *Une Baignarde*, was rejected by the Salon but exhibited at the Salon des Indépendants in 1884. The *Grande Jatte* followed at the 1886 Impressionist exhibition, Pissarro having persuaded the committee to allow the tiny group of Pointillists – himself included – to be represented. His imaginative advance on Impressionist principles was not well received, but he remained true to it until his early death on 29 March 1891.

## Signac, Paul

Born on 11 November 1863. Largely self-educated, he founded the Société des Artistes Indépendants with Seurat in 1884 and exhibited there until 1893. It was Signac who initiated Seurat into the techniques of Pointillism, otherwise known as Divisionism. The techniques were carried further after Seurat's death, when Signac became the leader of the Neo-Impressionists. He died on 15 August 1935.

## Sisley, Alfred

Born in Paris of English parents on 30 October 1839, Sisley was essentially a French painter and belongs among the most unwavering of the Impressionists. As an early comrade of Renoir, Monet and Pissarro, he shared the struggles of the 1860s and 1870s and took part in five of the Impressionist exhibitions. He made three journeys to England, but his painting country was the landscape on the outskirts of Paris, notably Louveciennes. Monet organized a sale of his work after his death on 29 Januarury 1899, which established his honoured position in the Impressionist circle.

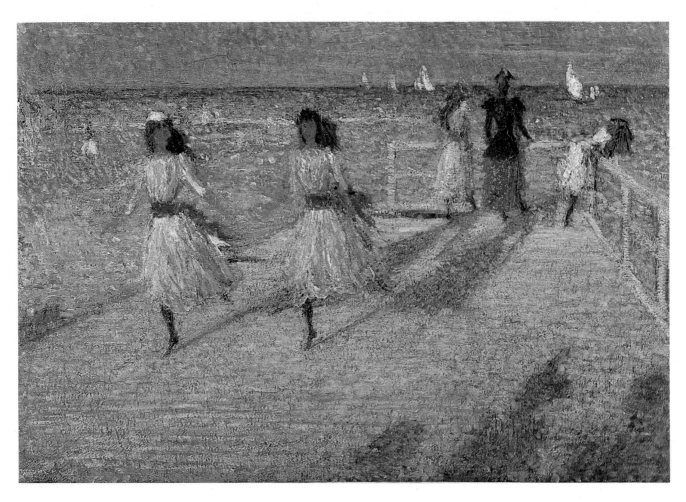

*Wilson Steer*. Girls Running,
Walberswick Pier, *1888–94. Tate
Gallery, London.*

### Steer, Philip Wilson
Born in 1860, son of a landscape and portrait painter, he failed to gain
admission to the Royal Academy Schools and instead went to Paris, where
he studied at the École des Beaux-Arts. He returned to England in 1884
having absorbed Impressionism, and after becoming a founder member of
the New English Art Club he left to help start another avant-garde faction,
the English Impressionist Group, in 1889. His best-known works from
that period include beach scenes painted in the iridescent Impressionist
style. His attachment to Turner and Constable later took over but he
retained a free, spontaneous touch. He died in 1942.

### Toulouse–Lautrec, Henri–Marie–Raymond de
Born at Albi, 24 November 1864, into an aristocratic family. Lautrec took
up painting after the crippling accident which prevented him leading an
active outdoor life. He encountered the Impressionists in the 1880s, when
he embarked on his famous series of studies of the denizens of Paris music-
halls and brothels. He was struck by the work of Manet and Degas, in
particular, and also became friendly with Van Gogh, whose move to
Provence he was instrumental in bringing about. He exhibited with the
Impressionists in 1889 at the Salon des Indépendents. He died on
9 September 1901.

### Valadon, Suzanne
Born in 1867. An artist's model turned graphic artist and painter, she sat
for Puvis de Chavannes, had a love affair with Renoir, and associated
herself with Toulouse-Lautrec, through whom she attracted the attention
of Degas. He admired her graphic work and remained helpful to her for the
rest of his life. A later influence on her was Gauguin, some of whose
energetic manner is found in her own paintings. She died in Paris in 1938.

*Toulouse-Lautrec.* Woman pulling on her Stockings. *Musée Toulouse-Lautrec, Albi.*

### Van Gogh, Vincent

Born on 30 March 1853 at Groot Zundert, Holland, the son of a clergyman. He turned to art in 1880, supported by his brother Theo, a dealer, who championed the Impressionists. Van Gogh first saw Impressionist pictures in Paris in 1886. His palette lightened, and in February 1888 he left the city for the sunnier environment of Arles. The rest of his life was the tragedy and triumph of the final two years. He shot himself at Auvers on 27 July 1890, and died two days later.

*Van Gogh.* Plane Trees at Arles, *1888. Musée Rodin, Paris.*

*Vollard by Cézanne, 1899. Musée du Petit Palais, Paris.*

## Vollard, Ambroise

A picture dealer, born in 1867, whose first coup was seeking out the all–but–unknown Cézanne in 1895 and mounting an exhibition of his work in Paris. He subsequently made a deal with the self-exiled Gauguin, then in Tahiti, to make him a regular allowance in return for his output of paintings. In 1901 he held the first exhibition of the young Picasso, who made him the subject of one of the earliest Cubist paintings. His portrait had already been painted by both Cézanne and Renoir. He died in 1938.

## Vuillard, Edouard

A contemporary of Bonnard, Denis and Serusier, born in 1869, and like them a member of the Nabis group, he worked in the theatre as a designer and decorator, mastered colour lithography, then went his own way as the best known 'Intimiste' of his day, content to work within a private range of subject-matter in a manner that owed more to Impressionism than any painter of his time except Bonnard. He died in 1940.

## Whistler, James Abbot McNeill

Born at Lowell, Massachusetts, and taken to St Petersburg as a child, where his father was a consultant engineer for the St Petersburg to Moscow railway. He was entered for West Point Academy but failed the course, and in 1855 went to Paris to study painting. He exhibited at the Salon des Refusés in 1863, along with Manet, Pissarro, Jongkind, Fantin-Latour, Guillaumin and Cézanne. Though he was never an Impressionist, his atmospheric *Nocturnes* share the Impressionist mood. He died in London on 17 July 1903.

THE PAINTERS, THEIR FRIENDS AND CONTEMPORARIES

*Zola by Manet, 1868. Musée d'Orsay, Paris.*

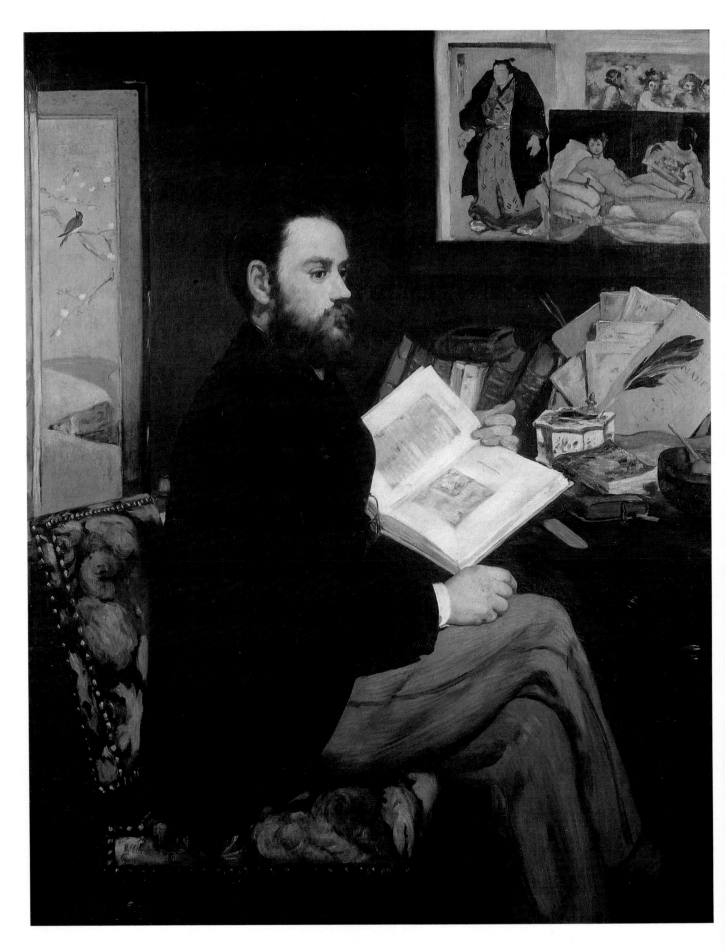

## Zola, Émile

Born on 2 April 1840, his critical writings and journalism did much to encourage the Impressionists in their early days. He visited the Salon des Refusés in company with his old schoolfriend, Cézanne, through whom he met Pissarro, Guillaumin and others. Zola's novel *La Confession de Claude* is dedicated to Cézanne, who helped him towards a view of the artist existing by virture of himself rather than of the subject he chooses to paint. His views were reinforced by an acquaintance with Manet, whom he marked out for a place in the Louvre. He appears in various Impressionist paintings, including one by Bazille and Cézanne. His portrait by Manet hangs in the Louvre. He died on 29 September 1902.

# Bibliography

Aubry, G. Jean, *Eugène Boudin*. Thames & Hudson 1969.
Callen, Anthea, *Techniques of the Impressionists*. Orbis 1982.
Callen, Anthea, *Renoir*. Oresko Books, London 1978.
Champs, K. S., *Studies in Early Impressionism*. Yale University Press 1973.
Dunlop & Orienti, *Complete Paintings of Cézanne*. Weidenfeld & Nicholson 1972.
Dunlop, Ian, *Degas*. Thames & Hudson 1979.
Flint, Kate (ed), *Impressionists in England*. Routledge 1984.
Hammacher, A. M. and Renilde, *Van Gogh: a documentary biography*. Thames & Hudson 1982.
Jaworska, W., *Gauguin & the Pont-Aven School*. Thames & Hudson 1972.
*Manet*. Editions de la Reunion des Musees Nationaux, Paris 1983.
McMullen, Roy, *Degas. His Life, Times and Work*. Secker & Warburg 1985.
Olsen, Stanley, *John Singer Sargent: his portrait*. Macmillan 1986.
Ormond, Richard, *John Singer Sargent*. Phaidon 1970.
*Pissaro*. Arts Council of Great Britain 1980.
*Post-Impressionism: cross-currents in European painting*. Royal Academy of Arts, London 1979.
*Renoir*. Arts Council of Great Britain 1985.
Rewald, John (ed), *Camille Pissarro: Letters to his son*. Routledge & Kegan Paul 1980.
Rewald, John, *Cézanne*. Thames & Hudson 1986.
Rewald, John, *The History of Impressionism*. Secker & Warburg 1973.
Rewald, John, *Post Impressionism*. Secker & Warburg 1956.
Richardson, John, *Manet*. Phaidon 1982.
*Sargent at Broadway: The Impressionist Years*. John Murray 1986.
Shackelford, George T. M., *Degas: The Dancers*. National Gallery of Art, Washington 1984.
Shikes, Ralph E. and Harper, Paul, *Pissarro: His Life and Work*. Quartet Books 1980.
Spalding, Frances, *Whistler*. Phaidon 1979.
Sutton, Denys, *James McNeill Whistler*. Phaidon 1966.
Tucker, P. H., *Monet at Argenteuil*. Yale University Press 1982.

# Index

7296